THE
MAVERICK'S
MUSEUM

ALSO BY BLAKE GOPNIK

Warhol

THE MAVERICK'S MUSEUM

ALBERT BARNES AND HIS AMERICAN DREAM

BLAKE GOPNIK

ecco
An Imprint of HarperCollins*Publishers*

THE MAVERICK'S MUSEUM. Copyright © 2025 by Blake Gopnik. All rights reserved. Printed in the United States of America. No part of this book may be used or reproduced in any manner whatsoever without written permission except in the case of brief quotations embodied in critical articles and reviews. For information, address HarperCollins Publishers, 195 Broadway, New York, NY 10007.

HarperCollins books may be purchased for educational, business, or sales promotional use. For information, please email the Special Markets Department at SPsales@harpercollins.com.

Ecco® and HarperCollins® are trademarks of HarperCollins Publishers.

FIRST EDITION

Designed by Alison Bloomer

Library of Congress Cataloging-in-Publication Data has been applied for.

ISBN 978-0-06-328403-6

25 26 27 28 29 LBC 5 4 3 2 1

For my parents, Irwin and Myrna,
who taught me to think and see.

Contents

PROLOGUE 1

1 **CIVIL WAR | CHILDHOOD | METHODISM** 8

2 **THE NECK | CENTRAL HIGH** 15

3 **MEDICAL SCHOOL | GERMANY | MULFORD** 23

4 **WEDDING | ARGYROL | MARKETING** 30

5 **BRIBES | LAWSUIT | THE MAIN LINE** 41

6 **COLLECTING | GLACKENS | PARIS** 50

7 **A BUYING SPREE** 62

8 **COLLECTING MANIA** 69

9 **ARMORY SHOW | JOHN QUINN | VITUPERATIONS** 79

10 **CULTURAL ASCENT | AMERICAN MODERNS | JUDGING ART** 87

11 **DEWEY** 96

12 **DEMOCRACY AND EDUCATION** 106

13 **FACTORY LIFE | WORKER EDUCATION** 113

14 **BUERMEYER | PRACTICAL PSYCHOLOGY | A MURDER CASE** 125

15 **WAR | A POLISH STUDY** 134

16 **WEALTH | RENOIR AND CÉZANNE** 141

17 **BUYING AMERICAN | ART IN THE FACTORY** 150

18 **PHILADELPHIA PHILISTINES | BIRTH OF THE FOUNDATION** 156

19 **PLANNING A FOUNDATION | YOUNG ART IN PARIS** 162

20 **PAUL GUILLAUME** 171

21 **DE CHIRICO | MODIGLIANI | SOUTINE | A FIRST EXHIBITION** 180

22 **AFRICAN ART | BLACK CULTURE** 192

23 **BLACK RIGHTS | BLACK EDUCATION** 202

24 **NEW BUILDINGS | THE COLLECTION** 213

25 **THE FOUNDATION OPENS | EDUCATION AND *THE ART IN PAINTING*** 223

26 **DEMOCRATIC AESTHETICS | FORM AND MEANING** 232

27 **UNIVERSITIES | THOMAS MUNRO | EUROPE | CÉZANNE AND SEURAT | ART EDUCATION** 245

28 **FAILED ALLIANCES | "THE GIRLS" AND DE MAZIA | DEMONSTRATIONS** 256

29 **EJECTING ELITES | FINE SCOTCH** 267

30 **THE NEGRO CENTER | FOUNDATION FELLOWSHIPS | HENRY HART** 274

31 **DEATHS | ZONITE | RETURNING AN O'KEEFFE** 284

32 ***THE DANCE* | A DOUBLE CROSS? | A MATISSE BOOK** 290

33 **GREAT DEPRESSION** | *ART AS EXPERIENCE* | **RENOIR** 304

34 **VOLLARD** | **CÉZANNE'S** *BATHERS* 314

35 **CRAFTS** | **HORACE PIPPIN** 321

36 **KER-FEAL** | **THE ARBORETUM** | **BERTRAND RUSSELL** 334

37 *THE SATURDAY EVENING POST* | **FIRING RUSSELL** 342

38 **FAILURES** | **WAR** 351

39 **PENN REDUX** | **HAVERFORD** | **PENN AGAIN** | **SARAH LAWRENCE** | **LINCOLN UNIVERSITY** 358

40 **THE END** 366

EPILOGUE 369

A NOTE ON SOURCES 379

ACKNOWLEDGMENTS 381

ILLUSTRATION CREDITS 383

INDEX 391

THE MAVERICK'S MUSEUM

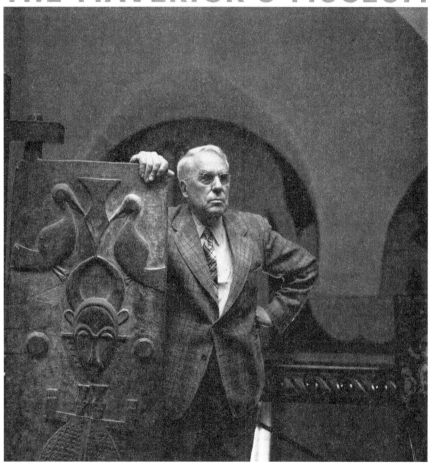

Albert Barnes with one of his African treasures.

PROLOGUE

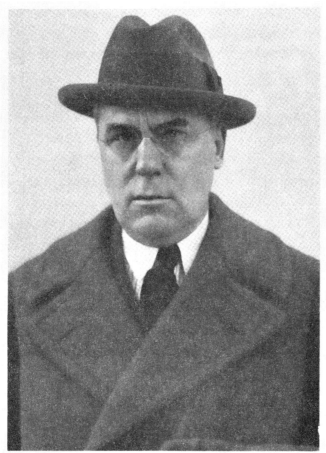

© Keystone
DR. ALBERT C. BARNES
Art connoisseur of Philadelphia who has established a $6,000,000 foundation to preserve the history of the modern revolt in the world of art. His own collection will be housed in a museum at Merion, Pa.

Barnes in February of 1923, as his plans for a foundation first attract notice.

The sun was setting on the unseasonably cold evening of March 21, 1924, when yellow cabs began to pull up in front of the grand old brownstone of the Civic Club, a meeting place for New York's progressive elite on Twelfth Street in Greenwich Village.

From Harlem and other Black enclaves came a crowd of African American writers, including the young poets Langston Hughes and Gwendolyn Bennett as well as the new-minted novelists Walter F. White and Jessie Fauset, all in their best evening clothes. They were joined by the philosopher Alain Locke, a professor at Howard University in Washington who was a Harvard graduate and Rhodes Scholar, and by the activist and intellectual W. E. B. Du Bois, fresh from a trip to West Africa as President Coolidge's "minister plenipotentiary."

Bourgeois neighborhoods of the Upper East Side and Brooklyn Heights delivered up leaders in progressive white culture such as H. L. Mencken and Carl Van Doren. They were joined by Horace Liveright and the other white publishers and editors daring to promote the New Negro movement, just then being defined by the evening's Black authors.

Even as cabs and passengers were gathering around the Civic Club doors, they found themselves giving way before a monster of a Packard sedan, a seven-seater Straight Eight with butter-yellow wheels, a body painted indigo blue, and fenders and headlamps custom enameled in black. Climbing out of his seat up front, a chauffeur swung open the carpeted door of the passenger compartment to release an ox of a man in a double-breasted greatcoat and

fedora. White hair above beetling dark brows gave him the look of an aging vice cop—someone who hit first and asked questions later, as this man did in all cultural fights. He was Albert Barnes, coming in from Philadelphia, where he'd first earned a fortune selling Argyrol, the gonorrheal antiseptic he'd invented, and then gone on to collect and show, and throw punches for, some of the newest modern art. Cross him in matters aesthetic, and you were likely to be outed for "clandestine fornication"; he kept bail bonds at hand in case of arrest for libel; he happily admitted that his "specialties" were vituperation and profanity. He offered to settle art world arguments with his fists.

That night in New York, Barnes, in a friendly mood, was joining a banquet attended by something like two hundred people, both Black and white, in a city where the "color line" still went largely uncrossed. They were meeting in New York's only integrated private club; Du Bois had been a charter member. The affair was organized by Charles Spurgeon Johnson, the Black activist who edited the Urban League's new *Opportunity* magazine, joined by Locke as the evening's master of ceremonies. The supper has long been considered the Harlem Renaissance's "coming out party"—the very words used to describe it in the next issue of *Opportunity*. It had been conceived to bring together a new generation of Black talent with white power players who had "vision enough to appreciate the significance of their work for America and present-day culture at large," as Locke wrote in his letter of invitation to Barnes. The collector must have been surprised to be counted among those visionaries.

Some of the banquet's diners might have read, and a few might even have remembered, the passing notice New York newspapers had given to Barnes's announcement, a year earlier, that he had plans for a museum near his suburban mansion on Philadelphia's ritzy Main Line. It would display the 600-odd works of radically modern art he'd amassed over just his first decade of buying—

"masterpieces" that precious few of Barnes's contemporaries would have seen as museum-worthy. The press noted Barnes's stockpile of 150 Renoirs, 50 Cézannes, 22 Picassos, and 12 Matisses, as well as his "interesting collection of African sculpture, believed by critics to be the most complete in existence."

Few guests at the Civic Club would have known more than that about this collection or its owner. Among those Jazz Age partiers, the fifty-two-year-old chemist stood out as notably stodgy.

So, after listening to several speakers' hopeful remarks about the bright future that must be just around the corner for America's Black creators ("they sense within their group . . . a spiritual wealth which if they can properly expound will be ample for a new judgment and re-appraisal of the race," said Locke), Barnes's fellow diners must have been surprised and pleased to find him talking, in quite concrete terms, about the African ancestors of Harlem's new talents. They would have been stunned to hear the strength of his support. "African art," Barnes insisted, "is as positive a form as Attic Greek art and as fine as anything in Egyptian art from 2000 B.C. to 5000 B.C. or in Greek art from the second to the sixth century." Despite the money they had on the line, it's not likely that even the most supportive of the white publishers on hand had ever argued—with reporters present, no less—that Du Bois and Locke were competition for Plato or even John Dewey, or that Shakespeare and Henry James had better watch out for rivals like Langston Hughes and Jessie Fauset. Most of America's elite, immersed in an era of the deepest racism, would never have imagined that any creation by a Black person, anywhere at any time, could rival the "heights" of white culture.

By the next day, Barnes was doubling down on his claims in a note to his Civic Club host. He told Johnson that the Barnes Foundation, soon to open its doors, would be giving "a crack between the eyes" to the stodgy old art world by showing African and classical sculpture side by side, proving the contest at best a

draw. Ditto for those same African works and the art of the latest innovators, such as Picasso and his followers, who could normally count on Barnes as their champion: "I have in my house ample proof in the works of these moderns that much of their inspiration came from ancient negro art." ("Negro" was the standard polite term at the time; it was the period version of today's "African American" or "Black.")

Unlike most of the era's white fans of African art, Barnes wasn't admiring it for the thrill of a charge they would have labeled primitive—as the product of some exotic Other that stood for a disruptive force that was "against everything," in the words of Picasso. Barnes was bringing African art right into the fold of all the high culture he and other aesthetes were supposed to admire and using it as a sign of the respect that all Black people, and their cultures, were owed.

A few months before the Civic Club bash, the editors of *Ex Libris*, a Parisian magazine that published in English, had asked Barnes to contribute an article on African art as "the basis of the whole modern movement," and Barnes had agreed—but only so long as he could range far beyond that to cover what African Americans had "achieved in thought, literature, music and the living of art expression in everyday life." Barnes explained that he'd "lived and worked" with Black people for more than twenty years, "and as human beings and as artists in living, I have the highest respect for them."

His article described Black people's "subjection" to the "fundamentally alien influence" of their Anglo-Saxon oppressors—an oppression that was still ongoing, Barnes said—and how that led to "the soul-stirring experiences which always find their expression in great art." For whites, art and religion had become "obsolete and meaningless forms," whereas spirituals, an African American art form Barnes had known since childhood, ranked with the biblical poetry that stood at the root of all Christian letters. Those

spirituals, Barnes insisted, were "the single form of great art which America can claim as her own"—up there with the great cathedrals of Europe, he felt—and he was asserting all this at a moment after World War I when the search was on for a new and uniquely American culture, worthy of the nation's new place on the world stage. According to Barnes, that new culture might end up being more Black than white, especially since America's nascent modernism was really just an offshoot of the European version, and that, he claimed, was based on African models anyway.

Discussing and presenting the latest works by Black poets, Barnes's article bore witness to what he referred to, and capitalized, as a "Renaissance"—a phrase yoked to "Harlem" just a bit later—describing it as "one of the events of our age which no seeker for beauty can afford to overlook." Barnes wrote that the "mental and moral stature" of African Americans "now stands measurement with those of the white man of equal educational and civilizing opportunities. . . . Our unjust oppression has been powerless to prevent the black man from realizing in a rich measure the expressions of his own rare gifts."

And Barnes was daring to make such claims in a country where a lynching took place at least once a month and the Ku Klux Klan could count millions of members; where whites were busy burning down Black businesses and neighborhoods from Wilmington to Chicago to Omaha. It was a country where the "hierarchy of races" and the pseudoscience of eugenics were taught in pretty much every university.

In 1924, Barnes's support for Black rights and culture stood out as bold, however flawed and paternalistic that support can seem now. If he couldn't rid himself of the racist idea that white, European culture was the touchstone against which all other cultures would be measured—and that he, as a white man, was the one to do the measuring—he was unusually willing to let the comparison happen at all.

"We have begun to imagine that a better education and a greater social and economic equality for the negro might produce something of true importance for a richer and fuller American life," Barnes wrote. He was determined to get in "a few good licks" for that cause. Only a handful of whites had the courage to do the same.

But there was nothing Barnes liked better than a fight, especially when he could back the underdog. His ferocious, lifelong rejection of elites and elitism—racial, economic, social, artistic, intellectual—was at the root of the achievement of this dedicated democrat as he collected, considered, and taught modern art. For Barnes, that art itself, however deluxe and elite, represented the possibility of egalitarian new beginnings and the passing of old hierarchical ways; it stood as a reminder of his own rise out of grimmest poverty and as a symbol of the ascent he desired for others. It was his weapon in the fight for democratic renewal being waged all around him in the Progressive Era, when the future of American culture seemed up for grabs.

CHAPTER 1

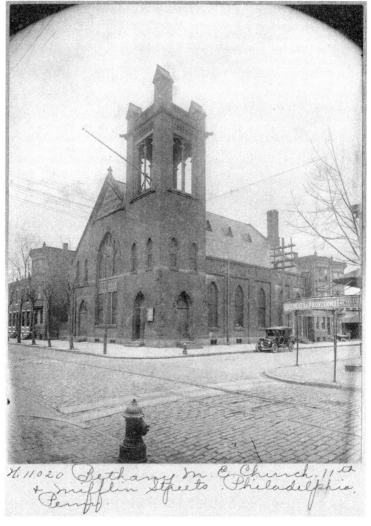

Bethany Methodist Episcopal Church, the Barnes family house of worship in South Philadelphia.

CIVIL WAR | CHILDHOOD | METHODISM

"I was switched suddenly from my everyday world to the realm of mysticism"

t was early morning, at a crossroads by the Cold Harbor Tavern near the Confederate capital of Richmond, Virginia, and the Union soldiers of the Eighty-Second Regiment of Pennsylvania Volunteers were almost blinded by smoke. Explosions roared above horses' screams, deafening soldiers on both sides of the fight. Bullets flew "thick as bees when they are swarming," one survivor wrote home to his wife. "The old soldiers say they never saw such a time and for my part I don't want to see another."

In the first days of June 1864, in the thirty-eighth month of the American Civil War, General Ulysses S. Grant was keen on smashing the Confederate forces where they had gathered at Cold Harbor. The Eighty-Second had signed up to help, but had no idea what it meant to march against an army deeply entrenched in the land. The men had been ordered to advance without priming their muskets, unable to fire even one shot, and the regiment took 173 casualties, more than half its men. The Union army as a whole lost 12,000 soldiers in the battle, compared with just 4,000 casualties suffered by the South. The wounded were left lying in the no-man's-land between the front lines; once stretcher-bearers could

go out, only two men were still alive, among corpses that covered the ground "about as thickly as they could be laid."

In later days, General Grant said he regretted ever launching his doomed Cold Harbor assault. Private John Jesse Barnes of the Eighty-Second, the future father of Albert, must have regretted it more. The twenty-year-old from Philadelphia, with only four months of service behind him, caught a bullet to the chest, and his right arm was so badly mangled by shot that army surgeons had to take it off above the elbow. When he left government care, he was still considered three-quarters disabled; the government's gift of a wooden arm did not solve the problem.

Somehow, none of this ruined his romantic prospects. On April 4, 1867, not quite two years after his army discharge, the twenty-two-year-old John Jesse Barnes married Lydia A. Schaffer.

The groom was a small man, just about five feet four, with brown hair, hazel eyes, and dark skin. Before the war, John J. had worked in one of Philadelphia's slaughterhouses, cutting meat that the nation traded for slave-grown sugar from the Caribbean. It was a humble occupation, but in Philadelphia a butcher could rise into the bourgeoisie, sometimes higher. At the slaughterhouse, John Barnes had wielded his knife alongside Peter Widener, who first got an army contract for pork and then parlayed that into truly vast wealth and a great art collection.

But any future in butchering required two arms.

At the time of his wedding, the one-armed veteran had been granted a government job as a letter carrier, plus a disabled veteran's pension of $8 a month. It wasn't a lot of money, but those veterans' pensions, acclaimed as "the wisest and most munificent enactment of the kind ever adopted by any nation," represented one of the first great applications of progressive social policy in

American history—policy that Albert Barnes's childhood survival depended on and that he later went on to champion.

When Barnes was born, the family lived at 1466 Cook (later Wilt) Street in Fishtown, in North Philadelphia, in a rented four-room brick house, two stories tall and barely two windows wide, on a narrow, winding street packed with endless rows of such homes. The area was crowded with workers from nearby textile mills, in a city whose population was undergoing huge growth. Their neighbors were mostly Irish and Scottish from the lower working class—impoverished but proud, and rarely destitute.

John and Lydia soon had a son, Charles, who had to drop school for work as an errand boy. A second and fourth son both died as babies, but in between, on January 2, 1872, came Albert Coombs Barnes. Dad was listed on the birth certificate as a "mechanic," but over coming years he would go on to hold a series of unskilled jobs, even working as a lowly watchman, one of the least skilled of all positions.

There was a firehouse near the Cook Street home, and it was the site of one of young Albert's first aesthetic experiences. As a six-year-old, he'd loved the gleaming engine and its prancing horses; trying to get the scene down on paper launched him into several decades of amateur art making and then a lasting love of art—and of firemen.

Once he'd acquired his fortune and a mansion on the Main Line, he became an avid friend and honorary "Lifetime Colonel" of the local Narberth Fire Company, riding the engine alongside its volunteer firefighters—an engine he helped fund.

Lydia Barnes was an ardent Methodist.

Her faith was narrow, Barnes recalled, "but it worked—for her." Her marriage had been consecrated in a Methodist ceremony,

and for years to come, the whole family spent its Sundays at Bethany Methodist Episcopal Church. It was an imposing place, with a touch of the fortress about it, founded shortly before in a crowded section of Philadelphia's far south, where endemic poverty left plenty of church "work" to be done, both evangelical and charitable. As an adult, Barnes followed up with good works of his own.

One of Bethany's leaders recalled to Barnes all the times he'd been able to count "that splendid Mother of yours, that big hearted Father, and the Youngster"—Barnes himself—"as helpers of mine." But the church and its services didn't much matter to Barnes. He came alive at the camp meetings where the congregation left behind the church and its ceremonials.

Streaming out to various country campgrounds, worshippers would flee the heat and stink of the city for a week or more almost every summer. Seeking God in the woods, they shared meals and prayers, listened to firebrand preachers, wandered about in ecstasy, shouted, waved their arms, danced, and broke out into declarations of faith and spirit that would never have been proper in their staid urban lives and city churches. Once in the forest, they could enjoy the "animal excitements" of excess zeal that a contemporary chided them for.

One summer around 1878, Barnes and his mother joined them, out in Philadelphia's leafy New Jersey exurbs. "Between the ages of six and eighteen," he recalled, "I was a constant attendant at the camp meetings at Merchantville and Burlington, and I rarely missed the baptisms by immersion in the Delaware River in front of my aunt's house at Burlington."

The worship Barnes witnessed had an effect "so deep that it has influenced my whole life," he recalled. "I was switched suddenly from my everyday world to the realm of mysticism—a realm where nothing else counts except the ineffable joy of the immediate moment." But the religion that led to was the gospel not of Christ, he said, but of art.

For Barnes, the years he later spent amassing and studying his great collection were all about transferring the aesthetic rush of those meetings in the woods into the new sacred space of the picture gallery. As he stood reverent in front of the art he so loved, the "animal excitements" of his youth surged again; the aesthetic theory he came to spin, at vast length, was all about finding rational explanations for them. His fortune and status had come from the reasoned procedures of medicine and chemistry, and he applied those to the unreasonable raptures of art.

Barnes confessed an aversion to any "hankering for the supernatural." Like so many of his era's new-minted rationalists, he spent a lifetime trying to reconcile an early exposure to faith and an adult insistence on logic—and never quite succeeding.

━━━

Barnes's faith didn't survive, but he claimed to remember more Methodist hymns than anyone he knew: "Every time I am out in the country, I let loose in my loudest voice of the complete repertoire." He sang camp-meeting classics such as "John Brown's Body," "Swing Low, Sweet Chariot," and "Old Time Religion." Later, when he became one of America's great art collectors, those were the songs he claimed as America's greatest aesthetic creations.

He learned them from African Americans.

Decades later, Barnes could still recall how Black participants would "get religion" at those childhood meetings: "It begins with a song or a wail which spreads like fire and soon becomes a spectacle of a harmony of rhythmic movement and rhythmic sound unequalled in the ceremonies of any other race."

Thanks to such raptures, he said, he became addicted to African American camp meetings, baptisms, and revivals, and to the company of Black Philadelphians "who, I soon discovered, car-

ried out in their daily lives the poetry, music, dance and drama which . . . gave the camp meeting its colorful, rhythmic, vivid and compelling charm." (Of course, "charm" is an adjective that always carries its share of condescension, and the rest of Barnes's praise comes with a dose of the racial stereotyping that he never managed to shed.)

There were always some Black members of Lydia's denomination, the Methodist Episcopal Church; they attended its camps, and some racial mingling was expected at moments of ecstasy. Philadelphia's vicious racism had led other Black Methodists to form a separate "conference"; it sounds as if Barnes ended up at some of their country meetings. However it happened, Barnes's embrace of Black culture was unusual in Philadelphia's white working class. His early willingness to cross the color line gives a first sign of the progressive ideals that went on to shape the rest of his life, however imperfectly he realized them.

The Methodist meetings had extra appeal, for both Barnes and his mother, as an escape from a home life that was ever more trying. The young family moved six times while Barnes was still in elementary school, a clear sign of social dislocation or even collapse. The last of those moves landed them at 2012 South Twelfth Street, on the northern edge of the hideous zone called the Neck.

CHAPTER 2

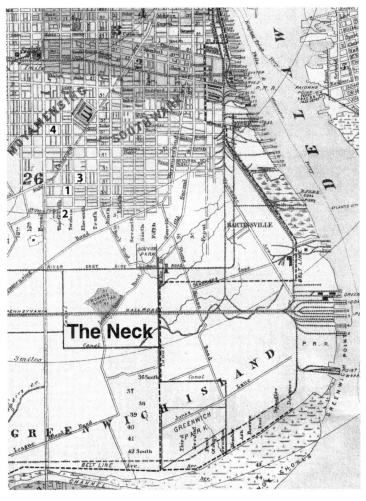

South Philadelphia in the 1890s: (1) The rental at 2012 South Twelfth Street that brought the Barneses to the edge of a slum; (2) William Welsh School, at 1248 Jackson, where Barnes began to shine; (3) Bethany church, at 1900 South Eleventh, where the family worshipped; (4) 1331 Tasker, the home that marked a rise in the Barnes fortunes.

THE NECK | CENTRAL HIGH

*"I wanted to change the status of
everything in my boyhood world"*

"A desolate, God-forsaken, filthy, ill-drained place, not fit for dogs to live in, and altogether unsuited for families—where decency is out of the question, and degradation certain," said Philadelphia's health inspectors in 1867. This was the Neck, filling a dank expanse of land at the far south end of the city, where its two rivers met and often flooded the hovels between them.

In the decades after the Civil War, the near destitute came to the Neck for squatters' housing set amid the waste heaps from soap factories. Stagnant ponds came slicked with rainbows by the nearby refiners of Pennsylvania's new oil. Those health inspectors described the neighborhood's residents as "half civilized and half human beings, living in ignorance and wretchedness."

According to an 1881 issue of *Scribner's Monthly*, if a family could grab and drain a stretch of soil, they might start a truck farm fertilized with their own feces, "that substance gathered in the night which they would not give up for the most approved of phosphates."

In *Scribner's*, all this could come off as picturesque, according to the era's Dickensian romance of destitution. But for a young Necker named Albert Barnes, it was indescribably grim. A friend of Barnes's who had gone slumming in the Neck as a youth re-

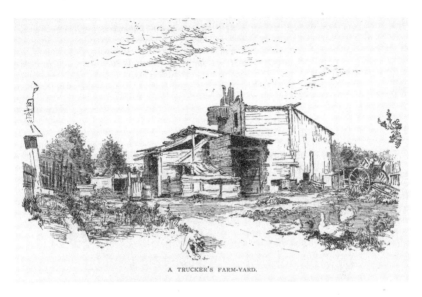

A scene in the Neck: A Trucker's Farm-Yard, *drawn by Joseph Pennell in about 1880.*

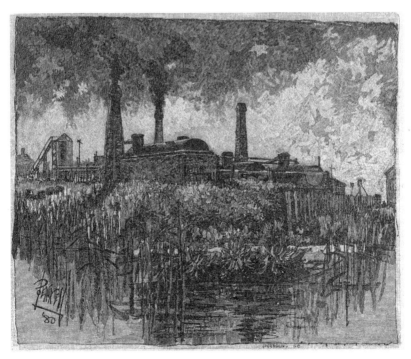

Contributing to a slum's reek: The 1880 Oil Refinery *drawn by Joseph Pennell.*

called having been in "mortal terror of meeting gangs of hoodlums."

Barnes himself got beaten by local bullies who stole the toy tops he'd scrimped to buy. In self-defense, he taught himself to box by sparring with his brother and watching the local bouts. "At 11 boy in tough neighborhood learns to fight," he wrote in notes on how he profited from his rough early life. "When I was a boy, down in the Neck," Barnes recalled, "when fresh kids made themselves a nuisance, their companions knocked them down and spit on a part of their anatomy that is usually kept covered."

Barnes hung around the notorious Vare brothers, Neckers who rose from selling potatoes door-to-door to being some of Philadelphia's most powerful and corrupt political bosses. (The youngest of them, Edwin H. Vare, later became a neighbor of Barnes's among the mansions of Philadelphia's Main Line.) One day, when one of the Vares came at Barnes with a shovel, he knocked him cold with a bottle. For the rest of his life, in whatever he did, Barnes kept his chin down and delivered a roundhouse before an opponent's guard was up.

As Barnes concluded, grimly but with some obvious pride, "Early habits crop up later in life."

Those years in the Neck could be blamed on his father. Albert Barnes spoke bitterly of the failings of his tobacco-chewing dad. More than a quarter century after his amputation John Jesse Barnes could be found stiff drunk in a basement and chasing one of his son's employees with a hatchet. In 1904 he took an oath to stop drinking, but it didn't stick: he would disappear for days at a time as his wife searched for him in tears. One observer called Barnes's father "utterly illiterate, vulgar, immoral" and described his assignations with a "scrub woman's daughter." Barnes himself described his father as having a "good intelligence and tremendous energy" but as lacking character and as having been essentially missing as a parent. "Unfortunately, I needed a father," Barnes wrote to a friend in 1920, when John J. still had a decade left to live.

And yet, for all Barnes's reputation for being brutally focused on his own advantage, he supported his father right until his death, shoring up the veteran's finances and paying the crippled old man's sometimes weekly medical bills. When John J. Barnes died of a heart attack in 1930, Albert gave him the final honor of a tombstone that listed him as serving for all four years of the Civil War, rather than for his real six months.

In May of 1912, Barnes explained the reason for the following decades of filial altruism, despite all his reservations about his old man: "It is my intention to make the remaining years of my father's life worthy of my mother's memory." Lydia Barnes had just died, at the age of sixty-five, and she had been the major force in her famous son's development. "I had a marvelous mother, one endowed with a keen, penetrating intelligence," he wrote. He had in fact supported that mother, in secret, from the moment that he'd become wealthy, and the savings she died with had actually come from him. A decade after her death, he had plans to call his celebrated foundation after her, but in the end he chose to call it the plain Barnes Foundation.

According to her son, Lydia Barnes had "a courage equal to Roger Baldwin"—the beleaguered conscientious objector who had co-founded the American Civil Liberties Union. (Looking for a model of courage, Barnes instinctively turned to a left-wing reformer.) But best of all, Barnes said, his mother had "poise and balance." He knew those two virtues had passed him by. "I came into the world maladjusted—and I'm still that," Barnes wrote.

■

Every day, from the summer of his thirteenth year, Albert Barnes got up at 4:00 a.m., put on his frayed pants and whatever semi-clean shirt he could find, and, after completing a local paper route, headed forty blocks north, up and out of the Neck, on one of

Philadelphia's new streetcars. (At least, he did that on the days he could afford not to walk.) The city's trolley system, funded by a rising class of entrepreneurs, had the promise of turning urban mobility into social mobility for the masses who took it every day. That worked for young Albert. His ride took him by Philadelphia's towering city hall, a Beaux-Arts wedding cake just then being finished, and up toward the new mansions of North Broad Street—evidence of a Gilded Age wealth Albert could only dream of, two decades before he achieved it. The trip ended a few minutes before 9:00 a.m. in front of Central High School, a hulking brick building with all the mod cons of Victorian pedagogy: high-ceilinged classrooms designed for maximum light and air; a six-hundred-seat assembly hall; the latest in astronomical observatories and science labs.

It was a miracle that Barnes ever stepped through its doors.

He had been earning his "own bread and butter," as he put it, for several years already, with just enough time and energy left over to learn the little that could be taught at his local primary school, a "cheerful and comfortable" place. Thanks to a fine mind, however, and especially to a resolve and drive that never left him, early in 1885 he passed the rigorous entrance exams for Central High, which served all the young (male) scholars of Philadelphia who could not afford private tuition. As the second public high school to open in the nation, it was granted the special honor of conferring bachelor's degrees. Rather than providing the classical culture of fancier schools, Central aimed at developing "men of affairs, fitted to cope with the practical problems of life." Barnes had a horror of impractical erudition for the rest of his days, delighting in constant attacks on "the doddering idiots that preach dogma instead of sense"—his description of almost all academics and intellectuals.

Central High came with a reformist, progressive mandate that was a good fit with—because it was an influence on—the

progressive politics and ideals that Barnes went on to espouse. "I was an inveterate experimenter and nothing I ever came in contact with did I accept as standard or right or ultimate," said Barnes about his teenage years. "I wanted to change the status of everything in my boyhood world." At least in its ideals, Central might have done as much to encourage those thoughts as dampen them.

Of all the hundreds of students who applied to Central's ninth grade, Barnes was one of 125 who got in, and only two of them came from his elementary school in the Neck. After his first term at Central, Barnes was noted as "meritorious," although his ranking then slipped to the middle of the pack. Where many of his classmates came from middle-class or even quite prosperous families, the sons of clergymen or insurance agents, Barnes was acutely aware of the tattered hems to his pants. The student newspaper teased, cruelly, that his "class cry" was "who's going to treat!"

However much vintage port or fancy art Barnes later consumed, it never erased a clear sense of himself as not quite *comme il faut*; the resentments this bred never left him.

At Central, Barnes concentrated in quite advanced science and math (on which he cheated). He later recalled how he "ate up" the chemistry labs that were a new thing at Central, even building a lab for himself at home. He took German, the grounding for his later fluency in that language, while a course called Mental and Political Science foreshadowed his later fascination with applied psychology, which he once said began when he was fourteen.

His eight semesters of art and drawing proved as precious to him as his chemistry labs. For all its reputation in the sciences, Central also had a strong tradition of art education, starting with the choice of the illustrious Rembrandt Peale himself as professor of drawing when the school opened. Barnes's closest friend at

Central, and then again for decades in adult life, was the young William Glackens, who went on to a notable career in illustration and painting; around 1910, he became the force behind Barnes's conversion to modern art. Barnes recalled how Butts Glackens—named for the brass buttons he once showed off to classmates—was a shirker in class but won the admiration of his peers for caricatures that invariably revealed their instructor "as the teacher was in reality, never what the teacher would have us believe that he was."

For a term or two early on, Barnes and Butts formed an aesthetic trio with John Sloan, who later joined Glackens as a founder of New York's Ashcan school of socially conscious painters. Some of Barnes's earliest moves as a collector involved Ashcan works by Sloan and Glackens and others, whose social conscience matched his.

But back in high school, Barnes and Glackens had forged an even stronger bond over baseball than art. The pair played on Central's team and shared the whole school's—the entire city's—obsession with the sport. Returning to Central in 1936 to give its annual address to alumni, Barnes said that Connie Mack, long-time manager of the Philadelphia Athletics, was "the greatest artist Philadelphia has ever produced. . . . His team has the attributes which all estheticians agree are the indispensable requisites of great art—unity, variety, individuality, and the production of esthetic pleasure." When he was a teen, Barnes's enthusiasm for the Summer Game would have been spurred by the fact that the illustrious catcher Albert "Doc" Bushong had graduated from Central not too long before, and in Barnes's sophomore year led St. Louis in a World Series victory over Chicago. Another Bushong achievement might have had an even bigger effect on Barnes: The athlete had gone on from Central High to the University of Pennsylvania, where he played baseball to fund a degree in dentistry. Barnes did the same, to fund his Penn MD.

CHAPTER 3

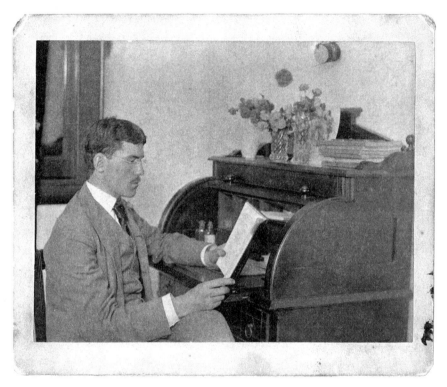

Barnes as a medical student, in 1891.

MEDICAL SCHOOL | GERMANY | MULFORD

"I was not cut out for the
practice of medicine"

The house was three stories tall but only two windows wide, though they were tall and arched and faced south on a bright corner. In the spring of 1888, it became the property of a certain Lydia Barnes, an amputee's wife who had somehow found the $3,500 to buy it. The house still stands, at 1331 Tasker Street, blocks from the family's Methodist church. The location marked a clear upswing in their fortunes. It was in South Philadelphia, one neighborhood north of the Neck among residents who were somewhat better off. One of them became Philadelphia's mayor and then governor of Pennsylvania; decades later Albert could still touch him for a favor.

At home on Tasker, John Barnes now managed a newspaper route, and his veteran's pension had recently increased to a reasonable $36 a month. It was not that much less than a skilled worker might earn. (But it's worth noting that his wife still didn't put his name on the deed to their new house.)

This was how things stood in June of 1889, when Central High handed Barnes his grand diploma, two feet long with a red seal on a fancy blue ribbon and signatures from his teachers. Barnes had risen to be vice president of the graduating class of

twenty-six students. He was one of only four or five of them who went on to college.

Medicine was an obvious choice of study: Penn's famous medical school vastly overshadowed all the university's other departments. Doctoring would have had a special appeal to Barnes, an incipient egalitarian just then rising out of poverty, since the profession was less class-bound than others. A European physician who moved to the United States in the 1880s was surprised to find that American patients generally felt themselves more or less matched in status with the physicians who treated them.

At Penn, Barnes scored high As in most of his classes. He was made a teaching assistant in chemistry, supervising "the practical examination of urine and animal fluids and the recognition and recovery of poisons from the animal body." His employment ended, he said, when he encouraged a student to mix two chemicals that blew out one end of the chem lab.

That job and a fellowship just about paid the bills, with a few extra dollars coming in from tutoring and playing bush-league baseball for something like $10 a game. "The soles of my shoes had holes in them," Barnes recalled. "I was at times hungry."

He was also as keen to fight as ever: At six feet tall, 178 pounds, he fought a boxing "duel" with a fellow student and figured he'd killed his rival after the man's head hit the curb. (His opponent was merely stunned.) He boasted of having been arrested several times "for being better able to use my hands than the fellow who started something." He once spent the night in his neighborhood's jail.

Barnes adopted a tough-guy pose for the rest of his life. Long after he had risen into wealth and power, when one small-time bureaucrat asked about some minor tax matters, Barnes responded with a volley of absurd threats about exposing the man's "improper sexual relations with boys." Such random intimidation seemed to function as self-defense, covering up a vulnerability that Barnes

thought others might sense. Based on a couple of years' close work with Barnes, Bertrand Russell, the British philosopher, said that the millionaire Necker "suffered tortures from an inferiority complex," and that seems the right explanation for his lifetime of excessive self-assertion.

But whatever poverty Barnes suffered at Penn, and the scraps and scrapes he got into, once again he pulled through with his studies. In May of 1892, pained at having to pay $2.25 to rent Penn's cap and gown, he was handed yet another red-sealed diploma.

As a "post-graduate course," Barnes recalled, he then made book at racetracks in Washington and Saratoga and gambled at baccarat, roulette, and poker.

Less fantastical memories have Barnes spending six months interning at the Warren State Hospital for the Insane, in the far northwest of Pennsylvania. Warren was a new, cutting-edge facility, recently founded as only the third public asylum in Pennsylvania and described in Barnes's day as "not surpassed by any similar institution in the State or on the continent" and having wards "better lighted, heated, ventilated, and kept cleaner than the rooms of the best hotel in your city." Barnes's stay there among its 650 patients, divided into eleven levels of mental illness, helped him acquire what he called "a practical laboratory training" in psychology. Its progressive values also helped set the stage for Barnes's own enduring commitment, even as a millionaire collector, to revealing how great art, and the right talk about it, could lead to the mental well-being of the nation.

He was especially interested in patients at Warren who seemed likely to heal if they could be made to change their thinking and behaviors, in a primitive version of what was later called cognitive behavioral therapy. The idea that psychic stability, even happiness, could be achieved by altering "mistaken" cognition dominated his thinking about the human condition for the rest of

his days. He made a habit of telling others how to "correct" their attitudes and behaviors, usually toward him, even if he himself admitted to being entirely incapable of making the changes that might put him less at odds with other people. Those included the "slave drivers" he worked under at Warren. They led him to leave the place.

Barnes also had stints as an intern in clinical medicine at the Mercy Hospital in Pittsburgh and the Polyclinic Hospital in Philadelphia. But rather than cementing his commitment to the sick, work in those hospitals, and a stab at private practice, led him to believe that he was "not cut out for the practice of medicine," and that he might be more suited to experimental science. "Most of the ills I treated were imaginary, or would have cured themselves, and I didn't like bluffing my way through the hard ones," he recalled.

Thanks to money saved from his asylum work and to the language lessons Barnes had received at Central, whose science teachers had themselves often studied in Germany, he was able to join the thousands of young Americans who had recently found themselves at the feet of German scientists. They would return home, their Zeiss microscopes in hand, "ready and anxious to impart their newly acquired knowledge to others," as one of them put it.

"In '94 and '95 worked with Klemperer (clinical medicine) in Berlin, Gad (experimental physiology)." This was Barnes's response to a survey of recent graduates from med school at Penn. "In 1895," he went on, "took up study of experimental therapeutics (pharmacology) and chemistry. In 1900 spent the year working in Gottlieb's Laboratory (pharmacology) at University of Heidelberg, where I made and completed my 'Doktor's Arbeit.'"

In the 1890s, training in chemistry meant training in Ger-

many. The American chemical industry had managed to double its total exports, thanks to bulk goods such as gunpowder and glue. But it also had to double or triple its import of the kinds of sophisticated, profitable products, like aniline dyes, recently perfected by great German firms such as Bayer, BASF, and Agfa.

Crossings on tramp steamers had put the German trips within Barnes's reach. Once his savings ran out, he kept himself in bratwurst thanks to work he found teaching English and selling American stoves. He bought himself a beer or two with the tips he earned singing spirituals in Heidelberg's student pubs or, in Berlin, in the "*cafés chantants* in Elsasserstrasse," as he recalled, wistfully. He also got into his usual scraps, even engaging in a classic German duel: "I waited upon my adversary at his apartments, accepted his challenge, named pistols as the weapons and he immediately got cold feet."

As Barnes was heading home, his funds ran out before he got farther than Antwerp. He booked passage as working crew on an oil tanker, but the captain heard him crooning his camp-meeting numbers, and after that Barnes sang for his supper each night in the officers' mess.

Back in Philly but poverty stricken, in 1895 Barnes decided to shift into the world of mass-market drugs, where he felt profits were easy to find. After a stint writing copy for Gray's Glycerine Tonic at an ad agency—he was a skilled adman for the rest of his life—Barnes got work at the Philadelphia drugmaker H. K. Mulford and Company. That was a new and newly prosperous firm committed to the latest ideas in mass production and clinical testing. The company was working hard to market its products as serving public health by embodying "the latest development of science." Barnes later picked up on this mix of science, public service, and marketing—or marketing by way of science in public service.

In 1900, one goal of Barnes's German trip had been to hunt up highly trained German staff for Mulford. The head of Heidel-

berg's chemistry department proposed the twenty-nine-year-old Hermann Hille, a licensed pharmacist and new-minted PhD.

At the age of ninety, Hille could still remember his first encounter with Barnes: "I found him living in a rented room, with a girl he had brought from America. He and I went for a walk along the Neckar River, and he offered me a job as a research chemist with H. K. Mulford Co. in Philadelphia."

In the first year of the new century, on September 27, Barnes and Hille began working side by side at Mulford. The firm had just won an award at the Paris world's fair and was expanding into grand new quarters in the suburbs. Its founder, who had begun as a simple druggist, had settled into the high life on Philadelphia's Main Line. He was a perfect role model for Barnes.

CHAPTER 4

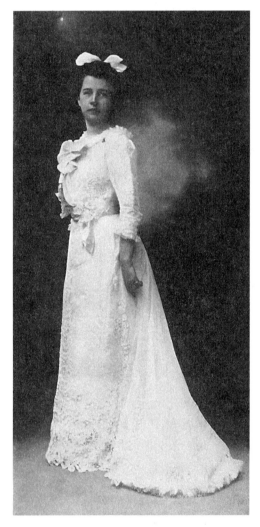

Laura Leggett, soon to be Barnes, wearing her deluxe wedding dress in the spring of 1901.

WEDDING | ARGYROL | MARKETING

"'World' has 'used' me well. Am making about six times the income of a fairly successful practitioner of medicine"

The groom cut a manly figure, as his fellow Edwardians would have said; he was tall and solidly built with a bold mustache above a thrusting, stubborn jaw. His brown eyes looked out through wire-rimmed glasses with a determination that seemed cultivated; he was intent on taking up psychic space. The bride had a stately posture and steady blue gaze that belied her twenty-six years. Her gown, as recorded in a lavish Bride's Book, was "Crepe de Meteor over taffeta silk" with a bodice of "tucked mousseline de Soie with a bertha of Point-lace." The wedding took place on June 4, 1901, in Brooklyn, at the brand-new St. James Protestant Episcopal Church, a grand Gothic pile with the latest in electric lighting.

The new wife was Laura Leggett, fifth child of Richard Lee Leggett, a prosperous businessman. His imposing neoclassical brownstone still stands at 281 Adelphi Street near downtown Brooklyn.

Her new husband was Albert Barnes, barely five years into his career as a chemist but so sure of his future, and so able to convince others of it, that he could arrange to marry far above the world he was born in. Laura's father, like his, had served during the Civil War, but as a commissioned lieutenant, not a private.

Barnes around 1900, as he begins to come into his own.

After the armistice he'd returned to a family business that *The Wall Street Journal* described as "one of the largest importing and wholesale grocery houses in New York." Laura had never caught a whiff of the Neck.

The young couple met on August 29, 1900 (that Bride's Book records it), some ten months before their marriage and just days after Barnes's return from Heidelberg. He was vacationing in the village of Milford, Pennsylvania, in the Pocono Mountains, at the home of a cousin-in-law who owned a small rural asylum. The Leggetts, too, were on a visit to Milford—its summer camps were popular with New Yorkers—and as the story goes, one day when the Leggetts' terrier needed a bandage, Barnes stepped in as vet. He was welcomed into the family circle and was even allowed to go cycling with Laura and to court her with five-pound boxes of candy.

"That young man means business," warned a friend of the Leggetts', but then, so did Laura. Her five siblings called her "the Boss." Within barely five weeks Laura had accepted Barnes's proposal of marriage. For the next half century, she stood beside Barnes in all he did as he pushed his way into fortune and then fame. When the great Barnes Foundation opened its doors in 1925, it included, as a major component, an arboretum that was Laura's project.

Bertrand Russell, the British philosopher, described Laura Barnes as "thoroughly nice" but far too much under her husband's thumb. Once, after a dinner with Barnes's school friend William Glackens and his wife, Edith, Barnes uttered the command, "Laura, my pipe!" upon which Edith Glackens, always a free spirit, ostentatiously dropped her handkerchief and exclaimed, "William, my handkerchief!" A guest at another dinner recalled Barnes banging the table and shouting at his wife when the glassware wasn't arrayed quite properly: "It was crude and rude."

Laura Barnes was once described as "a quiet homey sort of person, middle-aged, conventional and pleasant," but that may only reinforce her status as the grayest of éminences grises. When the philosopher John Dewey wrote an encomium to his friend Albert for the dedication of the Barnes Foundation, he felt compelled to add that it would be "altogether a mistake" not to recognize the vital role Laura had played: "No one will ever know or be able to tell how much the Foundation owes to her keen judgment, cultivated taste, remarkable executive ability and untiring work."

In 1901, Barnes must have been doing a fine job for Mulford. After just a few years' employment, he had the money and the leisure to take a ten-week honeymoon in Europe. He and Laura had stays in London and Paris and an adventurous time visiting the lakes and

falls and mountains of Switzerland, where together they climbed the ten-thousand-foot Schilthorn peak.

Returning to the United States in late August, by October they had found an impressive first home to rent: a stucco manse, ample but lumpish, at 6374 Drexel Road in the new "suburb deluxe" of Overbrook Farms. That was a quite un-farm-like, fully planned development—one of the first in the nation—that allowed an incursion of a newly prosperous middle class into the grand estates of Philadelphia's tony Main Line.

With his domestic life nicely settled, Barnes could concentrate on his chemical and business ambitions.

Barnes and Hille had become friends as well as collaborators. The German had been an usher at Barnes's wedding—he'd given the newlyweds a set of Japanese jars—and was then a frequent dinner guest in the new house at Overbrook Farms.

At Mulford, Barnes helped Hille get better lab space as well as a series of raises, since Hille's tiny salary had him living on rolls and ten-cent planked shad he trekked to New Jersey to buy. When Barnes became dissatisfied with his own salary, he convinced Hille that the two should work after hours on products that would let them set out on their own, in an American market where the demand for cures was soaring.

In the last decade of the nineteenth century, Philadelphia's pharmaceutical trade had quadrupled and ended up cornering more than a quarter of the American business in drugs. Barnes wanted a piece of that action. He rented an old stable on Thirteenth Street to use as a makeshift lab space, while Hille lived in rooms upstairs.

Barnes's first ideas were peculiar: he suggested they try their hand at a cheese and at biscuits. "Came out hard as rocks," Hille remembered. Then Barnes and Hille found their blockbuster product, inventing a silver-based antiseptic whose virtues, as Barnes was soon explaining to his medical colleagues, consisted of "the high amount of silver contained, its easy solubility, its intense pen-

etrative action and its freedom from the irritating properties possessed by the other silver salts." This was Argyrol, the source of the fortune that Barnes turned into art.

In an age before antibiotics and the systemic work they do in the body, bacteria were mostly killed topically, by dosing them with an antiseptic; one of the choicest of those was a solution of silver. When applied to sensitive tissues such as the eyes or genitals, however, those solutions could be fiercely caustic and irritating. Unfortunately, these were exactly the tissues involved in one of the era's worst bacterial scourges: gonorrhea.

A 1910 paper on the subject claimed that as much as 20 percent of the era's rampant blindness was caused when newborns' eyes got infected as they passed through their mother's vagina. A few drops of Barnes and Hille's product could, at least in theory, keep a baby's eyes clap-free without burning them, and many states eventually mandated drops of silver antiseptic for every infant.

"With the money acquired from a product which prevents blindness," said a 1928 profile in *The New Yorker*, "Dr. Barnes purchases pictures for the sight to feast upon."

As Barnes liked to tell the story, he had worried away at the subject of silver antiseptics for three years before a properly workable concept "sauntered" into his exhausted mind one steaming August day in 1900, in Heidelberg.

"The idea was entirely my own," said Barnes. He billed Hille's contribution as "merely" that of a technician, perfecting "the mechanical work of making the products."

Hille's version of the discovery was that Barnes "merely" came up with the general idea for Argyrol and then Hille did all the hard lab work that the invention and its production required.

Both of their accounts are correct, so long as you get rid of

the word "merely": a successful, salable product required the skills of both the ideas man, in Barnes, and the lab man, in Hille.

With their new product in hand, the two friends decided to risk leaving Mulford and go out on their own. Hille had been approached by potential backers, but in the spring of 1902, Barnes came through instead with a $1,000 investment from Clara Leggett, his wife's mother, which must have seemed the safer bet. Laura Barnes kept the new company's books.

On May 14, at a meeting of the American Therapeutic Society in New York, Barnes and Hille first reported on the success of their product, as tested by clinicians in the United States and Europe who declared it the best gonorrhea treatment to date. Within a week, the two men had ditched Mulford to be equal partners in the new Barnes & Hille Company.

With a total starting capital of something like $1,600—Barnes once said it would have lasted only three months, if their products had not taken off—they left their stable for space in an ornate Victorian building at 24 North Fortieth Street, out in West Philadelphia, not far from the University of Pennsylvania. (Like almost every building connected to Barnes, it is still standing.) The rent was all of $25 a month for eight rooms at the back of the ten-year-old Powelton Hotel. Hille claimed two of the best rooms in the building to live in and took many of his evening meals at the Barneses, just a few neighborhoods—but a social continent—farther west.

As Barnes described it, the Argyrol factory was in a deteriorating part of West Philadelphia that harbored "a crowd of bad boys" who, he said, were mostly Black. Those "bad boys," or their fathers and uncles, became a vital source of labor for his plant, and then over the years their well-being and education, and eventually their rights and

needs as workers and citizens and even as aesthetes, came to take up major space in Barnes's mental and emotional landscape.

From the beginning, Barnes had included any number of Black workers in his workforce—an unusual move, since most factories had only or mostly white workers. In *The Philadelphia Negro*, a landmark study written by no less than W. E. B. Du Bois himself at just the moment Argyrol was launching, there's talk of the "practical exclusion" of Black people from the industrial life of the city. Twenty years later, Barnes is still describing the more normal employment of African Americans as "boot-blacks, janitors, elevator-boys, porters and the like." He referred to Philadelphia as a "hotbed of prejudice."

In Barnes's era, if a Black man was allowed any kind of industrial work at all, it was doing dead-end jobs that were brutal and dangerous and hardly paid more than the menial labor he was normally limited to. As late as 1952, when one white high-school student in Philadelphia landed summer work in a power plant, he didn't find (and never expected to find) even a single African American employed alongside him, although there can't have been many worse jobs than feeding and cleaning coal furnaces. Black workers might have considered work at the Argyrol factory positively genteel compared with the normal labors imposed on them.

Barnes said that the factory's first employee was Black. "He was a nice chap and we liked him, so when we needed someone else we got in a friend of his," recalled Barnes. "It went on like that and now all our employees are negroes." The casual tone of that last phrase belies how unusual that fact really was, even if it might not have been strictly true: while most of the workers on the factory floor were Black men, the tidier work in the office was reserved for white women. And yet that itself made for a quite radical mix, given the almost total segregation of most Philadelphia workplaces, even all-male ones, let alone ones where the sexes

mixed. "Put negroes working with white women and found it was satisfactory to both," was a bullet point in a talk by Barnes.

He later put this into proper prose: "I have worked in a chemical factory for over twenty years where the only men were negroes and I have learned to appreciate how much they have contributed to the success of our business both from the financial and the social standpoint." Barnes went on to raise one Black man to the position of plant superintendent—saying this Jim Gray had "more skill in running the factory than any of the rest of us"—in an era when it was widely agreed, at least among whites, that no person of color should be given anything like a supervisory role.

Rather than employing African Americans out of stinginess, Barnes paid his Black staff something like 50 percent more than the average pay for American chemical workers, who would almost all have been white. In the mid-1920s, his workers' incomes would have put them in the top 5 percent of African American workers. Barnes made sure of his employees' pensions and also helped them buy houses. Already in 1917, he was warning real estate agents that he would not have their purchases hampered by the "temperamental idiosyncrasies" of racist sellers. During the Great Depression, he told a bank that if it foreclosed on Theodore Hill, a longtime Black employee, it risked hastening the day when the man's peers might "rise in sufficient numbers to get the upper hand"; Barnes said he'd be there cheering them on. (Not even the most senior Black thinkers would have dared use such language; as a white millionaire, Barnes had a freedom to be pugnacious that they never had.) When another Black worker, John White, was being gouged on a car loan, Barnes put his own lawyers on the case. Barnes also paid for, and closely supervised, the boarding school education and daily maintenance of two Black children orphaned by the death of Louis Dent, who had worked making Argyrol for fifteen years.

"In all walks of life the Negro is liable to meet some objection to his presence or some discourteous treatment," wrote Du Bois in

his Philadelphia study. The Argyrol factory was, at least to some extent, an exception.

Raised and trained in a world utterly suffused with racial discrimination, Barnes never imagined African Americans as fully his equals; his was always the *noblesse* that obliged. But he was willing to enforce, and do battle for, a kind of social and political politesse that insisted on at least an appearance of fairness. He wanted to think of himself as a "fair white man"—even if the whiteness, and its powers, always ruled in his psyche.

Weeks before he'd established his new firm with Hille, Barnes could already be found bragging to his med school classmates about his success—or maybe a success he felt so certain to achieve that he could boast about it in advance. "'World' has 'used' me well," he wrote, in that survey of Penn's medical graduates. "Am making about six times the income of a fairly successful practitioner of medicine. Devote all my time to research work in pharmacology."

Within half a year of its spring 1902 launch, Barnes & Hille had sold almost a thousand bottles of Argyrol in a single month. In the five years that followed, the company's annual profits grew from just under $5,000 to almost $200,000—about $6 million in 2024—and the partners could buy the factory's space. A couple of decades later, when the company finally got sold to a bigger drugmaker, the price was a vast $5 million. As late as 1957, more than a decade after antibiotics had become commonplace, a million bottles of Argyrol still sold every year.

Argyrol was a fine new product that filled a clear demand in the market. But Barnes always claimed, probably correctly, that

it made so much money because of how he sold it. Where other drugmakers spent vast sums on advertising and teams of salesmen, Barnes realized that he could spend maybe a tenth as much by appealing straight to medical specialists and researchers, he recalled, "because they write a lot and they talk a lot, and what they say reaches not only other specialists but a great many general practitioners who accept their statements as authoritative." And the appeal Barnes made to those experts, in that new age of scientific medicine—or at least of doctors' newfound faith in science—was built around the experimental proof he could offer for his drugs.

In 1903, he sent a "personal" letter to various physicians that discussed the original research he had recently published on a new iron salt—Ovoferrin, his firm's second product—that was more easily assimilated than any other. The letter closed with a modest appeal to his correspondents' reason: "I write to ask if you will kindly examine the facts concerning Ovoferrin . . . and give the product a trial."

Long after he'd moved on from science to art, examining the facts was still central to Barnes's approach, and to the spiel he made to his publics. Rationalism made for such a good sales pitch that Barnes sold himself on it completely. His lifelong challenge was to reconcile the demands that reason made on his judgment and the claims aesthetics had on his feelings.

A list Barnes made of his sales strategies talked about the articles he got scientists to place in the best journals and about getting his products used in the most prestigious hospitals and medical schools, "where large bodies of students and physicians would become acquainted with the results of the use of our products." But Barnes's marketing included one other ploy that he didn't put on his list: he handed over cold, hard, untraceable cash to the scientists who recommended his products and the journals that published the new "findings" about them.

CHAPTER 5

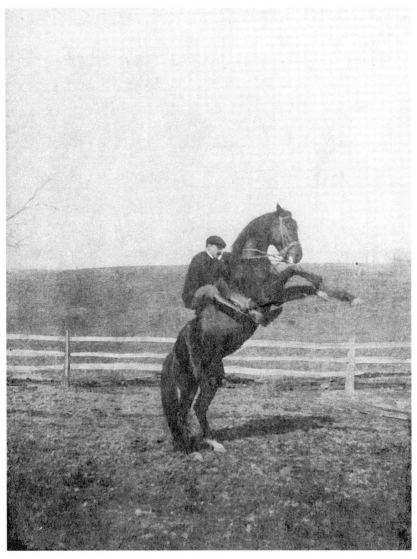

Barnes, mastering—or being mastered by—one of the "spirited" horses he preferred.

BRIBES | LAWSUIT | THE MAIN LINE

"Relations have become so hostile and
inharmonious that the complainant
cannot continue them consistently
with his self-respect"

n 1904, the British doctor Sydney Stephenson, editor and
owner of *The Ophthalmoscope: A Monthly Review of Current
Ophthalmology*, had written to Barnes that Argyrol was
"the best thing we have had since the introduction of cocaine." But
apparently Barnes felt that clinical enthusiasm alone might not
guarantee Stephenson's support. "Your generous offer of a cheque
overwhelms me," wrote the eye doctor. "Yet somehow it does not
seem quite right to accept, much as I might feel inclined to do so!
However, for me there is a simple way out. Will you give me a
second page advertisement of Argyrol to stand at the other end of
my journal? That I regard as most generous, and, from my point of
view, preferable to an actual gift, although I admit it amounts to
much the same thing."

Similar deals crop up in Barnes's letters as early as April of
1902, when he and Hille were only just going out on their own,
and they continue for the next decade at least, in correspondence
involving doctors as far afield as Germany, Austria, and even
Algeria.

In twenty-first-century investigations of Big Pharma and the perks and payments it has doled out to "independent" researchers, there are plenty of emails that describe the same ploys.

Barnes buried the cash payments as "Operating Expenses Special" on the Barnes & Hille books, with no names attached to the amounts because, he explained, "if it became known that a high-class ethical physician did such work for a commercial house, those physicians would be ruined professionally."

Early in 1907, Hille wrote a letter to Barnes raising the possibility that the cash had been paid out "for illegal and fraudulent purposes. If this be true, then I desire full information which will enable me to acquit myself for any responsibility which your illegal and fraudulent acts may have fixed upon me as a member of the firm of Barnes & Hille."

Barnes defended himself by insisting that the services his secret payments had procured had been "responsible for our efficient advertising and, therefore, our success."

If Barnes's own business partner had made him mount such a defense, it was because long-standing tensions between them had reached a head.

Barnes thought Hille had been freeloading on the funds Barnes had put into the firm and wasn't letting him in on the real formulas for their products.

Hille, for his part, felt that Barnes was not working as hard as him, that he was taking sole credit for their inventions, and that there had been skulduggery around the company's books. He complained that Barnes had treated him, an equal partner in the firm, in an "arbitrary, dictatorial, ungentlemanly and insulting manner."

"Arbitrary," "dictatorial," "ungentlemanly," "insulting": all adjectives that would be applied to Barnes over the following decades, often with good reason, by employees, suppliers, artists, art dealers, academics, and various people who, like Hille, had once thought themselves his friends. In the conflicts with Hille, we get

our first glimpse of how Barnes behaved toward anyone who had lost his trust or came to threaten his self-worth, as so many people eventually did. The power he sought, in all things, at all times, had to be cover for a psyche that always felt powerless—that imagined its owner as missing a limb and drowning in the Neck's oil-slicked mud.

Hille fought back. He claimed that Barnes was "wild with women," keeping two mistresses at the factory at a cost of $4 each and bringing other women in off the streets. (Barnes already had a reputation for being girl crazy at Central High.) Barnes might even have threatened Hille's life in one of their quarrels. "I knew at that moment that you had your hand on your revolver," Hille told Barnes. "I would have been justified in shooting you down like a dog."

Barnes, for his part, accused Hille of being the one to utter death threats, of being the one with loose morals (he'd compiled a list of Hille's affairs), and of hiring detectives to trail their bookkeeper, Nelle Mullen, since Hille believed she and Barnes were lovers. (She remained one of Barnes's closest collaborators for the next half century.) Instead of laboring in the lab, Barnes claimed, Hille spent his time as a rabid disciple of the esoteric and spiritualist faiths that the United States was just then drowning in.

Whatever the merits of Barnes's other accusations, this one was valid: Hille had joined Philadelphia's Theosophical Society several years before and went on to publish texts as the "beloved Friend and Brother" of a certain John Emmett Richardson, founder of the Great School of Natural Science who for some reason did not use his name in all mystic matters, but went by the two consonants "TK." (Richardson/TK is now barely known even to experts in occultist esoterica.) In a TK-ist essay titled "The Attitude of Soul," Hille asserted that most modern humans were heedlessly heading into "the yawning chasm of individual extinction, beyond the reach of the Soul-Element." On the other hand, wrote Hille,

the students of the Great School were "determined to follow the lead of our beloved TK and the blessed RA and of those other Great Souls whom we have learned to call 'The Great Friends'"—some of whom, it seems, had left the earthly plane thousands of years before.

Such ramblings must have been just about intolerable to Barnes, whose belief in reason and science rose to the status of faith.

In the end, on May 31, 1907, Barnes wrapped up all his complaints in a lawsuit, demanding the dissolution of the partnership since "relations have become so hostile and inharmonious that the complainant cannot continue them consistently with his self-respect." He asked for a public sale of the firm's assets, but a judge instead deferred to a clause in the partnership contract that forced the partners to bid against each other for sole ownership of the company. Barnes sold some of his stock to a friend, funding the $350,000 bid that won him the company.

Hille took off to Chicago, where he founded his own chemicals lab that for years marketed a silver colloid to compete with Argyrol. (Atypically, Barnes chose to ignore his rival.) In June of 1961, Hille celebrated his ninetieth and final birthday with, he said, a "highly spiritualized" party "ending in a veritable Apotheosis"—with the Great Friends of TK floating invisible among the guests, one supposes.

Barnes incorporated his factory as the A. C. Barnes Company and settled in to enjoy his wealth and power.

Any English lord might have been proud of the home: Its granite facade was pierced by three broad bays of windows topped by crenellated battlements under tall dormers. A wide terrace wrapped in a stone balustrade looked ready to receive a hunt's worth of houseguests to tea.

This was Lauraston, named after the lady of the manor, which Barnes built on a $30,000 lot he'd purchased early in 1905 on Rose Hill Road (today's Latches Lane) in the Main Line township of Merion, only a mile from his rental in Overbrook Farms. It had endless bedrooms, fully electrified stables, and a floor of dormer rooms for servants, none of which made the home count as more than modest, compared with the neighboring estates of Philadelphia's financial and industrial gentry. Over following years, the Barneses installed vastly expensive Persian carpets, custom-made oak furniture, and all kinds of modern and antique conveniences: the most advanced and costly Victrola—the high-end hi-fi of its day—but also a grand porte cochere so guests could pull up in old-world style.

A cook supplied celebrated delights such as canvasback ducks and fresh turtles ("which ought to be gold-plated out of respect for their price," according to one writer), all washed down with plentiful champagne. After dinner, Barnes might break out some of the Lords of England Havana cigars ("elegant in workmanship and superlatively fine in flavor") that he ordered by the score from an ancient Boston firm. He prepared them for smoking with a gold cigar cutter.

Barnes's sartorial luxuries included "drawers and vests" (that is, boxers and undershirts) made of the finest lisle cotton and ordered in from the firm of Chas. A. Hodgkinson, of Jermyn Street in posh St. James's, London, who supplied his underwear for the next forty years.

All this was perfectly suited to the couple's new social setting out on Philadelphia's Main Line. This famous suite of suburbs had begun to prosper in the Gilded Age along a rail line that stretched out west of the city, with a string of quaint station houses that, as the railroad boasted, could have been "brought bodily over from the castles of the Rhine or the cottages of Switzerland." Blue-blooded Philadelphians had been pushed out of downtown by

"business and the Russian Jew combined," as one chronicler said, so they laid out vast second homes and estates around those train stops. Enjoying the healthful country air—and minimal suburban taxation—the newly countrified elites marked their lofty status with British-y institutions: cricket and polo teams, golf and country clubs, debutante balls and gentlemen's farms.

Barnes later came to despise American "society," but at this first stage in his climb he was happy to fit into the new world he had entered.

"The Main Line seems to some to be largely a land of dinners and dances, of hunts and horse shows," wrote one old-school Main Liner who disapproved of these visible markers of social aspiration. For a few years, at least, Barnes pursued them. He engaged a Main Line horse trainer to bring his riding up to speed and to stable some of the dozen mounts he claimed to own. He preferred, he said, big-boned horses that were "spirited, active, alert" and even ones considered "too much horse." (In the few years since his marriage he had gained substantial weight; his "spirited" mounts also had to be strong.)

Barnes joined the ten-year-old Chester Valley Hunt Club, which, according to one issue of *Bit and Spur*, gathered something like a hundred Main Liners and their forty costly hounds to torment the local foxes and trample farmers' fields. (Barnes, a democrat even when horsed, started a fund to make good on the hunt's damage.) Dressed in scarlet jacket and white breeches and shod in bespoke "soft top riding boots" from Peal of London, he was known as a newbie rider who always had the courage to mount up after a tumble, which he took almost every time he hunted. He was also called a "thruster," defined by a certain W. Foster Reeve III, a Main Line hunt mate of Barnes's, as "one who thrusts his way in out of turn ahead of other people."

In Philadelphia, rising from the Neck to the Main Line would have automatically counted as that, in a city that prided

itself on social strata that kept to themselves—with "an agreeable absence of pushing" and "the most perfectly preserved of our local aristocracy," as one essayist put it. Barnes's fox hunting might easily come off as pure social climbing, but his enthusiasm feels authentic: he invited various friends to join him for "real horses and some real riding" and wrote that the Chester Hunt's monthly dinners were "the best fun that ever happened."

Around the time Barnes was "thrusting" on the Main Line, Henry James returned to the United States after an absence of several decades and wrote about his visit in *The American Scene*. He devoted a whole chapter to celebrating Philadelphia as a city that managed "a much nearer approach to the representation of an 'old order,' an *ancien régime*, socially speaking," than anywhere else in the nation, thanks to "a closed circle that would find itself happy enough if only it could remain closed enough."

Philadelphia, James crowed, was "neither eager, nor grasping, nor pushing . . . never sounding the charge, the awful 'Step lively' of New York." Barnes, who stepped livelier than most and was an inveterate "pusher," did his best to break into the closed circle of his city's ancien régime, although it soon became clear there was no room for him in it.

Not long after getting sole control of the Argyrol factory, Barnes launched into a hobby that must have suited him better than horses: a fascination with fast and stylish cars that lasted the rest of his life.

The first automobile in the area, a homemade one, had only arrived in 1900. When more arrived, the older locals thought of the cars on their lanes as "devilish things," but Barnes went automotive anyway, even telling his chauffeur to stop swerving for neighbors' chickens. In 1908 he spent something like $6,000—

an absurd amount at the time—on one of the new six-cylinder models, the 25, that the Peerless Motor Car Company had just introduced, with a full fifty horses under the hood and coverage in *Scientific American*. (The car cost Barnes about the same as fifty horses.)

Every year after that, and sometimes more often, Barnes traded up to the latest model, roadsters keeping company with phaetons, which touched bumpers with sedans in the Lauraston garage.

One year, after a trip to Paris, Barnes almost added one of the gorgeous Renault 35/45 Landaulets to his trove, but settled on a Peerless limo instead. As he explained to one Peerless dealer, "I object to the noises that develop in a car after a season's use, and . . . am willing to spend unnecessarily enormous sums on new cars."

As late as 1910, John Sloan, Barnes's Central High schoolmate, took his first ride in a car and was impressed by the sheer power it symbolized, calling it "the first vehicle which has trained humans to arrogance." Barnes might not have needed training in arrogance, but he certainly took pleasure in displaying it. He was a fearless, reckless—and wreckful—driver. He got so many tickets for speeding that some came with warrants for his arrest.

It feels as though, as the twentieth century took off, the technophilic Barnes was coming to prefer a modern world of machines to the nostalgia that came with the Main Line's hounds and horses. With new-model cars adorning Lauraston's driveway, some equivalently speedy and "thrusting" decoration was required for the walls inside. New-model art would do the job.

CHAPTER 6

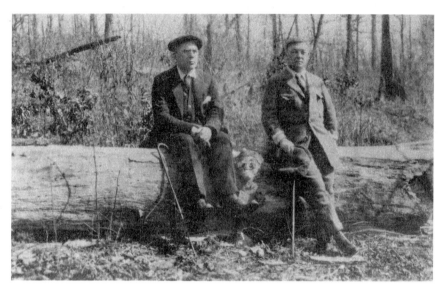

Barnes (left) and his pal William "Butts" Glackens, the painter who taught him to love modern art.

COLLECTING | GLACKENS | PARIS

"As you made certain discoveries with regard to convulsions, you may be able to explain what is the matter with art"

French peasants at work, rendered with maximum sentiment by the likes of Jean-François Millet. Forests near Paris captured at dawn, a-twinkle with the light of the Barbizon school. Redheaded femmes fatales, glaring their way into men's hearts thanks to the paintbrush of Jean-Jacques Henner.

With Lauraston's big walls to fill, Barnes had bought the art that any Gilded Age plutocrat was supposed to own. And then he found out that his dealers had sold him a bill of goods.

"They are just stinging you as they do everybody who has money to spend," explained his old classmate William Glackens. Even in America, let alone in Paris, the art Barnes was collecting hadn't been cutting-edge for a few decades.

Barnes clearly wanted the art of his day; he could have been buying the Dutch interiors and old British portraits favored by most fancy Philadelphians. The problem, as he was beginning to learn, was that the supposedly "new" art he'd hung on Lauraston's walls was more like a horseless carriage than the latest 50-horsepower roadster.

Glackens was in a position to know. In the two decades since playing baseball with Barnes at Central High, he had become a leader of the American avant-garde, helping to found New York's Ashcan school of painters. They promoted a messy, brushy realism dedicated to portraying the underside of American life, in contrast to the tidy styles and subjects favored by the reigning aesthetes and dealers of New York. The Ashcanners were about "art for life's sake" rather than for art's sake, as their leader Robert Henri put it. That left no room for poetic twinkle.

With Argyrol bringing in something like $200,000 a year, Barnes said that he'd felt a desire "to do something with my life other than the pursuit of money." Thinking back to the artistic interests he'd had as a boy, and to the long-lost schoolmate who had helped kindle them, Barnes had reached out to Glackens. He sent one letter without getting an answer, then something like a couple more, then finally a telegram asking why he was being ignored—by an old friend who, as it turned out, was simply too busy painting to keep track of his mail. When the artist did finally return Barnes's greeting, it renewed a friendship that lasted until Glackens's death, with little of the friction that came with Barnes's other relationships. If you were firmly enough lodged in the "friend" category—as only a handful of people ever were— Barnes could be loyal, generous, and forgiving.

In 1914, when Glackens was suffering from appendicitis, Barnes got him treated by the best of Philadelphia's surgeons; he made sure to be in the operating room, counting the surgical sponges to guarantee that as many came out as the doctors put in. He brought soup to the recovering patient, then had him convalesce at Lauraston. When Glackens died, in 1938, Barnes wrote to the painter's wife, "I loved Butts as I ever loved but half a dozen people in my lifetime. He was so *real*, and so gentle, and of a character I would have given millions to possess."

In his ego-girding search for success, Barnes had set himself goals: "To make an important discovery, have a million dollars, work out my own ideals as to happiness, have an opinion on any subject that could compare with any man's no matter how educated or experienced that man would be."

He'd managed the discovery and the millions.

Happiness he would work on until his death, as most of us do.

But the opinions—those he was in the process of figuring out. The only area where he had really achieved expertise was in selling drugs, and his interest in that had begun to fade. With help from Glackens, Barnes saw a chance to achieve an unrivaled level of opinionation in matters aesthetic—which, for good or ill, he certainly did.

Before the renewed friendship with Glackens, when Barnes wasn't collecting Millet and such other dead Frenchmen, he was buying works by "subdued Americans . . . who learned manners in dead academies," as one journalist described those purchases. So at first Barnes had a hard time with the more modern styles that American art was at last attempting—with "why Glackens is painting pink cats," as Barnes put it.

But he soon came to trust that artists of this new breed saw "colors that for the ordinary person do not exist." Barnes was looking to Glackens to coach him in such extra-ordinary vision. It looks as if it took almost two years for Glackens to do it, but by 1912 he had persuaded Barnes to go for the truly contemporary, in both subjects and treatments.

In *Pony Ballet*, one of the Glackens paintings that Barnes began to buy, the image crops in so tightly on a single figure in vaudeville's latest chorus line that the dancer to her left becomes just a rear end; the one to her right is so brutally cut off by the

William Glackens's Pony Ballet, *from early 1911—just when he was pointing Barnes to the latest in modern art.*

picture's edge that only the tip of her elbow gets left. (See figure 1 in color insert.) There's something daringly photographic about it, almost cinematic—as though Glackens had captured a single moment from one of the new panning shots used in movies. But reviewers were most in love with the painting's "kaleidoscopic hues" (shades of Barnes's "pink cats") or most in hate with its "puny and boneless arms too small for the girded figures." Barnes, always the contrarian, might have cared more about the pans than the praise.

The Ashcanners' "art for life's sake" agenda had automatic appeal to the working-class kid in Barnes, a nascent progressive who

eventually came to see all worthwhile culture, and even the most radical of modern art, as needing to serve social rather than purely aesthetic ends. Despite the reputation Barnes went on to have as one of the great formalist thinkers, dedicated to the surface look of art, he saw formal qualities like composition, color, and line as deeply at the service of some more humane purpose.

Under Glackens's guidance, Barnes began chasing works by all the Ashcans and their peers—so long as they could be had "at a decent price," Barnes insisted, as he became one of their most substantial supporters. He dined with them at least twice a month at Mouquin's, the louche French restaurant where New York's bad-boy artists and journalists gathered.

Barnes soon realized that to get a really significant sample of the art of his times he couldn't make do with New York artists, or New York dealers. By early 1912, he was writing to Glackens about his desire to acquire "Renoirs, Sisleys and others of the modern painters"—to be bought in Paris, with Glackens as Barnes's buyer. Before long, Glackens was aboard the brand-new French steamer *Rochambeau*, accompanied by his painter friend Alfred Maurer, sailing back to an expat's life in Paris where he'd embraced the newest art and could guide Glackens to it.

Glackens's gear for the trip included a draft for $20,000. "I know the keenness with which Europeans look upon ready money," Barnes had told him, "and I am confident that you would be able to drive better bargains if you are in a position to say that you are ready to pay spot cash."

For a Philadelphian with even the most casual interest in new art, turning toward Paris was hardly a radical or unexpected move. Local girl Mary Cassatt had spent her career among the impressionists in Paris and often sent pictures home to be shown, while

Cecilia Beaux, a more conservative Philadelphia painter, was also a product of Paris studies, as was the realist Thomas Eakins, hero of the Ashcan school. For most of the previous century, Paris had been the place that Americans went to come up to speed on new movements. By 1910, the only thing that had changed was that the latest movements were leaving those visitors more wide-eyed than ever.

Not long before Glackens's trip, *The Philadelphia Inquirer* had run a feature under the headline "New Art Movement Obtains Foothold in New York City: Introduced Through Painters, Sculptors and Writers Returning from Paris." The article is a bit confused about what's at stake: it dubs the Parisians "new-school Impressionists" (many Americans still thought of Monet and his peers as the *summum* of radicalism), and it portrays Cézanne as a country bumpkin, painting "just as primitive man did." But Matisse and Picasso both rate a mention, and there's more than enough meat in the piece to have given Barnes something to go on in his hunt for new art.

"I am to meet Alfy [Maurer] at one o'clock and he is going to introduce me to a Mr. Stein, a man who collects Renoirs, Matisse etc.," Glackens wrote home to his wife, the day after landing in Paris. This shows both how out of touch Glackens actually was— Leo Stein and his sister Gertrude, expats from San Francisco, were already among the best-known promoters of the new modern culture—and also the level of his ambitions, since he was going right to the source to build Barnes a truly modern collection.

Within a very few days, Glackens realized this was not going to be all that easy, as he reported in another letter home: "Hunting up pictures is not child's play. Poor Alfy is about worn out." Glackens had discovered that Barnes's budget would not stretch very far,

Van Gogh's Postman, *from 1889, one of the modern treasures shipped to Barnes from Paris in 1912.*

with the most trivial Cézanne going for $3,000. But by the end of two weeks he had bought a total of thirty-three works.

It was "a fine collection of pictures," as Glackens informed Barnes, although lacking Degas and Monet ("too expensive") or any Gauguins and Matisses ("as I had seen better ones I thought it better to wait").

The most notable modern works, among the thirty-three that Glackens sent home, included the great *Postman* that van Gogh had painted back in 1889. (See figure 2 in color insert.) You can see why Glackens chose it for Barnes: it has much the same "kaleidoscopic" colors and brushwork as Glackens's chorus girl did; its

Picasso's Young Woman Holding a Cigarette, *from 1901, Barnes's most daring early purchase.*

close-up on the working class hews closer to Ashcan art's urban ideals than many other, more bucolic van Goghs would have done. (Although it was built on a skeleton of traditional draftsmanship that Glackens had already found the courage to drop.) The portrait was the very first van Gogh to land in the United States—if Glackens had echoed its style, he'd got it at second hand—but word of the Dutchman's innovations was already spreading, so when the canvas arrived at Lauraston, Barnes would have known that he'd snagged something special and uniquely modern.

One Cézanne and a few minor Renoirs joined the van Gogh on the trip from Paris, along with the only piece by an artist who the true avant-gardists of Paris would have counted as one of their own: a certain "Pèccaso." But even then, Glackens chose to buy a relatively approachable female portrait from a decade earlier, when Picasso had just barely begun to find his voice as a radical. (See figure 3 in color insert.) It shows a redhead smoking in a café, and its fin de siècle, femme fatale feel is only a slight update on the redheads by Henner that Glackens had complained about to Barnes. It cost Barnes all of 1,000 francs—about $200, at the time—when he'd spent thirteen times that on the Cézanne.

"You would scarcely believe your eyes," Glackens wrote to Barnes from Paris. "Art is in a strange state at present among the youth. A series of convulsions apparently and as you made certain discoveries with regard to convulsions"—he means the research Barnes published in his Heidelberg days—"you may be able to explain what is the matter with art. I confess that lots of things I have seen over here are incomprehensible to me."

It's no surprise that none of those incomprehensible things made it back with Glackens across the Atlantic, and Barnes certainly didn't miss them. Tame as the Paris purchases might seem to jaded twenty-first-century eyes, they must have had a stupendous impact when they finally got unpacked at Lauraston. Even though Barnes had set Glackens in pursuit of modern French pictures, before the crates arrived he'd have seen almost no examples in the flesh. He could only have quaked at the radically new colors and forms exploding around him. But Barnes enjoyed being rocked back on his heels. If, as he claimed, his first aesthetic experiences came from roaring fire trucks and ecstatic devotions, his art needed to have the same power.

Before the Bath, *a Renoir from around 1875 that Barnes bought in 1912, ushered in the acres of female flesh that became a hallmark of his collection.*

In terms of predicting the future direction of the Barnes collection, the most important purchase of 1912 was a picture that was already more than thirty years old: *Before the Bath*, the very early Renoir painting of a topless woman that Barnes himself had nabbed, while Glackens was abroad, after the wife of a Chicago collector had found it crude. (See figure 4 in color insert.) It's one of the most nearly realist Renoirs that Barnes ever acquired—nothing like what Glackens was buying in Paris—but it inaugurated the acres of pink Renoir flesh that came to dominate his collection.

In hundreds of pages of comment on Renoir, Barnes, who advertised himself as the most red-blooded of males, went on to talk about all that flesh, and all that pink, as almost nothing more than studies in volume and color. It could be that the male dominance of his era was so deeply embedded in his psyche that, because he felt such total ownership of living women, painted ones could register as nothing other than paint; mere oils on canvas might not have much claim on his libido, that is, when real flesh was so much at his command. Or at least, treating female flesh in terms of mere aesthetics might have been so unlikely, for a lustful patriarch like Barnes, that he took it up as a compelling psychic challenge. And in fact if he wanted to outrage the other wealthy men who collected—there was nothing he enjoyed more—he would have had more luck with talk of half spheres and roseate hues than by waxing priapic over a half-naked model like many they'd seen before.

CHAPTER 7

A nude painted in 1913 by Barnes's high school friend John Sloan, one of the struggling American modernists who Barnes came to support.

A BUYING SPREE

"I am getting so many van Goghs, Cézannes,
Degas etc. that I am in need of room"

Was Barnes's new focus on art some kind of compensation or cover for trauma? In that spring of 1912, as he spent and spent, his mother had been suffering from the brain tumor she eventually died of in May. She had led the household when her damaged husband couldn't and, for good or ill, had been a key force behind Barnes's take-no-prisoners drive for achievement and status. But she died just too soon to see more than a hint of his greatest triumph of all, as an amasser and promoter of modern art.

"Her Christian experience gladdened her heart in trial sickness and death," her longtime pastor wrote to Barnes. "Great joy was in her heart because of your welfare." We can't tell how much sorrow was in her son's. The record only shows him trying to resolve the endless legalities of her estate. Barnes was clearly annoyed at the notion that they might interfere with a trip to Paris in June, following up on Glackens's adventure.

Although Barnes's brief stay in France did produce a Cézanne, a Gauguin, and a Delacroix, he expressed disappointment that the trip hadn't yielded "at least half a dozen good examples of Bonnard," which gives some sign of the voraciousness of his new art appetite. Barnes liked to buy in depth, "with the idea of

representing the versatility of the men as regards their art." But his purchases can also seem pretty conservative for someone shopping in a Paris art world where, in 1912, fauvism already seemed old hat and even cubism was starting to feel like an established style.

In the American context, however, Barnes's collection could count as radical.

Only five years before Glackens's Paris trip, he and his fellow realists among the Ashcanners had been exiled from a show at the National Academy of Design because they passed for extreme in that era's New York. In Philadelphia in 1912, Barnes could satisfy his innate rejection of the status quo while acquiring paintings that didn't ask for a wholesale rejection of a Main Line aesthetic.

In a magazine essay decrying most American collections as "smug, respectable and conservative," Barnes's decades-old "new" pictures got coverage—their very first—as visions "of rebellion, of fights against the easy traditional conventions of art, of honesty in the face of starvation, of integrity and bravery in the face of ridicule." For Barnes, the risen Necker, that would have counted as the highest of praise. (Disclosure: that essay was by an editor who was hoping to get Barnes to place a drug ad in his magazine.)

Barnes's art obsession pushed old interests aside. Within months of Glackens's return from Paris, Barnes had tendered his resignation to the Rose Tree Hunt.

In taking up art collecting, Barnes wasn't striking out on his own. He had plenty of models among wealthy Philadelphians, some of whom came from almost as modest roots as he did. Peter Widener, the tycoon who had cut meat alongside Barnes's father, had been collecting Italian Old Masters for several decades, while the cotton magnate John McFadden was buying and showing venerable British art. Barnes's most immediate influence was John

Graver Johnson, the blacksmith's son and then illustrious lawyer who had represented Barnes in his lawsuits against Hille and then later was his lawyer in matters artistic. Johnson had built a great collection of late-medieval and Renaissance works that went on to become treasures of the Philadelphia Museum of Art. Back in the 1880s, before he went medieval, Johnson had launched his collecting with works by French moderns such as Édouard Manet, Alfred Sisley, and Claude Monet, all of whom had counted as avant-garde when Johnson bought them but by Barnes's day had become safely blue-chip, much like the Millets and Barbizon landscapes that Glackens had cast doubt on.

Barnes was not planning to let his tastes change as Johnson's had. By the time he had returned to the United States from his June trip to Paris, he felt certain and proud enough of his echt-modern purchases to rewrite his will so that the people of Philadelphia would inherit them. As Barnes wrote to Johnson, "Some of my paintings are important ones of their class and all of them are good examples of the work of the respective artists"—all twenty-three of them, named in a list that Barnes sent to Johnson. About half of them might be recognized by art lovers today. At that date, Philadelphia was still waiting to get a decent art museum, so it's not clear what the city would have done with the Barnes pictures had he died with his will in that state. He lived and his will changed, more than once.

For the rest of 1912, Barnes went on a full-scale buying spree, with Maurer as his man in Paris.

"I feel under obligations to you in giving you so much trouble concerning the purchase of paintings for me," Barnes wrote to the painter, before telling him to be on the lookout for "good examples of works by Manet, Daumier, Ingres, Bazille, Goya," and any-

Van Gogh's The Smoker (Le Fumeur), *from 1888, one of the dozens of paintings bought by Barnes in 1912, once he was badly bitten by the collecting bug.*

one else still missing from the Barnes collection. Oh, and "if you have time," Barnes said, Maurer should also bargain for a fine van Gogh, *The Smoker*. And, said Barnes to Maurer, "it would facilitate matters" (for who isn't clear) if Maurer took a little trot to an American telegraph office on the Right Bank to get a properly registered cable address.

After barely six months of presence on the Paris art market, Barnes worried about his standing with the best French dealers. Some had been asking him for deposits before shipping his purchases, "but I refuse absolutely to do business on this basis," he

said. The great Ambroise Vollard, who had made the Cézanne market, would not budge on this issue, as Maurer told Barnes: "That God damned fool of a Vollard. . . . He can't let you have the goods without having the money he ought to go to Hell."

Barnes took steps to confirm his standing as a major, reliable operator: he wrote a check for $2,000 to the great Parisian gallery Durand-Ruel as the first monthly payment on an agreement that would give him favored access to its vast holdings in modern French art and, as Barnes always took care to insist, would guarantee him special pricing.

Barnes was not above suggesting elaborate ruses to get good deals. He hoped to have a minor French dealer buy from Vollard at a wholesale price so that Barnes and that stooge could then split the difference between that and what Barnes would have paid retail to Vollard. "I think we can outwit him and get what I want," Barnes wrote to Maurer, "but the plan must be carefully carried out."

As always with Barnes, shrewd dealings with the powerful, or those he perceived as such, had a leveling tone—the powerful deserve what they get—while that shrewdness came balanced by generosity toward the disempowered. Even as he accumulated great French paintings from major French dealers, he continued to support American artists with smaller reputations and bank accounts.

He deepened his holdings in Glackens and gave his school-friend John Sloan his very first noteworthy sale (of a quite racy nude, a perennial focus in Barnes's collecting).

Maurer, who had toiled so hard for Barnes in Paris, straddled American and French styles without quite excelling at either, but Barnes nevertheless rewarded his help with several purchases. He also arranged a show for Maurer stateside, reaching into his own pocket to rent a space and cover all expenses at a prominent gallery in New York. (Examples like this of Barnes's benevolence

have always been overshadowed by the much louder impression he made, and apparently preferred to make, as some kind of stingy bully. That was a role that left him feeling less vulnerable.) Barnes himself wrote, but didn't care to sign, the preface to the show's brochure, billing Maurer "as one of the most gifted of the Post-Impressionists."

But he didn't completely believe in his American artists, as he confessed when he offered some of his recent purchases by Glackens and Maurer to a Philadelphia public collection. The artists "are not great men, but they are sincere," his donation letter said—faint-praise damnation, for sure. The reason for the proposed gift? "I am getting so many van Goghs, Cézannes, Degas etc. that I am in need of room."

CHAPTER 8

One of van Gogh's paintings of a ravine from 1889, now at Boston's Museum of Fine Arts. Barnes called his version, now lost, "the weirdest thing I ever saw."

COLLECTING MANIA

"He did literally wave his
chequebook in the air"

While it is the weirdest thing I ever saw, I like it. It can be hung upside down, side-ways or end-ways, and in any position looks like the inside of an old agate dish-pan." That was Barnes's reaction, in October of 1912, to finally receiving van Gogh's *Ravine*, purchased for him by Maurer in Paris—after Barnes had read a critic granting it "a splendour of effect beyond anything ever yet achieved by easel pictures." Barnes's "dish-pan" description is remarkably accurate, but if it also sounds less than enthusiastic—more like some newspaper's account of a cubist Picasso—that's because for Barnes van Gogh was still just about as challenging as the Spaniard. (In fact, he went on to sell *Ravine* within the year.)

Even Cézanne could go too far for Barnes. He avoided the artist's paintings that left parts of the canvas blank—often seen as some of his most modern and compelling works—and found a now-famous portrait of Cézanne's wife to have "an unpleasing subject." He turned it down for his collection and went hunting instead for his first Toulouse-Lautrec, a choice sure to have been far more "pleasing." It's clear that after less than a year of exposure to modern European art Barnes was not quite prepared to embrace the depths of its challenge.

That began to change in December, when Barnes was doing business in London and stopped in Paris for an auction. The sale was of a major hoard of all the newly canonized modern masters. The prestigious *Burlington Magazine* reported that the auction marked "the definite commercial consecration" of such formerly recherché artists. By way of illustration, the magazine's writer described witnessing the sale of a tiny painting of bathers by Cézanne that went for more than double its estimate. Its purchase, by "Mr. Barnes, an American collector," provoked "derisive laughter" from the regulars in attendance: "Who, they evidently thought, are the lunatics let

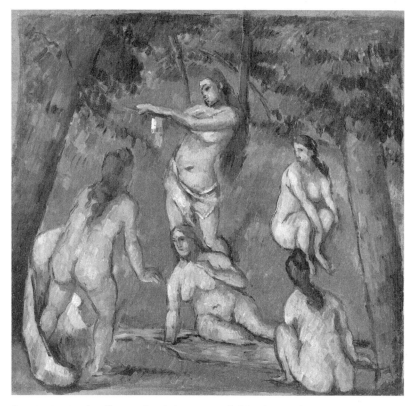

Late in 1912, when Barnes placed the winning bid for Cézanne's 1878 painting called Five Bathers, *"derisive laughter" broke out in the Paris auction house.*

loose among us? As the sale proceeded, their derision changed to indignation, for they saw all their standards of value shattered."

Their derision and indignation weren't absurd. Even by later standards, the five bathers in the painting ask a lot of a viewer. Each of the brushstrokes they're built from—or dissected into—is as big as a finger or nose, so there's total confusion between anatomy and paint, about whether nature or painter is the maker of these creatures. Where the whole point of earlier nudes had been to display female beauty, Cézanne seems happy, even eager, to let his naked women be as awkward and ugly as all the rest of us hairless apes really are. It's hard to know if we're witnessing misogyny or misanthropy or, as Barnes preferred to think, just an interest in paint that's so radical it overrides any received ideas about how an unclothed body should look.

However much Barnes might have truly enjoyed the pictures he bought, the iconoclast in him must have got as much pleasure from smashing genteel standards, and especially from being seen smashing them—using his hard-earned Yankee dollars to do so. The Paris auction, with its impact and coverage, marks the moment when Barnes begins to go public as Philadelphia's great gadfly collector. The newcomer had enough clout, at any rate, to get the great Pierre-Auguste Rodin himself to go looking at modern pictures with him.

That December in Paris, Barnes signaled his presence mostly by the sheer scale of his purchases: something like $60,000 for more than twenty pictures in the space of not much more than a week or ten days. That was truly a lot of money in the 1912 art market, but it didn't rival what old master paintings would have cost him. A single Rembrandt or Raphael could go for ten times that. For all the fame he accrued as a great collector, Barnes never had anything close to the wealth of a J. P. Morgan or a Henry Clay Frick; in modern art, he had found a niche market where even a middling-rich drugmaker could make himself known.

The dealer Vollard gave a nice account of Barnes's presence

Picasso's 1908 Wineglass and Fruit, *one of Barnes's more radical early purchases.*

on the Paris scene: "Mr. Barnes comes to see you. He gets you to show him twenty or thirty pictures. Unhesitatingly, as they pass before him, he picks out this one or that one. Then he goes away. In this expeditious fashion, which only a taste as sure as his made possible, Mr. Barnes brought together the incomparable collection which is the pride of Philadelphia."

Some of his smaller purchases that winter of 1912 were among the most important. Barnes sought out the radical young dealer Daniel-Henry Kahnweiler, and got the dealer to sell him half a dozen small Picassos, none for much more than $50. They included an unusually tough, even anti-aesthetic early painting of a courtesan that mixes absurdly wild brushwork with the

radical distortions of a political cartoon, although they derive from famous drawings by Leonardo da Vinci. (Links between old masters and modern artists later came to be a linchpin of Barnes's collecting and thought.) A number of that painting's mates, from a few years later, are even more daring, showing Picasso's first hints of cubism, a movement so radical that Barnes never fully embraced it. One of the Kahnweiler works seems to show some kind of a glass alongside some kind of a fruit, but Picasso's "glass" is massive and opaque and architectonic—it might as well be a concrete water tower—and his fruit is just a green blob that is so deliberately, obstinately nondescript that a foundation employee could take it for a head, after misreading the word *figue* (French for "fig") on Kahnweiler's invoice as *figure* ("face"). Picasso's new art didn't deconstruct our visual world, as the critical cliché would insist; it destroyed it, like a shell going off in a trench. Barnes liked the world too much to want to see it taken apart in his art, so he never invested deep in cubism.

With those Kahnweiler purchases, still very rare for an American, Barnes was on the way to bringing his collecting fully up to date. It was showing itself to be just about as tough-minded as its purchaser—more in the spirit of the Neck than of the Main Line.

Barnes's growing taste for resolutely modern art had been fully validated during that December's stay in London, where he took time away from his business matters to visit the great *Second Postimpressionist Exhibition* at the Grafton Galleries in Mayfair. The Grafton show gave just about the best summary of recent painting that Barnes could have seen, anywhere. With a pretty catholic range of examples, it gave pride of place to its forty Matisses and fifteen Picassos—the latter almost all from Kahnweiler, putting a stamp of approval on the purchases Barnes went on to make from him that winter.

Further confirmation that he was on the right track came in the show's catalog essays. (Barnes was soon pirating them

for his Maurer brochure.) Roger Fry and Clive Bell, two of modernism's top thinkers, let Barnes know that the art he had recently begun to collect "implied a reconsideration of the very purpose and aim as well as the methods of pictorial and plastic art." In collecting this art, that is, the millionaire could also be a revolutionary.

The Englishmen set out a number of principles that Barnes went on to adopt. Bell insisted that the new art was about "significant form" conveyed for its own sake, not in order to illustrate some content from high culture. "There is no reason why a mind sensitive to form and colour, though it inhabit another solar system, and a body altogether unlike our own, should fail to appreciate it," Bell wrote; Barnes eventually made similar claims about the new art's availability to people of every rank, background, and race. Fry for his part described the kind of art that Barnes had just purchased as "the work of highly civilised and modern men trying to find a pictorial language appropriate to the sensibilities of the modern outlook," insisting on the same link between art and society that Barnes would go on to champion—a link that has often been overshadowed, in our thinking on Barnes, by his Bell-ish interest in pure form and style.

Fry said the Picassos at the Grafton took the new art's radicalism to its "logical extreme." But however good that sounded on paper, those paintings, all small ones and mostly painted in browns and grays, must have been drowned out in the exhibition itself by its spread of colorful masterworks by Matisse. The great *Red Studio*, a huge view of Matisse's new atelier that he portrayed as hung with his earlier works, functioned as a kind of one-painting retrospective of his achievements.

Barnes clearly needed Matisses of his own, and in Paris he set out to get his first ones.

"He did literally wave his chequebook in the air," said Gertrude Stein, recalling Barnes's sudden appearance in the city she called home. She and her brother Leo hosted a Saturday salon in a Left Bank apartment hung floor to ceiling with works by Barnes favorites like Renoir and Cézanne as well as with the new paintings of Matisse and Picasso. An American paper was soon describing the siblings' collection as "the Mecca of artistic pilgrims who were seeking enlightenment as well as those who came to scoff." But Gertrude seemed to think that when Barnes paid a visit, looking "like a Jew" (she was one), he had mostly come to buy.

Despite her disdain for Barnes's filthy lucre, Gertrude was happy to take some of it in exchange for a Matisse—the first that entered the Barnes collection, bought as a pair because Gertrude would not sell just one. They were a still life and a seascape from 1906, and nothing like as daring as the more recent Matisses Barnes saw on show in London. But that seascape, in a genre normally meant to be placid, had garish colors and vibrant, almost arbitrary brushwork that would have been more than enough to shock a Main Liner off his polo pony. "Painter's Curious Joke" had been the headline on one American newspaper's article on Matisse, claiming that his art "hoaxed the public." Barnes, a born iconoclast, wanted in on the hoax.

But in Paris, in 1912, an American with money to spend couldn't be read as having any other goal than spending it.

When Barnes paid a visit to Gertrude's brother Michael, another art-loving Stein, a witness gave a colorful account of it that revels in that stereotype:

> One night a tall man came into the room and examined the walls. He stood before a large canvas, examined it for a moment, then walked across the room to Mr. Stein.

"My name is Barnes," he said. "That picture." He motioned to a large canvas over the couch, to a painting of a young nude.

"I'll take that one."

Mr. Stein followed the direction of his arm—the Picasso?

"I'll give you $5000 for it."

"We are not dealers." Mr. Stein said in the low voice habitual to him.

"Not dealers?"

"No, we are collectors."

"You don't sell? Anything?"

"No."

"What are you doing with all these paintings?"

"We enjoy them."

In fact, there might never have been any collector who enjoyed pictures with Barnes's commitment and intensity. Pretty much all collectors revel in the thrill of the chase and of simple acquisition, and Barnes certainly did. But for him, those became nothing more than pleasurable first steps on the long and troubled path toward achieving the most profound aesthetic insight he could, then making sure others would have access it to.

Whatever the reservations of Gertrude and Michael Stein, their brother Leo, a die-hard intellectual, certainly found enough courage and substance in Barnes to become his good friend and eager correspondent; they remained close, with the usual Barnesian ups and downs, for the next several decades. (Among other things, they shared a passion for baseball.)

When the two men first met, they were both forty years old, but Leo Stein seems to have played the role of cultural mentor: he had already spent a decade considering and promoting the new art that Barnes had only just discovered. "I was the only person anywhere, so far as I know, who in those early days recognized Picasso and Matisse," Leo went on to boast. Barnes, always eager to hone and systematize his own thought, was willing to let his new friend take the lead, asking him for help getting pictures from artists. Within a couple of years, when Barnes felt that he'd risen to Stein's level, he said it "hurt like hell" to have to listen to Stein expound without being given the chance to put in his own two cents. (A couple of decades later Stein acknowledged that he'd once dominated Barnes; in the grip of psychoanalysis, he said— but not to Barnes—that the acknowledgment triggered "a decided auto-erotic feeling in the sexual region as well as anal and in the digestive tract.")

CHAPTER 9

A postcard from New York's great Armory Show that opened in February of 1913.

ARMORY SHOW | JOHN QUINN | VITUPERATIONS

"Academic art received a blow from which it will never entirely recover"

ighteen van Goghs and the same number of Cézannes. Fifteen Matisses and eight Picassos. Another thousand works by their American peers and three hundred or so brought over from Europe. This was the bounty Barnes got to take in at the famous Armory Show, the *International Exhibition of Modern Art*, that opened on February 17, 1913, a couple of months after Barnes's return from Paris, in a vast drill hall on Lexington Avenue in New York. It drew mobs for weeks, then toured the nation. Modernism was no longer something Americans could safely mock, or even admire, from afar.

While the Armory Show was still on tour, Barnes raved about it to his new friend Leo Stein: "It was the sensation of the generation. . . . Academic art received a blow from which it will never entirely recover." He was soon insisting on the show's "tremendous influence for good upon the live American painters."

And yet he had refused to lend a single one of his own works to the show, despite entreaties from a curator: "If you knew what those paintings meant to me, I am sure you would not put me in the position where I appear selfish or unsympathetic in refusing the loan. They are with me not an incident or pieces of furniture—

they are simply my daily life itself and I could no more be without them for a month than I could go without food for a like period." He was writing this after barely a year of serious contact with the art he so cherished, giving a sense of how badly he'd been bit by the collecting bug.

This makes it all the stranger that he only seems to have bought a single painting from the show, a fauvist piece he'd already seen at the Grafton survey in London. The normal explanation has been that, for all his delight in the demise of the academic, Barnes could never stomach the full-blown revolution signaled in the works on view by the French cubists and the most radical Russians.

But at the time of the Armory Show itself, those reservations had yet to develop. Barnes was soon describing Picasso as "the most interesting, forceful and gifted man painting today," and even a decade later, when he is commonly supposed to have soured on the Spaniard, he could rave about a Picasso of his as "the best cubist picture ever painted" and as proof that the movement was "a *new end*, and not a means to an old end."

He can't have had sympathy with the establishment's knee-jerk attacks on the Armory's innovators. One critic was given a full page in *Harper's Weekly* to denounce the show as "heartrending and sickening," a "pathological museum" full of "revolting and defiling" works by the "artistic anarchists" of France. Some of his colleagues were less kind. And all this controversy ought to have been catnip to Barnes, who always loved a good dustup. But how could he come to the aid of the Armory when it was backed, and very publicly promoted, by his main rival in the field of vanguard collecting, the powerful New York lawyer John Quinn?

Born less than two years apart, the two men had been precocious children who climbed high above their humble roots. (Quinn's parents had fled the potato famine in Ireland.) Both Quinn and Barnes went on to have an interest in the latest ideas

in psychology and aesthetics; at Harvard, Quinn had even studied with William James and George Santayana, major influences on Barnes. Thanks to their hard-won ascent, both men were combative figures who committed to winning whatever fights they took on, in their profession and the culture at large. That helped the tastes they had in common to get expressed in competition rather than camaraderie.

Barnes and Quinn first came into contact when their notable support of the Ashcan school led them to the latest French painters. The two had discovered them at almost the same moment, with Barnes maybe six months in the lead. In March of 1912, Quinn had expressed interest in seeing the French art Glackens had just acquired for Barnes, even though he himself had yet to buy anything like it. Less than a year later, however, Barnes saw Quinn getting all the attention, and the credit: at the Armory's opening night, the lawyer got the chance to tell four thousand prominent Americans that they were being given a unique opportunity "to see and judge for themselves the work of the Europeans who are creating a new art," almost as though Quinn were the one to first discover them. Barnes couldn't buy, or even publicly admire, any of the luscious Renoirs or Cézannes or Matisses in the show, or lend any of his, as he did to other exhibitions, without validating the landmark project of his rival—and there was little that Barnes tended with more care than a good rivalry.

A few years later, Barnes lambasted the Armory for its "organized capital, salaried propagandist and press-agent," which was a calculated attack on the very aspects organized by Quinn, now become almost a declared enemy. Quinn came to refer to the Philadelphian as "fertilizer Barnes" and a "brute." For Barnes, the Irish American was nothing more than a dumb "mick" who had become an "ignorant ventriloquist" of trendy ideas. Barnes's aversion to Quinn seems to have carried over to the more radical modernism the lawyer was known to support.

Three years after the Armory, Barnes was claiming that Marcel Duchamp's *Nude Descending a Staircase*, the Armory's great succès de scandale, was so incoherent that it might as well have been called *Cow Eating Oysters*. That was in an ill-judged essay he published called "Cubism: Requiescat in Pace," and given Barnes's continuing support for Picasso, the essay might have been aimed at Quinn himself more than at the movement Quinn championed. (To be fair, much of Barnes's vitriol was directed at cubism's theoreticians and their "eccentricities of psychology and metaphysics," which deserved the attack. A critic's rebuttal to the article correctly pointed out that Barnes's rejection of the lousy theorizing might have blinded him to the movement's real artistic virtues.)

It might have been Quinn's RIP that Barnes's essay was truly wishing for. That came in 1924, when the lawyer, still in full collecting frenzy, succumbed to liver cancer at the age of fifty-four. When Quinn's art came to auction, Barnes wrote that his rival "has nothing very important and I doubt if I even go to the sale. . . . He had no knowledge of paintings and formed his collection chiefly through egotism and speculation." None of that was remotely true, but you can tell that death alone was not enough to truly end the competition—at least on Barnes's side.

Barnes's fight to the death with Quinn over modern art repeats his battle with Hille over Argyrol. It predicts another forty years of combat, waged with equal fury over fire truck funding, and real estate zoning, and public education, and racial equality and especially, again and again, over what art was truly great and the one way—the Barnesian way—it had to be understood.

Disagree even mildly with Barnes or provoke his ire through some quite trivial "fault," like having studied at the wrong college, and you might receive a letter filled with insults so honed over time

that his early attacks on Quinn start to look like compliments. One harmless journalist who came calling got labeled "a piano player in a whorehouse," a Jazz Age slur Barnes used again and again.

Come up against Barnes on some more consequential matter—or, God forbid, have a difference with him over art—and his letter was likely to be mailed far and wide, laying out your intellectual, moral, psychological, and sexual rot. Much as Barnes might truly care about the topic at hand, it's clear some of these fights expressed a sheer lust for battle.

Invective came so naturally to Barnes that a good friend like Leopold Stokowski, the conductor, could refer, in public, to Barnes's "brutal and sardonic manner." In France, Barnes earned such enmity that the government allowed him to go about armed with automatics.

Friends warned that his ferocity was counterproductive, that it often left him further from his goals. He listened and knew they were right and then let loose another broadside or ten. His toxic masculinity was an incurable affliction. Like many men, he enjoyed suffering from it. He had nothing but fond memories of smashing up a store that sold fake Argyrol. The prospect of being arrested or sued always left Barnes tickled pink.

Barnes simply found fighting fun and couldn't understand an opponent who didn't. (A very few were as happily pugilistic as him. Barnes once had a very public and very trivial fight with the writer James Michener that thrilled everyone involved. It ended with the two opponents embracing on a lecture stage.)

Barnes had a heartfelt conviction that vituperation and insolence were markers of humor and wit. He thought of himself as a hilarious insult comic—Don Rickles, *avant la lettre*—when, more often than not, he was really just grossly insulting. He spoke with some comic pride of his "ingrained habit of manipulating vituperation, venom, vindictiveness and personal abuse."

Again and again over the course of his life, Barnes was happy

to resume a cheerful correspondence with someone he had recently insulted in the most vicious terms—except that Barnes could never quite understand that he'd done so.

A few years after a brutal assault on a med school classmate's idea for a new antiseptic, he was taken aback when his old friend failed to return his warm greeting.

Another time, after threatening to release photos revealing a magazine editor to be a "pervert" and "grass widower," Barnes was happy to stand down again as soon as the poor man simply gave way on a minor publishing issue. "I apologize for all the nastiness written in my letter," Barnes wrote to him, with perfectly good cheer, "and I do it freely with a feeling of friendship for you personally."

All his "amusing" scorched-earth campaigns came with a side benefit he must have recognized: They brought Barnes more attention than successful diplomacy ever could. Their ferocity, that is, was more about making noise than outcomes or even bloodlust; they trumpeted "Barnes is here" for someone who could never shake the feeling that he came from nowhere.

His collecting played a similar role, as it does for all collectors who tout their finds. But where his famous acquisitions were also made to serve aesthetic, educational, and even social ends, his vituperations served no good beyond earning headlines. In fact, his gross intemperance did lasting harm, in distracting from the real substance of Barnes's achievements, ideas, and even character. For some observers, his virtues have remained hidden. He has come off as a fool, a monster, or both.

The sheer clamor of his attacks hides the fact that they were almost entirely verbal, and only rarely caused any actual damage. His most public, most fearsome diatribes were usually directed at major figures or institutions—civic officials, big museums, Ivy League schools—that would be sure to survive them. His more personal victims mostly suffered wounds to their egos. Unfortu-

nately, those are the wounds humans hold most deeply against their attacker.

Barnes's public cruelties might be just about balanced by private kindnesses. There were all the employees whose care he assured into old age. There was a gay tutor he supported through scandal, a beating, and a final stroke. There were artists Barnes patronized while doubting their art and students and musicians whose training and travels he subsidized.

His gifts to posterity, as a collector and thinker, pretty clearly outweigh his own lifetime's faults.

CHAPTER 10

Landscape with Figures, *painted around 1911 by Maurice Prendergast, who Barnes admired as an eccentric.*

CULTURAL ASCENT | AMERICAN MODERNS | JUDGING ART

"I've given more time and effort to trying to find out what is a good painting than I've ever given to any other subject in my life"

He feasted New York friends at the Lion Spaghetti House on Mulberry Street, when they might have expected pheasant at Delmonico's. He sometimes dressed carelessly, trying to "make himself into a bohemian," according to one witness. That could extend to insisting that he and his artist friends "go Dutch" on their spaghetti.

This was Albert Barnes after he'd fully embraced the modern avant-garde.

At home in Philadelphia, he took steps to see Walter Scott's *Waverley* novels and other deluxe products of Victorian literature give way, on his bookshelves, to the modernist plays of John Millington Synge. Synge's *Playboy of the Western World*, peopled by the Irish lower classes, had got its cast arrested for immorality when it was performed in Philadelphia in 1912. It took Quinn's lawyering to get the charges dismissed.

By 1914, Barnes was also investing in the modern prose of his new Parisian pal Gertrude Stein and in the symbolist writings of Maurice Maeterlinck, whose overripe allegories Barnes was soon recommending to a friend. (Barnes had yet to adopt the

hard-nosed rationalism that became his trademark in all things aesthetic.)

Music was also a passion with Barnes, especially after Leopold Stokowski, a committed avant-gardist, arrived to lead Philadelphia's symphony orchestra late in 1912. Stokowski remembered being invited to Lauraston to hear the violin of his celebrated friend Jacques Thibaud: "I said to Thibaud, when the host had gone out of hearing, 'When is it going to begin and where are the rest of the guests?' There were no guests—I was the only one. So Thibaud played his music and the host and I sat there and had a lovely time." Barnes's musical interests came with a dose of iconoclasm. He had a passion for early music played on old instruments, half a century before "historically informed performance" revolutionized Bach and Beethoven. In a gesture that at the time was seen as closely allied, he went so far as to defend the new atonal compositions of Arnold Schoenberg, who rivaled Picasso himself as the most hated of modern creators. Barnes was committed to the idea that modernist innovation happened in parallel in all the arts, from music to painting to poetry.

But visual art remained Barnes's focus. In the years after his first Paris trips, he worked hard to sell or trade some of his earlier, safer purchases in order to dig deeper into the roster of more recent French modernists that had supplanted them in his heart. He wrote to Durand-Ruel, his main dealers, asking them to take back a number of the 1912 purchases whose "importance" had worn off for him. (Their representative's response: "I consider it absolutely unfair that you can select from your collection the pictures which may have decreased in value and return them to me, while you seem to expect that you can reap the profit on those which have become more valuable." Of course, he knew better than to refuse Barnes's request.)

By the summer of 1914, Barnes was writing to Leo Stein, his new pen pal, about the pleasures and pains his collecting brought

him, since Barnes had been born, he said, without a strong "esthetic sense," and that made him learn more slowly than he did in science or business. "I have been reading and thinking so damn much about art during the past three years that it has become almost an obsession."

Already at the start of that year, Barnes had boasted that Lauraston's two hundred works included more than a dozen Picassos, fourteen Cézannes, and twenty-five Renoirs, all artists that remained at the very center of his collecting.

Since Barnes's drug business demanded only a few hours' attention each day, these new treasures became "constant companions and objects of study from two o'clock every day until ten o'clock at night." Barnes complained that for all his study—or because of it—his views were forever shifting: "I have in the storeroom of my house probably twenty paintings, many of which cost me considerable money and which were discarded because I think the personal message of the painter was either insincere or his presentation so bungling that it is not to be considered a work of art." Trained in a new scientific method based on trial and error and correction—the very method that had provided the fortune he spent on collecting—Barnes always felt that a similar progress toward truth might also be achieved in our understanding of art.

Barnes's image as a self-taught aesthete became so important to him that he came to deny even Glackens's role in his artistic education, proclaiming that no art expert had influenced his collecting—and then salving his conscience in a comically self-serving letter to Edith Glackens. If he'd mentioned her husband's role, Barnes explained, it would have let haters and rivals "broadcast the rumors about the collection being merely Butts's ideas, etc. I don't think he wants that."

World War I broke out in the late summer of 1914, and German U-boats soon ended Barnes's buying trips to Europe. (Before the war, he had sailed on the ill-fated *Lusitania* steamer, on which 1,195 passengers later lost their lives to a German torpedo.) That didn't much slow the growth of his collection. European paintings continued to pour into Lauraston, thanks to French works bought from the New York branches of Paris galleries and from fellow Americans, including Leo Stein, forced back to the United States and needing money. Barnes had plenty: he told the IRS he had made almost $250,000 in 1914 (closer to $8 million today); given his love of tax dodges, he probably had far more than that at his disposal.

Those U-boats might also have helped turn Barnes's attention back to local artists.

For a moment the collector had waxed retrospective, buying an 1889 portrait study for the great *Agnew Clinic*, by the veteran Philadelphian Thomas Eakins. Barnes wrote to the sixty-nine-year-old painter, a fellow Central High alumnus, about how the study was judged "the greatest portrait ever painted in America" and "worthy to hang among the best Velasquez's in the Prado."

Among the younger American painters, he widened his circle beyond Glackens and his Ashcanners to more dedicated and eccentric modernists such as his fellow Pennsylvanian Charles Demuth. Demuth, who was gay, was one of America's first devotees of Cézanne and his cubist heirs, translating their achievements into brilliantly fay watercolors. It's not clear if Barnes would have seen the most openly queer ones, but Demuth wouldn't have been the only man the collector knew was gay but supported anyway, despite Barnes's own overweening machismo.

"I write to Barnes quite often. I'll be nice to him—I like him and he has been nice to me," Demuth told his mother in 1921, maybe striking a sheepish note because Barnes was coming to be disliked by many of his peers. By the following year, the two men

were exchanging notes about scandalous modern books—Joyce's *Ulysses*; D. H. Lawrence's *Women in Love*—and Barnes was funding Demuth's diabetes treatment. "At this time you don't want to worry about such matters as arranging to see that I get the money back," Barnes wrote to Demuth in his hospital room, with a casual generosity he isn't much known for. "Just content yourself and stay there as long as your doctor wants you to." They went on to trade visits to Merion and Lancaster, the town an hour's train ride away where Demuth was born, lived, and died, young, in 1935.

Maurice Prendergast, a dear friend and Greenwich Village neighbor of Glackens's, became another Barnes favorite. Prendergast's work was at least as idiosyncratic as Demuth's, and Barnes at first found the artist so strange that he hesitated to collect him. As just about the first American to embrace postimpressionist willfulness, Prendergast built his paintings from patches of unblended color that made his scenes of urban pageantry look almost as if they'd been built from appliquéd fabrics. Barnes noted, and appreciated, the almost outsider quality of the work and of the man, an eccentric bachelor who was mostly deaf and lived for many years with his equally peculiar brother, Charles, who crafted many of the picture frames at Lauraston. Barnes was at least as taken with the modesty of the brothers' habits and biographies as with the actual art they produced. Before settling into the life of an artist, Maurice had worked wrapping packages and doing commercial lettering, the kind of life story that was catnip to Barnes, the diehard democrat.

Barnes described the naïveté in Prendergast's paintings as "not an affectation but the natural unaffected expression of the artist's temperament as revealed by his whole life. In his joyful appreciation of the beautiful things of life he remained a child." Even when he was at his most formalist, paying attention only to color, line, and composition, Barnes always saw art as the product of some particular person's vision and nature.

His fondness for Prendergast even survived an outburst that ought normally to have ended it, one day at Lauraston when Barnes had been spewing endless bombast about his pictures. "Finally, Maurice got mad," Glackens recalled. "You have no taste! Look at your home!" Prendergast shouted, pointing out the pseudo-British furniture all around him. "You have no taste!" the artist said again, grabbing the one nice chair in the room and pounding it on the parquet so that everyone present got to watch it fly into pieces.

While war raged in Europe, Barnes was buying Prendergasts in depth, only to come up against Maurice's prior commitments to John Quinn, who was a major backer of the New York gallery where the artist was showing. The insults that flew between Barnes and Quinn were truly toxic. Barnes went so far as to hire detectives to follow Quinn and the female gallery owner, hoping to catch them as lovers. He asked his lawyers if there was libel involved, on either side, in the letters that passed between them: "Their latest labels me 'cad,' 'brute,' 'intriguer' and 'bully,' and I pinned upon them 'stuffed shirt,' 'pair of silk tights,' 'common scold immodestly stripped to the nudity of the soul,' and a few other nice names." He was so worried about being arrested that he had bail arranged in advance. Poor Prendergast was caught in the middle. He seems to have preferred Quinn's urbanity to Barnes's steamrolling ways, but Barnes's affection and admiration for Prendergast remained steadfast.

Writing a kind of *summum* of the pleasures that he got from art, Barnes paid Prendergast the singular compliment of placing him in the company of the very best of French artists, as the only American among them. "Good paintings are more satisfying companions than the best of books and infinitely more so than most very nice people," Barnes wrote. "I can talk, without speaking, to Cézanne, Prendergast, Daumier, Renoir, and they talk to me in kind. I can criticize them and take, without offense, the refutation which comes silently but powerfully when I learn, months later,

what they mean and not what I thought they meant. That is one of the joys of a collection."

This, Barnes's first public utterance in the art world, came in an essay called "How to Judge a Painting," commissioned from him for a 1915 issue of the magazine *Arts & Decoration*.

With the publication of the essay, Barnes launched the profile he worked so hard to cultivate, and especially to control, over the following decades. Barnes, the Argyrol magnate who sometimes buys pictures, sets out to present himself as Barnes, the great collector and thinker who just happened to have once made a fortune in drugs.

The essay demonstrates that Barnes had achieved the strong opinions he had set as a life goal a few years before.

His article dismisses the great old master collections of Gilded Age magnates—Widener's Van Dycks, Frick's Vermeers, Altman's Rembrandts—as mere "swagger," less about taste than shopping. He clearly doesn't want to rise into the ranks of these plutocrats so much as set himself off from them.

"Picasso is a great artist and a great painter, and Matisse a greater artist than a painter," Barnes insists, with a combative certainty, and a certain opacity, that never quite left his prose. "As far as I know, I was the first in America to hang Matisses and Picassos in a collection." (He certainly knew that the Cone sisters of Baltimore had beaten him to it.)

The collector very happily admitted that his essay displayed manners "that one finds normally in the bar-rooms in the neighborhood of 6th & South Sts; in fact, if I had the courage of my convictions, I would occasionally associate with that bunch, with whom I have some characteristics in common." Barnes always preferred to imagine himself in a barroom than a fancy salon, however much his actual tastes ran to vintage port, Steinway grands, and gold-framed masterpieces. In his self-image, he was a workingman who had managed to nab some of the pleasures his betters

got wrong. He refused to see himself as a cultural aristocrat who might just have humble roots buried deep in his past.

Barnes once said that in 1914, when he first got hold of the galleys for Clive Bell's landmark book *Art*, the erudition, eloquence, and complexity of the book had left him convinced that he himself was a "hopeless ignoramus." And indeed, "How to Judge a Painting" contains almost nothing by way of complex aesthetic thought, such as Barnes was turning out by the ream within a few years. It was nothing more than a ramble through a collector's pet theories and especially peeves, many of which Barnes never shed.

But in this first public statement ("the manliest thing I have ever read on the subject," was how his schoolmate John Sloan described it to Barnes) the collector does manage to convey the sheer exultation he feels in going to bat for "the greatest movement in the entire history of art—the Frenchmen of about 1860 and later, whose work is so richly expressive of life that means most to the normal man alive today." That "normal man" went on to be the vital figure at the heart of Barnes's thinking on art, and on society, for the rest of his life.

After barely three years of close contact with art, Barnes had let it take him over. "Golf, dances, theatres, dinners, traveling, get a setback as worthy diversions," Barnes wrote, "when the rabies of pursuit of quality in painting, and its enjoyment, gets into a man's system. And when he has surrounded himself with that quality, bought with his blood, he is a King."

In the pages of *Arts & Decoration*, Barnes gave himself a public coronation.

CHAPTER 11

John Dewey photographed by Eva Watson-Schütze in 1902, as his fame began to grow.

DEWEY

"Simple, plain, penetrating, inspiring
and intensely interesting"

n the fading afternoon light of Tuesday, October 9, 1917, nine young men passed through the grand archway of Columbia University's Philosophy Hall on their way to the first meeting of their graduate seminar with John Dewey, the great pragmatist philosopher. Those students can only have been surprised to discover that the tenth seat at their classroom's table was occupied by a bulldog of a man in a bespoke pin-striped suit—a forty-five-year-old millionaire, already gray-haired, who seemed more at home bossing workers than pondering syllogisms.

Albert Barnes might have been almost as surprised at his own presence as his classmates were. "I wonder if it is too high-brow for me?" he'd asked just a few weeks before, when a scholar-friend suggested he attend. (That might have been the last time he admitted that anything might have a brow above his.) A few weeks after first showing up to audit the class, Barnes stood entirely convinced. "Since the death of William James, Dewey has been the unquestioned head of American philosophic thought, and he is simple, plain, penetrating, inspiring and intensely interesting," Barnes wrote to a friend, explaining that the seminar roamed widely across almost all of philosophy's most pressing concerns at

that moment—a moment when philosophy could happily venture into psychology, sociology, and even politics.

One afternoon at Columbia, after Dewey had done a particularly brilliant summation of some ideas of John Stuart Mill, Barnes exclaimed, "That recalls Beethoven's Fifth Symphony." The rest of the class was appalled at the naive businessman's near non sequitur; the fearless Barnes bought tickets for himself and Dewey to hear the Fifth performed by Philadelphia's orchestra, "to have him see the cognate objective factors that established the kinship between Mill and Beethoven." It was the first of Dewey's dozens of visits with Barnes, stretching across most of four decades.

It's not a stretch to say that almost everything in the collector's thinking was changed by his contact with Dewey's pragmatist ideas about the human mind and society, and about how the two could be made to shape each other through education. A fellow student in the Columbia seminar described how it had made the drugmaker "fanatical, almost unbalanced" in his enthusiasm for Dewey.

It was an unlikely enthusiasm, if only because that word is so hard to associate with Dewey. As a teacher, he was known for a manner that came closer to apathy. A classmate of Barnes's at Columbia described Dewey sitting at his desk, hardly aware of the class in front of him, "fumbling with a few crumpled yellow sheets and looking abstractedly out of the window." He spoke in such a low monotone that it was easy to miss half his words, if you were awake enough to catch any. And yet that same student realized, on studying his class notes, that Dewey's apparently disjointed, haphazard talk was actually "of an extraordinary coherence, texture, and brilliance. . . . I had been listening to a man actually *thinking* in the presence of a class." Barnes, always in love with intelligence, must have realized he was in the presence of a great one.

The next thirty-five years witnessed a deep and unbreakable friendship between the two men, one infamous for passions and outbursts, the other famously measured and mild mannered—

"simple, sturdy, unpretentious, quizzical, shrewd, devoted, fearless, a true Yankee saint," in the words of a Columbia colleague.

A vast trove of letters shows "Mr. Dewey" and "Mr. Barnes" becoming "Dewey" and "Barnes" and then "Jack" and "Al"—or even "Al, Old Potato," who might close a letter to Jack "with many sweet kisses."

Barnes could chastise his friend for his avoidance of conflict. Dewey could—timidly, of course—rebuke Barnes for the ferocity of his attacks on rivals, offering his bulldozing friend the surprising but insightful observation "I don't think you like to knock just for the sake of knocking. I think you have a sensitive constitution and on that account the relative importance of things sometimes get temporarily out of focus." Barnes happened to agree, sharing with Dewey the wildly unlikely claim "I was born without the fight instinct, and that's why people pick on me and the crazy things I try to do with my money and life."

When someone asked Dewey how he could stand being friends with a man as irascible as Barnes, the philosopher said, "Well, he is a diamond in the rough, but I can get him to undo the mischief he does."

When Barnes, for his part, once got tired of his friend's passivity at a dinner, he exclaimed, "John, why don't you show some life?" upon which Dewey threw a peanut in the air and tried to catch it in his mouth. This, according to a fellow diner, was "the only outgoing gesture Dewey had ever made."

Another observer, who described Barnes as someone "who questioned every man's right to be alive and usually found against the plaintiff" (but also, paradoxically, as "the most charming man you ever saw, utter graciousness"), gave a heartwarming account of a night in the 1930s when the collector served a "divine whiskey" to Dewey and a few others. "Now John, you've had enough," Barnes said, solicitous of his friend, who was thirteen years older. "One more and you'd be drunk." (Dewey kept drinking.)

Barnes eventually arranged for Dewey to receive a substantial stipend of $5,000 a year for life.

It was a friendship with few of the ups and downs (mostly downs) that were typical of Barnes's other relationships. Their final letters reveal two loving old men exchanging notes about their declining health, but also, as always, about their careers and ideas and their remaining ambitions for both. "I think of you every day and wonder if the internal devils have let up any on you," wrote Barnes.

According to their origins at least, the two friends should have had little to bring them together. Where Barnes was born into the rough-and-tumble working class of Philadelphia (population 675,000), and liked to boast about it, Dewey was born, in 1859, in almost-rural Burlington, Vermont (population 7,700), in an imposing clapboard house with gabled roof and wraparound porch—a long way from a rental on the edge of the Neck. And he would never have thought to boast about anything.

Dewey's father, a grocer, was a volunteer in the Union army—his First Vermont Cavalry was at Cold Harbor alongside the Eighty-Second Regiment of Pennsylvania Volunteers—but he served as a quartermaster supervising the baggage train, mostly at the rear of any action. In 1865, while Private Barnes of the Eighty-Second was still nursing his stump in the hospital, Archibald Dewey emerged from the war unscathed and with a promotion to captain. He settled into a tidy tobacconist's business in Burlington, which let his son spend his first two decades in Yankee tranquility. Like young Albert Barnes, young John Dewey had a newspaper route as a schoolboy—but for pocket money, not to help with family bills.

Dewey's mother was from a notable family of rural gentry; her cousin was president of the University of Vermont when Dewey studied there. (He didn't need the leg up of a Central High.) Lucina Dewey shared the deep religiosity of Lydia Barnes, but it was built around the dour Protestantism of the Pilgrim Fathers. She would not have tolerated the lively biracial camp meetings that had meant so much to Lydia and Albert. With only seventy-seven African Americans in Burlington, and no Black church, such a meeting would have been unlikely, anyway.

Despite Dewey's later move toward freethinking, it has often been pointed out that the interest in social reform he shared so strongly with Barnes very likely came to him first from his devout mother: An obituary spoke of her being "especially solicitous" of the "poor and unfortunate." (Even tiny Burlington had its slums.) If Dewey didn't have Barnes's intimate, personal knowledge of disadvantage and inequality, the philosopher learned to fight against them at his mother's knee, and in his mother's church. "Democracy is not in reality what it is in name until it is industrial as well as civil and political," Dewey had dared proclaim, flirting with socialism. "A democracy of wealth is a necessity."

Dewey's rationalism and secularism, so appealing to the scientist in Barnes, took hold during graduate studies in philosophy at Johns Hopkins University in Baltimore, and then as he taught and eventually became department head at the Universities of Michigan and Chicago. Under the influence of Barnes's hero William James, Dewey helped elaborate the rationalist philosophy known as pragmatism, built around a foundational maxim: "Consider what effects, which might conceivably have practical bearings, we conceive the object of our conception to have. Then, our conception of these effects is the whole of our conception of the object." Put more simply—pragmatism's language, and especially

Dewey's, can be surprisingly unpragmatic—all thought that was worthy of the name had to derive from, and be about, real action in and on our human world. If an intellectual proposition didn't address a real-world situation, and have real-world consequences, then it was just so much blather about nothing.

You can see why Barnes, the experimental chemist and factory boss, would have been attracted to a leading light of pragmatism. As Barnes interprets Dewey, thought itself had "no reason for being" unless it was solving some concrete problem.

Or as Dewey himself explained, quite simply for once, "An ounce of experience is better than a ton of theory simply because it is only in experience that any theory has vital and verifiable significance." For Dewey's pragmatism, and then for Barnes, that word "experience" had an almost magical, all-explaining power, since it encapsulated everything in the world that humans could ever encounter or know and the feedback loop that happened once humans encounter and know it. "Every significant human activity is a perpetual remaking of both the individual and the world in which he lives," was Barnes's formulation. The world exists for us—we can only know it—through what it lets us do in and with it, and then that knowledge shapes our doing, which shapes the world as we can know it, and so on ad infinitum.

The concrete outlet for pragmatism's supposedly concrete ideas came in educational theory. A classroom, after all, was a little world, a petri dish, where you could watch a human in the act of having "experiences," and where you might even be able to shape the knowing and doing that led to them. Education was an especially timely and topical subject at that early moment in the history of mass schooling—the new mass schooling that had done so much for Barnes, even though he always complained about how rigid and unthinking it had been and mostly still was.

Before Dewey arrived at Columbia in 1904, he had designed his famous Laboratory School in Chicago to make a practical test—pragmatic in both the everyday and philosophical senses—of a pedagogy that, as far as humanly possible, privileged "experience" over theory.

"The educator's part in the enterprise of education is to furnish the environment which stimulates responses and directs the learner's course," said Dewey's *Democracy and Education*, published in 1916 to great acclaim and soon to become Barnes's bible. "All that the educator can do is modify stimuli so that response will as surely as is possible result in the formation of desirable intellectual and emotional dispositions." Deweyan education focused on students solving problems that more or less naturally arose from the environment carefully created for them in the school, rather than on teachers providing solutions from on high. Whereas the era's more standard schooling, said Barnes, had neither intellectual substance nor educational purpose because it lacked relevance "to any problem arising out of the experience of the students themselves."

Dewey's very modern idea, still current more than a century later, was to provide students with tools for intelligent thought, which equipped them for dealing with all the "experience" the world could throw at them. This was precisely the way Barnes described the lessons later taught among the pictures he collected, which were supposed to provide ideas equally applicable to any works of art, of any kind, anywhere on the planet. Barnes came to think of the masterpieces amassed in his foundation as nothing more—nothing less, he would have said—than school supplies for a Deweyan classroom.

By the time the collector and the philosopher became friends, a leading magazine had covered Dewey as one of the "Major Prophets of Today," the only American it judged worthy of the title. What

might seem surprising is that this intellectual superstar had so much time for the mere businessman Barnes still was in 1917.

———

"I think Dewey enjoyed seeing Barnes in action as a vigorous, colorful, intelligent personality," said one close observer of both. In fact it was Barnes's lack of academic credentials that helped make him so compelling to Dewey, since Dewey's entire philosophy centered on the idea that philosophical theories, however general, had to be proven via, or derived from, their points of contact with everyday life. As a card-carrying pragmatist, Dewey condemned "the depreciation of action, of doing and making" that he found in his profession, and the "doing and making" found in everyday life was precisely Barnes's natural habitat, or at least the one he wanted to claim as his own, however much his luxuries and privileges might have come to shelter him from the everyday.

"I can start much freer from technical philosophy than I could before having the talks with you," Dewey wrote to Barnes, who wrote back deriding "too much philosophy and too little natural reaction to experience"—in pragmatist aesthetics, he meant, but also by extension in Dewey's entire thought. Barnes, that most practical of men and enemy of all metaphysicals, was after "straight thinking with a possible application to every day life," and he seems to have been a force in getting Dewey to engage more directly in public affairs—even public fights—than came naturally to the philosopher, who confessed to enjoying his ivory tower.

Dewey's work on aesthetics counts as part of this public engagement, since it was all about understanding the likely effects, on a real audience, of engaging directly with actual works of art. And he always insisted that *Art as Experience*, the landmark study

in aesthetics he published in 1934, was in deep debt to his collector friend, who was the book's dedicatee. In a letter to "Al" discussing the book, "Jack" signed off with "unabated devotion and with enthusiasm for picking your brains and plagiarizing your ideas and words."

That confession seems accurate: there's not much evidence that Dewey cared that deeply about art before Barnes came on the scene. "I have been conscious of living in a medium of color ever since Friday—almost swimming in it," Dewey wrote to Barnes in January of 1918 after the "extraordinary experience" of a first visit to Lauraston, just months after they'd met. Years of aesthetic dialogue were to follow.

CHAPTER 12

Albert Barnes in about 1915, when he began new studies in philosophy and the "social question."

DEMOCRACY AND EDUCATION

"Barnes was a political and social
liberal, just as Dewey was"

I f Barnes led Dewey in certain new directions, Dewey gave Barnes new continents to explore.

Within a few years of their first encounter, an art collection that had been intended as a mere assortment of great modern works, meant to find an eventual home in a museum, became for Barnes a full-blown experiment in workable pragmatics. In his first account of the collection's new function, he described it as "an effort to put into practical effect the work of those men—William James, George Santayana, John Dewey, Bertrand Russell—which seems to represent the soundest thinking for the development of human beings along the lines of democracy and education." Or rather, of *Democracy and Education*, the book that had made a huge splash for Dewey in 1916, the year before Barnes joined him at Columbia, and that shaped the next three decades of the collector's thinking about almost any issue you could name. He cited the book constantly, almost chapter and verse, in all sorts of contexts. It remained his main gateway into Dewey's ideas.

In more than four hundred pages of prose so systematic it can often plod—Barnes, the industrial chemist, always had a weakness for plodding systems—*Democracy and Education* outlined how true learning comes when people, schoolchildren but also adults,

are plunged into an environment that gets them asking questions about the new experience it provides. Education's "finest product," Dewey said, was the "inclination to learn from life itself and to make the conditions of life such that all will learn in the process of living"—just the kind of world-centered learning that Barnes held dear.

Despite a fine education, Barnes always thought of himself as an autodidact, which meant that a model that privileged responding to circumstances had a special appeal to him. The different settings he'd been plunged into as he rose to prominence—Methodist camps, the Neck, Central High, medical school, the drug business, the art world—could be conceived as Deweyan "environments," with Barnes as the student learning to take advantage of each one in turn and being transformed as he did so and readied for the next one that might come along.

By its choice of examples and metaphors alone, Dewey's book gave Barnes a sense that it was speaking to and about him. The book often made its educational points by noting parallels in American industry and business: the joint effort involved in manufacturing tailors' pins becomes a metaphor for group activity in general; a businessman is the prototypical case of the citizen who needs the larger social system to flourish; the education that would make Americans into better people and citizens would also, and not at all incidentally, make them better workers. Entering that Columbia classroom on his first day with Dewey, Barnes might have been a "mere" businessman, but he soon learned that this made him an exemplary Deweyan. After all, what could be a more impressive demonstration of lived pragmatism than a scientist who, using fine training in reasoned thought, discovers and then produces a drug that saves the eyesight of future learners. That history made Barnes, in reality but also in his own mind, an entirely different kind of collector from some rich heir who buys lovely art.

Having mastered the business experience, Barnes plunged into his great art collection as his final Deweyan environment. Rather than looking to established experts for help in understanding it, he felt the skills he'd garnered over the course of years gave him all the tools he needed. Dewey's "learning from life" would, for Barnes, include learning from art, where life was just about at its best. Shaping the "conditions of life" so as to promote such learning, as Dewey demanded, would involve making sure those conditions included art.

Barnes went on to establish his foundation as a pedagogical institution that quite explicitly did for art education what Dewey's Laboratory School had done for education in general: it provided an "experience" of paintings and sculptures that, by its very existence and structures, gave people—*all people*—everything they needed to arrive at deep understanding.

As a collector, Barnes was the opposite of the sensitive aesthete watching his jeweled tortoise parade through art-bedecked rooms. He expected his art to do real work in the world.

———

Democracy and Education was as much about democracy as education; it was as much political as pedagogical. A proper education, in Dewey's terms, would so deeply involve its students in the communal task of learning that they would, naturally, be prepared for the communal tasks of a truly democratic society. Crucially for Barnes, that society was supposed to come about because every learner had been given "an opportunity to escape from the limitations of the social group in which he was born, and to come into living contact with a broader environment." The lowborn Barnes was a natural leveler, but *Democracy and Education* gave him a model for understanding his own horror of hierarchy, and for acting on it.

Dewey's book was a product of, and a contributor to, the larger Progressive movement then reshaping American politics and political thought. Like that entire movement, the book's ideas had been deeply affected by the violent suppression of the great Pullman Strike of 1894 and Dewey's disgust at that suppression. He said the strike was a "spectacle of magnificent, widespread union of men about a common interest"; that is, it was a living demonstration of Deweyan democracy in action.

Insofar as Barnes was a Deweyan, and he would have insisted he was utterly that, he was also a fellow progressive. Barnes's thought and work as a social and cultural reformer, even eventually in the field of race, have been overshadowed by the glorious art he bought and the eccentric path he took in making it public. But he conceived of his collecting as very much part of his era's new movement toward reform, toward a world that "grows better because people wish that it should and take the right steps to make it better," in the words of the great progressive Jane Addams. Barnes's high-handed manner, easily read as pure egomania, can make it hard to place him in the reformist ecosystem, but he really was committed to improving things.

In the decades around 1900, the United States wasn't really doing that much worse, politically or economically, than it had at some other moments in its history, but as the historian Daniel Rodgers has written, the country's technocratic and academic elites "swam in a sudden abundance of solutions" and a set of especially evident new problems to apply them to. What reformers called the "social peace" of America's capitalist society seemed newly threatened by the combination of gross inequality, as the robber barons set out to gild their age, and newfound labor strife, as the union movement began to push back in response.

The "social question"—how to keep a capitalist democracy both just and functional—came to be the signature issue confronting a new generation of liberal sociologists, political scientists, and

actual politicians. Dewey and his ideas held a notable place in this network of thinkers and doers looking for ways to undo the iniquities and inequities of the new capitalism. Barnes himself could go so far as to contrast his own, virtuous wealth, made through a "scientific contribution to human needs," with "money gotten through capitalistic exploitation."

"Barnes was a political and social liberal, just as Dewey was," recalled one Dewey student who went on to work for Barnes. "They had much in common on that, in fighting what they considered to be oppressive power of some institutions in government, the church, big business, and universities."

Both men were in close touch with progressive leaders such as Herbert Croly, co-founder of *The New Republic*, the movement's central magazine, which Barnes once said shared the "general purposes" of his art foundation. Croly went on to publish both Barnes (on politics, as well as art) and Dewey (on art, as well as politics) and to get the two men involved in his New School for Social Research. Both Dewey and Barnes were also supporters of, and sometimes in touch with, President Woodrow Wilson himself, the Progressive in Chief if ever there was one.

Unlike many of his fellow progressives, however, Barnes was so fervently antiestablishment that he didn't much look to the state as a source of future order and progress. His progressivism was rooted in the private world of philanthropy and volunteerism where the Progressive movement had got its start. That suited both his demand for personal control in all things and the terminal doubts this supposed egalitarian had about the brains, skills, and morals of most of his fellow Americans. (Dewey was almost alone in being given a pass.)

Where most progressives recognized the deep corruption of American politics of their era and set out to reform them, Barnes seems to have believed that political reform was close to impossible. He might have better odds of effecting change by trying for

it on a smaller scale. If a Deweyan education, put in place across an entire nation, was supposed to lead to the perfection of its democracy, while awaiting that glorious zenith Barnes could do a trial run—a proof of concept—in the limited field of aesthetics, across the limited scope of an art collection.

As Barnes went on to put it, in the 1922 indenture of his new "democratic" foundation, "The establishment of the art gallery is an experiment to determine how much practical good to the public of all classes and stations of life, may be accomplished by means of the plans and principles learned by the Donor from a life-long study of the science of psychology as applied to education and aesthetics."

CHAPTER 13

The Hotel Powelton in West Philadelphia in about 1900. Barnes leased space on its site for his drug factory.

FACTORY LIFE | WORKER EDUCATION

"The business never had a boss and has never needed one"

There was the Argyrol worker found to be so hyperactive that she stirred up the placid labeling department. "We removed the contention by placing her in charge of the stock and shipping," recalled Barnes, "where a new motor coordination is necessary nearly every minute."

A colleague of hers seemed to have a conflict between "his desire to become a chauffeur and his liking for the job he held with us," so he was given the work of caring for a factory car.

Another laborer, as intent on his boxing hobby as on his factory duties, was given help moving up to a higher level of the sport.

All this, said Barnes—plus workplace harmony and steady profits—came from the practical application of Deweyan principles to the model management of his factory.

Barnes claimed that from the moment in 1908 that he first took over the drug-making business from Hille, he had organized its workings "on the principles of scientific psychology." That meant running it, post-Hille, on a "cooperative basis" that Barnes described in almost socialist terms: "The business never had a boss and has never needed one for each participant had evolved his or her own method of doing a particular job in a way that fitted into the common needs."

Barnes claimed that the factory's employees had as much of a role in its management as he did, and that the arrangement had turned around the lives of several troubled workers, one a "drunkard," a second a "wife-beater and deserter of his family," and a third "a weak soul that might have been anything"—all become useful members of society, as Barnes put it, thanks to their status as "partners" in the A. C. Barnes Company and the responsibility and agency that came with that.

There were echoes of Dewey in Barnes's management principles. The philosopher described how, for all the era's talk about "scientific management" of the workplace and of a worker's every action, "the chief opportunity for science"—the science that Barnes believed in above all—"is the discovery of the relations of a man to his work, including his relations to others who take part, which will enlist his intelligent interest in what he is doing." Forget widgets: the finest products of a workplace managed according to the "scientific" principles of pragmatism were the social relations inside it.

Barnes called what he had achieved in his workplace "a real industrial democracy," but given his mania for control, it's unlikely his employees would have recognized him as a mere first among equals. His surviving letters to workers, with collars both blue and white, are as officious and bossy as could be. Yet it's telling that he should even posit such leveling as an ideal. A childhood spent in poverty had left Barnes with a visceral hatred of hierarchy and inherited status, and a pugnacious desire to see both overturned. As an industrialist he might have aspired in a small way to robber baron status—he rose to bandit baronet, at most—but as a thinker his ideals were more in line with the Progressive Era's undoing of Gilded Age privilege.

By early 1915, Barnes was reminding his employees of "my policy of treating every one of you as a friend who is entitled to decent treatment, advice in their personal affairs when requested and more payment for their services than they could get if they were employed elsewhere."

If not truly a first among equals, Barnes did manage to act as a kind benefactor. When employees fell ill, he consulted with their doctors and even with their dentists. (Barnes's own teeth and gums were a suppurating mess.) He often paid workers' medical bills or made sure they were treated for free. He took care to give staff the benefit of a substantial pension plan, and a generous annuity would be paid out to them should Barnes die early and the factory be sold or shut down. A working-class volunteer in the local fire department described his pal Barnes as "a real democrat, always taking up the fight for the little feller."

Barnes's groom Charles Funk told endless stories about his boss's generosity and democratic spirit. On visits to Barnes's hunt club, Funk was invited to eat beside Albert and Laura rather than being relegated to the servants' quarters. Barnes took an interest in the health of Funk's children, and even paid the deposit on a house bought by Funk.

Although Barnes tended to take personal credit for the benevolence he showed toward his employees, maybe giving a bit of credit to Deweyan ideas as well, in fact he was in the thick of trends in American management. Businesses were moving toward, and also inoculating themselves against, the ambitious workplace reforms of the Progressive movement. Embracing the concept of "welfare work" promoted by some charities, a few large employers such as the National Cash Register Company earned headlines and goodwill for the low-cost meals and free kindergarten they offered their workers, as well as all sorts of health and fitness and housing benefits. While NCR was happy to boast that the 3 percent of payroll that was spent on such ben-

efits boosted profits by 5 or 10 percent, Barnes barely ever hinted at a profit motive.

In a country where only a tiny percentage of employers offered any kind of pension and where corporate health benefits, if any, were pitiful, Barnes's ambitious policies seem less capitalistic than like his own, private anticipation of the national insurance plans his friends of the Progressive Era were just then battling to put in place. They didn't succeed for another two decades, so it was lucky for the Argyrol workers that Barnes didn't wait.

In August of 1915, Barnes told a friend that he had decided to take his workers, from the social class "usually suffocated by industrial conditions," as he was soon describing them to Bertrand Russell himself, and give them the tools "to educate themselves, waste no time in unproductive things, and make the remainder of their lives a journey of pleasure and profit to themselves and society."

Barnes meant to set them on that life journey thanks to a series of in-house seminars where together they worked through some of their boss's favorite thinkers—the likes of Dewey, William James, and Russell. If he could "divert their minds to higher interests," they might also start getting into less trouble, he thought.

The goal, as Barnes explained it, was

> to have the workers realize that bread-winning is only a part of life and that the personal activities of the members of the class outside of their working hours could be intelligently guided by the understanding of the roots of all human behavior; that is, that the impulses, instincts, and habits common to all human beings, need to be guided and adapted in order that all human associations be most beneficial to the democratic way of life.

It turned out that only six hours were needed for the factory's dozen or so workers to make, pack, and ship the day's stock of medicines. But since it was necessary, Barnes said, to concede to the social custom of the eight-hour workday—most factories demanded ten—he let his workers fill two hours in each shift with the factory's humanist discussions, which he billed as purely optional.

As Barnes put it, in fully Deweyan terms, "the Community idea of no boss, no orders, was itself a stimulus to the unfolding of traits and powers which is education." In theory, at least, the "democracy" practiced in the Argyrol workplace would give each employee an equal opportunity to be immersed in the experiences that workplace made available, to learn from them, and to acquire the "traits and powers" that flowed from that learning. But the truth is, hierarchy hadn't been eliminated in the factory, or its seminars, even at a level below the Big Boss. Three white-collar women who did the factory's bookkeeping and admin also took the lead in the workers' classes, turning the ideas of Barnes's favorite philosophers into, as he said, "a part of the working-day capital, in and out of business, of a score of people who never saw the inside of a high school or college."

The women who led the discussions were Laura Geiger, a skilled stenographer who was on the Barnes staff for many decades, and Mary and Nelle Mullen, two sisters from rural Pennsylvania who had joined the firm in its very first years.

Nelle had not finished high school when she began keeping the factory's books, but already by 1907 Barnes was raving about her "rare degree of aptitude, reliability and skill" in helping him sell the firm's products and in going after rival firms who were copying them. He tripled her salary to a princely $35 per week, more than was earned by 99.9 percent of America's wage-earning women. (One percent of men might earn as much.) Before long she was named a director of the A. C. Barnes Company. Her en-

tire working life was spent with Barnes—she was his foundation's secretary and treasurer from its beginning—and she was living on the generous pension Barnes arranged for her when she died in 1967. Her sister Mary, born nine years earlier, was also a company director and then became the Barnes Foundation's associate director of education; she tended toward sickliness but died in her eighties in 1957.

Barnes's support of these women and others reveals a streak in him that can't quite be called feminist—Victorian patriarchy ran thick in his blood—but that shows him to be more female-friendly than most of his male peers. (Except Dewey, who marched for women's suffrage when that was still a radical move.)

In letters to Edith Glackens and later to Alice Dewey, the wives of men who were his dearest friends, Barnes writes with the same care, respect, and true attentiveness as in those he sent their husbands. "Dewey said he got some of his best ideas from women. So did I," Barnes wrote.

Early in his art buying, he dug deep into works by the female modernists of Paris, though it would hardly have earned him credit in the male-centered art world. (See figure 5 in color insert.) He accumulated pictures by Marie Laurencin, Hélène Perdriat, and the now-obscure Irène Lagut, whom he viewed, optimistically, as "destined to become one of the most famous painters of our age."

Women, including Geiger and the two Mullens and, later, Barnes's disciple Violette de Mazia, were consistently his chief lieutenants both at his factory and then at the foundation.

A passage in the foundation's first publication, written by Mary Mullen in close collaboration with Barnes, describes a situation at a hypothetical factory where its manager has to decide what "she will do, how many girls she will need, at which machines she

will place each girl. . . . [S]he uses imagination and experience—her imagination, guided by her past experience"—a concatenation of "shes" and "hers" that sounds positively second wave, at a moment when female managers of all-female factories must have been just about nonexistent.

Laura Barnes, that woman acknowledged by Dewey for her "remarkable executive ability," was also a force by her husband's side, despite his browbeating. Barnes made her vice president of his foundation, and for decades to come, she could count on his full support and funding for her ambitious horticultural projects.

The foundation's 1922 bylaws specified that since the A. C. Barnes Company had "in great degree acquired its value and its earning capacity through the intelligence and efforts of Nelle E. Mullen, Mary Mullen and Laura V. Geiger," after the deaths of Barnes and his wife those three would be put in sole charge of the company's production and administration, with all three to also be on the foundation board. Those were roles, and authority, vanishingly few companies or foundations would have assigned to women in Barnes's era. With their mostly modest backgrounds and educations, it would have been hard for Barnes's female lieutenants to find work with similar responsibilities and rewards almost anywhere else in their society; it's no wonder they were so utterly devoted to their boss and his causes. Compared with the work they might have expected to spend their lives doing, the art education they embarked on for Barnes was "an adventure, as much fun as playing a game," said Mary Mullen. Of course, the opportunities those women got from Barnes could also leave them dependent on him, giving him the dominance he always sought.

A deep-seated and quite genuine egalitarianism was also in play in Barnes's rejection of the era's sexism. He loved to stand up for the disadvantaged, and women would clearly have qualified in his day. But we might also find roots of all this in his early life, without even going to Freud for help (as Barnes himself would

have certainly done): with a father he considered a wastrel and a weakling, Barnes came to idolize his mother as a brilliant woman who never got to realize her talents, and whose echo he looked for in other women after her death.

———

Barnes, a serial exaggerator, liked to claim that the talented women in his factory's office had been dipping their toes into philosophy and psychology from early in the new century. In fact, their exposure seems to start around 1914, when the factory's three high school graduates began coursework in the extension program of the University of Pennsylvania, studying psychology, English lit, and a bit of recent ethics.

Back in the factory seminars, the women's job was to translate what they'd learned into layman's terms for the benefit of their laboring colleagues, all with just primary school educations except one who was fully illiterate. Barnes described the seminars as "a shot in the dark," a practical experiment in Deweyan ideas using "very dubious material, namely, unskilled workers with but little early schooling."

All technicalities were stripped out of the factory's learning sessions, avoiding even terms like "philosophy," "psychology," "education," and "scientific method," so that discussion could be reduced to a core of precepts that would "serve each person as a guide for facing and solving the problems encountered in daily life." The lessons even came to include the spinal and psychological "adjustments" of the Alexander Technique, an alternative therapy for mind and body that both Barnes and Dewey were taken with.

Workers were also encouraged to head to a factory bookshelf to borrow the latest in "serious" literature by the likes of H. L. Mencken, Dorothy Richardson, and Sherwood Anderson. Again, all this echoes the "welfare work" of other companies at the time:

NCR offered its employees a library of nine hundred books, subscriptions to journals, and classes in such topics as history and English. The A. C. Barnes Company stood out only for its unusual emphasis on the latest Deweyan psychology.

Mary Mullen wrote about having taught psychology to her colleagues in terms of "a study of the impulses, the instincts, which constitute the ultimate sources of behavior, the organization of these impulses into habits, and of habits into the personality as a whole," and of having related all this as closely as possible to "specific personal problems" of the factory staff.

In Barnes's beloved *Democracy and Education*, Dewey insisted that a properly progressive curriculum needed to "present situations where problems are relevant to the problems of living together, and where observation and information are calculated to develop social insight and interest." That was how good education fostered true democracy. As applied in the factory seminars, it meant that they ventured into current social and political issues thanks to Bertrand Russell's *Why Men Fight*—in the midst of World War I, its pacifism must have provoked fierce debate—and into past ones via a close reading of H. G. Wells's *Outline of History*. Two whole sessions were devoted to an article about the New School for Social Research, just then being founded by Dewey and his Progressive movement peers in New York, and Mullen claimed that the factory seminars even covered Darwinian evolution and the scientific method, since, as Dewey insisted, science was the only way for society to achieve "conscious, as distinct from accidental, progress." That was an assertion Barnes, the chemist, would have wholeheartedly cheered.

Dewey had declared undemocratic any educational system that gave utilitarian instruction to the working class and then reserved for the elites the traditions of "high" culture. He had insisted instead on a pedagogy that engaged all its learners in "the deepest problems of common humanity." That seemed to be the

model adopted in the Argyrol factory, at least according to Barnes's account of its seminars, which spent fully two years on the works of William James, from his *Principles of Psychology* to his *Varieties of Religious Experience*, all of which, said Barnes, "was found comparatively easy going."

Though Barnes and his comrades "foundered," he said, on James's ideas of radical empiricism, Barnes said that Dewey's *Reconstruction in Philosophy*, a slim little book that gave a kind of summary of current thinking in the field, got the seminar's attention for nearly a month, "three or four days a week, two hours at each setting." Together the group "separated each fact from its abstract setting and pinned it on concrete facts, situations and people as we know them in life; the war, Wilson, modern art and artists, newspapers, you, our individual selves. . . . We spared nobody's feelings—I came in for several knocks."

It's not hard to imagine that the people who mixed and packed Argyrol, who Barnes described as having "*natural* brains and intelligence," might have enjoyed discovering the latest ideas about the mind and society. (Also, knocking their boss.) They might have felt that such learning improved their lives. But the more pragmatic effects that Barnes hoped for from the seminars' pragmatist pedagogy were hard even for him to identify. The couple of cases he liked to cite were distinctly on the eccentric side.

One involved certain workers jealous of a peer who earned extra by his hard work. When they started to complain that the man beat his wife, Barnes is supposed to have stepped in with a psychology lesson. He explained that the man and his wife were of a psychological type called sadomasochists and that "if Jake wants to beat his wife, if she likes it and she doesn't complain, we don't approve of that, but we don't think it is any reason for you boys to hold him up to scorn."

And then there was John White, the employee who liked to box. After Barnes watched his worker get pummeled in ten-man group bouts, for 50 cents a fight, he persuaded Johnny to go one-on-one at a higher level of the sport where he'd earn more like $20. Barnes offered to help with some "scientific" training, somehow based on the latest psychological thought that, according to Barnes, boiled down to first "sizing-up" the situation, then deciding on a course of action, and finally not doing anything dumb. "He received more in one night for six rounds of boxing than we gave him for six days of working," Barnes recalled. "We put William James and John Dewey into his boxing and he fought his way up to a bout with the title-holder of his class for the championship, but lost." His opponent, Barnes opined, "just happened to know the psychology of William James better than Johnny, although probably not by that name."

Barnes could sometimes have less equanimity than that about his experiment in worker education, though perhaps more realism: One day in 1920, half a decade after the experiment began, he told his friend Dewey of his "tragic failure to make eight people in my own business get a glimpse of a life better than the drab of their ignorant, daily routine. Not one of them showed a spark of response." A few weeks later, Barnes claimed to have canceled his factory's seminars.

CHAPTER 14

Catherine Rosier, a murder suspect whose defense got a hand from Barnes in 1922.

BUERMEYER | PRACTICAL PSYCHOLOGY | A MURDER CASE

"At about sixteen, I had most of the stuff the formal psychologists were writing about and I knew the essence of Freudian theory"

n 1915, after enjoying a summer class in philosophy at the University of Pennsylvania, Barnes had been inspired to work with a tutor. "My object is to adapt my own, world-experience-acquired, not-very-academic, philosophy to that of the masters," Barnes wrote to his chosen candidate. "I expect to carry out my plans for study not only for the coming college year but for a long time to come—for I know I have a lot to learn."

That candidate was Laurence Buermeyer, a twenty-five-year-old Penn grad student who took on the task of guiding Barnes through the thickets of academic thought. Buermeyer was a slight, nervous young man who looked so much like Harold Lloyd, the Everyman star of silent comedies, that Barnes liked to call him Harold. He was almost a negative image of his burly, practically minded new boss. Deeply bookish, within a couple of years of beginning his work with Barnes he had completed a Princeton PhD on "the phenomenology of thought." He was also an alcoholic and gay, having fallen in "with the epicenes who are tolerated, at such disastrous cost, in and around our best schools and colleges," according to one homophobic member of the Barnes entourage.

Although Barnes knew of Buermeyer's "personal weaknesses," he considered him "a man whose intellectual equipment is better than any I've ever met" and so remained his fan. "I've traveled with him from Aristotle to Freud, and he's got the whole gamut ready to play without a false note and no over-accentuations," Barnes opined to Dewey.

Barnes supported the young scholar both financially and morally, the latter via a frequent underlining of Buermeyer's faults. (This was a helping hand that Barnes liked to extend to all his friends and acquaintances, and even to his enemies.) Barnes tried to arrange and even fund university positions for Buermeyer, and he paid him for all the research and writing, and ghostwriting, the younger man did over the years for the Barnes Foundation.

With a loyalty that was an important element in Barnes's character—whenever he wasn't dropping people for trivial faults—he even stood by Buermeyer through a scandalous moment in 1926 when the tutor's longtime boyfriend beat him almost to death, rendering Buermeyer's "lips, nose, cheeks and eyes an inseparable mass," as Barnes put it, when he and Laura Barnes took it upon themselves to arrange for his hospital treatment.

A quarter century after their first meeting, Barnes settled a lifetime stipend on his erstwhile amanuensis.

Although Barnes liked to speak of a "life-long" interest in psychology, his early encounters with research on the mind were informal and haphazard.

Barnes said that his psychological studies began at fourteen, but by that he simply meant that he had begun to ask himself what made people tick. By sixteen, he said, "I had pat most of the stuff the formal psychologists were writing about and I knew the essence of Freudian theory"—but only, he admitted, "by personal

knowledge of myself and others, long before Freud had even begun to earn a living."

He might have done some actual reading in psychology at Penn, and there would have been some kind of psychological theory involved in his long-ago internship at that asylum in western Pennsylvania.

He had his first encounter with formal philosophy a year or two later, during his stay in Heidelberg, when he took a seminar in epistemology. While Barnes was enthralled with such rigorous thinking about thought, the readings confirmed his view, which he claimed to hold until first meeting Dewey, that "philosophy is a sort of a poetical way of an individual's showing off his cock-eyed eccentricities."

Barnes said that it was only with the disruptions of World War I that he decided to dig deep into the era's most important new writings on mind and society. Working with his new tutor most days, often for as much as five hours, Barnes claimed to have tackled the entire corpus of Freud. He and Buermeyer burrowed into Santayana and James and also into Bertrand Russell.

In the spring of 1915, Barnes's "How to Judge a Painting" had been written in language almost any collector could have produced and understood. Within barely six months, his readings with Buermeyer had begun to make themselves felt: Barnes's RIP for cubism, published at the start of 1916, namechecks Big Thinkers such as William James on parts and wholes, Henri Bergson on metaphysics, and Robert Bosanquet on music and depiction.

By 1918, after training with Buermeyer for barely three years, Barnes felt qualified to write a damning review of a book by an eminent colleague of Dewey's at Columbia, citing chapter and verse from Freud, Jung, and Alfred Adler and complaining that the author had neglected all these "vast developments in modern

psychology." (At this early date, psychoanalysis of all kinds was still mostly seen as notably rational and scientific, speaking to the chemist in Barnes.)

It's true that intellectual snobs would always find room to point out the holes that remained in Barnes's knowledge and culture. The aristocratic Bertrand Russell once winked at another pooh-bah when he caught his lowborn fan pronouncing Pythagoras's name with the stress on the wrong syllable. But any gaps in Barnes's scholarly culture were more than made up for by his intellect.

Dewey once said that even among academics he had never met anyone whose sheer brainpower equaled Barnes's, and there's plenty of evidence to back up that account. When asked to weigh in on any given topic, Barnes could almost always muster a long list of authorities either that backed him or whose views needed to be discounted, quoting in detail from both friend and foe. It seemed that he could finish the most recondite book in a day or two—he bought such volumes by the bushel—and then could comment at length on its arguments. And of course he had vast expanses of Dewey's complex reasoning and wording at his fingertips.

A Barnes staffer who came along in the 1920s described how his employer read just about any new book of "genuine significance," whether fiction or nonfiction, and kept current on anything published in "*The New Republic, The Nation, Time, The New Leader, The New Yorker*, the *Mercure de France*, and the Philadelphia newspapers, including their society sections."

Barnes described himself as having "one of those memories that is a nuisance," unable to let go of any fact, however trivial: "names, dates, telephone numbers, etc.," as he said, but also information and arguments from his endless readings and conversations. That memory must have helped him acquire his almost perfect German as a young man and then pretty fluent

French in middle age. And if such tricks of recall make him seem more a savant than a genius, that's balanced by plenty of examples of Barnes's capacity for genuinely wise argumentation. He responded to the 1923 campaign for "The Outlawry of War," for instance, with a wonderfully measured analysis, supporting the campaign's aims but also listing all the reasons those might be beyond achieving.

But all this evidence for Barnes's true intellectual abilities has often been overshadowed, even eclipsed, by his real emotional and social stupidity—by the very public vituperation that brought him even more attention than the great art he amassed.

Barnes was keen on taking the psychological theory he studied with Buermeyer and putting it to immediate use.

Already in 1906, a gardener is supposed to have shared two months' worth of dreams with Barnes and then gone on to become "the proprietor of one of the largest florist establishments in central New Jersey," Barnes wrote, "and he owes it to my interpretations of his dreams." As the scholar Jeremy Braddock has pointed out, in Barnes's Philadelphia a posse of prominent doctors who favored ideas about biological, cultural, and even racial hierarchy and "degeneracy" were also fervent and well-known anti-Freudians. For Barnes, they would have represented a conservative upper class, whereas the Freudianism they attacked, brand-new to American culture, would have appealed to his taste for the progressive and democratic.

In late 1915, Barnes was asking a Penn neurologist he'd grown up with in the Neck to provide him with patients he could try out his Freudian chops on. Barnes claimed to score a notable success with a depressive who had developed a hatred

for her family but was restored to a good social function once Barnes discovered "a conflict between the parental and sexual impulses." His Freudian talents were also called on in the case of a thirteen-year-old whose epilepsy had "a marked sexual element," of a sixteen-year-old kleptomaniac, and of a man who was in the hospital with lumbago that might, apparently, respond to psychoanalytic treatment.

Barnes's most ambitious attempt at putting his studies in psychology to practical use came in 1922, when he and Buermeyer came to the aid of the lawyers defending a Philadelphia woman accused of a double murder. Catherine Rosier had been recovering from childbirth when she learned that her thirty-eight-year-old husband was having an affair with a stenographer exactly half his age; Rosier bought a gun at the local department store and, shades of "Frankie and Johnny," murdered her man and his mistress where they lay on his office couch. After deep reading in psychoanalysis, and a visit to the murderess in her prison cell, Buermeyer and Barnes proposed an insanity defense that described her as a pathological neurotic who had built a fantasy life fed by too much moviegoing, "with the murder as a final desperate attempt to exclude from the patient's dream-world a fact that if allowed to remain there would have made the place untenable"—that fact being her husband's desire for another woman. (Buermeyer suggested they not present the jury with another supposed sign of Mrs. Rosier's insanity: the anal sex she practiced with her husband. He thought an analysis of her Oedipus complex might be more useful.) Barnes hoped and planned to use the case to get psychoanalytic theory adopted into Pennsylvania law, at a moment in the Progressive Era when doctors and lawyers all across the country were grappling with the insanity defense.

But to Barnes's disgust, the defense lawyer he was working with on the Rosier case had no patience with such "bookish" ideas

but did take on a suggestion that Barnes derived from his years of practical work with people. While giving evidence at the trial, Barnes had noticed that the theater-loving prosecutor liked to ham it up before the jury; he got Rosier's lawyer to latch on to this "actor-stuff" and hammer away at his opponent's thespian mannerisms. The jury became focused on the prosecutor's delivery, and the insincerity it was supposed to demonstrate, to the point that the jurors quite ignored the content of his speech. The poor man broke into tears under this treatment, and the defense attorney was soon thanking Barnes for a full acquittal.

In fact, Barnes would have preferred to see Rosier judged insane according to the latest psychoanalytic theories, and sent to an asylum for lengthy Freudian treatment of the "manic-depressive psychosis" he had diagnosed in her.

In a letter to Leo Stein, who had just proclaimed his own near cure by psychoanalysis, Barnes spoke of "going at the Freud game with hammer and tongs" to overcome his own psychic troubles, self-diagnosed as "a very pronounced compensation-neurosis." He told Stein of the success he finally found by combining lessons from Santayana and James with daily readings from Adler's *Neurotic Constitution*: "I have not been as fortunate as you in dropping 90% of the scrappiness but am fairly contented to find that I can keep it from interfering with my practical life."

Along with his friend Dewey, Barnes also put much faith in the Alexander Technique, which combined theories about faulty posture with ideas about psychic order, as enunciated in Frederick Matthias Alexander's book *Man's Supreme Inheritance: Conscious Guidance and Control in Relation to Human Evolution in Civilization*. Barnes learned the technique from Alexander himself, on

weekly visits to his New York office that cost $15 a treatment, until he realized he could apply what he'd learned at home without those pesky payments to the Master and without Alexander's "hocus-pocus, vanity, etc. that gets on one's nerves." Besides, Barnes said, with the acute self-awareness he sometimes showed, he couldn't risk a complete cure because his fractured psyche "makes me what I am, gives individual color, as well as the joy of my life, and has made it possible to get some of the expensive things that most people have to forego, and do some things."

CHAPTER 15

The novelist Anzia Yezierska, John Dewey's poetic muse.

WAR | A POLISH STUDY

> "The war came, and with it the total
> collapse of the old system"

note that you are about to go to the front, and I hope that you'll not only dodge the German bullets, but plant countless pieces of English lead in the damned Germans." Barnes wrote those words to an English friend as World War I raged. Once a Teutonophile, Barnes was soon describing the kaiser as a "blasphemous, arrogant, insolent, egotistic paranoiac."

If the first reports he got from France were optimistic—"The French army is not yet in possession of Berlin," wrote one dealer early on, imagining it soon would be—before long Barnes was hearing of friends wounded or killed in battle, so he made efforts to help the Allied cause. He gave major, open-ended support to the medical volunteers at the American Ambulance Hospital of Paris, which had Philadelphia roots. In 1917, after the United States had joined the fight, he assisted with the "venereal problem" among its troops, presumably by supplying Argyrol to fight gonorrhea. (He cited his daily work on this task to be excused from jury duty, although he also admitted that the excuse was an "intelligent lie.") Hunting for "a niche in the universal doing that may compensate me for the comparative inertia entailed by my age"—he wrote this to his new friend Dewey, a former dove who was a notable booster of the war effort—Barnes also offered his services in founding a

facility for the psychological examination of servicemen, citing his interests in psychology and his years of Freudian experiments. The military politely turned him down. But it did thank him for his help in the effort to design a better gas mask. In addition to giving major funding to one researcher, Barnes offered "my specialties, vituperation or profanity" in the scientist's bureaucratic fights. Neither seems to have helped the man's cause.

In the last months of the war, Barnes supplied Argyrol in the battle against the Spanish flu, spending sixteen-hour days in his factory to meet the need.

"The war came, and with it the total collapse of the old system," Barnes said, about a year after the end of the conflict. And it was that breakdown, he recalled, that had led him to dig deeper than ever before into the ideas of his favorite progressive thinkers, "with the idea of helping bring about what they stood for."

Already in the first weeks of the Columbia seminar, Barnes had suggested that he could help Dewey's plans for the "intelligent prosecution of the war" by deploying "some of the means which college professors do not always have at their disposal—money, business organization, and the assistance of practical men of affairs."

In the spring of 1918, as the seminar drew to a close, he wrote to one of his Columbia classmates:

Dear Mr. Edman,

I would like you, Lamprecht, and the two Blanchards to come to Philadelphia about the first of June, and make a scientific study of the forces operative in the Polish colony in this city, which is composed of upwards of twenty thousand people.

The idea would be to work out a practical plan, based upon first-hand knowledge, to eliminate forces alien to democratic internationalism to promote American ideas.

On entering the war, President Wilson had set an independent and democratic Poland as one of his goals; Barnes and Dewey were keen on it, too. Members of the team that Barnes was assembling—grandly titled (at least by Barnes) the League for International Democracy and Education—would be looking into why America's four million Polish immigrants seemed to be putting obstacles in the way of that goal.

Irwin Edman, recipient of Barnes's letter, was a twenty-one-year-old poet and doctoral student, soon to become Dewey's colleague in the Columbia philosophy department; the other men Barnes was dragooning were similarly academic in inclination.

They were joined in Barnes's "League" by the author Anzia Yezierska, an immigrant from Poland and double divorcée in her thirties. Raised poor on New York's Lower East Side, in an Orthodox Jewish home, Yezierska bootstrapped herself, by hard labor and force of will, into a life of the mind and a career in education. With her usual fearlessness, she had gone for advice straight to the nation's leading thinker on all things scholastic. Dewey had been impressed enough to invite her into his upcoming graduate seminar—and to become romantically involved.

If that might not have extended to joining her in bed, he could imagine it, at least, in the poems he sent her:

Yet would I have you know
How utterly my thoughts go
With you to and fro . . .
I see your body's breathing
The curving of your breast
And hear the warm thoughts seething.

The redheaded Yezierska was "a dazzling, stunning volcano of a person . . . romantic, impatient, childlike, excitable and exciting," as her daughter described her. It's no wonder that Dewey, a notably unvolcanic fifty-eight-year-old, should have been inspired to poetastery.

Barnes described Yezierska as "a wizard" for the Polish project, because of her grasp of the language and culture, but also as being "all heart and very little intellect." Her reports to Barnes on the project bear out the size of her heart, at least. "I'm barefoot in a burning bush," she declared in one, "overawed with flaming revelations [and] hypersensitized to the intangible, occult visions that open-eyed, articulate science is powerless to fathom."

Barnes got Yezierska to come to Philadelphia a few weeks before her colleagues, as a kind of advance scout among the Poles, and then when the rest of the team arrived, they toured the humble neighborhood in Barnes's seven-seater Packard.

The project eventually settled into a nice little house that Barnes bought at 3007 Richmond Street, in North Philadelphia almost up against the Delaware River docks. It functioned as both shared lodgings and a base of operations in a neighborhood that to this day offers lots of kielbasa.

Dewey stayed in the house most weeks for several days in a row, often with Barnes—and Yezierska—alongside him. (Somehow, he "forgot" to give his wife the address.) The philosopher wrote about "personal difficulties—among the 'workers' and between Mr. Barnes & myself"—but held out hope that his new friend might yet become more subdued.

In a famous speech made not long before American forces left for Europe, President Wilson had insisted that "no right anywhere exists to hand peoples about from sovereignty to sovereignty as if they were property." As the war drew to a close, that meant, according to Barnes at least, ensuring a new, democratic Poland

truly independent of Germany, Austria-Hungary, and especially Russia, its former rulers.

What Barnes and his team discovered over the course of their summer in Philadelphia was an immigrant community that for cultural and especially religious reasons supported a faction of Poles led by the superstar pianist Ignacy Jan Paderewski, who Barnes viewed, and detested, as dangerously Russophilic. "The priests are the key to the situation here," explained one of the members of Barnes's research team. And, as in any Polish community at that time, there was clearly no turning that key.

Barnes's team did manage to at least cause a stir. Barnes described Yezierska as better at snooping than "the ferret and the bee," and when neighborhood politicians tried to stymie her investigations, he went to a local power broker "and told him in very unphilosophical language that if the three bastards who are opposing us did not immediately stop, they would be in jail within a week." (It was Barnes, however, who ended up "a guest of the city" for a couple of days, for striking an officer and resisting arrest.)

Dewey reported that his letters and Barnes's were being opened and that the Secret Service had expressed interest in their doings—as possible spies or saboteurs, "because so many typewriters were going so near the ship yards."

As the project wrapped up, Paderewski's people used Barnes's early studies in Germany to get him investigated for colluding with the enemy—H. K. Mulford, his old boss and then rival, seems to have provided "evidence" to that effect—and of course Barnes denied the accusation with his usual vehemence, trying to get the investigators investigated.

In September, Dewey presented a final, confidential report on "conditions among the Poles in the United States" to the government's Military Intelligence Bureau and to President Wilson as well. There's no sign Dewey's report triggered the slightest inter-

est or action, even though Barnes insisted that it had "cooked the goose" of Paderewski and his "crooks."

When he had first proposed the Polish project to Dewey, Barnes had billed it as a test of whether the philosopher's ideas "are what I think, namely, sensible, practical ideas, or whether they are the musings of a mere college professor." When that test failed, Barnes reported that Dewey took it as a sign that teaching was his job and that he'd stick to it.

That fall Dewey left for a three-year trip west, to promote his pedagogical theories in California, Japan, and China. If he ever saw Yezierska again, it was only in passing, but she showed no sign of regret or rancor when, a few years after the Polish study, she wrote to Barnes about turning her Philadelphia stay into a novel.

Barnes's own experience with the study also led to a kind of cultural outcome. Just days before the end of World War I, he declared the end of his "brief career in international politics and social service." Instead, he said, he was going to turn back to what he grandly called his "research in the psychology of aesthetics."

His art beckoned.

CHAPTER 16

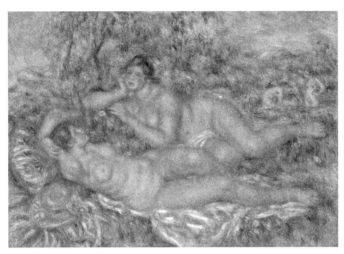

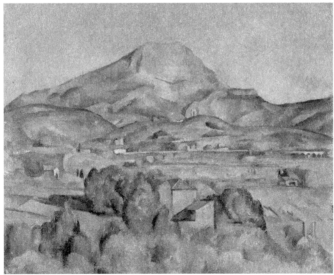

ABOVE: *Renoir's* Bathers, *now in the Musée d'Orsay in Paris, was one of his last works.* BELOW: *Cézanne painted his* Mont Sainte-Victoire *between 1892 and 1895.*

WEALTH | RENOIR AND CÉZANNE

*"I have never been able to decide whether
Renoir or Cézanne was the biggest man"*

A recession struck early in 1920. "Calamity rules business and finance," Barnes wrote to Leo Stein. Argyrol was exempt. In fact, the factory was expanding.

While even some Main Liners were struggling, Barnes was having the grounds of Lauraston dug up for a swimming pool. Inside the mansion, now filled with rare rugs and Chinese vases, Barnes was having the second-floor ceilings entirely remodeled, while the walls below were lined in fine French canvas finished in fully four coats of gray paint. "You can imagine the effect of my paintings on that background is almost ideal," Barnes boasted to an artist friend.

After a decade of serious collecting, there were so many paintings that they ended up hanging on closet doors and in bathrooms and over every inch of Lauraston's stairwells. After work on any given day, Barnes and his groom, Charley Funk, would spend hour after hour arranging and rearranging the precious display, on the walls of a home Dewey recalled as horribly fire-prone. It was pure luck that Barnes caught one blaze before it could spread.

Barnes could have afforded to add almost any modern art he wanted to his collection, but he mostly bought the artists he already prized. That was a roster that had barely changed since his first years collecting and which would stay mostly fixed for the next three decades.

"I have never been able to decide whether Renoir or Cézanne was the biggest man of the last century in art," he wrote to Alice Dewey. "Cézanne is intense, passionate, almost cruel in his insight into reality; Renoir is charming, human, lyric—sheer beauty and feeling." In postwar shopping, the charm won out, by a nose.

Already in 1915, Barnes had boasted of owning fifty works by Renoir, "greatest of modern painters," and of having spent something like $300,000 on them. By the spring of 1921, he had bumped up his holdings in Renoir to more than a hundred works.

The painter had died in December of 1919, at seventy-eight. "For many years he has been my God," Barnes wrote to a friend within days of the death, and he soon published a tribute:

> He preached nothing but beauty in the world and the joy
> of living: Life is supreme, irresponsible, full of movement,
> colour, drama, rhythm, music, poetry, and mystic charm.
> To live for the moment with Renoir's paintings is to be in a
> haven free from the ravages of one's own troubled spirit and
> from the vexations of a stupid external world. With him
> one may live vicariously the whole stream of the free spirit
> not dulled and depressed by the drab monotony of everyday
> affairs.

This sounds as if it really does come direct from Barnes's own "spirit," always troubled by the vexations of a world he mostly found stupid and often drab. He said in a letter that his "damnable" psychological complexes finally resolved in the presence of Renoir's paintings.

The eulogy counts as Barnes's first full expression of his ideas on art. In this moment of high feeling, however, faced with the death of his aesthetic god, he does only the barest of lip service to the "formal values" that dominated most of the rationalist art theory he admired and later came to echo. Barnes even ventures into full-blown idealism: "No painter ever more successfully converted material reality into what it is in its essence, the expression of the ideal."

But that romantic push toward ideals is in tension with down-to-earth Deweyan pragmatism. Barnes insists that art's worth "is determined by the extent to which the artist has enriched, improved, humanized, the common experience of man in the world in which he lives"—"common experience" being classic Dewey.

Art, writes Barnes, "is practical, never exotic, in that it deals with ideas that have served some purpose in human life." He insists that we reject "aesthetic interest that is not based upon a taste for existing things in the real world."

If Barnes's first venture into art theory doesn't yield much in terms of novel or even consistent ideas, it does give a glimpse into his psyche as a truly democratic art lover. He needed art to be rooted in the "common experience" of his working-class upbringing, which he never quite put behind him, while also wanting it to rise, as he put it, into the "rich garden of experience where imagination and beauty rule over matter"—into the world of high ideas that he aspired to as he himself rose in society.

As Barnes said at just this moment, in an exchange of letters with the modernist author William Carlos Williams, "My preference is for carpenters, milkmen, bartenders, farmers; but since boyhood I've been identified with various branches of art and science."

Barnes's Renoir obsession was probably at the root of the trip he made to Europe in July of 1921, the first in half a dozen years.

He spent a couple of weeks in Paris "hunting around among the small dealers and obscure cafés to find new talent." That talent included Marie Laurencin and Irène Lagut, the female artists he championed. (Hélène Perdriat, still in her twenties, joined the other two women on his walls the following year.) In general, Barnes's tastes ran to art that would have been gendered "feminine" at the time: Laurencin and her two colleagues made work that explicitly underlined their gender, but even when buying art by men, Barnes bought Matisse over Picasso and loved the deco-

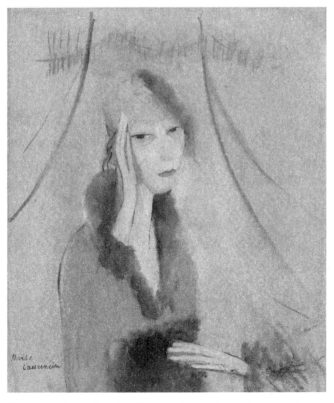

Woman with Muff, *painted in around 1914 by Marie Laurencin, who Barnes discovered in Paris when he was "hunting around among the small dealers and obscure cafés."*

rative patternings of Maurice Prendergast. Barnes, the tough guy from the Neck, might have been as surprised as anyone to find that he preferred such colorfulness to the cigar-and-leather art of the Manufacturers' Club. His macho posturings in daily life might have helped inoculate him, especially in his own mind, against the charges of decadence and effeminacy that could be leveled at modernist culture and its life of the eye.

But of course his Paris stay also included visits to the big men of the art market, selling him the big names of modern art: Kahnweiler came up with Picassos and Braques, Vollard supplied the finest Cézannes, and Galerie Durand-Ruel, whose New York branch was still his main art supplier, delivered yet another pile of deluxe Renoirs.

In the company of Georges Durand-Ruel, scion of the firm, Barnes left Paris for a weeklong tour of the stunning landscapes of the Dordogne, deploying his trademark hyperbole to declare them grander than the Grand Canyon. He stayed at the dealer's château there, where he drank the best wines he could ever imagine: "Good wine simply does not intoxicate—it just warms your heart and expands your soul."

The emotional heart of the trip was a visit to Cagnes-sur-Mer, on the French Riviera, where Renoir had established his final home and studio. Barnes claimed to have been shown something like eight hundred late Renoirs, most of them better than ones he already owned: "It almost broke my heart not to be able to get any of them but they are not for sale at present." The greatest heartbreaker among them was the great *Bathers* that the painter had completed shortly before his death, a vast and vastly strange painting of two pneumatic nudes who seem to have more in common with the era's new Michelin Man than with any earlier idea about female bodies or beauty. Yet Renoir had considered it the "culmination of his life's work" and a springboard for a new artistic direction that he never had the chance to bring about. Barnes

immediately offered the colossal sum of almost $50,000 for the picture, but Renoir's sons instead went on to accept a request for it from curators at the Louvre. It was just about the biggest disappointment Barnes ever suffered as a collector, although he tried to recover its aesthetic in the dozens of rubber nudes by Renoir that he went on to buy.

"I'm terribly excited about a windfall brought about by the war," Barnes had written to Dewey in June of 1920. "The thirteen finest Cézannes in existence—masterpieces of rare power—from the museum in Amsterdam changed ownership to-day when I delivered to Durand-Ruel my check to cover their price." The pictures, which had hung in the Rijksmuseum for two decades, had in fact been on loan from the relatives of a dead collector, and they had decided to cash them in. Rumor had it that the collector had been locked away in an asylum because of the fortune he'd wasted on modern art, a story that would have worked as a sales pitch to Barnes, given his self-image as a "mad" risk-taker and iconoclast.

The trove included a pile of Cézanne still lifes that covered the vast range of treatments the painter could give to a display of fruits, flowers, and tableware—with the occasional skull thrown in to flag the high stakes in play in those seemingly minor works. But the real prize of the purchase was one of the finest of Cézanne's great images of Mont Sainte-Victoire, the limestone peak the painter came back to again and again. In the Amsterdam picture, Barnes got to see one of the classic examples: It had an almost absurdly symmetrical, four-square composition that broke all the normal rules for picturesque dynamism in a painting, but this overall stasis came balanced by an almost frenetic rule breaking at the level of individual trees and buildings and brushstrokes. It marries the directness of a clumsy snapshot—just the facts, ma'am,

please, about this mountain—with a modernist artifice that rivals Picasso's. That unlikely combination makes the picture stand for what Barnes came to most admire in any artist's work: a sense of order that can sooth a man's unquiet soul coupled to a declaration of aesthetic fearlessness. You could say that Barnes himself longed for order—in America, his factory, his home—while being addicted to the license he permitted himself.

Barnes's Amsterdam pictures have been described as the greatest haul of Cézannes ever to cross the Atlantic; within a few years Lauraston could count something like fifty of the painter's works on its walls. Along with his latest Renoirs, Barnes said they made his collection "easily the most important in the world of modern art." He wasn't far wrong.

Already back in 1914, he'd told Stein about his love of Cézanne's "crudity, his baldness of statements" (the bald symmetry in that mountain landscape), of his "apparent lack of skill in the handicraft of painting" (the landscape's frantic brushwork), and of "the absolute sincerity of the man." He also admitted to being too new to modern art to see into Cézanne's depths.

The following decade, once Barnes had nabbed the Rijksmuseum paintings, he "looked at them, thought about them and dreamed about them for two months continuously," he said, until all that cogitation gave birth to his second notable art essay, "Cézanne: A Unique Figure Among the Painters of His Time."

Barnes describes his hero, whose "whole life was a struggle to express a self and soul that were his very own," as unique "because of the success of his passionate impulse to penetrate into the forms and structure of things." Nine months earlier, even Renoir had not conjured that kind of heat from Barnes. There's also now a loftiness he hadn't quite managed in the Renoir piece and an analytical

tone that seems especially suited to Cézanne. But the more notable thing about Barnes's prose, at this early date, is the sheer quantity of cliché it still relies on, built around long-standing romantic ideas of "self," "soul," "struggle," and the "universal." (Although, judging from a letter to Dewey, Barnes convinced himself, as always, that his insights were entirely original.) Cézanne, Barnes says, "welds reality, truth and beauty into an experience which we feel is a reflection of the world created by sheer magic out of the materials we live among every day." Barnes was soon admitting to Dewey that he could barely find words for the feelings and thoughts he had in front of Cézanne's works. To this day, many critics find themselves equally tongue-tied.

Aside from a few brief references to "forms constructed of radiant, singing color," to "melodious spaces," to "harmonious, rhythmic, decorative design," and to "the distorted line, the strangely-placed mass, the conflict with conventional ideas of color"—Barnes loved such conflict, given his own lifelong feud with convention—there's almost no evidence of the two full months of close looking that were supposed to have birthed the piece, and little sign of down-to-earth Deweyan rationalism. It would be several years before Barnes perfected the blend of intense observation and concentrated thought that came to count as his trademark.

At the dawn of the Jazz Age, Barnes's efforts at art theory were still immature. He'd only been buying serious modern art for about a decade and digging into the major modern sages for half that time. But regardless of the quality of his ideas, they gave him a long-term goal that makes him almost unique among the world's great collectors: Where they have mostly claimed fame as superlative shoppers, Barnes aimed to be as well known for thinking about his treasures as for owning them and for sharing that thinking with others. How many amassers of glorious objects have published thousands of pages about them?

CHAPTER 17

Charles Demuth's Masque of the Red Death, *from around 1918, hung in Barnes's factory. A worker said it looked like "a masquerade party but as though they were not having a very good time."*

BUYING AMERICAN | ART IN THE FACTORY

*"I've watched my little gang
awaken their aesthetic life"*

n the fall of 1920, Albert and Laura Barnes went to spend a weekend at the artists' colony in Woodstock, New York. Caroline Rohland, wife of one of its painters, recalled Barnes's bold laugh and good humor at a supper thrown for him. The Barneses, she recalled, were "genial and charming," confirming that Barnes could easily control the ogre self he so often chose to reveal. Rather than haggling over purchases he made from Paul Rohland, Barnes simply went home and then mailed a check for five works he had admired, along with a note that said they "successfully competed in cheerfulness and charm with a bright crisp day. You ought to do more canvases and show them. You're saying something."

Given all the public attention Barnes was giving to Renoir and Cézanne, it's easy to imagine that after the war his tastes had strayed completely from his friends in the American art world, but that wouldn't be quite right. At the same time as he was heading deeper than ever into European modernism, he still managed to buy at least fifty American works, none of which could have boosted his art world status the way buying French did. When he first came up with the idea of writing his

own books on art, he had in mind monographs on Glackens and Maurice Prendergast.

Barnes showed interest in the New Yorker Marsden Hartley, a leading American modernist in the circle of the dealer and photographer Alfred Stieglitz, who tended to take John Quinn's side against Barnes in any aesthetic or market dispute. Barnes dismissed the duo as a "kike" and a "mick." But the Stieglitz connection didn't instantly leave Hartley excommunicated: Lauraston was opened to the painter more than once, and Barnes bought Hartleys.

Barnes also connected with Thomas Hart Benton, a figurative painter who called himself "anti-avant-garde." He and Benton went on to have a rich interchange on all sorts of aesthetic topics, with Barnes swearing to use all his resources to defend Benton's views—while also insisting on how wrongheaded they were, if only from the artist's ignorance of (what else?) "the high-class psychology developed by the great thinking of men like James, Santayana, Dewey, Bertrand Russell and Havelock Ellis."

Benton recalled Barnes as "magnificent" but also as the most complex of men, both "friendly, kindly, hospitable" and "a ruthless, underhanded son of a bitch." Letters show Barnes attacking Benton's conservative painting style: "To try to push back the clock is an old pastime—and it is a sign of death, not life."

Barnes never did go fully public, in print, about his taste for American artists, the way he wrote in fulsome praise of Renoir and Cézanne. (His beloved Glackens was one exception.) But he showed genuine love, if not quite full respect, for at least some of his American pictures, given where they ended up: dozens filled the walls of his factory, where he got to enjoy them every working day.

Benton's work was in a file room and a couple of hallways.

A "rest room" had a pile of pictures by Demuth and also Glackens.

Hartley was in the dining room; he was joined by Barnes favorites including Prendergast and even Picasso on a wall in a room always known as Doctor's Office. (Barnes, the supposed egalitarian, always insisted on his professional title; he was just "Doctor" to most of his staff, even when he wasn't around.) "There is probably nothing in America that can touch the wall in sheer, potent, exquisite, meaningful beauty," Barnes reported to Hartley.

European moderns filled out the rest of the factory collection, which amounted to well over a hundred works filling every available space from the backs of doors to above the company safe.

Some factory employees even caught Barnes's collecting bug, with very much his full encouragement. He boasted that he let them buy work off the walls for the price he had paid. Within a few years, Barnes was claiming the Mullen sisters had the best collection in the neighborhood—barring his own, of course.

But the factory's collection, and the acquisition it inspired in the workforce, were meant to be about more than just passive pleasure. Barnes made sure that art, much of it cutting-edge, got incorporated into those factory seminars that had already introduced his employees to advanced work in philosophy and psychology. A few years before, Dewey had "scolded" Barnes—mildly, of course—for abandoning political and social progress in favor of the aesthetic. It seems as though the introduction of aesthetics into the factory seminars was Barnes's way of squaring that circle.

Given his Deweyan notion that art, life, education, and politics all came together into one indissoluble package, Barnes believed that exposing workers to the thoughts of Bertrand Russell was not different, in kind, from exposing them to the ideas in a Picasso or a Hartley. In Dewey's terms, you were just plunging them into two different corners of the best in our lived experience. "The

realm of industry and the realm of art are not different in kind; let industry be animated by intelligence and so humanized, and the transition to art is not only easy and natural but inevitable."

Alongside tomes by Dewey and Russell, Barnes's Argyrol makers began to read from Santayana's 1896 *Sense of Beauty* and Roger Fry's brand-new *Vision and Design.* Workers applied their ideas on aesthetics to the study of the paintings in the rooms where they ate and filed records.

As Barnes reported to Benton, "I've watched my little gang awaken their aesthetic life." He said as many as a dozen of his employees had achieved "as genuine an interest in the matter as one could possibly find. Some of them can analyze a painting as well as they write a letter or cork a bottle"—the task that the women and men, respectively, had in the Argyrol plant.

The collector even set out to test the capacities of his newly trained aesthetes, conducting a survey about workers' "reasons for liking or disliking, other than color," about whether "people painted (attitudes, expressions, etc.) appeal to them," or whether "any moral suggestions enter into liking or disliking"—for instance, into preferring the image of a church to a nude.

Countless pages of responses taken down right in front of the works reveal an impressive enthusiasm and critical ease, even if the answers aren't at the Roger Fry level that Barnes liked to claim.

One employee observed that a Demuth illustration of Edgar Allan Poe's "Masque of the Red Death" looked "like a masquerade party but as though they were not having a very good time; some expressions are gloomy." Faced with the precious Picasso in Doctor's Office, however, she felt empowered to declare that "she sees nothing in it, she don't know what it is and simply rejects it." The transcriber of her comments editorialized, "A child could see the pleasing composition. She didn't look."

The same Picasso was studied by a worker who might never have gone to high school; Barnes funded vocational night classes

A Picasso still life from 1915 that hung in the Argyrol factory: "I think the colors are good for that picture but I don't care for the black and yellow," said one of the workers.

for her and also substantial hospital bills. She took the kind of formalist tack found in the seminar readings, saying the image "looks to me like musical instruments and the way they are put together they form several designs. I like this picture. I think the colors are good for that picture but I don't care for the black and yellow." A colleague of hers had less patience with one of Chaim Soutine's famous paintings of a steer's carcass, appropriately hung above a closet door in the factory kitchen: "I like the colors of this picture but I can't see anything in it but a piece of beef."

CHAPTER 18

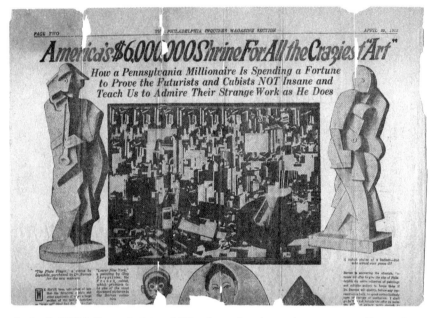

In April of 1923, Barnes had an uphill battle proving that modern art was not "insane."

PHILADELPHIA PHILISTINES |
BIRTH OF THE FOUNDATION

"The unfortunate situation so prevalent in
Philadelphia as regards intelligence and art"

"My mind surges and swells with the splendour in your home, still," Marsden Hartley wrote to Barnes after a visit to Lauraston in 1920. "If I were nearer I should be tempted to ask for a monthly entree into the real American Louvre of modern art."

The directors of the really real French Louvre and of Munich's great Alte Pinakothek also made the trip to see Barnes's paintings, as did Bernard Berenson, the giant of Renaissance art history. He suggested that Barnes might want to add some old masters into the mix. "I had a sense of compassion for what I thought was his lack of appreciation of good art," Barnes recalled. To his relief Berenson finally revealed his own admiration for moderns like Renoir and Cézanne.

There were visits by his Central High schoolmate John Sloan, by Barnes's philosophy professor at Penn, and by the Deweyites of Barnes's Polish project, who also got a private concert by members of the New York Philharmonic.

With art lovers showing up uninvited at all hours and making themselves "thoroughly at home," Barnes was forced to restrict

all visits to two hours on Wednesday mornings, which saw the painter Henry McCarter thanking him, one Thursday, for having admitted him and seventeen of his friends at those hours.

As far back as 1915, Barnes was already complaining that he was besieged with requests to see his pictures from members of the "necessarily stupid" American elite. Despite their eagerness, however, Barnes was sure they could only think him "crazy" for surrounding himself with modern art. Barnes had offered—or threatened—a tour to a professor friend: "I will call for you at about half past eleven Sunday morning, and give you a shock with pink cats, purple cows, cock-eyed houses, and a few other manifestations of artistic genius."

It feels as though presenting his radical modern art to Main Line elites, at Lauraston, was a kind of ritzy equivalent to the more democratic evangelism he was doing for it at his factory, among workers who might if anything have had fewer antimodern prejudices to overcome.

Had Barnes been living in New York, he might have felt less embattled. There, dealers had long since begun to follow Alfred Stieglitz in showing and selling the latest pictures by French and American moderns. Already at the start of World War I, a newspaper critic could build an entire comic column around the white-whiskered gents and "lovely ladies" he saw heading straight from a posh lunch at Delmonico's to a dealer's show of cubist work.

And then there was Philadelphia, where, early in the century, Henry James had rejoiced in the absence of "that sharp note of the outlandish" that he'd found unsettling everywhere else in his homeland. Thanks to modern art, that note was beginning to sound in Philly.

In the spring of 1921, a magazine had written optimistically about how a show at the Pennsylvania Academy of the Fine Arts was allowing eighty-six of the most modern of American painters

PHILADELPHIA PHILISTINES | BIRTH OF THE FOUNDATION *159*

to overcome the opposition those artists would once have got as "maniacs" and "charlatans."

PAFA's exhibition, called *Paintings and Drawings by American Artists Showing the Later Tendencies in Art,* featured Hartley, Demuth, Sloan, and pretty much all the other Americans that Barnes collected. The display at PAFA, "one of the most conservative institutions in the United States," the magazine said, proved the remarkable fact "that in so brief a time our younger artists should have been victorious over Philistine resentment."

In a public letter, Barnes cheered on the show as "a mighty fine thing for Philadelphia." But he seems to have underestimated the resentful philistinism of Philadelphia's cultural elites.

"I can only infer that, in a large degree, the pathological element enters into these paintings and drawings," opined Dr. Francis Xavier Dercum, a top local specialist in "nervous diseases." He had taught at Penn in Barnes's years there and was notable for seeing the new Freudian theories that Barnes admired as both a cause and a symptom of American degeneracy. Dercum was speaking at a meeting of doctors specially convened to diagnose the PAFA show for the conservative collectors and artists of the Philadelphia Art Alliance. The exhibition's artists, Dercum went on, had to be suffering from "the disease of the color sense, and the disease of a great many other mental faculties." A colleague hinted that those same lunatic artists must be syphilitic. A third doctor, who had once said that Freudianism represented "a return to darkest Africa," warned that modern artists risked triggering "unhealthy feelings" in "diseased" (that is, homosexual) onlookers. Then, in a notable instance of pot-kettle-calling, he referred to the PAFA artists as "quacks."

Barnes came to the rescue of his artists, launching one of the media blitzkriegs that soon became his trademark. In an open letter to a New York newspaper, he attacked the Art Alliance as

made up of painters looking to market "their substitutes for art" and of the city's worst social climbers, using art as a mere handhold in their climb. Barnes never saw a bridge he didn't want to burn, at least when it led to the local elites.

As for the Art Alliance's aesthetic diagnosticians, Barnes launched an ad hominem assault, calling those doctors "ignoramuses with a penchant for lime-lighting" and going after their old-fashioned psychiatry that fought against the latest work of Freud, Jung, and Adler. (This also let him demonstrate, as though in passing, that he was up to speed on such figures.) "The doctors mentioned should be seized by the state and put in a place where they cannot pervert public morality," Barnes said in closing his letter, giving them a taste of their own medicine but also sinking to their level.

All in all, Barnes said, the entire incident revealed "the unfortunate situation so prevalent in Philadelphia as regards intelligence and art."

What's surprising is that he set out to do something about it.

"Erect a building suitable to house a collection of paintings worth more than three million dollars," says one item in a kind of to-do list that Barnes scrawled in pencil on April 30, 1922. Another item describes the planned gallery as being "available to the public on certain days and under certain restrictions," on the model, Barnes wrote, of European house museums like the Wallace Collection in London. A third item calls for the creation of a foundation to run it, with an endowment of millions of dollars in government bonds. On that fair spring day, Barnes set in motion a plan that has borne fruit in the hundred years since, in what would soon become known as the Barnes Foundation.

The plan didn't have roots entirely in altruism or pedagogy.

There was almost certainly some rivalry involved: Duncan Phillips, a notable collector in Washington, D.C., had recently announced plans for a private museum of his own modern art—art that was far less "modern," and daring, than what Barnes had already bought, as the Philadelphian would soon be proving with his new foundation.

The foundation also evolved in tandem with its founder's business interests. Its birth was wrapped up in the most complex of real estate schemes involving the purchase of a six-acre tract of land from a wealthy neighbor, Captain Joseph Lapsley Wilson, who had been a friend of Thomas Eakins, the star of Philadelphia art. The deal was intended to let Barnes and a partner develop plans for several grand suburban houses and maybe even an apartment building. But for all its profit motive, the scheme included keeping a big expanse of Wilson's land intact, with its collection of 268 rare species of trees functioning as a research arboretum—the principal preoccupation of Wilson's friend Laura Barnes for the next four decades. Laura later claimed that it was her enthusiasm for horticulture, already honed through years of "scientific study" in the gardens of Europe, that had got her husband to buy the Wilson estate in the first place.

But as soon as Barnes was putting together his real estate package, he must have realized that his notion of gifting his art to a Philadelphia museum could be brought about with less loss of control if he expanded his plans for the Wilson land so that it could also host an art gallery built and funded—and run—by him.

CHAPTER 19

Girl with Cat, *painted in about 1920 by Hélène Perdriat, one of several female painters favored by Barnes.*

PLANNING A FOUNDATION | YOUNG ART IN PARIS

*"To promote the advancement of education
and the appreciation of the fine arts"*

On October 3, 1922, Albert Barnes had checks printed for a "Lydia Barnes Foundation" that did not in fact quite exist (and never would, under that name). On the eleventh, he closed on the Wilson estate.

By the end of the month, he was giving his new institution $7 million in bonds and stocks—based mostly on a transfer of his own shares in the drug company—along with seven hundred artworks. He had an architect drawing up plans for their home.

"I thought I'd open the place three days a week to the public"—among other things, Barnes's tax breaks depended on it—"and three days only to such organizations as the Pennsylvania Academy of Fine Arts for their art students, and to the University of Pennsylvania for their students of arboriculture," wrote Barnes to his friend Dewey. "If the institutions don't conform to my terms, they don't have a look in—and both institutions already realize that no better project could be conceived to make them first in the world in their respective fields. They will sign away their souls for the privilege."

The next few months were spent in endless administrative detail as Barnes schemed with his lawyers to preserve all possible

control of the project while avoiding every cent of taxes he could. There are moments in the legal correspondence that give a sense that the entire project was almost as much about keeping Barnes's money out of public coffers as using his art for the public good. Barnes's progressive politics didn't extend so far as to enjoy paying taxes. (There's at least one strange transaction that sees Barnes, the man, selling his own pictures to Barnes, the foundation.) And then finally, on December 4, 1922, after endless lawyering, Albert Coombs Barnes could announce that the State of Pennsylvania had granted a grand, blue-sealed charter to the Barnes Foundation of Merion, Pennsylvania. Its aim: "to promote the advancement of education and the appreciation of the fine arts; and for this purpose to erect, found and maintain, in the Township of Lower Merion, County of Montgomery, and State of Pennsylvania, an art gallery and other necessary buildings for the exhibition of works of ancient and modern art."

Barnes's great adventure had begun—an adventure that far exceeded the mere "art museum" that the art world, and even Barnes himself, had imagined coming together from his first decade of art shopping. Rather than providing a showcase for a collector's treasures, the Barnes Foundation would be "the first attempt made in America to put into practical effect the ideas which Dewey has devoted his life to working out."

The details of what that meant would take a few more years to finalize, but some principles had started to take shape.

Art would be on view, of course, but it would now be a tool—a wonderful, irresistible tool—for beginning the "educational" task of changing America. The ability to understand and appreciate art that Barnes planned to cultivate with his foundation would be a test case for understanding and appreciating good order in the world at large and for making more of it come into being. The "level and style" of the arts, Dewey argued, "do more than all else to determine the current direction of ideas and endeavors in

a community," with the goal of "re-creating the world into a more orderly place."

Get the art right, that is—make sure that everyone in the culture has the chance to do that—and American life might come right in more things. Barnes, the great progressive, insisted that art was vital to the "improvement of human nature."

With that scope to his ambitions, Barnes had to reconceive who his foundation would serve. Instead of imagining an audience of elite culturati, joined now and then by the occasional regular joe—the mix of visitors most museums then drew, and have since—Barnes claimed to have those joes in mind almost to the exclusion of their "betters."

The foundation's bylaws went so far as to state that "the purpose of this gift is democratic and educational in the true meaning of those words"—the Deweyan meaning, that is—"and special privileges are forbidden." The institution would be barred from ever hosting society functions of any kind—receptions, tea parties, dinners, dances—and the bylaws bound the foundation itself, in perpetuity, to pay the legal expenses of anyone who spotted such goings-on and then sued that very foundation to stop them.

Barnes never quite lost an allegiance to his modest roots, and those shaped the peculiarly—and peculiar—democratic instincts behind his projects.

The moment Barnes had bought Captain Wilson's land and began plans for the gallery on it, he'd declared that he needed to snag all the "important pictures" he could. Two months later, just as his foundation was taking on a full legal life, Barnes had hunted down one of its most notable treasures: *The Joy of Life* by Henri Matisse, paying some $3,000 for it. That big painting had helped cement Matisse's standing in modern art, and his infamy as well among

One of Barnes's most prized treasures: Matisse's Joy of Life, *finished in 1906. Its "great aesthetic power," Barnes said, came from "rhythmic movement that embraces all the plastic elements."*

traditionalists, when it was first shown in Paris at the 1906 Salon des Indépendants, among other paintings by the newly christened *fauves*, the "wild beasts." In 1915, Barnes's new friend Leo Stein had proclaimed it "the most attractive big picture that Matisse ever painted . . . singularly rich, full, charming and tranquil." That was a view that could hardly have been shared by many contemporaries, who could only have found the painting both wild and beastly; when Matisse painted it, barely anything in the Western tradition could have counted as equally extreme and extremist. Its classical subject is charming enough, and could even be called tranquil: Nude women and the occasional couple—even a few goats—gambol and pet and relax in an arcadian landscape. (See figure 7 in color insert.) The scene has roots in old master paintings by Giorgione and Poussin. But all that ease and tradi-

tion is in absurd tension with the painting's acid, unnatural colors and an opium-dream rendering of anatomy and botany that makes bodies and trees look like melted wax. That mix of tranquility, of hallowed history, and of radical innovation was catnip to Barnes; it went on to be at the heart of his theories of art. When he heard the *Joy* was on the market in early December of 1922, he cabled a Paris dealer to offer 50,000 francs to its Danish owner and got the painting for 5,000 less than that. Within a couple of years, Barnes was hymning the "great aesthetic power" Matisse had achieved in the painting thanks to "rhythmic movement that embraces all the plastic elements, is infinitely varied, and functions in all parts of the canvas"—the highest of praise in the formalist terms Barnes was just then adopting, and also a useful smoke screen, possibly, for the painting's unbridled erotics.

That December of 1922, with his foundation now a legal (if not material) reality, Barnes was in acquisition mode, and another Paris trip was called for. Within weeks of chartering his foundation, he had landed at the Hôtel Mirabeau on the Rue de la Paix, which billed itself as "the grandest and most up-to-date hotel in Paris."

His art shopping took a new turn. Rather than focus on the big names he'd banked on before, such as Renoir and Cézanne, Barnes was taking chances on what he called the "younger generation . . . of that independent group." They included figures such as André Derain, one of the more radical of the fauves—Barnes judged him a "wonderfully skillful fellow"—and the newcomer Hélène Perdriat, who *Time* magazine was soon describing as "a young and almost legendary French painter" who was crafting bizarre pictures of the most radical *bohémiennes* of Paris, including herself. (See figure 6 in color insert.) In the self-portrait Barnes got from her, the stretched limbs and electric colors make Perdriat look like one of the figures from Matisse's *Joy of Life*, come alive on the Riviera in the 1920s: she sports an extreme flapper haircut and painted-on eye-

brows that reach to her ears, as she did in real life; her rubber limbs cradle a black pussy in her lap. (The wordplay works in French as well.) Barnes also bought *Idyl*, an ambitious Perdriat almost six feet square, in which, as Barnes said, "she shows her beautiful nude body with complete details of the visible parts that make her a woman; and for added aesthetic charm she displays her shapely buttocks framed in a design of branches and leaves. . . . The result is not only a work of art but an intelligible frank desire to exhibit her body and soul to whosoever cares to look." For once, Barnes couldn't seem to restrict his analysis to color, texture, and composition. Oddly, sadly, he seems to have sold the painting just a few years before his death, maybe as he came to realize the neglect Perdriat had fallen into. He didn't always prune his collection wisely.

The sculptor Jacques Lipchitz, who was in his early thirties when he and Barnes met, described the collector as "extremely courageous in his gambles on young and unrecognized talent"— which at that point included Lipchitz himself, as he tried to think through cubist ideas in 3D. On a very first studio visit, Barnes bought a pile of sculptures, at prices Lipchitz inflated in the face of Barnes's unguarded enthusiasm. He then gave the artist his first major commission, for a series of reliefs on the exterior of the yet-to-be-built Barnes Foundation. That meant that on the most public surface Barnes could imagine, he'd be promoting radical modern art that came as close to abstraction as even he could tolerate: the reliefs were of musical scenes, but to this day you're lucky to spot more than a couple of frets, some finger holes, and a few fingers and strings. That doesn't make them any less gorgeous.

Barnes and Lipchitz were chummy for a year or two, doing frequent rounds of the Paris art scene, but grew apart after Lipchitz declared an El Greco Barnes bought to be a mere copy. The final break—with Barnes, there usually was one—came after Lipchitz nagged his patron to buy some works from a friend desperately in need of money for his wife's doctors' bills. Barnes assented,

Harlequin with Clarinet, *a 1919 sculpture by Jacques Lipchitz. Barnes imagined the works he got from Lipchitz would see him condemned as "not only a radical but a Bolshevist."*

recalled Lipchitz, but then later exploded: "I'll never forgive you for what you made me do! You made me confound art with philanthropy! I never want to see you again!"

That fall of 1922, the turn toward younger—and cheaper—artists might in part have been triggered by Barnes's new building campaign: he told one Paris dealer that construction would leave him short of cash, too short even to take up an offer of some fine van Goghs.

Almost from the first, plans for the foundation's buildings had been lavish: the architect had settled on two different colors of Burgundian limestone, from two different quarries. Once Barnes got to France, he ended up having to buy his stone for three times more than he'd paid even for his champion Matisse, despite attempts to find cheaper options and then interminable bargaining with suppliers.

(Barnes was cheap just by nature, or at least by nurture in a slum. Lipchitz liked to tell the story of an evening's walk in Paris when Barnes bought a tin of honey for his wife, then later rushed all the way back to the store to exchange it for the same thing in cardboard; the fancier packaging would just end up being discarded, said Barnes, and had cost several cents more. A few years later, Barnes complained when Buermeyer didn't fully repay him for a couple of telegrams and phone calls: "God knows I need money just now," wrote the millionaire to the struggling scholar.)

After the stone's crossing to the United States—during a storm, blocks that got loose almost wrecked the ship—Barnes made sure to get the local press to trumpet it as the precious material for his new "temple of art."

CHAPTER 20

Paul Guillaume, Novo Pilota, *Modigliani's 1915 portrait of Barnes's beloved Paris dealer.*

PAUL GUILLAUME

> "The high priest of the temple
> is Paul Guillaume, a creator in the
> greatest of arts, life itself"

When he enters the halls of the Hôtel Drouot, grandly wrapped in furs, his appearance triggers a deep rumble among the mass of painting lovers and patrons—even among the auctioneers, who pause, hammer in air, in expectation. . . . A small army of secretaries and stenographers, both male and female, hangs on Paul Guillaume's every word, acting with military discipline at his smallest gesture. Two magnificent Hispano-Suizas are waiting at the curb, their drivers bolt upright at the wheel and uniformed like generals in the czar's Imperial Guard.

This was the scene at the main Paris auction house one evening in 1926, as orchestrated by the young dealer who, three years earlier, had steered Barnes toward that first crop of emerging artists. Barely into his thirties when he and Barnes met, Paul Guillaume was already on his way to rivaling great dealers of the modern movement such as Ambroise Vollard and Paul Rosenberg. But it was winning Barnes as his client that let Guillaume go on to adopt the manners and trappings of a

potentate. And it was committing to Guillaume as his principal dealer and adviser that allowed Barnes to mature as a collector. The Barnes Foundation would be a very different place if Guillaume had not made his appearance. He was second only to Dewey, and possibly tied with Glackens, in the effect he had on the tastes and ideas of Albert Barnes.

Guillaume was born into the working class in 1891, in Paris, as the son of a uniformed bank runner—shades of the delivery jobs held by Barnes's father—but by 1912 the aspiring dealer had been welcomed into the bohemian scene by Picasso's friends Guillaume Apollinaire and Max Jacob. They fed him the names of young artists they believed in, and before long he had opened a gallery that dealt in a new crop of Parisians—"the extremists," as one visitor to his space was still calling them decades later. By 1914, while still in its first crummy incarnation, the Galerie Paul Guillaume had already become "the focal point for world painting," one observer recalled, even as its owner was dining on tinned sardines and pickled onions. Guillaume became one of the first dealers in Paris to put out catalogs for his exhibitions, and he also published a house journal, *Les Arts à Paris*, with writings on his artists by such grand figures as Captain W. Redstone, Colonel Bonardi, and Dr. Allainby—all pen names used by Guillaume, in sales tactics that recall Barnes's approach to Argyrol.

It wasn't long before the sardines were replaced by pheasants reclining in grand aspic constructions.

Guillaume and Barnes must have connected at least in part because of their parallel climbs into luxury from modest roots: Guillaume had started life in Paris doing grunt work in a garage, but once he found success, his Hispano-Suizas made Barnes's Packards seem like Model Ts. He favored the spats and brush mustache of a swell and hair macassared like Valentino's.

In Paris, Guillaume and his chauffeur would find Barnes at the Mirabeau every morning at nine. Leading him out through

a crowd of courtiers—one hopeful artist had even bunked down in the hall outside the Barnes suite—the dealer would guide his client through the day's visits to museums and mansions, where they'd study everything from Italian old masters to ancient Chinese sculpture.

In the wee hours of one New Year's Eve, Barnes dragged Guillaume out of a party, reminding him of the art they were supposed to look at in the morning. The dealer remembered hearing from Barnes again all of six hours later, warning that he was on his way to continue their hunt for treasures. "I never saw Barnes tired," recalled Waldemar George, a kind of house critic for Guillaume. "That man had such a mania for paintings and sculptures that it could make him forget to eat or sleep."

Guillaume managed negotiations for the foundation's Burgundian limestone. He brokered Barnes's purchase of *The Joy of Life*. He took care of Barnes's endless art transactions: purchases of Renoirs, Cézannes, Courbets, all negotiated in infinitesimal detail, sometimes via coded cables, with a share of each sale going to Guillaume. The advent of his Hispano-Suizas must have been linked to the arrival of Barnes.

Max Jacob described how Guillaume "was ready, at a moment's notice, to take on any idea, any project, so long as it wasn't completely unreasonable," and it's clear that Guillaume had the kind of lively, fearless, independent mind Barnes most admired. The dealer was a photographic inventor (Barnes would have approved) and a keen occultist (no approval for that), and he also wrote avant-garde texts so full of obscure words and rhythms that Jacob dubbed him "the great verbal numismatist." The copy on one ad for Guillaume's magazine had a positively Barnesian mix of disdain and play. "Don't subscribe to *Les Arts à Paris*," read the ad, "it's not about giving you pleasure.

It's a magic drug meant to trip up your spirits, attack your circulation, and fiddle with your nervous system."

In the letters that passed between Barnes and Guillaume, their bond comes off as built partly on a shared love of misbehavior. Barnes reported gleefully to Guillaume about scurrilous letters he'd sent to art world enemies, saying that he couldn't actually share them because they were "so libelous and so scourging that it would be unsafe. . . . They can have me arrested by the United States officials." He boasted to Guillaume about the "stupidity" of the French government—Guillaume's own government—in having let him take so many masterpieces out of the country. Barnes seemed equally happy to share news of his own stupidity, as when he almost killed himself and his wife one day in a close encounter with a telephone pole, totaling his "beautiful blue, twelve cylinder Packard roadster," with poor Laura Barnes emerging cut and bruised from head to foot.

The two men also shared a cruel and even immoral streak. With great glee Guillaume wrote to Barnes about a trick they could play to get some paintings cheap from a rival dealer who was Jewish, "an obnoxious, loathsome, disgusting character" and "a cynical usurer," as Guillaume called him. He knew Barnes wouldn't mind such language, since Barnes himself had recently described a different dealer to him as a "contemptible, dirty Jew."

Barnes's correspondence includes language like that in several places. "There can be no question that they are natively 'bright,' but, as my data on the Jew neurosis shows, it is really a fixated precocity and the most that ever arrive are vaudevillians," Barnes wrote in one particularly grotesque letter to a Columbia instructor. "They have no place in intelligent society because they hog the stage, get the spot-light on themselves and anything intelligent or constructive is in the deepest angle of the penumbra. So if any kikes in your class want to come to Philadelphia to see the pictures, they will be welcome providing they pay their own carfare."

In some cases where Barnes was in direct conflict with someone who happened to be Jewish, his antisemitic rhetoric, rather than reflecting deep-seated bigotry, probably stemmed from his reflexive habit of delivering a sucker punch to any opponent, so as not to have the bother of engaging in a more civilized debate he might lose. Barnes could sometimes come close to philosemitism.

He certainly had a deep admiration for a long list of Jewish thinkers and creators, from Freud to Schoenberg to Einstein, and friendships with others, like Lipchitz and Stokowski, the conductor. Barnes proudly told Dewey about the talented young woman he had hired after she had been rejected from other employment only because she was "a Jewess," and he had another Jewish woman as his lieutenant for the last twenty-five years of his life. He also supported an early employee's effort, using "approved psychological and sociological methods," to help "the better class of Jews to overcome the prejudice which, however much America tries to conceal it, certainly exists." During World War II, he was happy to attack *The Saturday Evening Post* for the flagrant antisemitism of articles such as "The Case Against the Jew." (Although Barnes had more private reasons for going after the *Post*.) And this support for Jews, however qualified, was happening against a rising tide of antisemitism in the United States, with new limits set on Jewish immigration and Henry Ford happily disseminating the grotesque lies of *The Protocols of the Elders of Zion*.

In an era when cultures and ethnicities were almost universally seen as having fixed, essential traits, Barnes could deny the slightest "taint" of antisemitism and then immediately go on to this bizarre mix of blame and praise:

> The simple fact is that there are certain innate qualities in Jews who get to the forefront in civilized society that are productive of social evil. A reasonable question is, "Don't

gentiles have the same traits that produce identical evils?" The answer to that is, "Yes, they do, but it does seem that they pre-dominate more in the intellectual Jew than they do in the intellectual gentile." The probable explanation is that the Jew undoubtedly has, by nature, a finer quality of intellect and, perhaps, more efficient go-get-it ability than the gentile of similar grade.

Barnes eventually published a full and fulsome paean to Guillaume's gallery that dubbed it "the Temple." The dealer himself was described as its High Priest, "a creator in the greatest of arts, life itself . . . honored by nearly every artist, collector, connoisseur, and writer on three continents as the Parisian who felt the pulse-beat of the modern movement when its creators were obscure and unknown."

Barnes wrote about the "hundreds" of visits he had made to Guillaume's space and about his close encounters there with "six chiefs of African tribes, besides fours chefs de ballet russes," as well as with all the new modernist composers, from Igor Stravinsky to Erik Satie. He also engaged there with such leading art critics as Roger Fry and Waldemar George. In one conversation, Barnes became so completely engrossed that he did not even realize he'd sat down on the gallery floor. The gallery's atmosphere of heated debate was nonetheless "imperturbably peaceful," Barnes wrote, because "one instinctively and always respects a sanctuary."

Guillaume's take on his new "friend" had a more pecuniary cast.

"The golden clink of dollars went before him," Guillaume wrote of Barnes only months after their first meeting, "so that avarice sprang up beside him like a ghost, followed after him, teased him, chased him like fairy flashes."

Back in 1920, a tanking economy had forced Guillaume to drop his in-house journal after just six issues; he launched it again shortly after Barnes came into his life, and it might as well have been called *Les Arts à Philadelphie*. Large parts of it, sometimes whole issues, were written by or about Barnes and his crew.

Even a visit by the dealer to Merion was seen as worthy of coverage. Readers got breathless news of how grandly Guillaume had been feted, with visits to a Black choir Barnes cherished and to the collector's friends in the Narberth Fire Company, who terrified the dealer with a run on the "steel monster" of their fire engine. (The one Barnes had helped fund.) "The driver accelerates; the dizzying speed ramps up, up, up," Guillaume recalled, confirming the accelerated modernity of Barnes's American life. "Like a race car we pass crossings, streets, bridges; we scale peaks and cling to descents." When the driver was begged to slow down, he sped up. Guillaume's ordeal got him named Honorary Captain of the fire department, of which Barnes was Lifetime Colonel.

A French newspaper poked fun at the magazine's Barnes obsession. That didn't stop Guillaume from finagling a knighthood in the French Legion of Honor for his favorite client, which you might say Barnes repaid by agreeing, uncharacteristically, to lend the dealer $50,000, interest-free, to buy a grand new Parisian home.

Guillaume's duties also included keeping Albert and Laura Barnes company in their social life in Paris, a city that Barnes loved "because nowhere else is life so untrammeled, so unrestricted, so freely expressive of the human qualities that every normal person loves." One year, angling for Dewey to join him in France, Barnes offered a crossing on the brand-new *Majestic*—the world's largest steamship, with a lounge paneled in walnut and a "splendid Pompeian swimming bath"—and tendered the city's joys as further bait: "I'll go through the Louvre with you, get you

a dinner that only one place in the world can furnish and a bottle of wine that will make you contented with things as they are." Barnes's very visible obsession with art and collecting—and with the cultural power both supplied—can mask the true and wider pleasures he took in life. There's a frolicsome side to the man for all the meanness that's there as well: one of Guillaume's tasks was to accompany the Barneses on frequent trips to see the dancers of the Folies Bergère.

Somehow, those trips didn't make Barnes grab the opportunity to buy Manet's great painting of the bar there, when Guillaume came to offer it to him, admittedly at a vast price. That was probably the biggest mistake Barnes ever made as a collector, up there with turning down van Gogh's *Starry Night*, which he did a few months after his first buying spree with Guillaume.

CHAPTER 21

Giorgio de Chirico's 1926 portrait of Barnes. De Chirico accepted "no standards except those established by his own intelligence," said Barnes—almost describing himself.

FIGURE 1. William Glackens, *Pony Ballet*, 1910 to early 1911.

Figure 2. Vincent van Gogh, *The Postman*, 1889.

Figure 3. Pablo Picasso, *Young Woman Holding a Cigarette*, 1901.

FIGURE 4. Pierre-Auguste Renoir, *Before the Bath*, c. 1875.

Figure 5. Marie Laurencin, *Woman with Muff*, c. 1914.

Figure 6. Hélène Perdriat, *Girl with Cat*, c. 1920.

FIGURE 7. Henri Matisse, *The Joy of Life*, October 1905 to March 1906.

FIGURE 8. Giorgio de Chirico, *The Arrival*, 1912 to 1913.

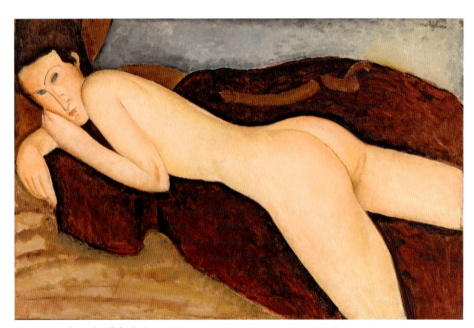

FIGURE 9. Amedeo Modigliani, *Reclining Nude from the Back*, 1917.

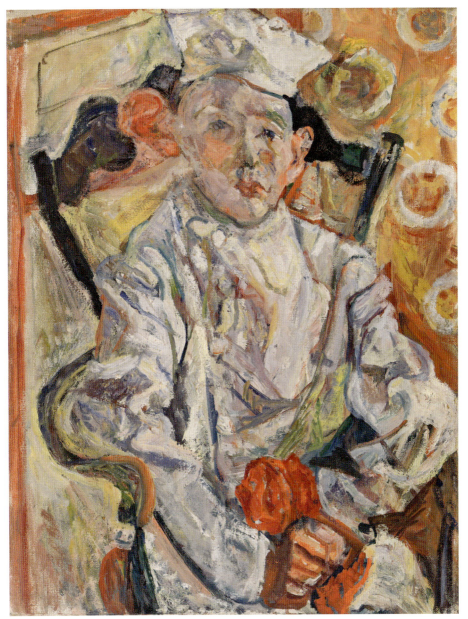

Figure 10. Chaim Soutine, *The Pastry Chef*, c. 1919.

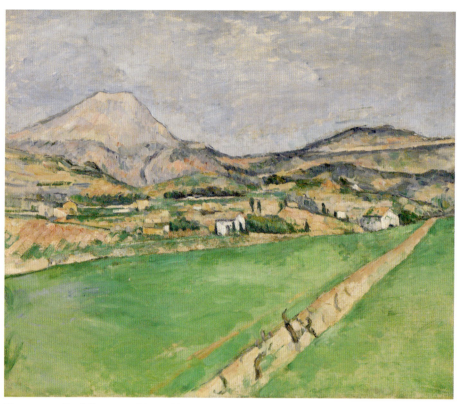

FIGURE 11. Paul Cézanne, *Toward Mont Sainte-Victoire*, 1878 to 1879.

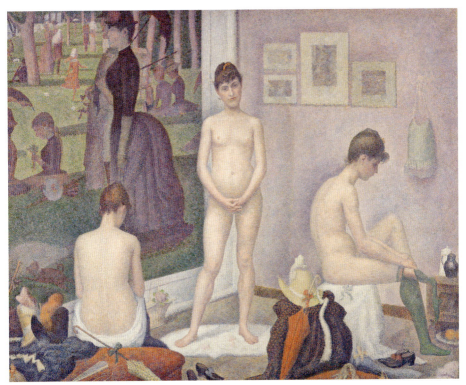

FIGURE 12. Georges Seurat, *Models*, 1886 to 1888.

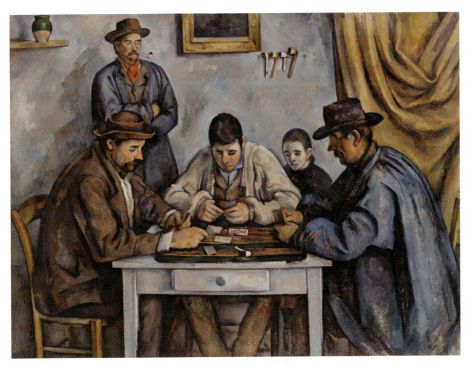

FIGURE 13. Paul Cézanne, *The Card Players*, 1890 to 1892.

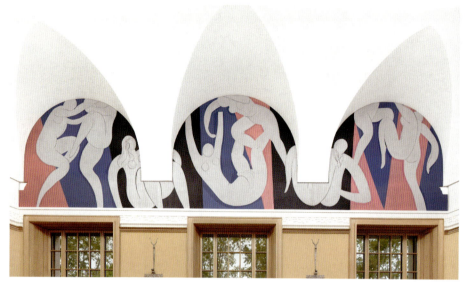

FIGURE 14. Henri Matisse, *The Dance*, summer 1932 to April 1933.

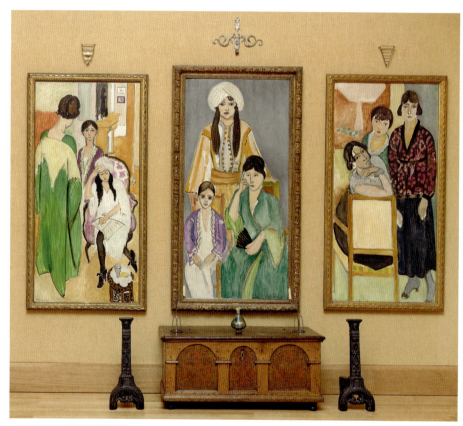

FIGURE 15. Henri Matisse, *Three Sisters with Grey Background*, May to mid-July 1917, between Matisse's *Three Sisters with an African Sculpture*, May to mid-July 1917, and his *Three Sisters and "The Rose Marble Table,"* April to May 1917.

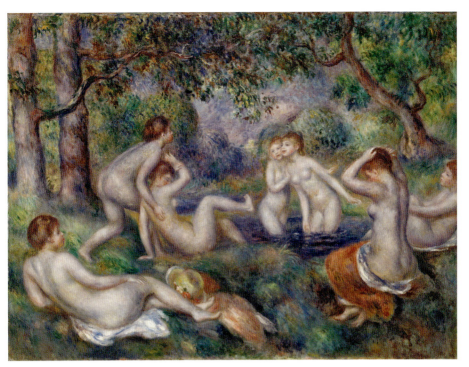

FIGURE 16. Pierre-Auguste Renoir, *Bathers in the Forest*, c. 1897.

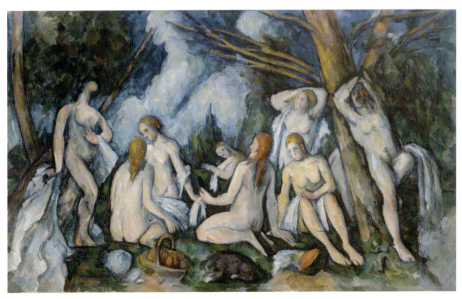

FIGURE 17. Paul Cézanne, *The Large Bathers*, c. 1894 to 1906.

FIGURE 18. Pablo Picasso with Atelier Delarbre, *Secrets (Confidences) or Inspiration*, 1934.

FIGURE 19. Horace Pippin, *Supper Time*, c. 1940.

FIGURE 20. John Kane, *Children Picking Daisies*, 1931.

Figure 21. Pierre-Auguste Renoir, *Mussel-Fishers at Berneval*, 1879.

DE CHIRICO | MODIGLIANI | SOUTINE | A FIRST EXHIBITION

"I am trying to do the biggest thing for Philadelphia that any one man has ever attempted"

Two days before Christmas of 1922, after working with Barnes for maybe five months, Guillaume sent him a sales statement, totaling about $10,000, that captures how central the dealer had already become to the foundation's collecting: The document lists a small Matisse and a minor van Gogh, but the other eleven works are all by that new crop of artists Barnes was just then committing to. The female artists Lagut and Perdriat are there, as well as Odilon Redon, next to two other artists who had just then come to matter to Barnes: Giorgio de Chirico and Amedeo Modigliani, appearing in Barnes's orbit for the first time on that Guillaume statement.

Guillaume had been one of the first and most steadfast supporters of de Chirico, the great surrealist forerunner, and the careers of the painter and the dealer took off and grew in tandem. In that first fall of buying from Guillaume, Barnes got only a single de Chirico—a painting of an empty neoclassical plaza centered on a lumbering statue of a modern man in a business suit; Barnes must have seen him as his own alter ego. (See figure 8 in color insert.) The painting sets its accidental avatar for Barnes in a Mediterranean

De Chirico's The Arrival, *from 1912–13, one of the painter's "good plastic equivalents of mystical poetry," in Barnes's words.*

world of colonnades and golden sun and palm trees, but the smoke from a passing train makes it clear that modernity has not been left behind. De Chirico's dreamworld is in striking contrast to Philly, but it's the reality Barnes came to enjoy on his stays in Italy and Provence, thanks to the mod cons of rail lines and steamships.

Before long Barnes had got de Chirico to paint his actual business-suited portrait—it came free, Barnes boasted, as an expression of the painter's gratitude—and eventually the foundation ended up with another dozen de Chiricos. "I was the first to bring Chirico's work to the attention of the public," Barnes later claimed—not at all true, but a sign of how much he valued the discovery Guillaume had helped him make.

Within a few years of that first purchase from Guillaume, Barnes was writing about de Chirico's "exotic" color and about how the Italian's paintings were "good plastic equivalents of mystical poetry"—the mysticism itself being almost certainly of less

interest to Barnes than the idea of a good plastic equivalent to just about anything.

De Chirico, Barnes went on to write in a catalog essay for Guillaume, was a scholar and sage "whose native commonsense guided him to accept no standards except those established by his own intelligence. He has been a lonely figure in this, his own epoch." The notion of an independent-minded creator, going it alone based on his own native intelligence, had an obvious appeal to a collector who thought of himself in just those terms. Moreover, as an artist who had "steeped himself in the great traditions of the painting of the past," de Chirico stood, in a general way, for the important Barnesian idea that certain aesthetic values and ideas might be universally applicable, across time and space and race, cultures, and classes. The link that de Chirico represented between older art and the moderns—"so that something new and moving aesthetically is added to the tradition," in the words of an early foundation essay—was a notion that Barnes had begun exploring in depth, in the pocketbook terms of his collecting, that fall when he met Guillaume.

In Paris he discovered a Greek collector, "so old he is tottering," who was willing to part with something like forty Greek and Egyptian antiquities after Barnes "shook a good-sized check at him," as the collector wrote home to his friend Glackens. Within months Barnes was writing about the equivalent appeal of all good art, from ancient to modern, and was soon going on about the "unalloyed satisfaction" found in Egyptian statuary. In de Chirico, Barnes recognized "a mystic feeling such as one finds in El Greco"—because his collecting was now putting the two artists in proximity.

Having nearly "dropped dead" at the sight of a gorgeous El Greco sitting neglected in a private collection, he produced his checkbook once again, joking with Glackens that nabbing the sacred work by El Greco was "a just act of God's kindness for the

saintly life I've led." (Barnes recognized his own sins, even if he always forgave himself for them.) Truly saintly paintings from the Middle Ages also began to join his hoard, and Guillaume found Barnes some Romanesque heads that look astoundingly like precedents for modernist sculpture—almost certainly because they were fakes newly carved to look that way, as Guillaume probably knew.

"NOVO PILOTA"—the New Helmsman. That's what Amedeo Modigliani scrawled across a 1915 portrait of Guillaume, who was indeed the first person to steer Modigliani toward some kind of success and safe haven. Capturing the dealer in hat and gloves in the corner of a bistro, Modigliani gave him a dandy's disdainful gaze, with a sophistication and potency Guillaume would later have but was probably faking at that early point. When Modigliani was an unknown, drunken wreck, despised even in bohemia, Guillaume gave him a stipend and paid for a studio. For all the spite and bile Modigliani could spew, and despite his Jewish roots, Guillaume could nevertheless choose to remember him as "all charm, all impulsiveness, all disdain," with an "aristocratic soul" that survived in his art even after his death from tuberculosis, at thirty-five, in 1920.

Three years later, in the first months of Guillaume's sales to Barnes, nine Modiglianis passed into the American's hands. Barnes collected the oval-faced, almond-eyed portraits that now count as the most classic of all Modiglianis. He also bought a female nude that paired a slender, almost androgenous body, still fairly fleshlike, with a face stylized into simple, geometrical forms that clearly derive from some of the African masks that had become a specialty of Guillaume's. (That cross-continental, colonialist connection was about to mean the world to Barnes.) The kind of modernist stylization used for that face is what helped Barnes

A 1917 nude by Modigliani: "The character of his line gives a particular plastic quality to the colored area between the linear contours," said Barnes, disdaining talk of subject matter.

learn to see anything found in a painting—even the credible flesh of the same woman's buttocks—as a series of simple forms and tones. (See figure 9 in color insert.) It's as though, for Barnes, radical modern style could spread from its more extreme examples to be found lurking, like one of the newly discovered viruses, in what untrained eyes might see as a pretty normal representation.

Guillaume had written about Modigliani working in the studio "with passion, with violence, temperamentally, extravagantly," but by the time Barnes comes to write about the paintings, he has eyes only for their shapes, lines, and colors. He insists that Modigliani has no interest in the "psychological states in the sitter" and talks instead about how "the character of his line gives a particular plastic quality to the colored area between the linear contours" and about "his subtle use of space as a constructive factor in his general design." Barnes, the budding formalist, had not been able to ignore de Chirico's classical themes—their "universality" got folded into his thoughts on art—but Modigliani's much more standard

range of motifs, mostly portraits with maybe a landscape thrown in, made him a ready-made subject for Barnes's new approach. It wasn't hard for him to see the lozenges of Modigliani's faces as nothing more than lozenges, the salmon skin of his nudes as just a new tint, the boneless arms of his lovers as just examples of a gracile modern line.

If the sitters' humanity got lost in the formalist process—if their pains and lives and particular *selves* went unrecognized—that, Barnes might have said, is the cost of progress.

———

"I discovered some very fine work by a Russian artist called Soutine," Barnes told an American newspaper on January 13, 1923, the day his steamship landed in New York from Le Havre. "His life reads like a romance—work in a garret, no money and all that sort of stuff. As soon as I bought some of his work his stock went up like a skyrocket."

For once, Barnes's boast of having dug up a complete unknown was close to true, even if Paul Guillaume had helped make it happen. Chaim Soutine was an eastern European Jew who since 1913 had lived in Paris, where he had been Modigliani's companion in drunken poverty; one acquaintance says that he lived infested by vermin in some kind of sty for pigs. As Guillaume tells the tale, he was in some painter's studio looking at a Modigliani when a nearby Soutine caught his eye. It was a painting of a pastry chef, slathered with insanely thick paint in white and pink and baby blue; its subject's flapping ears looked like the sugary *palmiers* sold in any decent *patisserie*. (See figure 10 in color insert.) The canvas might as well have been titled *The Pastry*. Guillaume bought it, and when Barnes saw it in the dealer's gallery, in the first days of 1923, he called it "a peach." Insisting on a visit to a poet turned dealer who kept a

Chaim Soutine's Pastry Chef, *from around 1919. Barnes called it "a peach" when he first saw it, and went on to make Soutine's career.*

large stock of Soutines—because he'd barely been able to sell them—Barnes tried to keep his keenness to himself, but gave the game away by clenching his jaws until his cheeks turned red. He bought thirty-six Soutines on the spot, then got another sixteen through Guillaume, including his pastry chef. With the money Soutine earned from Barnes, he splurged on silk shirts and bespoke suits and an all-day taxi ride to Nice.

"The works of Soutine, like anchovies, are a matter of taste. They are bizarre, they are ugly, they are not apt to cause one to fall in love with them at sight. But they are different. The painter

says something that has not been said before." That was the judgment of an American newspaper some weeks after Barnes had returned home from Paris, in an article Barnes admitted to having had a hand in writing. If those are indeed Barnes's words, or at least his thoughts, they get at something important that underlies his taste: It is at least as sociological as aesthetic. It is at least as much about championing the rejected (the "bizarre," the "ugly") as about celebrating the merely excellent. Soutine, a literally starving artist, deployed a frantically expressive, excessive brushwork that was the perfect symbol of an unforgiving, go-it-alone avant-gardism.

Soutine, at his most extreme, is just about the least naturalistic painter that Barnes collected in depth, but it's likely that this was acceptable to Barnes because it seemed the directly expressive product of the disadvantaged—a direct upwelling from below, almost from the sewers of Montmartre—as compared with the elite, oblique, cerebral anti-naturalism practiced by a cubist like Picasso, who was already a cultural overdog and therefore suspect by the time Barnes encountered him. As Barnes's friends in the Progressive movement imagined reshaping the hierarchies of American society, he did his part when he reordered the food chain in art.

▬▬▬

Dr. Barnes has just left Paris. He was here for three weeks, spending his every hour not on worldly visits, parties or official receptions, but rather on the matters required by this extraordinary, democratic, vibrant, inexhaustible, invincible, charming, impulsive, generous, unique man. He has visited everything, seen everything presented by dealers, artists, connoisseurs. He has bought, refused to buy, admired, criticized. He has pleased, displeased, made friends and enemies.

Those words come from an entire article Guillaume published about this "Medici of the New World" in the January 1923 issue of his gallery's house journal.

The paean acted as a kind of repayment for a singular if purely symbolic honor Barnes had recently rendered to Guillaume: he had just appointed him foreign secretary of the Barnes Foundation, an institution homeless and all of one month old at the time.

Just a few weeks after Barnes had sailed for home, Guillaume opened a show of the Paris acquisitions that had yet to be shipped, helping polish Barnes's reputation as a great collector, which the American cared about almost as much as any single work he collected.

A French newspaper talked about the works on view as the stuff of an art lover's dreams, and the show garnered three articles in American newspapers as well.

Barnes decided to bring it to Philadelphia, supplemented with works already at Lauraston and an even bigger pile of Soutines so it would be "the most important show of modern art ever held."

He pitched the show to the Pennsylvania Academy of the Fine Arts, the conservative local art school and museum whose last presentation of relatively tame American moderns had been declared diseased by those local doctors. Barnes had an ally on the faculty, the modernist painter Arthur Carles, but he knew from the beginning that attacks were to come, gleefully warning Guillaume that "everybody connected with the exhibition will be denounced by academicians and fossils as crazy." After two decades of modernist innovation, Barnes's French paintings were starting to look almost tame among true cognoscenti. But in Philadelphia, and especially at PAFA, they would have still seemed wildly daring, confirming the audacity that their owner always longed to demonstrate.

A first hint of trouble came when one of PAFA's "fossils," a Mr. Myers, worried that there might be nudes in the show.

Barnes gave one of his classic replies. Hélène Perdriat, he said, "undoubtedly the greatest woman painter of this age," was so shameless in her *Idyl* that "she painted herself stark-naked—hair and everything. . . . I never noticed either the lady's trimmings, or what they might suggest to any person, until Mr. Myers put the idea in my head." As for what Barnes called the "great art" of Matisse's *Joy of Life*, he admitted that it had "several nudes in it and especially a young man and a young woman stark-naked and in each other's arms. It never occurred to me, until Mr. Myers sprung his idea, that that young man and woman are not to be trusted together in that condition. They might do what some of your officials and faculty probably would like the opportunity to do."

Faced with a vituperator of Barnes's caliber—and with a threat of resignation from Barnes's PAFA ally—Mr. Myers backed off and the show went ahead, naked bodies and all. Seventy-five of the most modern treasures from the future Barnes Foundation went on view, floodlit under tasteful garlands.

Barnes must have been prepared for blowback, and as a contrarian might even have planned for it: he'd chosen not to include any of his more audience-friendly paintings by impressionists or even by the most familiar of the postimpressionists. But part of him must also have hoped for a welcome like the show got in Paris. Those hopes were dashed within days of the PAFA opening, held on a Wednesday in early April.

Reading the Sunday papers that followed, Barnes found Dorothy Grafly, of Philadelphia's *North American*, judging that the PAFA gallery might as well have been "infested with some infectious scourge." Waxing wroth, she went on, "Unclean thoughts crowd into the mind—thoughts utterly untrue to oneself. . . . 'Passion,' say the artists. And it is. The fevered passion for unclean things!"

Turning to the Philadelphia *Public Ledger*, Barnes found the paper attacking his Perdriats' "unabashed presentation, and even

flouting of the unmentionables," while wondering how "even a Parisienne" could paint such subjects.

For its part, that same day's *Philadelphia Inquirer* described the show as "artistic caviare washed down with ox-blood." By the end of the month, the *Inquirer* took another potshot, giving a full page over to Barnes's support for what its banner headline called "All the Craziest 'Art,'" while trotting out those four doctors, once again, to prove the collection was truly insane.

The unkindest cut of all? That *The New York Times* gave all of two inches of coverage to Barnes's "most important" show of modern pictures. Whereas the paper had devoted an entire page, with three big illustrations, to a show that PAFA was hosting just down the hall from Barnes's works, of old-master-ish pieces by Philadelphia's great Peale family of painters.

Barnes responded to all this, as always, with a flamethrower. Writing to the editors of *The North American*, he said Grafly's review stood as her "unconscious public confession of well-recognized sexual vagaries."

In a letter to the *Ledger*, Barnes said that the "degeneracy" the paper had found in his pictures applied better to "your crowd and their friends who are alleged to indulge in such practices as lime-lighting, trafficking in whiskey and gin, clandestine fornication and in one instance of a person still living, a case of town-talked-of homosexual perversion."

"I am trying to do the biggest thing for Philadelphia that any one man has ever attempted," Barnes wrote. "If you were not damned fools you would have helped me instead of trying to push back the clock."

CHAPTER 22

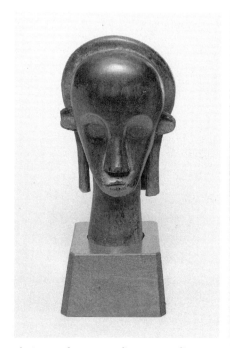 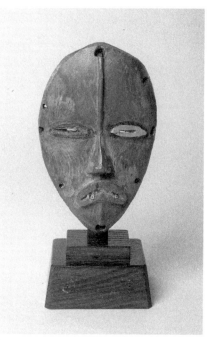

A nineteenth-century reliquary guardian head from the Fang Betsi culture. Barnes said African sculpture was "equal to the best of ancient Greece and Egypt"—a radical claim in Jazz Age America.

A miniature mask from the Dan culture, made early in the twentieth century. African art, said Barnes, was "the basis of the whole modern movement."

AFRICAN ART | BLACK CULTURE

"There is no young musician, poet or painter of first rank whose work does not owe its inspiration to the ancient negro art"

The first newspaper feature on the Barnes Foundation was sensibly headlined "Merion to House Art of 'Radicals.'" But here's what's strange: it held up African sculpture as a perfect example of Barnes's radicalism.

There had been nothing African in the PAFA show; the pans would have been even more vicious if there had been. But reviews of the earlier Paul Guillaume show, in Paris, had revealed this new and "unusual" direction in Barnes's collecting: the show, they emphasized, had included a substantial sampling of works from Africa.

By December of 1922, Guillaume had already been billing Barnes for eighty African works, ranging from a Congolese chair to objects from the Dan, Mpongwe, and Mossi peoples. Guillaume's invoices show Barnes paying more for many of his pieces from Africa than, say, for a nude by André Derain—five times more, in the case of one statue from the Ivory Coast.

If paintings by Derain and his fellow fauves could easily be attacked as "crazy," the cultural establishment could attack works from Africa as not being art at all—as "morbidly curious fetish relics of the mystical religions of the dark continent," in the words

of a full-page article in a New York newspaper. Naturally, Barnes, the iconoclast, immediately trumpeted his newfound interest in such work. In the letter to a magazine editor in which he first went public with plans for his foundation, before it had even been chartered, he made sure to mention that it would include "the best private collection in the world" of African sculpture—a collection that was barely weeks old.

Soon after, a Philadelphia newspaper decided that a piece on the new foundation would attract most eyes under the headline "African Art Work for Merion Museum Is Most Comprehensive in the World," even though the bulk of the story was about the art Barnes had bought by the likes of Soutine and Modigliani.

Barnes's love of disruption and attention ran neck and neck, and the African art he bought from Guillaume gave him both. Its coverage must have spurred his invitation to the famous "coming-out party" of the Harlem Renaissance, just a few months later in March of 1924.

Within days of announcing his holdings in African sculpture, Barnes was describing it to a friend as "equal to the best of ancient Greece and Egypt"—truly fighting words to utter in a white European culture still deeply rooted in classical antiquity and newly Egypt-mad because of treasures just then being pulled from Tutankhamen's tomb.

Before long Barnes was publishing books that made claims such as that African sculptures had been "fashioned with consummate skill to achieve effects that Europeans had not been able to see or appreciate. Instead of being the beginnings of art, valuable only as historical relics, they were perhaps a stage in advance of European evolution, and valuable as ideals."

In Barnes's hands, those were Western, modern ideals. What he looked for in African objects was precisely what he had already discovered and admired in the work of current French art—extreme stylization, simplified forms, sometimes unpolished

making. Barnes bought African pieces like the guardian head by a Fang craftsman that has the same sleek forms as a face by Modigliani, or a little Dan mask that recalls a Picasso head that Barnes owned from his "African" phase (because that mask was the kind of thing Picasso was admiring at the time). Barnes didn't care, at all, that the Fang head would have been carved to connect with ancestors, or that the Dan mask would have originally served as an amulet that invited ritual "feeding." He was taking the complex, quite functional visual cultures of Africa and pulling out of them that weird, peculiarly Western, much more restricted thing called fine art. And that was quite explicitly his goal: any aspect of an African object that he could describe as of merely "anthropological" interest, including all of its original symbolic or social functions, was to be dismissed as "data irrelevant to art values"—that is, to the purely Western values that were his life's work.

In the twenty-first century, that approach stands out as racist. It ignores the thoughts and goals of African makers in favor of the merely aesthetic interests of a white American collector—as though the work itself had little value outside that interest, or before white eyes had seen it. And Barnes certainly didn't give a second's thought to how his African pieces had arrived in Paris, or to the colonial violence that had taken them out of Black hands. But in Barnes's own psyche, at least, the elevation of African objects into the realm of his culture's elite high art stood as a marker of care for Black people of all eras and places.

When the Barnes Foundation eventually opened for business, in the spring of 1925, a newspaper covered it under the headline "Negro Art Sets School Going." But two years earlier, during its earliest planning, Barnes was instructing the foundation's very French architect to replace the various bits of standard Beaux-Arts detail-

ing in the original plans with African-derived ornaments. With the launch of his new institution—that is, when Barnes knew he was putting himself more in the public eye than ever before—he was also paying to put race quite literally at the center of his project.

In February of 1923, at that watershed moment when Barnes was beginning to spread word of his newly chartered foundation and its African collection, he encouraged his friend Leopold Stokowski, daring conductor of Philadelphia's orchestra, to program a "ballet nègre" by Darius Milhaud that Barnes had just heard about. "The ballet and its music ought to be marvels," Barnes wrote, "for there is no young musician, poet or painter of first rank whose work does not owe its inspiration to the ancient negro art. They all admit that—even pride themselves on it."

This was becoming a standard claim among the *négrophiles* of Paris. Guillaume extended the influence of African art to an endless list of contemporary white creators—to Picasso, Modigliani, Soutine, Archipenko, and Lipchitz, among visual artists, to musicians like Satie, Poulenc, and Honegger, and to poets including Rimbaud, Apollinaire, and Blaise Cendrars.

Back in 1919, Guillaume had hosted a "Fête nègre" that was a mash-up of bits and pieces of African-ish culture, conceived and performed by white avant-gardists who'd had only the barest exposure to living Black people. It can't have been far from a modernist minstrel show, indulging in all the worst fantasies of European primitivism.

Whereas Barnes, lapping his mentor, took this new interest in the "ancient" arts of Africa—following Guillaume, he liked to date his pieces to many centuries before they were made—and let it refocus his cultural and social priorities, at least for a while, on the works and lives of contemporary Black people.

Barnes, the collector of African art, now began to cast his mind back to his earliest contacts with actual African American culture. A few months after Guillaume billed him for his eighty

African sculptures, Barnes sent him a list of Black folk songs and spirituals, "the ones I can sing for you from my boyhood memories." Barnes even sent the dealer cloth woven by North Carolina sharecroppers, to be made into a cap, suit, and spare trousers.

Some six months later still, when Barnes sat composing his first essay on modern Black culture, his thoughts strayed once again to those childhood camp meetings. He waxed eloquent about how African American spirituals ("America's only great music," he called them) "have taught us to live music that rakes our souls and gives us moments of exquisite joy."

The "Renaissance" of Black art, Barnes concluded in his essay, was "as characteristically negro as are the primitive African sculptures."

There's no doubt that this kind of thinking involved an obnoxious, racialized collapse of culture across time and place so as to include anything created by someone with dark skin, anytime, anywhere—a standard move in Barnes's era among both white and Black thinkers. The same racial essentialism could collapse the "white" cultures of Julius Caesar's blue-painted Celts and of the Irish modernists from two thousand years later. Ethnic essentialism inevitably leads to stereotyping, and Barnes wasn't immune to the problem when he talked about Africans and African Americans and their cultures. But the stereotypes he did deploy tended to have a positive tone, counteracting the worst of the belittling caricatures all around him. Even among the least explicitly racist white people of Barnes's era, "Africa and the black man were framed in notions of high adventure, savagery, fear, peril and death," in the words of the scholar Petrine Archer-Shaw, and Barnes resisted the most pernicious of those clichés. "Primitive," for him, was as likely to mean "early" or "original" as "crude" or "barbarous," and sometimes he rejected the term altogether.

It's true that when he equated "ancient" African sculpture, "authentic Negro spirituals," and modern Black culture, he was

ignoring the vast and vital differences between them, and there's every reason to call him out for it today. As the scholar Alison Boyd has pointed out, Barnes tended to have a nostalgic view of Black culture: In his mind, current Black creativity—in music, for instance—was automatically linked to his long-ago encounters with African American religion and then back further to the "primitive" cultures of plantation slaves and African tribes. He sometimes—not always—had a hard time seeing Black culture as fully modern; it could all become part of the same old-timey picture. But, in the context of his era, Barnes's flawed view had a fine realpolitik effect: by lumping together his favorite examples of superlative Blackness, Barnes could fight the vicious denigrations of Black people and their cultures that ruled among most of his contemporaries. He came up with a syllogism that vastly oversimplifies cultural and historical truths, but it did the job: If Black cultures of every kind and era can be proven to rival what white people produce—always assumed by Barnes to be the *summum* of creations—then Black inferiority is a myth. That was a position adopted by many African American creators and thinkers.

Barnes cited their quite modern achievements as proof of the position.

He had been invited to the Civic Club dinner as a collector of art made, as he thought, by long-dead Africans. He had said in his RSVP that the Black authors who were being feted were still new to him. But he was always a quick study, and within weeks he was writing to the editors of *Opportunity* about discussions on the latest Black writings taking place in his factory's seminars: "One feature of your journal which we think is especially commendable is the publication of the works of such artists"—Black artists, all— "as Miss Grimke, Countee Cullen, Eric Walrond and others. The contributions of these artists rank with the highest to be found in America today regardless of color."

His *Ex Libris* article name-checks Sojourner Truth and

Frederick Douglass and describes Paul Laurence Dunbar and Booker T. Washington as godfathers of the Black "renascence" in twentieth-century America, with its "poetry which connoisseurs place in the class reserved for the disciplined art of all races." Thanks to Du Bois (per Barnes, "one of America's real intellectuals") as well as Locke and Charles S. Johnson and the other guests at the Civic Club, Barnes said, African Americans were "revealing to the rest of the world the essential oneness of all human beings."

That oneness demanded equal treatment for all, or at least a political rhetoric of equality.

▬▬

> A little group made up of five white women, of three colored men and of one white—Dr. Albert C. Barnes, the project's organizer—got together to create a core of sociological and artistic knowledge, and also to give access to art to the kind of people who, given their place in society and level of culture, had until then been if not against art, at least indifferent to it. . . . On December 4, 1922, the group received a charter from the State of Pennsylvania.

Thus began the first substantial article on the Barnes Foundation, published in Paris. It is the first time, of many to come, that race gets mentioned in an account of Barnes's new project. The lead photo in the piece shows an African work from his collection.

Two years later, as Dewey spoke at the foundation's ribbon cutting, the collector had asked him to turn his words to the vital role Black people—the people whose ancestral imagery now framed the doors themselves to the institution—had played in the conception of the place. "I know of no more significant, symbolic contribution," said Dewey (note the proper emphasis on "sym-

bolic"), "than that which Mr. Barnes's work in the past has made to the solution of what sometimes seems to be not merely a perplexing but a hopeless problem—it is the matter of race relations."

"Race relations" had been at stake in Barnes's Argyrol factory since its earliest years, given its Black staff and the uncommon pay and benefits they received. In 1918, he was already mailing clippings about an attack on Black people by white Philadelphians to Herbert Croly, founder of the progressive *New Republic*. It's just that, before his encounter with African art, Barnes had rarely seemed to think the issue worth highlighting.

Even for someone aligned with the new century's Progressive movement, Barnes's interest in the welfare and rights of African Americans was unusual. In the twenty-first century, the Progressive movement has in fact lost much of its luster because of the way it could sideline vital issues of race. President Wilson, champion of many progressive causes, was a southern racist who helped segregate the American government, leaving his Black allies feeling deeply betrayed.

But Barnes, in announcing the pedagogical goals of his new foundation and its holdings in African art, is suddenly dwelling on the place of his Black staff in the "industrial democracy" of the Argyrol factory and on their role in the seminars taught there—whereas before the birth of his African collection his Black employees were likely to be referred to as just "working men," with no mention of their skin color. By the spring of 1924, after Barnes had spent his swell evening at the Civic Club, he is writing to *Opportunity*, the magazine of Black rights and culture, boasting of how the Argyrol factory had "for many years conducted an educational programme and several times a week we hold classes composed of our negro employees." An unnamed Black employee, once close to illiterate, in fact led the discussion of H. G. Wells's *Outline of History*. Barnes claimed that, thanks to their Black participants, the

seminars had a "vividness and intensity" that impressed a visiting academic as better than anything he'd seen from his students at Princeton.

According to Barnes, the entire pedagogical project that ruled his foundation for the rest of his life had its roots in the racial issues he'd explored at the Argyrol factory: "I never intended to start a foundation until Dewey urged me to after he saw for himself our experiment with a group of mixed white and black people."

CHAPTER 23

Quelques-uns des Chanteurs de Bordentown

The Bordentown Singers, a New Jersey choir that performed the spirituals Barnes called "the single form of great art which America can claim as her own."

BLACK RIGHTS | BLACK EDUCATION

"Of the tremendous growth and
prosperity achieved by America
since emancipation day the negro
has had scarcely a pittance"

don't care how you spent last Friday night but it's a cinch
that you had a less delightful time than the negroes
afforded me. . . . Imagine what a treat I had from keen
intellects finely trained and first-class poets performing in the
same ring." That was Barnes's report to Dewey a few days after
that supper at the Civic Club in March of 1924. The collector's
growing awareness of racial issues, and eventually of racial justice,
must have come in part from the philosopher.

Dewey, who had RSVP'd his regrets to the Civic Club sup-
per, would in fact have been a more obvious guest there than
Barnes. The supper's organizers would have certainly known of
Dewey's role in founding the National Association for the Ad-
vancement of Colored People, back in 1909. At the time, Dewey
made such then-radical claims as that "all points of skill are rep-
resented in every race" and that "the members of a race so-called
should each have the same opportunities of social environment
and personality as those of a more favored race." (That "so-called"

is important, since even many progressives assumed that race was some kind of biological fact that produced predictable cultural and social outcomes, whereas Dewey called race "largely a fiction." With his deep investment in fixed ideas of "Black culture," it's not clear Barnes would have gone that far; he always had a keen sense of his distance from the Black people he deigned to support—and to drop when he saw fit.)

Just two years before the Civic Club dinner Dewey had written a paper on racism that described it as a "deep seated and widespread social disease." Three decades later, when Dewey died, Walter White, the novelist and NAACP official who had sat beside Barnes at the Civic Club dinner, described the philosopher as "unremittingly and uncompromisingly a supporter of the fight for full citizenship rights for the American Negro."

It's true that Dewey did not, in general, place race at the center of his political philosophy and that his views on the issue can seem naive: he thought mere coexistence might get racism to fade, as it hadn't in the three hundred years that Black and white Americans had lived side by side. But he was deeply concerned about all kinds of abuses of power, including of white people over Black Americans, while resistance to prejudice of all kinds was a vital thread in his thinking. "Democracy will be a farce," he wrote, "unless individuals are trained to think for themselves, to judge independently, to be critical," a position he extended to include a challenge to the unreasoned groupthink of racism. Nothing could have spoken more strongly to Barnes: he saw himself as groupthink's greatest foe, and Dewey's rationalist pragmatism gave him the weapons he needed against it.

Thanks to Dewey, Barnes had become deeply invested in collapsing distinctions between art and other aspects of the human "experience" that was so central to pragmatist theories of education. As Dewey wrote in *Democracy and Education*, Barnes's

bible, "Every subject at some phase of its development should possess, what is for the individual concerned with it, an aesthetic quality." When Barnes talked about a baseball manager as a "great artist," it was a serious claim, and a brave one, by the standards of his time, but also a claim that sat comfortably among the Progressive Era's latest ideas. Talking about the artfulness of daily life among Black people was even more serious, and much braver. But Barnes went so far as to claim that this Black artfulness is what first got him thinking about the entire field of art in the expanded, Deweyan sense—in the sense that his foundation went on to champion—because every aspect of the African American experience, he claimed, was "shot through and through with natural-born artistic expression." (Although that "natural-born" betrays the primitivism that the scholar Alison Boyd has studied in Barnes; it might also suggest the carefree, singing Black worker of racist stereotypes.)

It was generally understood, in Barnes's progressive circles, that new kinds of art, "fine" or lived, had more than aesthetic implications; they could also shape new social forms. "Negro art is so big, so loaded with possibilities for a transfer of its values to other spheres where negro life must be raised to higher levels, that it should be handled with the utmost care," Barnes wrote, not long after his evening at the Civic Club.

Although his interest in Blackness had first been focused by his African purchases, and then extended to the writings of the New Negro movement, it soon came to include properly political issues and stands.

Barnes's *Ex Libris* article, still being edited as he drove up to the Civic Club, was supposed to be about Black creativity, but that

didn't stop him from including the impassioned claim that a Black man of that so-called Progressive Era was "still a slave to the ignorance, the prejudice, the cruelty which were the fate of his forefathers. Today he finds no place of equality in the social, educational or industrial world of the white man. . . . Of the tremendous growth and prosperity achieved by America since emancipation day the negro has had scarcely a pittance."

Barnes claimed that, in the "real industrial democracy" of his drug plant, "four colored men—one, a former drunkard, another, a professional fighter—have as much to say in running it as the founder." However unlikely that claim may be, he did make sure issues of race and discrimination were raised among the Black workers in the factory's seminars. The class spent three full sessions discussing the play *Roseanne*, a melodrama Barnes had taken them to in New York that was about poor Georgia sharecroppers, originally played entirely by white people in blackface but then soon revived with a Black cast. (All the white actors had held "a real affection for some old darkey mammy," according to Nan Bagby Stephens, the "society woman of Atlanta" who wrote the play.) Barnes encouraged his Black employees to express themselves directly on civil rights and racial equality. "I may self believe in Equal rights for the negro race," reads a record of one worker's thoughts, "which every one of the race should. But as to social rights in all its forms. I think it best for the Negro race to be to its self at the present."

Over the decade that followed, Barnes bought a lifetime membership in the Association for the Study of Negro Life and History and contributed to struggling Black churches and their members, even more impoverished than their white neighbors during the Great Depression. He recommended young African Americans for admission and fellowships at major universities and funded the stays of a handful of them at his own foundation. Se-

nior Black thinkers were invited for overnight visits to his home, to look at new art and to plot racial progress, and he paid the train fare to get them there. He also paid for and distributed hundreds of copies of Black publications and made $1,000 contributions to them, all the while insisting on anonymity for most of his donations. (This can't have been to hide his support from other white Americans; Barnes was on the record, and then some, in his fight for Black causes.)

When Charles Spurgeon Johnson, Barnes's Civic Club host, moved to Nashville to take up a position at Fisk, the Black university there, Barnes lent him $1,000 to cover his expenses and then perpetually delayed its repayment.

A few years later, Barnes called in favors to get advanced surgical training in Paris for Dr. DeHaven Hinkson, "one of the most intelligent, well-informed and able surgeons in America," Barnes said, who had the unfortunate fate of having been born Black in racist Philadelphia. Barnes had known him as one of the most promising young people to come out of the rough African American neighborhood that surrounded the Argyrol factory. Once Hinkson had made the crossing to France with his family, at Barnes's expense, one of his many thankful letters home to his patron described how in studying in Paris, he at last experienced "no hindrance from my skin pigmentation." The next year, Barnes was thrilled to have been in attendance when, he said, the "doctor fraternity" of Black Philadelphia threw a party for their returning comrade.

"It is safe to say that no American doctor ever got the inside track as well as Hinkson did in the clinics of Europe," wrote Barnes, as he tried, and failed, to get Hinkson a staff position at an all-white hospital in Philadelphia. (Since a crowd of its nurses had come up from the South, said one of its doctors, appointing Hinkson would cause "a complete disruption and disorganization.")

Barnes became an especially notable patron of the choir at the Manual Training and Industrial School for Colored Youth of Bordentown ("the Tuskegee of the North"), based in New Jersey an hour or so from the foundation. On Guillaume's visit to Merion, Barnes took him to hear the students sing, and driving home, the two men spoke about all the Black "lawyers, engineers, doctors, chemists and professors" that might have been, but who instead were working shining shoes and lugging goods. Barnes gave the singers Sunday gigs at the foundation, to which he invited all his favorite VIPs, and he had the Bordentowners as his guests one night when Paul Robeson was singing at a hall in Philadelphia. He offered to pay steamship fares for the choir to tour Europe and also arranged for it to perform at a famously racist college, where he hoped to "get in a few good licks" for Black people "as a valuable asset to American civilization."

Barnes argued that the Bordentown choir's artistry helped prove that when an African American was given equal treatment, and a job that "requires the mentality which supposedly is exclusively the property of the white man," the Black person would perform it just as well as any white.

"We have begun to imagine that a better education and a greater social and economic equality for the negro might produce something of true importance for a richer and fuller American life," Barnes wrote, around the time of his dinner with Black leaders at the Civic Club. He followed up on such imagining with a full-blown program to bring some equality to African Americans, in what he called "the first regular move by the Foundation in that direction"—implying that more were to follow.

"I hope not to be excommunicated for it," he wrote to Johnson, "but I don't give a damn if I am."

The "it" was a proposal to launch an education campaign, for even the most ill-schooled of African Americans, that would lead them to "really change some of the conditions that keep their race in an undesirable situation." Barnes teamed up with Philadelphia's all-Black Fleur de Lis Club, of which his worker Paul Hogans was a member, and Barnes and Hogans offered up "A New Plan for Negro Education," soon presented also to the NAACP. It was advertised in thousands of flyers that began by asking, "Are you a thinker or a sleeper? Do you want to see your race make progress?" and then offered news of the educational initiative: "The MAIN IDEA is to get ourselves to thinking, and thinking straight. . . . No more jumping to conclusions without knowing the facts; no more sleeping at the switch when we might be up and doing."

But then, within weeks of launching his venture, Barnes started to undermine it, in his typical fashion. He leaped up at a vast "Go to High School—Go to College" meeting at a Philadelphia theater to excoriate a Black speaker. According to Barnes, the man had offered "soporific platitudes and sophistries" and seemed to blame Black people for their plight. "I had trouble keeping my fist out of his face," Barnes wrote to Johnson. Keeping his fists by his sides, Barnes informed the Dunbar audience that if the speaker were right, "there is nothing for your whole race to do but commit suicide." But on the contrary, he said, they had lots of options for education and advancement, on the model of the Black men in "executive positions" in his factory. An African American columnist nevertheless reported on Barnes's presence as "the regrettable part of the program," making him out to be your classic condescending white racist. (The charge wasn't entirely false; the condescension was certainly there in almost all of Barnes's dealings with Black people.) An organizer of the meeting tried to explain to Barnes that his outburst, whatever the merits of its claims, had caused confusion and embarrassment and led the promising gathering to become "lost in a fog of misunderstanding and mixed impressions."

Over the course of the next four or five months, as the educational plan didn't move forward as quickly as Barnes wanted, or in exactly the way he preferred, he began to lose interest in the whole project; by October of 1924 he'd decided to drop out completely.

He declared to Johnson, not unreasonably, that only African Americans could really take proper charge of the plan, but then added a more unpleasant note: "If the plan doesn't pan out as a practical, every-day working measure it will be because the negroes—leaders and masses—don't know their salvation when they see it." For all his support of Black causes, Barnes had the same white-savior complex as many of his peers on the left.

On a couple of occasions, at least, Barnes used fully racist language: a letter to Alain Locke that was all about Barnes's ardent support for Black causes and culture nevertheless uses the N-word to refer to how the "damned" issue of race "is getting to be quite a time consumer for me." As so often, and so self-destructively, Barnes launches exaggerated broadsides of insult and aggression as a way to assert power in any relationship that he sees as threatening, whether he's truly invested in those insults or not. (Just then, he was in a huff about an article by Locke that Barnes felt had used his ideas without credit.) If Barnes had any reason at all for attacking you, he'd look for the most likely vulnerability to prod with his invective: An offending Irishman becomes a "mick," a homosexual a "fairy," an Italian a "wop." The list of insults was endless, each one matched to its appropriate recipient and none expressing a particular dislike for the larger group that got vilified; Barnes might very well come to its ardent defense if someone else were launching the attack. But he was quite unable, or unwilling, to see that by resorting to those particular insults, he was shoring up the culture of discrimination he pretended to despise; the insults only worked because that culture held sway and had already tortured the people Barnes was insulting.

Lyndon Johnson, that other champion of Black rights, had the same talent for using racist words as a lash, says his biographer

Robert Caro, "finding a person's most sensitive point, the rawest of his wounds, and striking it, over and over."

But more than anything else, and even when arguing for racial justice, Barnes trafficked in the damaging stereotypes and diminishments that permeated his era and culture, even in civil rights circles.

In the outline for a rousing speech Barnes gave to his Black workers, encouraging them to force their local leaders to respond to their needs—"more schools, negro on Board of Education, magistrate, judge, better insurance, better housing"—there are also talking points that show him speaking about the tendency of African Americans, he said, to give their emotions "full play in many situations where thinking should hold first place" and "racial endowment—great emotion and imagination—these qualities good servants but cruel masters."

The philosopher Bertrand Russell, who spent several years in Barnes's orbit, said that the collector "liked to patronize coloured people and treated them as equals, because he was quite sure that they were not," and there's some truth in that. George S. Schuyler, an African American journalist, complained that "the mere mention of the word 'Negro' conjures up in the average white American's mind a composite stereotype of Bert Williams, Aunt Jemima, Uncle Tom, Jack Johnson, Florian Slappey, and the various monstrosities scrawled by the cartoonists," and those stereotypes clearly lurked in Barnes's psyche, for all his quite unaverage agitation for equal rights.

A typical passage in one of Barnes's letters to Johnson strikes a strange balance between passionate encouragement and white condescension, speaking of how the only attribute of Black psychology that "falls short of celestial perfection is that they sometimes forget time and place when such are connected with the ordinary affairs of this earth. Of course that is due to the fact that every negro is a poet and artist and the practical affairs of the

world don't interest him much." Another letter chides Black people for "the deep-rooted vice of your race which makes the average negro's unconscious behavior prove that he accepts the white man's assumed superiority"—a superiority entirely assumed by Barnes as well.

Barnes's commitment to Black culture and Black rights was clearly real, and heartfelt, at the very least when it came to rhetoric and ideology. It's also clear that Barnes, like many a philanthropist, liked to champion the underdog in part because it made clear, to others but especially to himself, that he was an overdog. Coming to the aid of the powerless was a sure sign of Barnes's own power.

CHAPTER 24

The galleries of the Barnes Foundation, unveiled in March of 1925.

NEW BUILDINGS | THE COLLECTION

"The most impressive
appearance I have ever seen
in any gallery in the world"

Ain't I a damned fool not to have a yacht, a house in Paris, a whore in New York . . . instead of an educational plan," wrote Barnes to Dewey in the spring of 1923, as he began to give substance to his Barnes Foundation.

If that sounds like the collector had been planning for some kind of schoolhouse, what he ended up with added up to more than said yacht, house, and mistress could ever have cost. By the late summer of 1924, the foundation was close to having a new, fireproof home, three doors over from Lauraston, that had cost $592,698.01, "a great deal more than I had expected," said Barnes—twice as much.

The new building was designed by Paul Cret, a French-born architect and Penn professor who had trained at the École des Beaux-Arts in Paris and never quite left behind a Beaux-Arts classicism. When Barnes brought him on board to build his foundation, Cret was at work on the great Detroit Institute of Arts, which had got him digging deep into the latest ideas about museums.

"Special features in design will make the gallery among the most modern in existence," Cret explained, when his ideas for the

Barnes Foundation were first made public. "The pictures will be displayed in small rooms, rather than all together in large halls, as in older art galleries. . . . The windows will be constructed high in the walls to shed light downward on the pictures." The goal was architecture of an entirely new type that would get rid of the ceremonial spaces of grand civic museums—"cemeteries of works of art," Cret called them. Those would be replaced by the intimate conditions that artists might find in the studios where their works were created. "Throughout, no decoration," wrote Cret, "the paintings composing the collection being of the modern school, which strives for simplicity of expression."

If that conjures up images of the radical, Bauhausian minimalism just being born at that time, in fact the design Cret delivered was almost retro: the building was explicitly planned to evoke the pleasures of an art-filled Italian palazzo, with a facade full of quite Renaissance ornaments. (But the concealed vapor-vacuum heating was entirely modern, as Barnes demanded of all his conveniences.)

Off to one side of the galleries, in the same style, Cret had placed a so-called administration building that had in fact always been intended as a lovely rent- and tax-free residence for the Barneses, with Lauraston sold to fund it. (If the IRS had found out, there might have been trouble: a lawyer had warned Barnes that the foundation's tax exemption depended on every inch of the property being for public, charitable use; when a sign went up saying PRIVATE, NO TRESPASSING in front of the new Barnes residence, Merion officials launched an investigation.)

"I am very enthusiastic about my new galleries," Barnes had written to Guillaume, early on, describing Cret as "our best architect." And yet for the next two years Barnes made the Frenchman's life hell.

He began by refusing to sign the architect's standard contract and moved on to blaming Cret's bad supervision for delays caused

by a stonemason's strike, which a progressive like Barnes ought to have supported—hardly the first or last time that a reformer's principles might give way to self-interest.

"With a dead man functioning as superintendent it is no wonder that the operation has long since degenerated into a badly conducted funeral," Barnes wrote to Cret, as usual going for a knockout when a wrist slap might have done the job. One day, Cret came back at Barnes with a sarcastic note saying that it was a shame that Barnes hadn't been able to employ medieval laborers, since they had "the bad habit of working long hours without wages, not knowing that recent triumph of the proletariat: The strike." More screeds from Barnes had the illustrious architect complaining of being treated "as you would not treat your chauffeur." (True. Barnes was inordinately fond of his driver, Albert Nulty, who he named associate curator of paintings—while Nulty was still tending the cars—and who he got trained as the collection's restorer. Barnes was always more likely to show kindness toward underlings than toward an Ayn Rand *Übermensch* like Cret.)

Barnes, like some terrible parent, didn't necessarily intend a stream of abuse to signal real contempt for the abusee. Sometimes, it can seem that he imagined (or hallucinated) that his vituperation could be a strategic tool for educating, even encouraging, people who were disappointing him. Barnes might have thought it worked in Cret's case: he ended up thrilled with the architect's project.

By early in the winter of 1924, Barnes was telling Guillaume that the finished installation "makes the most impressive appearance I have ever seen in any gallery in the world."

Twenty-three galleries spanned two floors, avoiding "useless" corridors to provide, said Cret, "a simple circulation through the rooms, dividing each floor in two circuits, starting from and

leading to a central hall." That double-story hall had vast, floor-to-ceiling windows giving onto the gardens beyond. The rest of the galleries had smaller windows that also kept the outdoors pleasantly in sight, unlike what Cret described as the "gloomy," jail-like spaces of traditional museums. The rooms were domestically scaled in varying sizes ("to avoid monotony") but always small enough so that any given wall could host only paintings working in harmony with each other. Each wall became "a wonderful creation, comparable in its unity and loveliness with the separate paintings; in that case the collector is the artist," according to one early foundation publication. These mural "ensembles"—the foundation's term of art—became a Barnes signature, and he gave them almost as much attention as the individual works that made them up.

Cret's walls were covered in a self-effacing beige burlap, and in their early years they held a surprisingly spare arrangement of paintings. Those were often displayed in a single row, with, for instance, a big Modigliani portrait flanked by smaller Soutines, or they might be hung at most two deep, with a bold Daumier flanked by a couple of horizontal landscapes, all three topped by little vertical still lifes. The effect would have counted as suitably modern by the standards of that era; the salon-hung galleries we now imagine as typical of the Barnes Foundation, with rafts of paintings and antique metalwork jockeying floor to ceiling for space, didn't take shape until much later. Cret would have been building for a much smaller collection, letting works breathe amid modern space and light.

Also modern: the racy nude women that were soon on prominent display, for instance, in almost pornographic works by van Gogh and Courbet and in an array of topless Renoirs. They testify to a taste for the lascivious that has often been papered over but is of a piece with Barnes's disdain for the tame.

An 1887 nude by van Gogh bears witness to Barnes's taste for exposed female flesh.

Courbet's Woman with White Stockings *from 1864: an almost pornographic painting prized by Barnes, who was always happy to shock.*

A nude painted by Renoir in around 1910. Barnes said he bought the artist's nudes by the dozen to enjoy their colors, volumes, and surfaces.

By February of 1925, Barnes was so pleased that he told his architect to schedule a "Paul Cret Day," as a kind of celebratory soft opening for the project and maybe as quiet compensation for the abuse the Frenchman had suffered.

Today, when the Barnes Foundation is just one of many purpose-built havens for modern art, in Philadelphia and beyond, it's hard to recognize the unique opportunity it offered at its founding. One newspaper described it as "the first public museum in this country devoted to modern art," and another said it made staid old Philadelphia "the 'radical' art centre of the country and one of the greatest citadels of the modern school of art in the world"—a school that had until then been judged "a passing phase, an experiment, rather than a definite artistic achievement."

The Museum of Modern Art would not come to modern art's defense for another four years and wouldn't get a proper home for another decade after that. The Phillips Collection had opened to the public in Washington the same year Barnes incorporated his

foundation, but it was in a private residence rather than a purpose-built gallery and at that point had half as many pictures, mostly American, representing more catholic, conservative tastes.

Whereas at the Barnes one early visitor described the collection as offering a rare chance for the close study of Matisse and Picasso, those leaders of the avant-garde. This was true, in terms of the number of their works it held, but the collection tended to scant what we now think of as their most daring achievements. Its Picassos, especially, tended to be early ones that, a decade after Barnes bought them, had come to seem relatively tame, with a handful of cubist exceptions that could win raves from Barnes. As a movement, however, Barnes felt cubism had roots in sensationalism and market hype and, once systematized by its most doctrinaire proponents, had become "academic, repetitive, banal, dead," a judgment Picasso himself might have handed down. Barnes complained of "the anarchy of the movement as well as its lack of the permanent appeal which is common to the great art of all epochs"—ironically, the same complaints that Barnes's own critics leveled against all the modern art he collected.

His collection shows him having just as little patience for the first stabs at full-blown abstraction being made in Russia and Germany. Work like that is barely hinted at in *The Art in Painting*, the 530-page statement of principles Barnes published just months before opening his foundation, after several years' work. (That hard labor was one reason, or excuse, for withdrawing from his civil rights efforts.) "The idea of abstract form divorced from a clue, however vague, of its representative equivalent in the real world, is sheer nonsense," was the volume's final and pretty much only word on nonobjective art.

As for the revolutionary moves Marcel Duchamp was making in New York with his readymades—a bottle rack or urinal

presented as art—Barnes knew all about them and liked them that much less. Back in 1917, at the time of the "porcelain urinal incident," as he described it, he'd prepared to make a public attack on Duchamp on behalf of Glackens, who had been caught up in the controversy. A few years later, in a letter to the Duchamp fan William Carlos Williams, Barnes summed up his view that readymades had nothing to do with art: "God knows we have enough unavoidable confusion of values without introducing factitious ones—I might say fatuous ones."

But few of the first visitors to the foundation were likely to recognize Barnes's blindness to the cutting edge. "In the United States in the 1920s, 'modern art' meant Cézanne, Renoir, Van Gogh, Gauguin, and several later Impressionists and Post-Impressionists," recalled a scholar who worked at the foundation for its first few years.

The female nudes of even Renoir, although hardly explicit, could leave 1920s visitors repelled by what a local paper described, euphemistically, as "the unpleasant subject matter it is the vogue for certain of the moderns to exploit unabashed whenever so inclined." Just about any Picasso at all counted as intolerably radical, and even Matisse, now seen as the most charming of modernists, could be described as having indulged in "audacious exaggerations" that made him more enraging to conservatives than any other artist. (That gives new meaning to the mural that Barnes would soon commission from Matisse, however evidently attractive *The Dance* has come to seem.)

When it came to the foundation's Lipchitz reliefs, Barnes imagined—with delight—that they would leave him condemned as "not only a radical but a Bolshevist."

An art magazine publishing the very first coverage of the foundation's birth could celebrate the daring of its holdings: "The fact that many people are likely to be non-plussed, on their first in-

troduction to this collection, only shows how much we need such a museum. . . . Something definite and rather drastic has happened to art in our time, and museums in general have not taken sufficient cognizance of it."

What did it matter, asked the author, "if a large part of the public is not yet prepared to enjoy this art"?

CHAPTER 25

Cézanne's Toward Mont Sainte-Victoire, *finished in 1879. Barnes described it as "a succession of yellow rhythms alternating with green rhythms which vary from the horizontal to the angular and curvilinear."*

THE FOUNDATION OPENS | EDUCATION AND *THE ART IN PAINTING*

"It is the first effort to apply scientific
educational methods to make
aethetics a reality to plain people"

March 19, 1925, was a warm day that had started stormy but ended with sun, as though the weather were channeling the changeable man of the hour. On that day, Albert Barnes was marking the inauguration of his foundation. With a crowd of some two hundred notables in attendance, the day's list of speakers included a state senator, a local judge, and representatives of both Columbia University and Penn.

Barnes had drawn up his list without asking those speakers if they wanted to appear.

"If you don't come, I'll tell the audience that you had a sudden attack of belly-ache, or something," wrote Barnes to his friend Stokowski, who did indeed show up. He told the gathering that Barnes had fought the good fight against philistines who "look at some marvelous pictures, like these, and will tell you that it is just a daub, that it is the result of a kind of disordered mind." American artists, he said, owed Barnes a huge debt. "There are not many people in the world, only a few, who have the courage to fight as I know he has fought."

Barnes himself spoke at length, taking care to let the assembled academics know that, despite their invited presence, he was actually on the side of "the mutts"—the "common people." A member of his staff recorded, perhaps optimistically, that the dons corralled onto one side of the main table had kept their good humor throughout.

It goes without saying that Dewey, the foundation's (honorary) director of education, took a less contentious tone in his keynote address as he dedicated the foundation to the Cause of Education. He felt confident, he said, that the influence of the Barnes Foundation would eventually be felt right across the nation, making its launch "one of the most profound educational deeds of the age in which we are living."

Ever since the birth of civic and state museums, collectors have framed their art donations as serving the public good. When collectors have opened their own private museums, as several of Barnes's peers were then doing, they've made similar claims about a benefit to the public. But there's not a single collector who has thought through what that might mean with Barnes's ambition and energy. Rather than taking the virtues of art as a given, Barnes turned a simple collection of artworks, such as any millionaire shopper might build, into an experiment in the nature of art's virtues, both aesthetic and social, in how they could be understood and communicated and who might benefit from them. For the next three decades, he spent countless classroom hours working through those problems.

———

Education, education, education.

Barnes had been beating that drum almost since the first day he'd imagined his foundation. But what exactly did it mean for something that looked just like an art museum to instead be, as

its architect insisted, "an educational institution in which is conducted research in art"?

For one thing, it meant the near-total exclusion of the typical museum-going public.

On first announcing plans for his new institution, Barnes had imagined it having several days' free admission each week, for the artistic enjoyment of Everyman, and he made a point of letting the public know about it. Two years later, however, with the foundation's actual opening, Barnes seemed keen on keeping the news, like the institution, almost private. He appears to have given only a single interview of any note, to a reporter who not incidentally was publishing in far-off Paris. (And who, as it happened, gave the collector's name as "Charles L. Barnes"; you can only imagine Albert C. Barnes's fury at seeing it.)

The foundation, explained the article, was not "open to the casual visits of the undiscriminating seeker for amusement." Barnes was perpetually frustrated by the deep inattention of the majority of museumgoers, a frustration shared by many a serious art lover to this day; the twenty-first century's "slow looking" movement is heir to Barnes's hours-long attention to single pictures. As he was soon proclaiming in a statement of the foundation's principles, "Art appreciation can no more be absorbed by aimless wandering in galleries than surgery can be learned by casual visits to a hospital." He wanted his institution to encourage, and even enforce, the close study and hard work that serious art deserved and demanded. It was to be a training center, of sorts, for teachers and dedicated students of art, meant "not to give them the cut and dried criteria of academic appreciation but to liberate and train their faculties for genuine critical appreciation." If Barnes's first model for aesthetic experience came from the Methodist meetings of his childhood, it makes sense to think of him building his foundation around the ideal of a dedicated and devout artistic "congregation" that needed to be inculcated

into a set of "scriptures" before they could start down the path toward true and passionate illumination.

The Barnes Foundation had made a first stab at a founding text some six months before it opened, with a little publication, its first of many, called *An Approach to Art*. It included a heavy dose of what would come to be Barnes's trademark ideas and prose, although it was officially authored by Mary Mullen. She was still in management at the Argyrol factory, and getting well paid for it, but she had also been named associate director of education at the foundation, a title the high school graduate now shared with Laurence Buermeyer, Princeton PhD. According to the book's preface, it was a primer for budding, everyday aesthetes who "wish to see in works of art and in life itself those aesthetic aspects which are too often overlooked." Its twenty-five pages of text went on to explain some basic tenets of modernism: that worthwhile art had to be about more than just realist technique; that moral messaging in a picture risked eliminating "the spontaneity and freedom of art"; that form and content must be inextricably blended into a successful whole. (After Barnes's recent debacle with Black education, the volume notably avoided any mention of race.) Yet most of the book's lessons are expressed in such general terms that the whole thing ends up seeming a bit vague and unpragmatic. Barnes called it "the first effort to apply scientific educational methods to make aesthetics a reality to plain people of average intelligence," but it's hard to see how any plain person might make use of a claim such as that "art values . . . have the qualities of non-rationality, immediacy and permanency and, since beauty is an art value, it must necessarily share these same qualities of non-rationality, immediacy and permanency." When the Argyrol workers took up the book in their seminars, even the literate ones had a hard time making their way through it, according to one teacher's notes. Rather than pulling out the "art values" in Barnes's pictures, as the teacher had dearly hoped, the workers, she said, continued at best to respond to

the mere "sentiment and color" in the paintings—or to give them a simple thumbs-up or thumbs-down. (But John White, the factory's Deweyan boxer, had learned that Soutine's self-portraits were about not what the painter looked like but "the way he feels about himself," and he took pains to explain this to colleagues.)

To propagate the aesthetic principles behind the foundation, Mullen's book might not do the trick. Barnes would have to do the heavy lifting himself, as he saw himself doing in so many spheres in his life.

———

Nine months after the opening of the Barnes Foundation, a page of notes on recent visitors mentioned a "special favorable interest shown by a young Mr. Barr," described as a junior instructor at Princeton who showed himself to be "a little timid." This was Alfred H. Barr, who ended the 1920s as the first director of the Museum of Modern Art and over the following decades was anything but timid—was sometimes close to Barnesian—in his backing of the most challenging modernism.

After his pilgrimage to what he called "the finest collection of modern painting in America," Barr found himself reviewing its founder's new magnum opus, *The Art in Painting*.

Barr chuckled at the book's mauling of the art historical establishment, such as Barnes's dismissal of one scholar's four-volume chronicle of the history of art as "a historical romance in which painters and paintings are extensively mentioned."

Barnes's doubts about Picasso and cubism also got praise from Barr, who would eventually switch to becoming Picasso's most eager fan. In general, Barr, at twenty-four, comes off as more conservative than Barnes, a man thirty years older; it seems likely that Barr's turn to an adamant formalism got some impetus from Barnes's "important book," as Barr called it.

"Aesthetic illiteracy," wrote Barr, was the fate of almost all art lovers, because of their obsession with "subject matter, historical and biographical backgrounds, archaeological problems, stylistic differentiation, literary association and all [such] ancillary baggage." But then there were a few rarer, more modern spirits, and most especially a certain Dr. Barnes of Philadelphia, who were "deeply interested in plastic values"—in what would come to be called the "formal" concerns of line, shape, color, composition, space, and surface. In 1925, Barnes was on the cutting edge of the formalist thinking that ruled the art world for the next fifty years. In the twenty-first century, when formalist talk is either taken for granted, called into question, or simply ignored as old-fashioned, it's easy to lose track of Barnes's innovation and influence.

Across chapter after chapter, subsection after subsection— with titles like "The Problem of Appreciation," "Plastic Art and Decoration," "Quality in Painting," and thirteen other such topics—*The Art in Painting* staked out the issues involved in understanding art in terms of what could be seen right there on a work's surface.

Barnes boasted that he had taken his formalism to the point that of the hundreds of paintings he'd pored over for his book, very few meant anything to him "in terms of their subject matter." Titian's sixteenth-century painting of Christ being entombed could be pronounced a close equivalent to a Cézanne still life, leading Barnes to declare the "irrelevancy of subject matter to plastic values," and therefore to all that mattered most in art. The emotions aroused by any good painting ought to be about qualities "really present in the painting," Barnes clarified, rather than about "subject-matter, the landscape depicted, for example, the woman or the plate of fruit."

He espoused the notion, later made famous by the adamant formalist Clement Greenberg, that painters had to explore what was proper to paint, leaving photographers and authors to work

out depiction and storytelling. (Greenberg once cited a book by Barnes as one of the few Matisse studies worth reading.)

Some three hundred pages of *The Art in Painting* were devoted to close pictorial analyses, in which Barnes went looking for his basic formal values in the actual paintings he cherished, from Renaissance altarpieces to modern experiments, digging deeper than anyone before him. But there's a fault in his digging that can't be denied: Barnes's massive volume was, as Barr said, "onerous as any text book."

Its analysis of *Toward Mont Sainte-Victoire*, one of the very first Cézannes that Glackens had picked up for Barnes, could dwell (the operative word) on how—and this can't be abridged—"in the background to the right there is a succession of yellow rhythms alternating with green rhythms which vary from the horizontal to the angular and curvilinear. They start in the middle distance with a comparatively broad area of yellow and meet a small but very narrow green rhythm; they are continued by a rhythm made up of an admixture of green and yellow, followed by a deeper irregular green area with an island of yellow in the middle; then another admixture of green and yellow enters, and so on up to the lower mountain on the right side of the canvas. The general tendency of these rhythms on the right side of the canvas is horizontal; on the left, the rhythms consist of a series of alternating green and yellow narrow bands which radiate from the center, somewhat like the spokes of a wheel, for some distance, and then become generally horizontal. The area between the volumes on each side constitutes a central rhythm, contrasting in shape and direction with both the left and the right sides, and binding the two parts of the canvas together in a perfect whole. These rhythms, reinforced by subsidiary rhythms formed by the variously distributed houses and trees of fine three-dimensional solidity, give an unusually dynamic character to that part of the landscape." (See figure 11 in color insert.)

The Art in Painting declares that the study of art should be

no more subjective, or less rigorous in its methods, than scientific research. And Barnes, the industrial chemist, was nothing if not methodical in his aesthetics: Laura Geiger, living up to her title of recording secretary of the Barnes Foundation, would spend countless hours taking dictation in front of his pictures, as he expatiated on their every detail. That mass of words seems sometimes to have passed almost unchanged into his big book, to the point where reading analysis after analysis of his favorite paintings can feel like consulting the lab notes from a year's worth of assays on a silver colloid.

The review of another foundation book, on African sculpture, complained of "a smothering mass of verbiage" that would leave the reader "so covered with rods, axes, planes, bulbous curves, and what-not, that his appreciation of the art form he is regarding will be quite suffocated."

But what risks getting lost under Barnes's undeniable verbiage is that he didn't value axes, planes, and bulbous curves for their own sakes, as some of his formalist successors have. For him, forms came with political stakes and humanist implications. They were just the experimental data, you might say, upon which he built theories about the good art can do.

CHAPTER 26

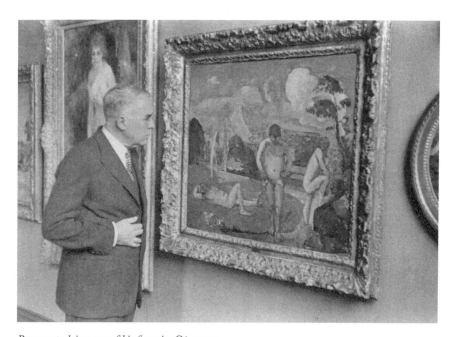

Barnes studying one of his favorite Cézannes.

DEMOCRATIC AESTHETICS |
FORM AND MEANING

"A place where people can
see for themselves"

He looks forward to a society in which art shall not be the exclusive possession of a privileged few, but in which all members will share in and contribute to artistic experience." This was the picture of Barnes, the democrat, that got painted in the single interview he gave after the opening of the foundation's new building.

That picture might come across as unlikely.

After all, Barnes's almost microscopic analyses of his art could, and still can, make him sound terribly hifalutin, like someone concerned with art's most esoteric qualities, to be recognized by a select few deploying the latest in positivist procedures. When Barnes perorates on the yellow and green rhythms in a Cézanne, and whether they are horizontal or circular, it can seem like deeply technical, specialist talk. He spoke of having built his foundation around a deep faith that "art is great in so far as it is intelligent" and that "the product of the philosophers and psychologists—that is, the definition of intelligence—illuminates art. . . ."

But it's worth filling in the ellipsis at the end of that quotation. All of that highbrow philosophical and psychological expertise, Barnes went on to say, illuminates art by making it "more

understandable, more appealing, more universal." For all that Barnes's approach to art can seem obscurely scientistic, it was actually meant to make access to paintings vastly more democratic.

In his own mind at least, Barnes's formalism was one element in the leveling of hierarchies that meant so much to him and his progressive circle. He insisted that viewers pay attention only to what can be seen sitting right on a painting's surface, without recourse to the knowledge of a historian, classicist, or theologian. Mere cultural mastery, as handed down to the elites and then wielded by them from on high, had to be traded for a true democracy's reasoned argument and tangible, very tangible, proof. He claimed his foundation's teachings in front of paintings were built on the same rationalist principles as the revolutionary clinical labs of Penn's medical school, which brought scientific advances to bear on illness in actual people. This seems a peculiarly American approach to a modernism that, in its European birthplace, might as easily be read as all about a willful venture into unreason, or at least into the twisted byways of Einsteinian thought. Barnes, the Philadelphia industrialist, prefers an almost Fordist efficiency in his art encounters.

The African American philosopher Alain Locke once insisted that "value disciplines"—all the social sciences and humanities—needed to adopt "the tentative and revisionist procedure of natural science." If one of Barnes's aims was to adopt just those for art, it was because the "revisions" of science resisted authority in favor of objective fact that could, at least in theory, be tested by anyone. The rationalism of Barnes's approach to art really linked it, he said, to "the kind of action that operates when we purchase an automobile or a suit of clothes intelligently."

The art component of the factory seminars had already acted as a kind of test case for this approach, Barnes said, encouraging barely educated manual laborers to express themselves freely about the art in his collection. Once that collection had its new charter as

the Barnes Foundation, at first it was still described by its founder as "nothing but a place where people can see for themselves."

Even after a more structured pedagogy had started to take hold, Barnes had imagined that its teaching might be built entirely around the handful of new art lovers who worked in his factory: "Those few will take the others of our workers into the Foundation a couple of times a week and each will describe his own honest reactions to what he sees."

"Seeing for yourself" was at the very center of Barnes's ideas about most things in life. He always insisted, with less than perfect truth, that he'd "seen for himself" when it came to his early education, to inventing Argyrol, to figuring out how to market it, and then to selecting art to spend the profits on—which was art, as he liked to imply, whose qualities were at first recognized only by him. (One sure way to enrage Barnes was to give his friend Glackens credit—deserved credit—for the collection's genesis. Barnes even came to deny Paul Guillaume's indubitable role in expanding it.) At just about the moment Barnes was first chartering his foundation, he was hugely proud of having been, as he claimed, the first man in Paris to "discover" Soutine, whose frantically expressive brushwork was the perfect symbol of a go-it-alone avant-gardism. He was soon also claiming to have bought his first Picasso three years earlier than he actually did, in order to claim to have got to him before any other American, and he even pretended to have discovered modernism before Le Corbusier, one of its founding creators.

Barnes's psychic need for independence of mind was perfectly suited to that moment in the history of ideas.

His friend Dewey was insisting that anyone could learn almost anything, almost on their own, so long as they were bathed in a suitable setting for learning. And that was true even of taste and aesthetics. "Deeper standards of judgments of value are framed by the situations into which a person habitually enters," Dewey

said, so mere exposure to important art would go far in helping us understand and judge it. "Conscious teaching can hardly do more than convey second-hand information as to what others think."

Barnes felt that just by getting access to great pictures, any average person had as good a chance of coming to grips with their virtues as a fancy art historian. This was the truly democratic, Deweyan principle at the heart of the almost evangelical promotion of formalist criticism that became typical of Barnes's mature thought. If art's essence was in its forms and colors and textures, then that essence was available to anyone who cared to look, regardless of their class or even, or especially, their race. Given the demographics of his drug factory, those workers who Barnes was inviting to have "honest reactions" to his collection must have mostly been Black.

There was another way that Barnes's formalism flattened the hierarchies that ruled in his era's culture: by putting all its products on the same plane. "The world does not know that a people is great until that people produces great literature and art," wrote James Weldon Johnson, about to become Barnes's supper mate at the Civic Club; formalism helped Barnes confirm Black culture's greatness. Inviting the Bordentown singers into his deluxe picture gallery, Barnes would analyze an African American spiritual in precisely the same formal terms as, and in close comparison with, an official masterpiece by a white painter, refusing to draw the normal "color line" between the art forms; for the sake of formal analysis, jazz and Bach could take turns on the same foundation Victrola, ignoring that one had an audience of everyday people and the other was enjoyed by elites. The effect, or at least the aim, was to raise the status of Black and working-class cultures by proving that they could go head-to-head, in any formal analysis, against the stuff that wealthy white people treasured. (Although in his actual analyses Barnes often came to the conclusion, with apparent reluctance, that the elite stuff had the edge.)

Yet this egalitarian(-ish) formalism came with serious downsides, prioritizing "aestheticized black culture over black politics," as the scholar Alison Boyd has put it. The Barnes Method drained spirituals of the actual religious and even political content that mattered to their makers and performers; jazz risked losing all its social meaning to become just another bunch of well-structured sounds. And in the end every creation, "high" or "low," by a white artist or a Black one, was reduced to mere raw material for processing by the authoritative eyes and ears of Main Line Barnes and his well-trained apostles. But Barnes, the Gilded Age progressive, couldn't see those downsides—those social and political downsides—because of the promise formalism held out in canceling social distinctions. In its formalism, the foundation would leave "a total freedom of appreciation" to its art lookers, whatever their backgrounds.

Dewey had proclaimed that "the aim of progressive education is to take part in correcting unfair privilege and unfair deprivation." Progressive *art* education, such as might be provided by a private collection gone public, could be part of that Deweyan mission.

———

There was a contradiction, almost a paradox, built into the pedagogy of the Barnes Foundation.

If its Everyman students were supposed to "see for themselves" in objects whose meanings were all revealed right there on their surfaces, then what was the foundation's educational mandate all about? Dewey, for one, thought that viewers should be left mostly to themselves to make aesthetic judgments. The foundation's retort, only partly oxymoronic, was that it took training to undo your previous training so that your eyes could then learn to see what truly mattered, on their own.

As Buermeyer explained, a month after the foundation's opening, the Barnes Method required "emancipation from the archaeological and sentimental irrelevancies which at present cluster so thickly about art in all its forms." The foundation let its students slough off the educational specifics acquired in traditional classes on art—specifics about historical contexts, religious iconography, and the like—so they could engage in a Deweyan immersion in the art experience. But with Buermeyer insisting that the love of art was a kind of religion, the experience of art promoted by Barnes could be as strict as any Catholic credo. At his foundation, "seeing for yourself" meant making sure to see precisely the kinds of things Barnes's theories prescribed as worth seeing, in the ways they were supposed to be seen, with the labor that entailed.

"Genuine aesthetic experience," Barnes said, requires "methods systematically elaborated in the light of valid psychological knowledge"—his methods, that is—"and a reorientation of the whole personality which few indeed have either the desire or the opportunity to undertake." Barnes's approach, so dedicated to the art and pleasures of looking, has the peculiar quality of sometimes making it harder and less pleasant to look.

The Barnes Foundation, dedicated to Deweyism, became famous for a very un-Deweyan rigidity in its teachings. One sometime disciple of both Barnes and Dewey wondered whether the two had ever discussed how "an autocratic institution could exemplify 'democracy in education.'"

Visitors might find themselves ejected for admiring Barnes's paintings in "incorrect" ways. One early invitee felt certain that Barnes lurked behind Lauraston's curtains to make sure his guests weren't talking about a work's subject matter. *The New Yorker* reported that Barnes would put on a workman's overalls, so as to better listen in on his visitors. Later, there were rumors of hidden microphones.

Barnes himself couldn't always stick to his own precepts. Most of his judgments might have been visual, based on "whether the artist has succeeded in unifying and harmonizing his plastic means," as one of the foundation's first instructors put it. But Barnes was also deeply committed to the echt-modernist concept of originality, the extent to which an artist "has added something new" to the tradition. And there was no way to judge originality except by knowing who had made what, when, and in what historical and cultural contexts, which was just the kind of traditional, art historical, non-perceptual stuff a dedicated Barnesian was not supposed to attend to.

To twenty-first-century minds, there's another problem with Barnes's claim to care only about lines, colors, shapes, and textures: It seems to leave out the idea that art can have actual content—can talk effectively, importantly about the glories and troubles in the world around us. Those were just the kinds of things Barnes's peers in the Progressive movement cared most about.

It's surprising to discover that Barnes, with his long-standing reputation as formalism's Defender of the Faith, also demanded that art speak to the human condition. As Barnes said, "A truly esthetic form is always a faithful record of a particular artist's reaction to a particular time in the world's history."

A quotation from the writer Havelock Ellis was almost a sutra at the Barnes Foundation:

> Instead of imitating those philosophers who with
> analyses and syntheses worry over the goal of life, and the
> justification of the world, and the meaning of the strange

and painful phenomenon called Existence, the artist
takes up some fragment of that existence, transfigures
it, shows it: There! And therewith the spectator is filled
with enthusiastic joy, and the transcendent Adventure of
Existence is justified.

Or as Barnes put it in *The Art in Painting*, more prosaically,
"From among the many visual qualities of things the artist selects
and emphasizes those which will provide us with a richer and bet-
ter grasp of the world than we could achieve unaided."

For all his talk of surface effects—of greens and yellows and
rhythms—Barnes's ideas are built around an interest in the environ-
ment we live in. Art, and its artists, simply provide our best windows
onto it: A great painting "sees" better than we ever could without its
help. Its maker grasps "certain significant aspects of persons and
things of the real world which our blindness and preoccupation with
personal and practical concerns ordinarily hide from us."

The painter, says Barnes, "shows us the familiar world in
which we live, but with its colors so modified, heightened or toned
down, its lights and shadows so rearranged, its volumes defined
and its spaces so ordered that experience of them becomes fuller,
more varied, more coherent, therefore more absorbing and intrin-
sically satisfying, than our experience of the objects that nature
scatters haphazardly about us."

In that letter where Barnes describes Cézanne as "intense,
passionate, almost cruel in his insight into reality" and Renoir as
"charming, human, lyric," the collector can seem almost more in-
terested in artists and their spirits than in the objects they make.
It turns out that for Barnes those objects are just tools that let us
witness artists in the act of seeing the world in unique and compel-
ling ways, and feeling it more intensely than the rest of us do. "The
purpose of art is to record and make communicable an individual
experience," he said.

In all of Barnes's writings there's an accent on psychology that helped him assert his bona fides as a scientific rationalist and a Deweyan, and that he could also connect to his earliest studies in the subject, at Penn and in that mental asylum. "The person who comprehends and appreciates the work of art shares the emotions which prompted the artist to create," he wrote in *The Art in Painting*. Barnes was so committed to Black spirituals because, he felt, they gave listeners such direct access to their creators in the act of having strong feelings.

You get the sense, reading Barnes, that if there were a more direct way to access the eyes and mind of an artist, he would take it. Short of a mind meld, however, he's stuck with a painting or song as his way into its maker's view of the world. "Art is a fragment of life presented to us enriched in feeling by means of the creative spirit of the artist," was one early précis of the Barnes model.

That "fragment of life" didn't equate with subject matter as traditionally understood and analyzed: Barnes wouldn't permit titles to be included in the image captions for *The Art in Painting* because "the essential principle of the whole book is that plastic form is independent of subject matter." But his objection was only—or mostly; he wasn't consistent on this—to the kind of subject that pointed beyond what could actually be seen in the picture itself. He was willing to mention that the Cézanne landscape whose rhythms and colors he analyzed at such length depicted "mountains in the distance and a curiously placed diagonal road in the foreground"—even if that was all he said about mountains or road. What he rejected was any talk of stories and symbols that required prior knowledge gleaned from book learning or historical research—anything that risked treating an artwork as a "literary or historical document."

But he was at least equally opposed to the notion, taking hold among modernists, that art should be understood purely in terms of its visual effects. One early Barnes disciple said it was no more

than "superstition" to think that a painting could be understood as "a pattern, a set of fixed rules for the use of color, line and space." After meaning so much to Barnes in his early days as a collector, Clive Bell's influential theory of "significant form," the major source of such superstitions, had been demoted by Barnes to the status of "straight, unadulterated b.s."

"Critics of the so-called advanced school"—Bell, that is— "prove by their writings that all that they see in paintings is mere pattern," Barnes wrote. But pattern was just a "skeleton," Barnes said, that then needed to be fleshed out with "the universal human values of experience." There's a sense that Barnes came to see Bell's patterning as yet another example of an effete, old-world, navel-gazing aestheticism, to be replaced by his own virile, rationalist, pragmatic, and American view, in contact with things as they are.

Pattern was, to Barnes's eyes, the sole interest and therefore the downfall of abstraction or of any of the new movements— cubism, vorticism, constructivism—that distorted reality beyond the easily recognizable. (The cubist reliefs he'd bought from Lipchitz got a pass.) Art, he said, is never about "bringing into existence out of nothing a peculiar kind of thing" but rather about "depicting the already existing things of our common experience" so that they register more potently. It's ironic that Barnes, who inveighed endlessly against the "academicism" that fixed rules for what art should be, turned out to be unable to accept paintings that might have other aims than the ones he countenanced.

Barnes replaced the flawed idea of "pattern" with a new concept of "design" that was about an effort to leave a record of human experience in the forms visible in a painting; design is "the sum total of what an artist uses to express the organic reaction of his whole being." A correctly "designed" work gives the viewer the possibility of "reproducing in himself the experience of which the picture is a record."

"Great art has always been realistic," Barnes said, the year his foundation opened, and it's worth remembering that he was fifty-three when he said it. He had come of age in a Victorian era when art's realism was still taken absolutely for granted, even by figures like John Ruskin who were pioneers in describing art's formal effects. The first art Barnes admired was by Butts Glackens and John Sloan, Central High's great classroom realists, at a school that had also trained Thomas Eakins. Decades later, when Glackens and Sloan became grown-up Ashcan artists, Barnes began his life as a collector by buying their paintings; he never stopped admiring them. When he then fell in love with more modern works coming out of Paris, with their far more peculiar styles, his psychic task was to find a way to spot the world in them, and to see what they had to say about it. He was willing to claim, for instance, that modernism's methodical investigation of new forms ran in parallel with the methodical progress that nineteenth-century science had made toward new facts.

Barnes declared his "prime and unwavering contention" to be that art is "no device for the entertainment of dilettantes, or upholstery for the houses of the wealthy, but a source of insight into the world, for which there is and can be no substitute." That, at least in theory, was what the foundation's interminable formal analyses were really about: demonstrating precisely how the details of what a picture looked like, right there on the surface, managed to reveal its novel vision of reality.

Even as he celebrated the latest in modern art, Barnes still hoped for just a hint of the "moral improvement" his Victorian upbringing had taught him to seek. His model came with reformist implications that rhymed with the social concerns of the Progressive movement, equally committed to new ways of understanding our human world. As Barnes put it, "the intellectual and spiritual

requirements" of the modern age demanded that his contemporaries be exposed to "the objective facts that embody the spiritual meanings of our art experiences." Those "objective facts" were what the seven hundred art objects on view in Barnes's foundation were meant to provide. The 530 pages of *The Art in Painting* were supposed to explain how, just by themselves, those facts—those *visual* facts—could reveal the "spiritual meanings" that all art was supposed to convey. At least in Barnes's mind, art was part of America's cure for what ailed it, and that put art in the same basket as the more explicitly social and political reforms that he backed. As Barnes had written to Dewey in the early 1920s, modernist stylings—in this case, the disjointed literary stylings of his new pen pal William Carlos Williams—could express "the new spirit of the new times we are entering in the spiritual field which will later be manifested in social and political spheres."

However unlikely it may seem, promoting the "correct" study of a Cézanne landscape was not all that different, for Barnes, from extending America's democracy to its Black citizens.

CHAPTER 27

Albert and Laura Barnes in about 1930, on one of their many Atlantic crossings.

UNIVERSITIES | THOMAS MUNRO | EUROPE | CÉZANNE AND SEURAT | ART EDUCATION

"Barnes was indefatigable, tireless mentally and physically in looking, thinking, and arguing"

Early on, Barnes had said that the museum he hoped someday to establish would have as its only rule "that no guided tours, lectures, or critical explanations whatever were to be allowed: the public could come and look for itself." Once his collection had opened as a tax-free foundation dedicated to "the advancement of education," such lectures and explanations were now more than allowed; they were required.

"Ours is not a public gallery, but a chartered educational institution," read one of the boilerplate letters that began to go out to anyone who expressed an interest in seeing the art. Only students enrolled for "systematic study" in its classes, either homegrown or at affiliated universities, would be admitted.

But the question remained as to who precisely would be conducting those classes.

Barnes had begun by saying that he wanted "to have the teaching done in the colleges and to have students look at what we have in the galleries and establish some link between the two."

UNIVERSITIES | THOMAS MUNRO | EUROPE | CÉZANNE AND SEURAT | ART EDUCATION *247*

But before the foundation's new buildings even went up, its founder had already decided that even such substantial institutions as Princeton, Columbia, and Penn could never end up with an art course that would satisfy him, "even if the atmosphere of academic death would permit it to grow." Approaching any of them was sure to lead to one of those "damned university blind alleys," he said—so of course he went on to approach them.

As Barnes told Dewey, "If the universities want to come in, with their prestige and other bunk checked with their umbrellas, we'll be glad to have them."

With its strong concentration in the arts Bryn Mawr, the Main Line women's college, made special sense as a collaborator, especially since it was just up the road. The correspondence with Bryn Mawr stayed mostly cordial for the first year of the foundation's existence. By the spring of 1924, however, Barnes was telling the college president that the institution's teaching was a relic of a pre-Deweyan past when "day dreaming and reality" were not told apart. Barnes had no choice, he said, but to imagine himself "one of the mourners at the public obsequies when Bryn Mawr students find that the Foundation doors are closed to them."

Never one to let a good grudge go stale, years later Barnes was still writing about the "psychoanalytic test" he would demand of any Bryn Mawrite seeking admission: "If the faculty applicant is a woman, we test the sensitivity of her clitoris by titillation with the finger. If the faculty applicant is a man, we make an examination of the man's scrotum to determine the presence or absence of testicles. The reason we make these tests is that it is commonly believed that women candidates for professorship at Bryn Mawr must be sexually dead and the men candidates lacking in testicles."

Don Rickles Sr. at work once again.

Beyond Bryn Mawr and the Main Line, Barnes tested the waters with Princeton University and then actually launched programs with the Pennsylvania Academy of the Fine Arts and Co-

lumbia. But he saw the University of Pennsylvania, his alma mater, as his most likely prospect, and more likely to bow to his will. Before the new Merion buildings were even finished, he dangled the idea of a new, Barnes-funded Chair of Modern Art before Penn's president, with the condition that its first holder be the foundation's own Laurence Buermeyer.

Barnes was careful to point out that his tempting offer was backed by the foundation's millions of dollars in art and endowments, which the university must have imagined someday making its own. By March 1924, Penn had sent a fulsome letter of acceptance of Barnes's offer: a new Barnes Foundation professor would be teaching at Penn. In the end, however, that would not be Buermeyer.

The gay scholar had suffered public attacks on his "personal conduct" as well as a series of nervous breakdowns, so while Buermeyer took time off to recover, Barnes got Dewey to dig up a promising Columbia PhD, with better "habits," to do his teaching. That was a young philosopher named Thomas Munro who had completed a doctorate on what he described as "the theory of progress and related theories of biological evolution as applied to ethics and social philosophy." Barnes described him as "only 27 years old and extraordinarily brilliant." The plan, wrote Barnes to Munro, is "to make your course at the University of Pennsylvania the only one in America where real instruction in art can be had."

The press release announcing Munro's appointment had proclaimed two goals for the foundation: to effect a "thorough-going application of scientific method to the study of plastic art" and to show "for the first time, the continuity of great art in its entire course of evolution from Egyptian sculpture to painting in the nineteenth and twentieth centuries." There still being only half a

UNIVERSITIES | THOMAS MUNRO | EUROPE | CÉZANNE AND SEURAT | ART EDUCATION *249*

building in which the first goal could be pursued, Barnes began work on preparing Munro for the second by sending him on a survey of the artistic treasures of Europe. The itinerary included the van Goghs in Amsterdam, the El Grecos and Goyas in Toledo and Madrid, and the churches and palazzos of Venice, where Munro noted that the gorgeous youth and nursing mother in Giorgione's great *Tempesta* made "a square design" that got turned into "a sort of irregular pyramid" by the pillar between them.

"Perhaps you can tell by these notes at least whether I am going at the thing in the right way," Munro queried Barnes. "It's a darned good beginning," Barnes replied, "and it is quite evident that you are seeing plastically more than in any other sense." That enthusiasm was tempered by Barnes's mention of a laundry bill left unpaid in Paris, a sure sign of Munro's Scottish roots, said Barnes, for once going after a Celt instead of a Jew: "Now that you are away from mamma and papa, you ought to can all such sybaritic, anti-social, solipsism stuff."

Those summer trips became a regular feature of life for much of the foundation's staff and even for some fees-paying students, all led on aesthetic safari by the founder himself.

"Barnes would get us up very early in the morning, say six o'clock; we would be quickly through breakfast and ready to start out," as Munro recalled. "We would climb up the towers and balconies of churches and make notes. When we got done with a long, tiring day's work of looking, he wanted us to make more notes and let him read them. He would criticize them and talk them over. Barnes was indefatigable, tireless mentally and physically in looking, thinking, and arguing."

Barnes provided decent comforts for his companions in Europe, recommending good hotels and restaurants, but he himself traveled in proper luxury. When he had occasion to cross the Channel to London, Barnes splurged on one of the new airline flights, "a great, worthwhile experience." He stayed at the finest

hotels: the Carlton in London; the Adlon in Berlin; in Paris the Royal Monceau off the Arc de Triomphe or his old standby the Mirabeau. Eating at classic French restaurants—L'Âne Rouge, Le Boeuf à la Mode, L'Escargot d'Or—he reveled in "bisque ecrivisse" and "poulet chambertin," and especially in a memorable *soupe à l'oignon*. He once enjoyed a brace of pheasants brought aboard a steamer just to guarantee fine food on the trip home from Paris; another ship brought a whole wheel of Roquefort to him in the United States. (The heat in the ship's hold liquefied it.)

But the trips were far from holidays for anyone involved, least of all Barnes. He would stage assaults on Argyrol's European competition at the same time as he hunted out gems for his collection and amassed vast stores of information for the books he went on to write.

He finally managed to get Cézanne's great *Card Players*, after two years of fierce negotiation with Vollard. (See figure 13 in color insert.) It was one of the artist's biggest and most impressive paintings, on one of his most curiously banal subjects: just a bunch of modern peasants playing cards after work. Finished in 1892, when Barnes would have been twenty—about the same age as the youngest of the card players—it must, at least subliminally, have reminded him of the world of workingmen he grew up in, and the homosociality that any twenty-first-century critic is likely to dwell on. The painting's almost absurdly modest subject must also have spoken to Barnes's progressive, Deweyan ideas about modest Everyman values. But the truth is the painting's subject probably mattered most for how its banality made that very subject so easy to ignore. At least for someone of Barnes's generation, men playing cards was almost a nonsubject, not begging for any kind of complex exposition, which made it all the easier for a properly Barnesian viewer to recall the "irrelevancy of subject matter to plastic values" and then pass on to the wildly new, utterly un-banal way Cézanne paints his nonsubject. He throws together broken patches of pris-

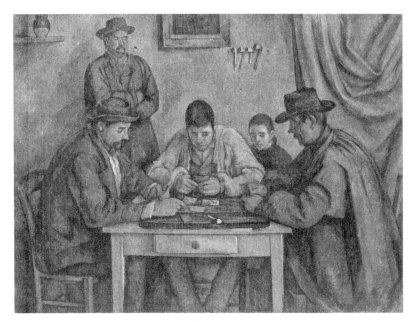

Cézanne's Card Players, *finished in 1892, might have spoken to Barnes about working people, but he preferred to talk about how its "volumes, planes and spatial depth are accentuated in the group of figures and in the setting."*

matic color to describe even the drabbest grays and tans of the peasants' clothes and setting; he paints fingers that barely separate out into individual digits and eyes that quite disappear into their sockets, defined only by black brows above and lashes below, or rather by the dabs of black paint that depict both. And throughout all this, "contrast is ubiquitous," as Barnes noted when he came to expatiate on the painting. "It extends to the color-scheme, in which tones of red, green and orange-yellow relieve and diversify the prevailing blue; to the kind of rhythms and the degree of their perceptibility; to the alternation of angular and oval motifs in the pattern of lines and planes; and to the degree in which volumes, planes and spatial depth are accentuated in the group of figures and in the setting, respectively."

What Barnes could never acknowledge were the incoherence and illegibility—the deep weirdness—that do so much to make

Cézanne great. The scientist in him needed to find order where, maybe, disorder was the thing to enjoy.

A few months after getting that Cézanne, a future icon of the foundation, Barnes heard news of a rare Seurat that had come on the market, the stunning 1888 *Models*, and he spent the summer of 1926 haggling to buy it. (See figure 12 in color insert.) The painting stood as the apogee of pointillism, he said, better than Seurat's *La Grande Jatte*, then a new treasure at the Art Institute of Chicago, because "more novel and daring in composition and richer in the color content." In a sense, Barnes could feel that his purchase also gave him a hold on the Chicago picture, since Seurat had shown it filling one wall of the studio his models were posing in.

Another aspect of the painting might have had a special ap-

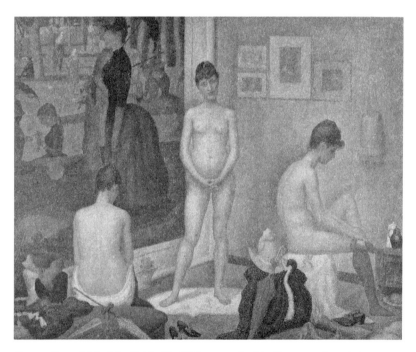

Georges Seurat's Models, *finished in 1888, was prized by Barnes as the artist's "most important work" because it represented pointillism at its height.*

UNIVERSITIES | THOMAS MUNRO | EUROPE | CÉZANNE AND SEURAT | ART EDUCATION *253*

peal for Barnes: the models of its title were three quite young girls, posing stark naked. There's no denying the whiff of lechery always hovering around Barnes and the appeal to him of anything earthy and demotic; he reveled in being "bad." (A doctor acquaintance wrote to him, laddishly, to ask if one of Seurat's models might perhaps need some Argyrol, as a cure for VD.) But the painting's prurience wasn't completely gratuitous and obnoxious, since sex and its sale played a serious role among modernists of Seurat's era, as a marker of the "modern life" that was supposed to be their new subject. Given that Barnes came into adulthood just when Seurat painted his *Models*, to him its subject could still register as modern (if his formalism would permit it to register at all) in a way it couldn't for a younger collector or critic, who would already have viewed the Belle Époque as quaintly nostalgic. By 1926, a flapper's bob had replaced Seurat's chignons as a sign of sexy modernity.

By the time the foundation moved into its new building, early in 1925, it could announce a course at Columbia plus two more at Penn to be taught by Munro, all evangelizing for Barnes's Dewey-ized aesthetics.

At home in Merion, the foundation itself led the charge for that cause seven days a week. It announced that on Sunday and Friday mornings local professors of art and music, accompanied by "teachers in the public schools, stenographers, clerks, chauffeurs," would gather to hear Barnes himself demonstrate his theories in front of his pictures, for fully three hours at a time. On other days, students from one university or another would be in attendance, to profit from a Deweyan exposure to Barnes's art, as led by one of his more scholarly lieutenants. Other art-looking sessions, led by staff who had mostly trained themselves, would follow on from the

successes Barnes claimed for the Argyrol factory seminars, reaching "the kind of people who do not go to colleges but who have a genuine interest in art."

And all that in-person teaching would be supplemented by the wider outreach provided by the new *Journal of the Barnes Foundation*.

Readers around the globe could turn to it for upbeat accounts of the foundation itself (by Mary Mullen), of African art (by Paul Guillaume), of psychological aesthetics (by John Dewey), and of Cézanne and Renoir (by the foundation's own founder). But that positivity was more than counterbalanced by the journal's screeds—by Munro's takedown of the "authoritarian" aesthetics of Bernard Berenson and Buermeyer's fish-in-a-barrel denunciation of a local art club's "low level of taste and discrimination," but especially by such items as "Educational Disorder at the Metropolitan Museum of Art" and "The Shame in the Public Schools of Philadelphia," all written by Barnes himself.

"We cannot construct anything new and important without hurting somebody," Barnes said. But as Dewey warned his collector friend, "If you pursue a too negative policy you will find the foundation isolated."

It didn't take long for Dewey to be proven right.

When Barnes's new institution had first opened for business, it had declared plans to host a weekly "conference" of local educational leaders to discuss ways to improve art instruction across America and especially in Philadelphia's school system. Barnes at first took steps to keep feathers unruffled among local educators, insisting that his goal wasn't to promote "cubism, futurism and other extremist types of art in the schools."

But his meetings came with a tendentious *parti pris*: "The idea of this conference is to organise a definite program and endeavor to have it supplant the admittedly antiquated ones now in general operation." Thanks to a briefcase of "data" supplied by an

informant in the state capital, Barnes launched a broadside attack on the various "antiquated" pedagogues and school boards in Pennsylvania.

For once, Barnes hadn't thrown the first punch. Back when he'd first announced the foundation's collaboration with Penn, the Philadelphia school board's new head of art instruction had aimed a roundhouse at Barnes and his art. "No one could be expected to hang such examples on the wall of a home. Paintings of that nature make me physically ill," he had said to a local reporter. And now, as Barnes was weirdly happy to admit, he was hitting back. He brought his foundation staff to an art teachers' meeting to lambaste local art education as "merely a reshuffling of cards long since defaced and mutilated" by instructors impervious to real art.

"Now what have you done?" wrote one art teacher to Barnes, after the once-promising relationship had soured. "Have you shown any sympathy for the problems with which we are faced every day? What do you even know about those problems? . . . You profess to have an idea that you wish the teachers of Philadelphia to accept, and just at the minute that they were ready to listen to you, you antagonise them one and all."

Philadelphia's educators and its Main Line collector went their separate ways.

CHAPTER 28

Barnes between his assistants Violette de Mazia (left) and Laura Geiger, in Brides-les-Bains, France, in about 1930.

FAILED ALLIANCES | "THE GIRLS" AND DE MAZIA | DEMONSTRATIONS

"When we got rid of the Penn and
Columbia incubi we went on our own"

Few alliances with Barnes ever lasted.

Early in 1926, barely a year after the foundation's ribbon cutting, Barnes was accusing Buermeyer of laziness and disloyalty, despite the young scholar's decade-long attendance on him. "It is futile to try to combat paralysis of the will," wrote Barnes, "I am finished with you." (That wasn't true. Some months later, he lent strong, sympathetic support to Buermeyer after he survived that near-fatal beating by his lover. He gave him work of one kind or another for years afterward.)

Barnes didn't have any more patience with Munro. "If I saw any hopes to wake you up, to bump the fatuity, nerve and 'front' out of you, I would be willing to put up for a while with the kind of teaching and other activities you have done with us," Barnes wrote to Munro.

By the spring of 1927, Barnes had had enough of watching his "nonchalant, indifferent and lazy" employee live a life of "voluptuous ease" on his foundation salary—a modest $400 a month. "The pupils have learned nothing about pictures because the teacher never learned about them himself in terms of experience," wrote Barnes. He fired his former favorite.

Munro soon got a fine university job and published an important little book called *Scientific Method in Aesthetics* that could easily be read as a repudiation of Barnes's method. It talked about the absurdity of banishing subject matter from talk about art and how a good critic would "feel it tiresome to go into meticulous analysis of a form, or of his responses to it; few readers would follow him." Munro's quite un-Barnesian conclusion? "Rather than to start out with an exclusive definition of what is *really* aesthetic experience, or a dictum as to how people *ought* to look at art, an experimental attitude would be to find out in what various ways they *do* look at art"—almost a direct attack on the Barnes Method, but just veiled enough that Barnes himself didn't seem to notice when he read the volume, and praised it. He could recognize an attack only if it was pretty blatant; otherwise he enjoyed most any kind of attention.

Just when he fired Munro, Barnes was talking about how the foundation's journal, founded for outreach to a larger public, had to give way to "class work" within the foundation walls. He killed the publication.

He had also given up on the idea of sowing his ideas at Penn. Barnes claimed to ditch Penn because its students were hopeless, but the real reason comes out in a pile of baleful letters that accuse a Penn professor of plagiarizing him.

The "deadwood" on the Columbia faculty led him to break with that university, too.

At one point, he was depressed enough about these pedagogical failures to talk about dispersing the collection and moving to France. Instead, he regrouped, moving all classes to the foundation's own buildings and having them taught by the people trained there.

"When we got rid of the Penn and Columbia incubi," Barnes later recalled, "we went on our own." Amazingly, for that era, aside from

himself the "we" he had in mind were all women—"the girls," as he called them.

Failing to find a man to replace Munro—"society demands that it be male and not a female," Barnes had written to Dewey, knowing society was wrong—he looked instead to Nelle and Mary Mullen, joined in their educational work by their longtime colleague Laura Geiger, seconded from her Argyrol duties.

A new colleague joined them, remaining on board for a full sixty years, thirty-five of them as the foundation's key figure after Barnes's death. This was Violette de Mazia, born in France in 1896, as "Yetta," into an elite family of eastern European Jews. De Mazia got a fine education, in French, Flemish, English, German, and Italian, as her parents moved to Belgium and then England. She had grand plans for marriage to an RAF pilot and a home in Palestine. The two lovers exchanged piles of heart-wrenching letters, in three languages, while he trained in Egypt. "My head aches, *la gorge m'étreint à en mourir* and all I can do is to let my heart throb as it has continually been doing since God last allowed me to notice your divine little arm waving at me from the pier," the pilot wrote. And then he nose-dived his plane during a training flight. Instead of settling into married life, de Mazia ended up an immigrant, leaving for the United States in May of 1924, apparently with hopes for a career as an "artist (painter)." She landed with relatives who were prominent in Philadelphia's cigar trade and in the city's Jewish life. (Although when asked her "race" on a form, the new immigrant preferred to write "Russian.") De Mazia found work teaching French at a girls' school but also to women at the Argyrol factory. By her second summer with Barnes, in 1926, she had been asked to join a foundation trip to Europe—where she had to go, anyway, since she'd been ordered deported for overstaying her welcome in the United States. By the fall, de Mazia was back and rendering "fine services" on Barnes's *Art in Painting*, as he acknowledged in the preface to that magnum opus. She went

on to be one of the most ardent evangelists for the Barnes Method; she was a co-author on all her leader's future books.

Barnes raved about her to Dewey: "Five days a week, for over a year, she has spent an average of six hours a day in our gallery by herself looking at what is in the paintings. . . . She has made me see things in pictures I never saw before"—high praise from a man who tended to rate his own eyes over anyone else's.

Violette de Mazia was a small, slim woman who had once practiced gymnastics and competitive swimming; at almost forty, on holiday with Barnes in the South of France, she was aquaplaning behind a motorboat. She had pale blue eyes, dark hair cut almost flapper short, and a soft, transatlantic accent, leaving her with a classy and faintly exotic air. There has always been talk that the decades de Mazia spent at Barnes's side also involved time in his bed, given her boss's reputation as a womanizer. (A female employee once accused Barnes, with no offspring, of having offered her money to bear his child; he called it a shakedown.) In a letter from the summer of 1936, de Mazia writes of steaming across the Atlantic with "Doctor," who moved her into a first-class suite with private deck next to his, "and we both felt as if we owned the ship or were travelling on our own private yacht."

But there's no actual proof of an affair, and some evidence against one.

On their many trips abroad they were sometimes joined by Laura Barnes, who might have raised objections to their proximity if she had suspected a romance. Later, when Laura Barnes admitted to detesting de Mazia, the rivalry could have been as much for power and attention at the foundation as for Barnes's bed.

Also, in Barnes's vast and quite personal correspondence with Dewey there's no hint of boy talk when he mentions de Mazia, as there could be in the case of other women. A few years before de Mazia came on the scene, Barnes had described how "Helen of Troy and Venus were cross-eyed cronies" com-

pared with a certain thirty-three-year-old he'd met named Olive Skemp. Wife of a steelman, she was "a stunning woman physically," said Barnes. She wrote to Barnes that even after they'd decided to be "just friends," his absence one day when she called made "all the hope and expectancy in my mind and heart . . . roll together into a great *futility*."

De Mazia's appeal to Barnes might have had something to do with the contrast between them: she was a fancy Jew who had rather fallen; he, born into Methodist poverty, had ascended. But above all, Barnes seemed compelled by de Mazia's sheer energy, competence, and intelligence—she had a steel-trap memory like his—and especially by her astounding loyalty.

"Miss de Mazia has developed into a wonderful lecturer in front of the paintings," Barnes wrote to Paul Guillaume in the spring of 1927. "She lectures on the plastic qualities of the pictures themselves, and Miss Portenar"—another of Barnes's "girls"—"lectures on the general aesthetic principles. . . . They have had two classes thus far and they were the best we have ever had." Those two classes set the model for another six decades of the same.

In what were called "demonstrations," the foundation staff would aim to get students to have a reaction to each individual painting that would make it as much a part of their quotidian lives, said one foundation instructor, as "eating, sleeping and reading." Undistracted by art historical facts, students could be taught to "see" anew, opening themselves to a work's "plastic form," which included everything visible on its surface but also how that came together to render the world through an artist's personal vision. When lessons involved comparing the visions of various artists, from various eras, their works would be hoisted off the walls and gathered in one lecture space—a practice that continued even af-

ter Barnes's death, well into an era when such manhandling was anathema to any conservator.

These comparisons would walk students through the Barnes holdings from Greek sculpture to Renaissance painting to Rubens, Fragonard, and Renoir, so as to reveal how plastic form evolved across those traditions—one of the most important tenets of Barnes Thought.

Mary Mullen said that in one demonstration she proved, by the "objective" proofs Barnes held so dear, that a Barnes canvas

Moïse Kisling's Buste de jeune fille, *from 1922. A laddish visitor to the Barnes Foundation teased that he admired the painting's "fine spatial relations."*

by Moïse Kisling, a minor French modernist, took off from spatial problems first explored in the work of the early Florentines. Her anecdote doesn't mention that Kisling had painted a distinctly modern woman with her large breasts exposed. The painting is surprisingly tender, even poignant: making a half-hearted effort to cover her breasts, the sitter has an awkward self-awareness that male artists rarely capture. But attending Mullen's session, a local art professor—a man, of course—said that he was finally able to take pleasure in Kisling's nude after Mullen had pointed out its "fine spatial relations." He had to have been poking fun, but Mullen quoted him as a convert to the Barnes Method. Barnes tended to elevate straitlaced disciples who were never as ready for ribaldry and double entendre as he was.

Of a Sunday morning, Barnes himself would speak before as many as three hundred people, recalled Paul Guillaume from a Merion visit. "He doesn't use notes; he stands there, composed, taking in the crowd, and then launches into his speech, going right to the heart of the matter on whatever subject he thinks will trigger the most contention," said Guillaume, wearing his courtier's hat. "His tone ranges from tender to tuneful to grumpy to harsh. He marshals his breath, avoids wearing himself out, rests then starts again. The faces before him show understanding, joy, excitement." Barnes would invite questions after he spoke, and anyone with the courage to ask one would be treated to the Doctor's endless analysis of the issues at stake, "studying the question, clarifying it, folding, unfolding and twisting it around for his own fun," said Guillaume. You wonder how many follow-up questions there might have been.

The foundation eventually registered as many as two hundred students at once, according to Barnes, about half coming from quite nearby and the others from across the country or as far away as Greece and India. One weekly class might be dedicated to the

artists who had enrolled, another to the educators, and a third to people of "general culture," with Barnes then batting cleanup with his Sunday lecture.

There was no tuition fee. Applicants—more like supplicants—submitted informal letters of interest, which were judged according to criteria known only to the foundation. As Barnes put it, "We do not always follow priority but do our best to select what we think is the most promising material for instruction." Too much prior knowledge or training might actually be an obstacle to getting in, while a personal connection to Barnes clearly helped, as did just the right kind of social, intellectual, or cultural status—while the wrong kind could ruin an applicant's chances. Some hopeful souls were asked to show up to be judged in person, sometimes on the first day of classes. Course requirements were "a genuine interest in the work, do all required reading and attend all the classes regularly." Inattentive students were soon shown the door; so were students who questioned the Barnes Method.

Throughout all the foundation's teachings, works of art old and new were tied, somehow or other, to the Deweyan psychology that students were also immersed in.

That psychology certainly supported the central Barnesian tenet that any true understanding of art came only from an immediate immersion in it. But in practice, even the simplest of Mullen's attempts to explain the "demonstrable" connections between Deweyan theory and Barnesian observation can verge on the opaque and arbitrary. It's easy to resist Mullen's "proof" that Barnes's two heroes Titian and Renoir are in fact and definitively closely akin, and that anyone who might disagree has failed to understand the Deweyan truth that correct aesthetic "sight" involves "a series of flashes of varying intensities (perception, consciousness), thrown

intermittently upon that persistent, substantial structure of meanings which is mind." Deweyan theory, in Barnesian hands, could easily become the "mere verbal formula" that the philosopher inveighed against.

Sophisticated visitors could be less than impressed with the quality of the foundation's pedagogy.

An academic who had actually taught at the foundation described its teaching as "a sincere (though misguided) thing" that was "of extremely poor caliber."

Attending his first Sunday lecture by Barnes, Fiske Kimball, newly appointed director of Philadelphia's art museum, found the great collector intolerably long-winded and prosy.

After being rudely informed that he couldn't see the art without being lectured about it, a young Columbia colleague of Dewey's challenged the foundation's entire pedagogical premise. "I take it that you do not recognize educational activity unless it is officially designated as such by the presence of a teacher," he wrote, and then showed, quite correctly, that this went against Dewey's educational principles. "I have passed the time when I study under personal supervision; the days of my tutelage are over," he concluded—at the ripe age of twenty-six.

Barnes sat down to write a reply, signing it "Peter Kelly, Third Assistant Mailing Clerk." It's worth quoting at length as a classic example of his style:

> When your letter of December 26th arrived, I felt I had made a *faux pas* of some kind and I hastened to lay the matter before Dr. Barnes. Unfortunately, the conditions were not favorable as you can imagine when I give you some of the details:
>
> A group of French artists are spending the Christmas holidays at the Foundation, and this morning I found them seated around the table, with empty bottles strewn every-

where. Several effigies, obviously of modern and contemporary artists, were seated at the table and one of them, who resembled Cézanne, had his lips manipulated by one of the other artists and was singing a ribald song in which the whole group joined in the chorus. I learned that the party had been in continuous session since Saturday night. When I attempted to get Dr. Barnes's attention to your letter, he playfully threw a bottle at me and resumed his singing. From what I know of similar parties I fear it will be several days before Dr. Barnes will be in condition to consider your proposition to bring your friends to the gallery at any old time that their other engagements permit them to come here.

Ezra Pound, who once said that he had never known "anyone worth a damn who wasn't irascible," described Barnes as living in "a state of high-tension hysteria, at war with mankind." By the time Pound gave this description, that was already the general impression, which Barnes did more to encourage than not.

CHAPTER 29

Charles Laughton at the Barnes Foundation in October of 1940. "I enjoy having you here, you are not a damn bit of bother and I get a kick out of your enjoyment of the pictures," Barnes wrote to the movie star.

EJECTING ELITES | FINE SCOTCH

"It is a very ticklish business to obtain
admission into the Barnes Foundation"

lready by 1926, barely a year after its inauguration,
the foundation's leader and staff began to register
the resistance they faced. They complained bitterly
about how slowly they were making progress against the "outworn
and irrational methods" that still prevailed among both their
colleagues in art education and the students who had been misled
by them. After a few months welcoming such people into their
midst, said Mullen, it had become clear that "from the educational
standpoint, these professors and their students got hardly more out
of their visits than did the group of bankers, lawyers and college
professors who had also been admitted frequently."

The only option was to man the ramparts and raise the draw-
bridge against those overcivilized hordes.

It soon became "a very ticklish business" to get access to the
Barnes Foundation. "There are formalities to be undergone, rec-
ords to be looked into. The Pope, sitting on his throne in the Vati-
can, is much less careful for his most holy toe than is Dr. Albert
Barnes for his hundred and twenty Renoirs and his two and forty
Soutines," wrote a certain Guy Eglington, in *The Art News*. Once
admitted, through the good graces of a friend, he had found the
foundation's pedagogy particularly tedious, but he didn't have to

suffer it for long. Before the morning's teaching was over, Barnes had caught on to Eglington's reservations and handed a note to the man who had brought him: "Tell that blackhaired bird his manners are bad—he talks, looks around, smiles superiorly, and pays no attention to the speaker. . . . His background, his intelligence is too meagre to even begin the kind of work this class represents. Tell him to beat it!"

Eglington was an early example of the ejecta the institution went on to be known for. In the 1960s, a state prosecutor who had fought to broaden admission to the foundation spoke of "the despair and exasperation of art lovers throughout the world who have been rudely barred from its doors."

Almost from the beginning, Barnes had been describing his method and his collection as inseparable parts of one whole, meaning that only those prepared to learn the ideas would get to see the art: "The general public is admitted if it conforms to the conditions of the educational institution." In his earliest negotiations for Captain Wilson's land and trees, Barnes had written to his lawyer, the future Supreme Court justice Owen Roberts, that like all modernist culture his art was "caviare to the public"—that is, beyond the appreciation of average Americans, like the ones Barnes employed making Argyrol. Public admission would therefore be restricted to just two days a week, and "only upon cards of admission issued by or under the direction of the Board of Trustees." (Buyers of Barnes's *Art in Painting* got one automatically.) In a later lawsuit, he was heard to say that his foundation was "no place for the rabble. I have nothing to say against the rabble, only that it is a rabble. I came from the rabble, as I think most of our people did—what was once the rabble. The only thing is, we have risen."

But as news spread of Barnes's collection, he decided to keep out the non-rabble, or risen rabble, as well. He said he had it "up his sleeve" to have his foundation go after "the prominentists and

ignoramuses who control the regimented flock that inhabit the academies, art alliances, etc."

For all Barnes's love of deep and even complex thought, as offered up by quite academic heroes of his such as Dewey and Bertrand Russell and also on display in the sophisticated art he preferred, he had an almost paranoid view of intellectuals and culturati—"the doddering idiots that preach dogma instead of sense."

After receiving a copy of an article on Matisse from the young scholar Meyer Schapiro, Dewey's new colleague at Columbia and one of art history's great pioneers, Barnes sent this offensive reply:

> I recalled, as I read it: "Little Jack Horner, sat in a corner, eating a Christmas pie. He put in his thumb and pulled out a plum and said 'what a great boy am I.'" But you go Jack one better by that Olympian elaboration of the obvious and insignificant which is as characteristic of how you got that way as is your amputated prepuce. It would be difficult to decide whether the cock-eyed thinking or the diarrhoea of highfalutin words is the more offensive of your substitutes for authentic experience.

According to Barnes, a lot of college education didn't even rise to the level of cockeyed thinking; it was mostly about providing "polish-oil" for social display.

In a rare moment of almost Barnesian aggression, Dewey seemed to agree. In Barnes's beloved *Democracy and Education*, the philosopher had launched an attack on upper-class culture as "sterile," on its art as "showy display and artificial," on its knowledge as "overspecialized," and on its manners as "fastidious rather than humane."

Already when Cret's buildings were still months from being finished, Barnes had decided to bar entry to most academics, experts, and connoisseurs—to anyone who might represent "the em-

bodiment of the affectation and pretense which is the antithesis of the reality which the Foundation represents." In the end, "the carpenter, baker, chauffeur, who stand the test of interest," was supposed to be given preference over "elks and Presbyterian ministers installed in high places." What frustrated hopeful art lovers for the next twenty-five years was that only Barnes and a lieutenant or two seemed to know for sure who belonged to which category. As *The New Yorker* put it, in its 1928 profile of Barnes, "Visitors to the foundation are admitted or not, depending on Dr. Barnes's mood."

The list of the admitted was never very long, and dwindled over time.

In his foundation's first years, Barnes could still be found letting in various book clubs and teachers' associations and the like. A group of local painters was also welcomed, although warned not to bring along "collectors and newspaper writers." (The latter, he once said, "after our dogs are finished with them we bury in the manure pit.") And even after Barnes had mostly closed the gates, he might send a car as far as New York City to bring up some worthy guests, if he thought the visit worthwhile.

T. S. Eliot was admitted—Barnes knew and admired the great modernist's criticism—as was Carl Van Vechten, the photographer who documented the Harlem Renaissance.

Once Barnes befriended the actor Charles Laughton, a fellow fan of Renoir, the foundation's doors opened wide: "Stop kidding me in saying that your visits to the Foundation are subject to any possible restrictions on my part. I enjoy having you here, you are not a damn bit of bother and I get a kick out of your enjoyment of the pictures. If you don't make this a stopping place on each of your trips east I'll feel slighted." Unbelievably, Barnes went so far as to lend Laughton almost twenty works from the foundation's collection, to help him decorate a new house. Reading the sprightly letters that Barnes sent to his pal "Buster," you'd never guess the collector had ever been the least bit dyspeptic.

Even a pillar of the establishment like Kenneth Clark, director of London's National Gallery, could find a surprisingly warm welcome at the foundation, despite being Oxford trained and brought up as one of England's "idle rich," as he himself phrased it. Out of the blue, he asked for admission to the foundation and got it, and that was the beginning of a friendship that was "almost embarrassingly warm," according to the British lord's memories of a collector he judged "not at all an attractive character . . . but his passionate love of painting made him supportable."

And then Barnes showed himself as insupportable as ever when a minor British notable tried to use a recommendation from Clark to get access to the foundation, only to find himself diagnosed as emotionally disturbed. Unlike many founders of private museums, who use their art to show off their culture and wealth to established elites—often so as to join their ranks—Barnes could use his foundation to prove his contempt for his supposed "betters," thereby bringing them down a notch.

The motives behind Barnes's closed-door policies weren't entirely bad, or selfish, or exclusionary. They were not only about his private and persistent neuroses. He really was committed to finding new ways of looking at art and teaching about it; he imagined an institution entirely undistracted from those goals. But the net result was that vast numbers of great paintings remained mostly unseen, and an unseen painting is an impotent one, foiled from doing its cultural work.

Barnes's rejection or ejection of most elites didn't stop him from adopting their lifestyles, taking his earlier extravagances to the next level. He went shopping for a deluxe, 80-horsepower Voisin C3L sedan, one of the first passenger cars to be wind-tunnel tested. (Guillaume already owned one.) And despite Prohibition,

somehow Barnes developed a taste for twenty-five-year-old Glen Grant scotch, a single-malt whisky that was a "favorite of the King of England," or so Barnes had heard. The collector became legendary for it, single malts not being available to the American public until decades later. After repeal, Barnes had visiting art dealers bring cases of Glen Grant over from Europe so he could prepare the "top-notch aesthetic experience" of his signature cocktail: three ounces whisky mixed with three ounces Perrier water. As Lord Clark recalled, "Barnes used to dispense whisky with great solemnity. 'I'm a doctor, you know. This is a scientific high-ball' and he measured each tot in a test tube and weighed the cubes of ice." (Before repeal, Dr. Barnes seems to have prescribed himself Old Forester bourbon as "medicinal whiskey.") Barnes went on to cellar the best vintage Bordeaux and the rarest of Spanish wines.

"A few weeks ago we drank to your health in the last glass from a bottle of 1860 sherry you gave us," wrote a Princeton professor to Barnes. "It was the finest I have ever tasted."

CHAPTER 30

The grand Barnes Foundation on its deluxe grounds. When developers planned to build modest houses nearby, Barnes said he would change his institution into "a center for the development of the artistic and intellectual endowments of Negroes."

THE NEGRO CENTER | FOUNDATION FELLOWSHIPS | HENRY HART

"Dr. Barnes's ridiculous proposal will be
fought with every ounce of energy"

MERION GIRDS TO FIGHT NEGRO SCHOOL PLAN
*Fashionable Main Line Section Aroused by New Project
of the Barnes Foundation—National Centre Proposed—
N.Y. to Get Great Art Collection—Reprisal for Zoning Seen*

On April 14, 1927, readers of *The Philadelphia Inquirer* woke up to find that headline on the front page, and it pretty much summed up the situation. Without much consultation with locals—in particular, with a certain gentleman named Albert Coombs Barnes— commissioners of Lower Merion Township had changed the area's zoning, allowing them to approve the development of fully 126 small houses on a plot that bordered the foundation. Barnes was appalled at the prospect of his deluxe neighborhood devolving into what he described as a slum—"the very urban conditions I sought to escape"—which he felt sure would weigh against the "civilizing influences" of his Barnes Foundation.

With visions of the Neck crowding his sleep, the collector once again went on the attack. He said he refused to join his

neighbors in accepting "ignominy and an impending enormous depreciation in their own property values." Instead, Barnes intended to let his $10 million collection and endowment find a less "incongruous" home in New York, at the Metropolitan Museum of Art: "I shall be a humble and unworthy follower of great people like Stokowski, Mary Cassatt, Abbey, Sloan, Glackens and many others—who leave Philadelphia to get a breath of fresh air and never come back." He would then turn his Merion campus into a national center for the "development of the artistic and intellectual endowments" of Black Americans drawn from across the country.

After his neighbors voiced opposition to his plans, Barnes told the *Inquirer* that "arousing race prejudice is a dangerous thing"—although "race prejudice" was precisely what he was trying to arouse in those neighbors.

Barnes denied that his new center was in any way a reprisal for the zoning change; he cited his longtime interest in Black culture and rights. But if not a reprisal, his proposal was clearly meant as the most brutal of bargaining chips. He told his lawyer he was wielding "the negro menace" to get his way.

He had already promised (threatened, really) to buy at least six of Merion's modest new homes to donate to a group of elite African Americans—college graduates, he said, and professionals— "who wish to establish a settlement in the suburbs of Philadelphia where intellectual people of their race and class would find a congenial place to live." Barnes billed this as part of the "idealistic project" for Black rights and education that he'd been working on for many years.

To get local officials to revoke permission for the housing project, he made what he seemed to think was a foolproof and generous offer: He'd give them a private tour of the wonders of his art collection, to prove how much they'd miss it once

it moved, and if that didn't do the trick, he'd soften them up with the last three bottles of the 1840 sherry left in his cellar. No softening was in view, however; Barnes actually waited at his door for the county commissioners, but they were no-shows. Once steam shovels began clearing the way for those new homes, Barnes began to make new threats: He would be discontinuing work with Columbia University, he said, in order to devote his resources to a collaboration with another university just a few miles south of Merion. "We expect a howl of protest," Barnes said—because the new collaborator he had in mind turned out to be Lincoln University, the African American institution that, after Barnes's death a quarter century later, would be deeply involved in the foundation's future.

It was only after his hints and pressure campaign got no results that Barnes went fully public with the plans for his Black culture center, earning headlines in papers all along the East Coast. As the *Inquirer* put it, Barnes's announcement had "driven residents of the highly fashionable and ultra-conservative community into a state closely bordering on hysteria." Which of course was precisely his goal. "I think I can speak for almost every citizen of Merion when I say that Dr. Barnes's ridiculous proposal will be fought with every ounce of energy," said the local magistrate Howard S. Stillwagon Jr.

Within days, Merion officials seemed to be giving way, with a special board formed to hear appeals to the zoning change. But in the end, the suburb was not allowed to return to the mansion-filled state that Barnes was angling for. The tidy houses were built and stand there to this day.

Barnes had to content himself with building a wall, three hundred feet long and ten feet high, so he didn't have to see the development and its new residents couldn't enjoy a view of his foundation's lovely grounds. Newspapers dubbed it a "spite fence,"

which seems just about right. Barnes took care to give the stone on his side a lovely old-world elegance, and to make its other face look like a cellar wall.

Barnes's proposal for his "Negro Center"—or rather, his threats of one—clearly came with a big dose of cynicism and cruelty, but it wasn't entirely cynical and cruel. Barnes did truly have, still, an interest in Black advancement.

Unlike many of his peers in Philadelphia's deeply and explicitly racist establishment, he would almost certainly have been pleased to see someone, somewhere, establish a center for Black education and culture. He might even have pictured himself having been that someone, in some alternate reality where art didn't dominate his life.

At just the time the zoning change was being planned, Barnes was reading *Porgy*, the novel of Black life that went on to become a hit play and then the famous Gershwin opera. That same spring, he donated $1,000 to *Opportunity* magazine, which had been on very hard times, while an educator who wanted to launch a new mass-market magazine for Black people—to be called *Ebony*—thought it natural to ask Barnes for help.

Barnes presented his plan for the Negro Center in such detail to the Black activists he knew, and with such apparent earnestness, that they certainly took it seriously. Charles S. Johnson, editor of *Opportunity*, jumped on a train to Merion at Barnes's sudden and urgent request and was shown the announcement about the center that Barnes was planning to pass to reporters. In a clever move, Barnes proposed to invite Black people to Merion, which involved such an extreme act of desegregation, by 1920s standards, that the activists themselves hesitated to support it, for fear of stalling

more modest progress they were hoping for across the nation. That left them the ones backing off from the plan, reassuring journalists that it was only in utero and might not come about exactly as announced by Barnes, whose real hope was that it would never come about at all. As he admitted in an open letter to the citizens of Merion, "I would be the last person to do anything contrary to the wishes of my neighbors of the past twenty-two years. The ideal would be to continue our present educational plans and to have Merion retain our art collections for all the ages to come." It's likely that America's Black progressives knew perfectly well that they were, as usual, being manipulated to serve white ends, but hoped to earn some slight benefit from the manipulators. If nothing else, there might be something to be gained from the sheer force of Barnes's rhetoric in support of their cause, even if it didn't pan out in action of equal impact.

That fall of 1927, when it became clear that Barnes had lost his fight against the "slum" houses and that his threat of a Black presence in Merion had been empty, his support for African American culture didn't just come to a halt. If anything, it became all the more public, although not at the scale Barnes's threats had suggested. Maybe, deep in his heart, Barnes knew that he had betrayed the trust of Black leaders and felt some desire to earn it back.

In October, Barnes won headlines when his foundation funded its first two Black fellowship students. Gwendolyn Bennett, "eager, sensitive, but greatly in need of guidance," according to Johnson's recommendation, was a young author and artist who had been with Barnes at that Civic Club party a few years before; her poetry had been included in the "Black art" issue of *Opportunity* that Barnes had a hand in putting together. After a few months at the foundation, she traveled to North Carolina to speak at the Stock-Taking and Fact-Finding Conference on the Ameri-

can Negro, and wrote home to Barnes that it was particularly appropriate for her to appear there "because of my also being at the Barnes Foundation which represents so much in the search for the true type of development the Negro needs"—words that don't seem to harbor any doubts about Barnes's commitment to helping African Americans.

Joining her on fellowship was Aaron Douglas, the "most genuinely talented" of younger Black artists, according to Johnson, who had visited the foundation the year before, when he had been too shy to corner Barnes but had reveled in its African objects. After Barnes had had a chance to see some of Douglas's illustrations, the artist arrived at the foundation to take a "specialized course in picture analysis."

Barnes offered to extend the same funding to a young white man: "Why don't you blacken your face long enough to enroll with Douglas and Bennett in the remaining Foundation fellowship?" The offer was made to Henry Hart, twenty-four years old, a reporter turned acolyte who Barnes had cultivated for some months already and who himself had cultivated Barnes with a zeal that can sound close to sycophantic. After getting Barnes's help on a series of articles on Pennsylvania's mental hospitals, Hart wrote to the collector that he recognized "the essential elements of greatness in your character . . . your vitality, your capacity for living fully, and your insistence upon reliance in the strongest and bravest adventures of the human mind." Barnes returned the compliment by "helpfully" pointing out the many flaws in his new disciple's character and then giving him work.

In the fall of 1927, he assigned Hart an important task: joining him in defending Black rights and culture at a meeting of the NAACP. "White Speaker Urges Negroes to Solidify: Stresses Importance of Not Trusting the White Man at All Times" was

the headline published in a local Black paper that covered Hart's speech. The meeting led to Barnes's suggestion that Hart put on (metaphorical) blackface and accept a fellowship that was supposed to support him while he did further work for the Black cause. An experiment in integration would already be under way, said Barnes, in the mere fact of having a white fellowship holder studying alongside two Black ones.

For all Barnes's manipulation, condescension, and racialized language and thoughts, and however hedged around by his neuroses and artistic interests, his ideological commitment to desegregation and equality was real.

Within a few months of the NAACP meeting, Barnes joined a group of Black creators—including Douglas, Bennett, and the poet Countee Cullen—on the *Negro Achievement Hour* of a mainstream radio network. Broadcasting from the prestigious Steinway Hall in New York, Barnes spoke of African American music as "infinitely richer in rhythms" than anything European. He praised the art of Africans, when free from white depredations, as equal to anything produced by the Chinese, Egyptians, or ancient Greeks. It was also, he said, at the root of all the best in modern painting and sculpture and of the latest in music, dance, decorating, and even fashion; the revolutionary clothes of Paul Poiret were said to depend on African aesthetics.

Someday, said Barnes, waking up to that influence was sure to end "superciliousness on the part of the white race."

By Christmas of 1927, tensions between Barnes and Hart had led to a break in their relationship, prompting Hart to share a particularly astute analysis of Barnes's character with the man himself:

1. To a fundamental feeling of inferiority there has become attached a persecution mania, which leads you into irrational hostilities with your environment and results in the terrible aloneness in which you are now lost.

2. Various overcompensations have become habits and seem to you valid and even preferable *modi vivendi*; they have trapped you, and made your life and the Foundation sterile.

They are:

a. Finding solace in the flattery and "yessing" of mediocre women, and thus avoiding the fact of your inability to associate with men on genuine terms.

b. Incomplete interest in minority movements, such as the Negro; your act of last spring proves your interest in the Negro to be merely a compensation for your isolation from the environment.

c. Your delusion that 18 boys and girls, selected by whim, listening to a woman recite with no conviction and no charm what you have drilled into her, constitute a justification for your hopes.

d. Your elaborate rationalizations for your failures to affect the environment.

e. Your constant chatter about method, when you have none, either in your own life or in the Foundation.

f. Your escape to the dream world, via the discovery of significance in the most trivial aspects of a painter's technique.

Those bullet points and several more that followed triggered the usual Barnes invective ("many objective facts cast a doubt upon your assumed intelligence and virile manhood") but ended in reconciliation. Barnes had a grudging respect for the rare subordinate willing to go toe-to-toe with him; the two men worked together for a few more years and then were good friends for decades, exchanging frank views of each other's work.

Hart offered to write his friend's biography and after Barnes's death did publish an "appreciation" of the collector meant to counter other writings that had come closer to the bullet points Hart had once shared.

CHAPTER 31

El Greco's Apparition of the Virgin and Child to Saint Hyacinth, *from around 1610: Barnes saw some older art as prefiguring the modern.*

Picasso painted Composition: The Peasants *in 1906, but Barnes spotted its roots in Spanish art from three centuries earlier.*

DEATHS | ZONITE | RETURNING AN O'KEEFFE

"I am ready to retire and devote all my efforts to the Foundation"

The 1920s closed for Barnes with several endings. His fertile relationship with Paul Guillaume collapsed just seven years after it began, although that counts as an eon for any Barnes friendship. In the summer of 1929, a letter to the dealer confirming the "divorce" sees Barnes chastising his former hero for "your insolence to a benefactor, your satisfaction with standards of success characterized by false pretense, and your ignorance of the fact that even the sycophants who prey on you, ridicule your pretentious parade." The offense? Someone had written an account of Guillaume and had granted him a role—his true role—in forming Barnes's tastes and collection. After trying to calm the waters, Guillaume had at long last given up on that impossible task. He signed off on the friendship with elegance, refusing, he said, to tarnish memories of a relationship that saw the two of them fighting a battle for modern art that, said Guillaume, "is known, and will be forever known, for its quality, its substance and its beauty." Barnes couldn't manage anything like the same grace, probably because, deep down, the relationship had actually mattered more to him than to Guillaume. In a much rewritten letter,

he announced that the dealer's name would be erased from the gallery in the foundation once dedicated to him and declared Guillaume formally "deposed" from his (meaningless) post as foreign secretary.

The demise of the friendship with Guillaume was followed by the actual death of Barnes's father, which might have hurt him less. Despite his war wounds, John J. Barnes lived to be eighty-five, dying of a heart attack on February 26, 1930, under the care of a dear old med school classmate of Barnes's. The old man was buried alongside his wife in the Odd Fellows Cemetery in Burlington, New Jersey, where his tombstone still stands.

Another ending must have helped allay the pain of that one. The previous May, in one of the last roaring months of the Roaring Twenties, some New York bankers had reached out with an offer to help Barnes find a buyer to take over the Argyrol factory. For years, Barnes's company had had annual profits of around $500,000, meaning it was worth something like ten times that much in a sale—and much more than that, Barnes said, for anyone willing to concentrate on it as he hadn't in ages.

"I am ready to retire and devote all my efforts to the Foundation which interests me much more than business," Barnes said to his agent in the transaction. On July 19, 1929, a deal was sealed. For a payment of $5 million, the A. C. Barnes Company would be absorbed into Zonite Products Corporation of Park Avenue, New York, with Argyrol joining its other main product, an antiseptic for "modern young women," which, said its ads, "gives the feeling of daintiness and well-being so necessary to their happiness. *Does not* cause areas of scar tissue nor deaden sensitive membranes."

Luck was on Barnes's side: in three months, Wall Street's Black Tuesday crash would have destroyed any hope of such a transaction. Yet the Barnes products survived the downturn mostly intact. They continued to turn profits for decades.

The following year was fine for Barnes's art shopping, though it's hard to know if credit should go to those new Zonite millions or to falling prices already being caused by the economic crisis. In 1930, he bought the usual suspects: Cézannes and Renoirs (a bunch of those) and works by other French stars he already owned such as Georges Rouault. He also acquired a pile of medieval miniatures and Renaissance panels and one of the famous Benin bronzes from Africa, as well as a big and pretty fine El Greco altarpiece from around 1610, of Mary appearing to Saint Hyacinth. The painter had meant to impress his Spanish audience with the mannerist chops he'd learned in Italy—swirling brushwork and serpentine forms, built on a grid of one-point perspective—but Barnes liked to read such works as prophesying modern styles from four centuries later. (In one sense he was correct, since Picasso and his ilk had borrowed straight from El Greco. Barnes had a perfect example in Picasso's 1906 *Composition: The Peasants*, an early purchase of his that came to hang in the foundation's central hall.)

Barnes's latest purchases offered him something closer to aesthetic comfort than to the challenges he'd faced, and enjoyed, when he first started collecting two decades earlier. But he did go so far as to buy at least one artist's works he was pretty sure he didn't actually like. In March, he'd seen some Georgia O'Keeffes at her husband Alfred Stieglitz's New York gallery, criticized them to his crew when she and Stieglitz were out of sight, and then, to his followers' surprise, went on to purchase two of them, for $2,400. One was a still life and the other depicted a humble New Mexican statue of the Virgin Mary, and both had a certain avant-garde appeal: the still life was the longest of horizontals, with a dish of eggs smack in the middle and then acres of empty modern space at each end; the painting of the statue was a weirdly narrow vertical that brought to mind the taffy-pull distortions of an

El Greco and the saturated colors of a comic strip. "I think they are authentic expressions of yourself and, therefore, genuine art," Barnes wrote to O'Keeffe. And then, adding bitter to the sweet: "Just what they are in the hierarchy of the artists they will live with, time alone will tell."

Writing to Barnes in the loopy scrawl of an aesthete, O'Keeffe said that she felt sure that her paintings had found a friend at the foundation, "and the best friend is the one that sees and understands—ones ups and downs. . . . You must tell me the best and worst that you have to say about them." Friendly letters followed for months: Barnes wrote to O'Keeffe about "enjoying the flavor and color of your picturesque and vivid self." But then he had to confess that he'd bought her pictures from Stieglitz as an experiment, to see if by living with them he could find in them what he had noted as "the charm and force of the art in your personality." But the experiment had failed, he said, and he sent them back to Stieglitz for the refund he'd been promised.

"I am deeply and sincerely sorry not only that I couldn't fit the pictures in the collection but that I should have to tell you about it," he wrote, with a sensitivity and even self-doubt that he almost never showed, and that might have had something to do with his embryonic feminism, or merely with old-school chivalry. "What it means when an experiment turns out this way is, of course, simply a record of a personal reaction—not a universal law that should bother the artist thus involved. . . . I have had the same experience with the work of other artists whom the world has recognized as important. It may perfectly well be that there are phases of art that I miss because of my own deficiencies."

The truth is, like almost all collectors, Barnes could find himself liking and buying—and in his case sometimes returning—a huge variety of very different objects, and it isn't always clear what made one work appeal and another miss the mark. When, in his writings,

he tries to fit his collection into a single conceptual framework, he seems to be struggling with the problem of that variety without ever solving it. His explanations for the greatness of one work over another can feel almost arbitrary, more like after-the-fact justifications for his tastes than convincing accounts of why his judgments might be correct and consistent. The rationalism he held so dear was often in conflict with—or just cover for—the emotional reactions to art that politesse had made him admit, for once, to O'Keeffe.

CHAPTER 32

Matisse in his studio in Nice in 1931, plotting out his ideas for the Barnes Foundation Dance. *Barnes told the artist the mural would be "probably the most important monument to your life's work."*

THE DANCE | A DOUBLE CROSS? |
A MATISSE BOOK

"We always knew Barnes
was a son of a bitch"

ere's the oft-told tale of the birth of *The Dance*, one of Henri Matisse's most spectacular works and a signature treasure of the Barnes Foundation. (See figure 14 in color insert.)

In September of 1930, the sixty-year-old Frenchman visited the United States to sit on the jury for the Carnegie International exhibition in Pittsburgh, the country's most prestigious invitational show. Leaving Pittsburgh, Matisse and a couple of the other judges, plus the Carnegie's director, made their way to New York for Matisse to catch his steamer, but with a stop on the way in Philadelphia. Lunch was planned there with a prominent patron of the city's art museum, so with the morning to kill, Matisse and a translator headed out to Merion for a meeting with Barnes. At the door to the foundation, Barnes sent the translator off for a stroll around the grounds. He walked Matisse into the foundation's grandest gallery, where they were surrounded by the work of the painter's greatest predecessors—Cézanne's *Card Players*; Seurat's *Models*—and then Barnes dropped a bombshell: Would the painter accept a commission for what Barnes called "probably the most important monument to your life's work"? It

would be a mural, something like forty feet long by more than ten feet high, to fill the vast vaulted spaces high above the gallery's floor-to-ceiling windows. The conversation that followed ran long. The poor translator, on the wrong side of a locked door but tasked with getting the Frenchman to the luncheon on time, eventually found a coal chute that could give him access. Climbing up from the foundation's cellar, he released Matisse from Barnes's clutches and spirited him off to his meal.

It's a lovely genesis story, repeated in several versions, and adds to the long list of yarns that enliven our collective Life of Saint Barnes. (For some it's a Barnes demonology.) And there's every reason to think much of it is myth.

What the record actually shows is Matisse writing to Barnes from New York to ask for "permission," as he put it, to visit the foundation and meet its founder at some point during his American stay. He then seems to have made the trip twice within the same week—alone, as far as we can tell—getting the mural commission on the first, then fleshing it out on the second.

Once back in France, Matisse immediately wrote to Barnes that despite a hideous crossing his mind had been entirely focused on the "honor" of the new project. He gingerly asked Barnes what the fee might be, and in reply Barnes took the clever step of asking Matisse himself to set it: "The discussion of money in all such matters is an embarrassing one"—not at all true for Barnes, ever—"and especially in this case since I am sure you would take into consideration the fact that your work would have a setting such as it would have nowhere else in the world." In the end the painter asked for $30,000, fifteen times what a French professor might earn in a year but less than Barnes spent on four of the Matisse canvases he began to stock up on that very fall.

It seems that Matisse knew he'd lowballed his fee. "Although there'll be no profit in it for me, this work will have important consequences," Matisse told his wife.

His excitement about the mural made sense. Early in the century, he had launched his career as the most radical of radicals—*The New York Times* had called his paintings "revolting in their inhumanity"—but for most of the 1920s he had been making attractive works that functioned "like a good armchair," as Matisse himself had written. Critics had begun to agree and to complain about his new work's complacency. Barnes himself rarely bought the painter's art from that era, and talked about it as a retread of what had come before.

"I was beginning to walk in place," Matisse admitted to his daughter, and now he would have the chance to move forward again thanks to the commission from Barnes. "He said, 'Paint whatever you like just as if you were painting for yourself,'" Matisse recalled.

What Matisse "liked" turned out to be a series of dancing, leaping bodies floating against a blue and pink "sky," the whole thing more stylized than anything he'd done before, nudging up against cutting-edge abstraction. (Although those bodies' hemi-

Matisse's Dance, *in the final version that got installed high on a wall at the Barnes in May of 1933. Matisse heard that Barnes "assembled all of his students, a hundred of them, and spoke for two hours in front of the decoration."*

spherical breasts might have been inspired by some rather earlier stylizations: Matisse would have noticed the half grapefruits that Renoir installed on the beloved nudes that Barnes would be hanging near the mural; Matisse's dancers pun on them.)

When Matisse had first hit his stride as an artist in fin de siècle Paris, mural paintings (*décorations* was the term of art) had been in vogue among leaders of the avant-garde like Édouard Vuillard and Pierre Bonnard. Three decades later, with the Barnes commission, Matisse realized that he could move the whole genre beyond what they had done. He complained that his predecessors' murals had mostly been nothing more than extra-large paintings that happened to be stuck on the wall; at the foundation, he would one-up them by making a work that merged with the architecture, even pretending to pierce it to let in a view of the real sky outside. Ever since the Italian Renaissance, those kinds of *quadratura* effects had been the major conceit behind murals, but they had been out of favor for something like a century and so were ripe for revival.

As Matisse told an American journalist, "My aim has been to translate paint into architecture, to make of the fresco the equivalent of stone or cement. This, I think, is not often done any more." He went so far as to use a stony gray for the skin of the dancers, as though they were sculptural ornaments for a building rather than living figures—just as Michelangelo had mimicked bronze and marble "statues" in his frescoes in the Sistine Chapel. Matisse made sure his viewpoint on the canvas in the vast garage where he painted it would match the view onto it at the foundation, just the kind of strategy Renaissance muralists deployed as they worked to erase the boundary between the painted and the real.

And then Matisse combined that retrospective gesture, which suited the conservative streak in his art, with an experimental modernism that spoke to the *fauve*—the "wild beast"—in him.

You have to wonder if the mural's radically pared-back look, quite new to Matisse, had something to do with the nation it was conceived in; watersheds in his art often had to do with recent travel. He'd been impressed by New York and its potential as artistic inspiration—"those towers, those masses rearing themselves in the air in that light which is like crystals"—and thought that the sheer dynamism of America could pass over into its art. Ideas about the New World might have played a role in the new dynamism Matisse decided to instill into his American mural.

"An American artist should express America," Matisse had said, at the time of his first visit to Merion. Did that hold true for a painting commissioned to live there? With the United States recognized worldwide as the home of everything truly modern, the country maybe deserved to see a mural that revealed Matisse at his most modern as well.

Barnes had no complaint—or at least no comment—when Matisse sent him photos of the full-size sketches for the Merion project, a few months after taking it on. But that was about all that Matisse's patron did get to see, because a delivery date for the mural got put off again and again.

<hr />

Before the *Dance* commission, Barnes had already amassed something like twenty-five Matisses, including such gorgeously "inhuman" early works as *The Joy of Life* and the *Red Madras Headdress*. As Barnes waited for *The Dance* to appear on his wall, he dug still deeper into Matisse, picking up almost as many pictures as he had in the previous two decades.

In February of 1931, a New York dealer offered to sell Barnes the *Three Sisters with Gray Background*, a classic Matisse from 1917 of white women in exoticizing "Eastern" dress. Barnes already owned Matisse's two other paintings of those same women,

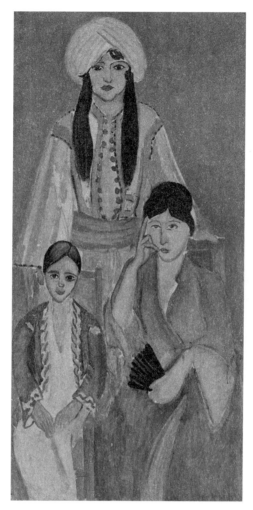

Matisse's Three Sisters with Grey Background, *from 1917. Rumors spread that Barnes had bought it out from under Philadelphia's art museum.*

and snagging the third would give his collection an ideal window into his favorite chapter in modern art, when figures were still far from abstract but had fully escaped old master realism. The *Sisters* triptych, said Barnes in one of his trademark disquisitions, gave "enough information to make the figures interesting as human be-

ings" while also providing "a form suitable for inclusion in a highly ornamental ordering of color-planes." (See figure 15 in color insert.) The triptych had exactly the balance of modern design and classic humanism that was at the heart of his theory of plastic form. To his eyes, the sisters' oblong faces also rhymed with the African masks that meant so much to him and with the Persian miniatures he'd now begun to collect. One of the *Sisters* paintings actually featured an African statue, as though Matisse had set out to illustrate the Civic Club lecture by Barnes. The compare-and-contrast among the three paintings, and then with their various exotic "precedents," made for the kind of teaching moment the foundation was built around.

And yet, in an uncharacteristic moment of generosity, Barnes asked the dealer to delay the sale for a few days to see if curators in the deluxe new buildings of Philadelphia's art museum, who also had their eyes on the painting, might be able to raise the money and take it themselves. When the museum's fundraising came up short, its board asked Barnes to arrange for the deadline on the sale to be extended. Since the dealer insisted on sticking to the original timeline, Barnes bought the painting for himself instead, for $15,000, and that was that. Or at least that's how the dealer and Barnes recalled the transaction, with documentation to back them up. Museum officials, used to years of abuse from Barnes, claimed they had discovered the picture in the first place and accused Barnes of buying it out from under them. "We always knew Barnes was a son of a bitch," the museum's director, Fiske Kimball, wrote to a local collector, "and now we can prove it."

Their tale of a double cross began to circulate, and when it was still doing the rounds almost four years later, Barnes had had enough: Anyone of note in the Philadelphia art world received an open letter setting out the evidence for his version of events. Barnes insisted that the tale "could have originated only in the imagina-

tion of either an ignoramus or an ungrateful son-of-a-bitch" and described the art museum, not for the last time, as a "house of artistic and educational prostitution." He invited the museum's chairman, Sturgis Ingersoll, to settle the "libel" with his fists.

Setting out to clear his name, Barnes merely confirmed his growing reputation as a brute.

It's worth remembering, however, that in most of what passed for his brutish acts, Barnes did little actual harm to anyone but himself—the Matisse squabble being a possible and rather minor exception, if there really was a double cross involved.

He was like a great bulldog, unmuzzled, with the most brutal of barks but hardly ever proceeding to bite.

At the dawn of the 1930s, Barnes had a huge emotional investment in Matisse, and a financial one as well. As always with him, those had to be matched by an intellectual engagement. Just weeks after proposing the mural commission, Barnes told Matisse that the foundation would be publishing an entire monograph about him, "from your earliest pictures to the latest ones."

That book was the major preoccupation for Barnes and his staff over the next few years. They worked, valiantly, to arrange a trip to see the great early Matisses in Soviet Russia, but ultimately failed. Barnes was especially keen on seeing a dance-themed *décoration* commissioned two decades earlier by a Moscow plutocrat that was a major precedent for the foundation's own *Dance*. Although the work made for Russia was radical in the almost total stylization of its figures—Matisse was returning to that in the foundation commission—the Moscow piece was, in Matisse's own terms, just a "picture" stuck on the wall, not a "mural" meant to join with the architecture around it.

In the summer of 1931, barely six months after signing the contract for *The Dance*, Barnes was chortling over his good fortune that a big Matisse retrospective was opening at a gallery in Paris. He claimed to have been there almost daily, from the moment it opened until 6:00 p.m., carrying his note-taking to such manic lengths that he went home that fall with a thousand pages of thoughts on the paintings.

Barnes roped his former staffer Henry Hart, now an editor at Scribner's publishing house, into persuading his bosses to put out the book, despite a depressed economy that made it an unlikely purchase for struggling Americans. (At $5 a book, it ended up selling all of 462 copies in its first nine months.)

"It's discerning, it's imaginative and it's wise," Hart wrote to Barnes. "At the risk of being emotional, I want to say that it is exactly the mature production, shorn of all triviality, that is typical of your best moments."

But Barnes himself might have had a more accurate take. "I am afraid it is too meaty and too scientific to be a popular book," he wrote to Dewey. Even most specialists might have found the book on the chewy side. After the usual throat clearing about Deweyan psychology and aesthetics, it proceeds to cover all the usual Barnesian ground—Matisse and drawing, Matisse and color, Matisse and light—and then gives wildly detailed accounts of sixteen exemplary paintings, every last one of which happened to be in a certain Barnes Foundation.

"Dr. Barnes and Violette de Mazia, his assistant in the dissecting rooms at Merion, Pa., have performed an autopsy on the art of Henri-Matisse," said the book's review in the *New York Herald Tribune*. "It is difficult to cut very deep into an art that is all on the surface, but the incision, if it must be made, has been made with the utmost thoroughness. It has indeed been performed so satisfactorily and with such extraordinary skill in the handling of

modern esthetic instruments, that it need never be repeated. For that we should all be thankful."

That review was written by a longtime enemy of Barnes's who should never have been given the assignment. But it does capture a fundamental flaw in the Barnes approach. As many an art critic has had to learn, whatever the excitement and pleasure that come with protracted looking at a picture—noting its every detail, digging deep into how and why those details come together—the excitement isn't matched by the experience of protracted *reading* about the results of such looking. In the five solid pages Barnes devotes to his analysis of the *Sisters* triptych, you can tell how much he enjoyed taking his notes. It's hard to share in that enjoyment, reading a typical sentence like the following: "In the central canvas, one hand with six fingers makes a rhythm with the many-lined pattern of a fan; the hand holding the fan resembles a fin, but in shape it is related to the sleeve and various sections of the gown, together with which it forms a rosette-pattern radiating from the wrist; in the panel on the right, the hand with only two fingers looks more like a lobster's claw than a human hand, but the pattern made by this distortion harmonizes with the adjacent linear patterns of the cuff, collar, face and arm; likewise, the right hand of the seated figure in the picture on the left is an integral part of the pattern of the turban." (To Barnes's credit, this time he made sure to include his analyses at the very back of his book, merely as a vast appendix.)

Even after hiring Matisse to fill a major space in the foundation and buying his paintings by the dozen, Barnes avoids the unrelenting enthusiasm we'd expect from just about any other collector. He's willing to praise Matisse for having vitality, great erudition, and an adventurous spirit. But those don't in the end counterbalance an accomplishment that Barnes sees as essentially decorative, lacking "the more profound interpretative values, both human and plastic, characteristic of the greatest artists."

THE DANCE | A DOUBLE CROSS? | A MATISSE BOOK

"Henri Matisse, one of France's greatest living painters, is just finishing a mural 14 by 40 feet in his Nice studio, which he expects to be recognized as his greatest canvas. It has been painted for the Barnes Foundation at Merion, Pa." That news appeared in *The Wall Street Journal* on February 10, 1932, and you can just imagine Barnes's excitement at the prospect of receiving, and at last *seeing*, his long-awaited mural.

And then, disaster.

"Avez fait erreur énorme," Barnes cabled Matisse some ten days later—*You've made a huge mistake.*

For the previous few weeks, Matisse had been wiring Barnes with questions about the dimensions of his almost-finished mural, and Barnes finally came to realize that the painting would not fit the foundation's architecture: it was off by several feet where the vault curved down to meet the wall. The telegram Matisse sent in reply was surprisingly sanguine, saying he would put the final touches on the failed first version—it ended up at the Musée d'Art Moderne in Paris—and then would start at once on a brand-new one.

Barnes made an emergency trip to France, but there's no record of fireworks when the two men met in Paris. Barnes recalled that they had a fine time together, and in a cheery letter to the painter he merely expressed hope that the work on the new mural was "advancing in a manner that is satisfactory."

One explanation seems most likely for Barnes's improbable equipoise: He might not have been entirely convinced by the final studies for the mural, apparently given to him by Matisse as a kind of consolation for messing up its measurements. While Barnes had been complaining that, in the previous decade, Matisse had lapsed into ringing minor changes on his early innovations, it's not clear the collector was looking for anything as new as the minimal, almost geometric style of the mural. Barnes criticized Picasso for a

tendency to "veer about in obedience to the latest wind that blows." And here was his man Matisse apparently making like a wind sock, veering toward the "wholly non-representative painting" that had been making recent inroads but that Barnes had always condemned as empty play with pattern.

Whatever his true feelings, Barnes wasn't about to give up on a commission that had been so much in the news.

As he painted, Matisse had found Barnes and his team so eager to get the mural that it was "as if they were waiting for a god." The pressure seems to have brought out the perfectionist in him, until Barnes had to beg him just to declare the thing done, after delays caused by such absurdities as the disabling sunburn Matisse got on his legs one time when he was working outside on some drawings.

But at last came the day, on May 14, 1933, when the great painting was up on the wall in Merion—and fit its allotted space.

The accident-prone project came with yet another near disaster. Matisse had insisted on starting the installation himself, hammering away for two hours—and then collapsing from a heart attack. "We gave him some whiskey and made him rest and he was all right in an hour or two," Barnes said, but he nevertheless had the artist examined by a specialist. After running the latest in high-tech tests, the doctor ordered absolute rest and Matisse's immediate return from America.

Shipboard on his way home, Matisse had written to his daughter that Barnes had been pleased with the newly installed painting. "To prove this to me"—note the sense that it needed proving—"Madame Barnes told me that the next day the Doctor assembled all of his students, a hundred of them, and spoke for two hours in front of the decoration." But he was disappointed that Barnes, "a complete misanthrope," was now refusing to show it to the public, as had once been promised. Barnes put off several

visitors who asked to see the mural that summer and fall; he kept claiming that its scaffolding had yet to be removed.

Just before he'd packed it up for shipping to Merion, Matisse had voiced high hopes for the canvas. He'd felt confident that his "real mural painting" would do just the architectural work he had planned on, adding a fictional sky to the real greenery seen through the huge windows below. But contemplating the painting on its wall at the foundation, Barnes would have realized, at least intuitively, that the piercing of the painted surface in the new mural, however notional, risked contradicting the virtues of "design" he held so dear. His *Art in Painting* had inveighed against effects "of depth and solidity by tricks of perspective," which were sure to yield "a specious unreality, more unreal than a frank two-dimensional pattern." And that was a pretty good description of the entire five-hundred-year tradition of mural painting that Matisse had channeled.

Barnes kept the drapes closed on the windows that gave views onto the garden beyond Matisse's piece.

CHAPTER 33

Barnes and Dewey talking art with the ever-faithful Fidèle. "Whatever is sound in this volume is due more than I can say to the great educational work carried on in the Barnes Foundation," Dewey wrote in Art as Experience, *his landmark book on aesthetics.*

GREAT DEPRESSION | *ART AS EXPERIENCE* | RENOIR

"Dewey, dean of philosophers,
writes real art means life"

t was the depths of the Great Depression, and Barnes had personal knowledge of the effect it was having. In the spring of 1933, Henry Hart, the editor who had helped birth the Matisse book, wrote to his former boss about the disastrous state of the publishing business—and then about getting laid off.

As a card-carrying progressive, Barnes was happy to see moves to solve the crisis. "President Roosevelt has attacked the trouble from the foundations and the people are giving him their whole-hearted support," he wrote to an art-dealer friend. "Everybody is confident, and indeed they should be, because the foundations of the country are secure."

Barnes had left-wing bona fides. He had planned a trip to spread the foundation's teachings to Soviet Russia and even subscribed to *In Fact*, a newsletter published by the sometime-communist George Seldes. (It later took Barnes's side in a press squabble.) But, although he idolized Roosevelt, there's no sign that he got deeply involved in New Deal efforts. He seemed to think of his work with the Black community—a few foundation fellowships plus some donations to local churches—as a notable and noble enough social program. After signing the Zonite deal,

he focused all his energies on his collection and its educational promise, sure in his belief that those would be the true source of long-term social progress.

In 1934, he got confirmation of that belief from the most unimpeachable of sources. "To Albert C. Barnes, in gratitude," read the dedication to *Art as Experience*, the landmark contribution to aesthetic theory that Dewey published in March.

"Whatever is sound in this volume is due more than I can say to the great educational work carried on in the Barnes Foundation," Dewey went on in his preface. "I should be glad to think of this volume as one phase of the widespread influence the Foundation is exercising." That influence had been especially potent on Dewey himself, since he had spent good stretches of time working on his book in front of the paintings in the foundation, in order, as Barnes put it, "to convert every single philosophic point into a real, vivid, personal psychological experience."

Barnes had spent the previous decade or so attempting an awkward marriage of Deweyan ideas about the human mind with Barnesian close looking at art. The mating could seem more impressive for its ambition than its results, but here was Barnes's great friend and mentor lending it new authority. Dewey cites Barnes any number of times in his book and adopts a great deal of his language, talking about line and color and space and how those combine into those Barnesian watchwords of "plastic form" and "expression."

Dewey's book came loaded with his usual density and complexity—an admirer admitted his books "do not deliver up for the asking the philosophy which is condensed in them"—and that meant Barnes could choose to pull out of its tangles only the things he already believed about art, and ignore those he disliked. (Dewey was interested in the purely social, even religious functions of art, as his old friend was not.) But from its first pages the book concentrated on one important new dimension that had a

profound effect on Barnes, in part by confirming ideas he'd already glimpsed. Dewey expanded the definition of art to include almost any complex behavior that humans engage in with care and deep self-awareness. With a pragmatist's commitment to everyday experience—a commitment shared by Barnes, the leveling democrat—Dewey found his examples of the aesthetic in activities such as commuting to work on a ferry or taking a test at school or playing tennis, not merely in paintings by Renoir or even works by an African carver. Or as *The Washington Post* put it in a headline, "Dewey, Dean of Philosophers, Writes Real Art Means Life: Great Educator, Near 75, Elaborates Old Tenets in New Book. Reaffirms Stand That Test of Greatness Is Usefulness." Dewey said his goal was to bridge the gap that's normally seen between "refined and intensified forms of experience" that are associated with fine art and the "everyday events, doings, and sufferings" that matter in the rest of our lives. Aesthetics, Dewey says, are "implicit in every normal experience."

Barnes himself had been making similar claims for a decade already, mostly (if condescendingly) in his praise for how African Americans excelled in "the living of art expression in everyday life" and for how the entire Black experience was "shot through and through with natural-born artistic expression." But then in 1936, within a few years of reading Dewey's book, he expanded the scope of those ideas. He delivered that Central High lecture where he gave baseball the same aestheticizing treatment: the Philadelphia Athletics, he said, had "the indispensable requisites of great art—unity, variety, individuality, and the production of esthetic pleasure in others." In the same lecture, he used the example of firemen fighting a fire, and the expert pleasures and perceptions they bring to bear on the experience, to explain the pleasures and perceptions that artists put into their art and that expert viewers take from it.

And in fact both those examples had been in Dewey's book, because he'd got them straight from Barnes's mouth as he wrote it.

The year after Dewey published his thoughts on art, they came into play again in the latest volume from Barnes and possibly the one that mattered most to him: *The Art of Renoir*. Here was Barnes, as usual working with de Mazia, at last coming to grips with his all-time favorite artist, and the Deweyan everyday comes up again and again. Renoir, says Barnes, has a "natural preoccupation with the aspects and events of the everyday world" and from early on the painter had managed "a convincing realization of the homely and familiar aspects of everyday persons and events." But while those ideas have a great fit with the democratic interests that Barnes had from almost the beginning of his adult life, they don't seem to map particularly well onto most of the 180 Renoirs that dominate the foundation's walls to this day. The pneumatic nudes of Renoir's late career, in particular, hardly seem like everyday sights. (In two paintings that Barnes bought just when he was helping Dewey work through his aesthetics, the nudes are living caryatids holding up classical architecture—not quite standard fare on Philly streets.) With their saccharine colors, jointless limbs, and sometimes almost simian faces, the women and girls in late Renoir have come to puzzle more viewers than they impress; they might even repel a good number. Even as Renoir was painting them, his friend Mary Cassatt objected to his "enormously fat red women with very small heads."

One explanation for their appeal to Barnes is that those late Renoirs—he had dozens of them—depict the idyllic, Apollonian everyday of the collector's imagination, which he flees to from the real everyday of conflict that he built for himself. (Guillaume's Paris gallery was a "temple," Barnes said, because it was never "desecrated by a personal quarrel.") According to the scholar Neil Rudenstine, who was once on the Barnes Foundation board, the peaceable family scenes in several Barnes Renoirs—for instance,

Renoir's Caryatids *from around 1910. Barnes described Renoir's "natural preoccupation with the aspects and events of the everyday world"—but maybe not in these paintings.*

Renoir's Henriot Family, *from around 1875, might represent an idealized everyday life.*

the *Henriot Family* that cost Barnes a fortune, $50,000, in 1935— represent precisely the everyday that Barnes himself, childless and perpetually embattled, never got to enjoy. Of course, Barnes would have had to forgo a fair amount of his precious rationalism to bill Renoir's obviously idealized, stylized later scenes as anything close to quotidian, but this Necker of the Main Line—this patriarchal feminist, this tyrannical egalitarian—was good at living with contradiction. Around the time he was working on Renoir, he did jot a note that says that art is great because it "burns away the crudities of life and leaves the imperishable residues of serenity, peace + happiness."

Another explanation for Barnes's Renoir obsession is simply that a conservative impulse that had always been there gets the upper hand as he ages. The tendency toward sentiment and sugar in many of Barnes's favorite Renoirs brings them close to the Bouguereaus and Cabanels of his Victorian youth, so when

Barnes talked about Renoir's "joy in painting the real life of red-blooded people," that real life might have included just those "red-blooded people"—a.k.a., heterosexual males—who enjoyed the bared flesh in the academic nudes of the Paris Salons. Barnes's praise for Renoir's "skill in conveying his sensations to my consciousness" is at least in part about the sensations of one "red-blooded" man being conveyed to another. And in that utterly patriarchal era, no one would have questioned that providing such "sensations" to men was one of any woman's main social roles, even duties. Depicting her in that role—with clothes or without—would have seemed a perfectly laudable and natural task for a painter.

By admiring late Renoir, Barnes could return to the tastes he was brought up in without forsaking his allegiance to the modern. By moving backward toward Victoriana, that is, his taste could leapfrog over the tough early Matisses and Picassos that he'd learned to admire, if not to love, in the years before World War I. After that conflict's horrors, there were plenty of people wanting to make that leap.

The only problem with that explanation is that even in their early, radical years both Matisse and Picasso were big fans of those same Renoirs—of one in particular that Barnes would soon buy—as were any number of serious modernists of that era, such as Barnes's friends William Glackens and Leo Stein.

What really seems to be happening is that the avant-garde was reading Renoir's strange take on the everyday as a truly modernist willfulness, a kind of realist's precursor to cubism's perversity—as a "pure engagement with form," as the art historian Martha Lucy has put it. It's worth remembering that in the years after 1900, just when Renoir was painting the late works Barnes so admired, even the fairly modest stylizations of Picasso's Blue and Rose periods counted as outlandishly radical, and were admired as such by Gertrude and Leo Stein.

Barnes condemned impressionists like Monet for having "an interest of sunlight on color, which interest is more photographic than plastic"—more about sun than pictures, that is—while Renoir, billed as the true harbinger of properly modern art, used sunshine only to arrive at "a design which is purely plastic."

By the same logic, inflated limbs in a late Renoir nude become studies in arcs and cylinders. Colors that we see as garish and chocolate box become examples of a chromatic ambition that leaves nature behind. An artfully arranged composition like Renoir's late *Bathers in the Forest* can be enjoyed for its artifice—for how "solid, delicate, graceful volumes of light and color unite in a fluid, all-embracing rhythmic arabesque-movement through colorful atmosphere"—while the fact that it's built from naked teens gets ignored or repressed.

We're witnessing the ultimate victory of the formalism Barnes had been touting, for more than a decade, with the same energy

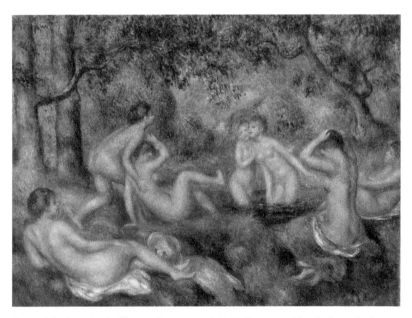

Renoir's Bathers in the Forest, *from around 1897. Barnes could talk about the shapes and light and color in this painting, without mentioning its teenage subjects.*

he'd once used to sell Argyrol. If you read Renoir as about "color," "light," and "drawing"—all headings in *The Art of Renoir*—then you can ignore what his nude figures really *look like*, as creatures in the world, or anything they might imply about such things as sex and power or even real human bodies. (See figure 16 in color insert.) And then—here's the weird, peculiarly Barnesian part—you can see the forms you've found in Renoir as sensuous expressions of the "universal human values" that you'd like to find in your Deweyan everyday. But for Barnes, the values involved could be very general, generic, vaguely aesthetic ones, such as "power, delicacy, joie de vivre," rather than anything more specifically ethical that we'd normally think of as a "human value."

It's important for Barnes that forms carry meaning, that they not be mere pattern. But this meaning isn't about what those forms might seem to tell us about the world they describe. That is, Barnes doesn't want his Renoirs to be read as old-fashioned, informative representations—read for what Barnes would denigrate as their "photographic" values. Instead, he wants the forms in his hero's art to be deeply *expressive* of some larger outlook on reality—of an artistic personality, you might say—but without reflecting on any particular reality of naked girls and simpering smiles that they seem to depict. Those are just excuses for a painting to yield the "richness, fineness and juicy colorfulness" that Barnes said he so loved in Renoir.

CHAPTER 34

Barnes and the great French dealer Ambroise Vollard in 1936, admiring one of the masterpieces Vollard had sold to the collector.

VOLLARD | CÉZANNE'S *BATHERS*

"Thanks to the depression, I came back
from Europe with the richest plunder ever"

The walls of the Barnes Foundation gained more from the Great Depression than they lost. Although the foundation's bonds would have taken a hit, regardless of how "gilt edged" Barnes might have declared them, the art market took a much deeper plunge. Always happy to present himself as a head-cracking tough, Barnes boasted that his specialty in the 1930s had been "robbing the suckers who had invested their money in flimsy securities and then had to sell their priceless paintings to keep a roof over their heads."

"Thanks to the depression I came back from Europe with the richest plunder ever," Barnes said. He got Vollard, the great Parisian dealer, to take $70,000 for a Cézanne that Barnes claimed had once had a price tag of $200,000, and he pried similar prizes from other people whose hard times had left them in need of funds. He bought more than forty Renoirs during—or because of—the decade of the Depression.

Barnes's sharp dealing never came with animus toward the dealt. In November of 1936, Vollard crossed the Atlantic for a show in his honor, and Barnes gave a radio talk describing him to the American public as a pioneer on the order of Daniel Boone and therefore "the most important figure in the art history of the

Renoir's Portrait of Jeanne Durand-Ruel, *from 1876: one of the artist's greatest masterpieces, according to a critic who saw it at the Barnes Foundation in 1936.*

19th and 20th centuries." He also held a reception best remembered, by its many guests, for the unsupervised access they got to Barnes's paintings and for the quantity of "fabulous" scotch whisky they were served. Vollard got tipsy enough to tell risqué stories, but in a peculiar French accent that few understood.

For once, Barnes welcomed several art critics to his bash, and one of them described how the collection had risen to new heights as Barnes added such treasures as Manet's *Le Linge*, Renoir's *Henriot Family*, and the $50,000 *Portrait of Jeanne Durand-Ruel*—"probably

Renoir's masterpieces," said the critic—and also, and most important, Cézanne's *Large Bathers* recently bought from the "sucker" Vollard for $50,000, as one of the biggest canvases to find a home at the foundation. (See figure 17 in color insert.) It was more impressive, and more impressively radical, than any of the collection's many other Cézannes: one of its nudes—female? male?—has a face, or what's left of one, worthy of Picasso at his most cruel; another has a neck that might have melted alongside Dalí's clocks.

Completed in 1906, the year of Cézanne's death, it was the largest painting of the painter's career and the final summation of his career-long study of nudes in a classical landscape—this time making room for fully fifteen fractured bodies stretched across an eight-foot expanse of canvas, and seeming almost to melt into it. Yet for all its size and radicalism, it deployed color with the sensitivity and grace of a modest Cézanne watercolor.

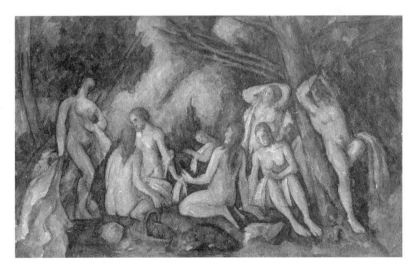

Cézanne's Large Bathers, *finished not long before the painter's death in 1906, combined for Barnes "the values of both ancient sculpture and monumental classic architecture."*

This wasn't Barnes's *Bathers*, but another even bigger version that hit the news on November 11, 1937, when Philadelphia's grand new art museum announced that it had acquired this "master invention of Cézanne's architectural imagination." The acquisition, said the painting's donor, gave Philadelphia "the distinction of owning the two best-known versions of the painter's famous subject. The second version, and a slightly smaller picture, is in the collection of the Barnes Foundation at Merion."

When Barnes read the announcement in *The New York Times*, he did not take the name-check as a compliment, as the museum must have intended. Here was his own *Bathers*, a treasure that he'd cleverly plundered from Vollard just a few years earlier, now getting second billing to a picture in an institution that for almost a decade Barnes had described as a "house of artistic and educational prostitution"—had described as that even *before* the fall of 1934, when the museum had accused him of that double cross in the Matisse *Sisters* affair.

Worse yet, the donor who had described—denigrated, Barnes would have said—the foundation's "smaller," "second" version was Joseph Widener, son of the pork-and-trolley tycoon who had started life cutting meat with Barnes's father. Joe Widener stood for just the kind of collector Barnes was eager to prove that he wasn't: a man whose chief talent was spending money—inherited money, worse still. In fact, Widener had recently declared a dislike of modern art and a commitment to acquire only "the classics—those paintings which have lived through the centuries." The millionaire's main preoccupation right then was his deluxe racing stable, but "Turfman Widener," as a journalist called him, had set aside his own tastes for long enough to help Philadelphia's art museum nab a landmark for its modern collection, funding it to the tune of $110,000—thus outspending Barnes as well as out-Cézanning him.

Barnes lashed out, releasing yet another of his infamous open letters. As quoted in newspapers across the nation, it claimed

the museum had been "stung" in its extravagant purchase, since Barnes himself had once refused to pay even $50,000 for the Widener picture. He described the work as a never-finished "fifth-rate" Cézanne, "monotonous, dry and lusterless," with any number of other faults of composition and coloring that he took care to list. (But which he apparently hadn't noticed a few years earlier, when he'd referred to the painting as the "one Cézanne to see in Paris.")

The museum wisely refused to take the bait, but journalists, knowing a good art story when they saw one, spun out the affair as long as they could: one paper questioned whether both the museum and Barnes had spent too much for their pictures of "a group of undressed fat women"; another asked whether the money dedicated to the museum's *Bathers* might not have been better used supplying tubs to the forty-one thousand Philadelphians who lacked one. Barnes never spotted bait he didn't want to take, and so let himself be endlessly quoted as the jealous old grump he was at real risk of becoming. Within a couple of months, he'd solidified that image in a pamphlet called *A Disgrace to Philadelphia*, meant to deliver a death blow to the city's museum by listing its sins—mostly against him—but acting more like a bullet to his own foot.

Two years later, not yet finished with the issue, Barnes launched a more subtle attack in the five-hundred-page book he and de Mazia published on Cézanne, the last of Barnes's monumental statements on art. (*The New York Times* said it would "make its principal appeal to students"; it was not widely reviewed.) Refusing to use the now-sullied word "bathers" in the title of his prize painting, Barnes gave his painting, now *Nudes in Landscape*, major play as the work representing "the complete flowering" of Cézanne's genius.

In a perfect hat trick of Barnesian virtues, the painting-formerly-known-as-*Bathers* embodied "the values of both ancient sculpture and monumental classic architecture" (illustrating the continuity of traditions so important to Barnes) while making sure that those values were "wholly re-created in the medium of paint-

ing" (the commitment to medium was a second pillar of Barnes Thought) in order finally to reveal "a wider range of human values than ever before" (the third of Barnes's pictorial perfections).

Rather than ignoring *The Large Bathers* purchased for Philly's museum, Barnes's book cleverly gave it at least equal play to the foundation version, but only to show how it represented "an expressive form arrested at a relatively early stage of its development," with color that was "dead, drab" and a composition that suffered from an "aborted function of planes."

There was certainly a grudge lurking behind Barnes's comparison between the two *Bathers*, but his disdain for the museum picture was actually of a piece with his larger, implicitly conservative view of fine art, still rooted in the Victorian world of his youth. Barnes had always resisted the way truly radical modernism could come close to celebrating failure and breakdown, tearing apart the visible world without building it up again into something new and coherent: cubism was the most obvious example, with Barnes making sure it was represented in the foundation by only a very few choice examples, but his resistance to Duchamp's Dada gestures had similar roots.

Even with his hero Cézanne, from the start he had harbored doubts about works where the artist had left too many parts of the canvas unpainted and ill-defined—precisely the works that had mattered most to Picasso and company. Instead, Barnes favored Cézannes that seemed to most fully and coherently represent a world rebuilt according to the artist's new vision, in an American pragmatist's take on modern French art. Based on those preconceptions, the Philadelphia museum's painting could, all grudges aside, reasonably be dismissed as "esthetically barren" with a "general lack of substance." His own painting could just as sensibly be termed Cézanne's "greatest imaginative triumph."

CHAPTER 35

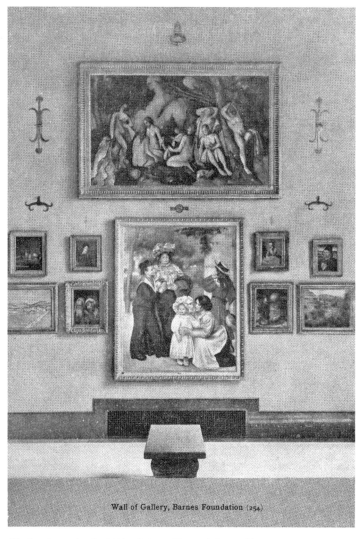

The first image in the 1937 edition of Barnes's Art in Painting, *with ironwork now joining his painted treasures.*

CRAFTS | HORACE PIPPIN

"We regard the creators of antique
wrought iron just as authentic an
artist as a Titian, Renoir, or Cézanne"

t was one of the great walls at the Barnes Foundation,
rehung in 1937 with some of its certified treasures.

Cézanne's great *Bathers* reigned at top, in all its frac-
tured strangeness. Below it, almost as big, hung *The Artist's Fam-
ily*, a late Renoir full of the cheery, rotund figures that Barnes
so adored. Other, smaller gems filled in the blanks to either side:
a Chardin still life; Corot portraits; landscapes by Cézanne and
Renoir; three Renaissance paintings.

And then, orbiting around the *Bathers*, hung objects that
would have come as a surprise to visitors from even the previ-
ous year: an ornate door knocker from medieval France; a pair
of fancy keyhole plates—"escutcheons"—from the reign of Louis
XIII; even wrought-iron hinges boldly forged in colonial Penn-
sylvania.

Since Barnes's death, with his galleries welcoming an ever-
wider public, visitors have been surprised to find walls that mix
masterpieces of modern painting with ironmongery and folk
crafts, and have seen that as a trademark of the founder's aesthetic.
In fact, that "trademark" combination came a quarter century into
Barnes's life as a collector—but just a few years after the publica-

Picasso's Secrets (Confidences) or Inspiration, *a tapestry woven in 1934 by the Atelier Delarbre. Barnes said that textiles made from his favorite artists' works had ushered in a new "epoch in art history."*

tion, in 1934, of Dewey's *Art as Experience*, with its equation of high art and the artfulness of the everyday.

In 1936, in a radio address in fact introduced by Dewey, Barnes went to bat, with his rhetoric turned up to eleven, for the tapestries just then being produced by a Frenchwoman named Marie Cuttoli, based on designs supplied by Picasso, Matisse, Miró, and their peers. (See figure 18 in color insert.) Barnes proclaimed that they had ushered in a new "epoch in art history."

Here was Barnes suddenly willing to give textiles the same kind of attention he'd given to paintings over the previous two decades. In the book on Renoir he'd recently published, Barnes

found himself again and again likening his hero's use of color and pattern to "the stitchwork of tapestry"—an association he would have been unlikely to make before then.

And just when he was talking up those deluxe textiles by Cuttoli, he'd also begun, more quietly, to pack his collection with humbler objects by anonymous workers in wood and metal, most often bought on shopping safaris to the foundation's backyard in rural Pennsylvania.

Andirons

2 copper pans

2 dippers

1 iron 3-leg

3 hinges

1 hinge

1 pair hinges

2 dutch latches

3 hoes

1 iron

1 iron ????

3 iron forks

1 poker

1 tramel

1 sawtooth tramel

1 chopper

1 waffle iron

2 iron dippers

1 bayonet

1 3-leg with handle

1 3-prong chain

That's the hoard of antique metalwork listed in a typical invoice sent to Barnes in the later 1930s. A single invoice for old ceramics includes almost fifty pieces.

Barnes wasn't an easy client. He would have his staff pull apart every antique, to make sure it was strictly original. "Let one screw, a strip of new molding, a replaced bit of wood be found—and back the article would hurtle to the dealer's shop," recalled a young secretary then new to her job. "If the dealer was humble and contrite, Barnes was back the next day to make a new purchase. But if the man asked one question, or offered one explanation, he was instantly blackballed." Endless letters bear out her account.

Local antiques dealers had already counted Barnes as a notable client since the birth of Lauraston and its lush decor, early in the century, and he'd done some serious collecting of indigenous ceramics, jewelry, and blankets during visits to the American Southwest, soon after selling his factory in late 1929. (The trips were in aid of Laura Barnes's respiratory troubles; some of the objects from the Southwest ended up in foundation galleries before any ironmongery did.) In the fall of 1935, however, when de Mazia and the Mullen sisters and Laura Geiger all had new homes to decorate, de Mazia said that they and "Doctor" had all caught "the bug of antiques" then epidemic in the United States. But that decorating soon promised to develop into something "of larger scope," said de Mazia: "Doctor is as excited about it almost as much as about pictures."

Barnes began to buy old crafts, both fine and folk, in quantities that had nothing to do with his or anyone else's domestic decor.

Those purchases soon found a place in a foundation lecture, on the gallery's walls, and from there onto the pages of Barnes's books—or onto one of those pages at least. In the spring of 1937, Barnes prepared a third edition of his magisterial *Art in Painting* with a new frontispiece that was a photo of that wall with the great *Bathers* and its constellation of hinges.

Some months before, Barnes had written to his new friend Kenneth Clark, director of the National Gallery in London, for

help in collecting fine British metalwork, since Barnes found "no essential esthetic difference between the forms of the great painters or sculptors, and those of the iron-workers of several hundred years ago." He told a journalist friend about how his rehung walls would shrink "the gap between 'fine art' and 'industrial art.' I mean the 'industrial art' of two or three hundred years ago in America and Europe." Barnes doubled down a few years later, saying that the foundation now considered "the creators of antique wrought iron just as authentic an artist as a Titian, Renoir, or Cézanne."

All this was a notable update on the views Barnes had once held. In the 1920s, the foundation had been careful, in its collecting and writings, to bill Africa's figurative "sculptures" as superior to the African "handicrafts" that others might collect. As recently as 1933, before Barnes started hoarding those hinges, he'd declared the "aesthetic limitation" of the decorative arts: "No one would think of Chippendale or Gobelin as artists of the same order and standing as Titian or Rembrandt."

Barnes's switch to a wider embrace that included both "high" and "low" art forms wasn't all that novel. For the better part of a century already, other fans of the applied arts had insisted on giving them space in museums, as Dewey had acknowledged in his own praise for such objects in *Art as Experience*. (That praise must have encouraged Barnes's hinge buying.)

But where Barnes's predecessors and peers mostly saw fine old works of craft as useful models for improving the taste and skills and conditions of the current working class, Barnes was willing to talk about crafts in the same breath, and in the same terms, as he spoke of acknowledged masterworks of fine art. (Even if he might still deny that a great hinge and a great painting were "of equal importance or magnitude.")

Barnes, the die-hard egalitarian, wanted to insist that old housewares deserved a place in the thick of high, elite culture, on

their own terms—literally a place with great paintings right up there on his walls. That mix of high and low empowered Barnes— and he always liked to have power—since it meant that he didn't find himself dependent on the greatness of some famous artist to make his formalist points. He could prove himself just as potent a thinker even when dealing with a modest hinge.

His new purchases were also in harmony with his longtime social needs. By hanging some anonymous blacksmith beside as great an artist as Cézanne, Barnes could feel every right to compare himself, an aesthete raised in the mud, to a toff like Kenneth Clark.

Barnes's collecting of decorative treasures cast him as a more conservative figure than he had seemed in earlier decades, when his purchases were clearly focused on avant-garde and African art. With his galleries filled with antique old furniture and fun old metalwork, it was easy to see him as just another rich guy accumulating chic home goods—especially now that his once radical paintings were coming to seem increasingly *bon bourgeois*. His formalist art theory still counted as advanced, but he was applying it to a collection that was beginning to feel tame and tasteful, as much about shopping as looking.

And Barnes couldn't incorporate his craft objects into that theory as easily as he could add them to his walls. Rather than discover deep, Renoir-worthy insight into reality in his crafted objects, he seemed to find mostly "pattern," putting them in the same category as the painted abstraction he condemned.

A dozen years earlier, he had concluded that there was "a whole world of values" in figurative painting that more purely ornamental arts could never achieve. Now mixing paintings and hinges on the foundation's walls committed him to an almost value-free

formalism, where simple rhymes between shapes were the main concern. If the ironwork above three well-matched Matisses "harmonizes with their pattern of lines," as de Mazia said, it's hard to see how it fills us in on the best of reality, as the forms in great figurative painting were supposed to do.

When *House & Garden* magazine ran an essay on the foundation by de Mazia, that might have been partly because her accounts of the galleries' wall compositions, their "ensembles," fit so well with the magazine's interest in home decor. In fact, those ensembles, unchanged since Barnes's death, are often more simpleminded than the sophisticated pictures that make them up. Most displays are governed by a simple bilateral symmetry, often determined just by the shapes of the paintings that Barnes grouped together: A typical wall in the main gallery presents a central canvas that's vertical, flanked by two horizontals, flanked in turn by two more verticals. Would Barnes have bought a painting with such a trite compositional plan?

The two horizontals in that ensemble echo each other in having ochers on the bottom and blues on top—although that seems a slim, decorator's pretext for bringing together Cézanne's landscape called *The Bellevue Plain*, from 1892, with a crowd of bathing beauties painted by Renoir in 1916. When an ensemble seems to yield more substance than that, as when the three seated men in Cézanne's *Card Players* hang below the three naked models in Barnes's famous Seurat, you can be almost sure that it was meant to be about pairing trios, not contrasting how men and women get painted.

But maybe that was part of the point: the formal echoes across a Barnes ensemble almost force you to see any one picture in terms of the shapes and colors it shares with its wall mates; you have to work that much harder to recognize its quite individual subject—just what Barnes wanted us to ignore. He might even have imagined that, considered as an ensemble, the two Renoir bathers that flanked his shocking Courbet nude, with its almost-

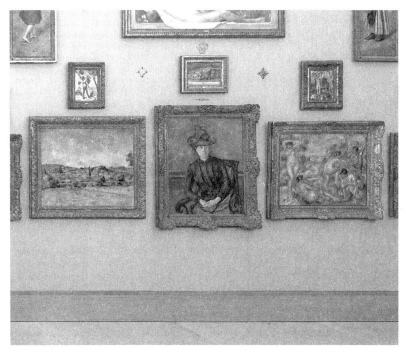

An "ensemble" of paintings on a wall of the Barnes Foundation, spelling out visual rhymes between Cézanne and Renoir.

open crotch, might be seen as nothing more than a concatenation of curves. Or at the very least, the ensemble could let him flout sexual decorum while plausibly denying that he was doing so.

Horace Pippin [is] one of the most distinctive artists that has appeared on the scene in recent years. He is a Negro, fifty years old, crippled by shrapnel in the shoulder in the last world war, and only began to paint a few years ago. I saw his work for the first time the other day and I immediately bought, for a song, one painting for the Foundation and one to send to you.

Horace Pippin's Supper Time, *from around 1940. Barnes called Pippin, a Black veteran in his fifties, "one of the most distinctive artists that has appeared on the scene in recent years."*

John Kane's Children Picking Daisies, *from 1931. Kane was one of several artists Barnes collected from "the group of natural, untaught painters to be found at all periods and in all nations."*

Barnes wrote those words to his good friend Charles Laughton early in the New Year of 1940, after seeing the first solo show mounted for Pippin, whose war wound was almost as grievous as the one suffered by Barnes's father. Pippin painted poignant scenes of Black life, and sometimes biblical or historical narratives, that he condensed into bold, simple forms rendered in flat fields of bright color. (See figure 19 in color insert.) At its best, his work melded the documentary impulse and social conscience of a New Deal photographer like Dorothea Lange with the visual impact of an American modern like Georgia O'Keeffe. Pippin became the first notable discovery Barnes could claim since Soutine, although he'd really come to both after they'd already got some slight attention.

Barnes's new openness to old objects from outside the sphere of official fine art seemed to have opened his mind, and his checkbook, to living creators from outside that sphere as well.

"Pippin's closest kinship is perforce with the group of natural, untaught painters to be found at all periods and in all nations, and to which custom has attached the word primitive," Barnes wrote, in an essay for that Pippin solo. (Note his interesting hedge on the word "primitive.")

Pippin wasn't the first of these "natural" artists that Barnes had collected. He already owned a few folk paintings from France and works by the self-taught Pittsburgher John Kane, as well as superb canvases by the Douanier Rousseau. (See figure 20 in color insert.) But all those creators were dead, whereas Pippin, for all that he was "untaught," could count as a truly contemporary painter, making the clearly new and obviously modernist work that Barnes always liked to be seen buying.

It also mattered that this modern painter was Black.

In his writings and his philanthropy, Barnes had been an avowed supporter of African American culture, and even of its music and musicians; weirdly, that had never before extended to

Henri Rousseau's View of the Quai d'Asnières, *from 1900. Rousseau was the most celebrated of the outsider artists Barnes collected.*

buying work by an African American artist, even though Aaron Douglas, a particularly notable one, had been resident at the foundation in 1928. Pippin let Barnes correct that, if only very modestly and belatedly. Barnes went so far as to say that a bold use of paint and a "crude, bald, starkness of statement" made Pippin's early works peas in a pod with Cézanne's. The very fact that such a person had found a place in the foundation's great collection signaled the undeniable capacities of Pippin's race and, as importantly, let Barnes claim a glorious role in helping those capacities win recognition. On the other hand, the fact that the first Black artist to be accepted into his collection had to be an outsider speaks to the notion that, as the scholar Alison Boyd has said, Barnes "positioned Negro art as a kind of permanent folk or primitive art: part of the past no matter when it had been created."

That went along with decades of cringeworthy statements uttered by Barnes and his people, and in fact by most white and Black thinkers of their era, about the "natural" musicality of African Americans, their soulfulness, joyfulness, emotional "authenticity," and roots in the soil—"nearer to the ideal of man's harmony with nature," as Barnes described them, using a Romantic conceit that risked depriving Black people of a full presence in modern

urban culture, or at least stranding them in some Edenic, more "natural" past.

Yet Barnes's actions could be more egalitarian than his attitudes. He welcomed Pippin to the foundation classes, backed him for a Guggenheim fellowship, and gave him the job of designing the memorial Barnes was sponsoring for the great Black "minstrel" James Bland—he had performed before Queen Victoria as the "Prince of Negro Songwriters"—whose pauper's grave had just been discovered not far from the foundation. That ambitious project was hardly a job for someone imagined as a quaint survival from a "primitive" Black past.

"One object of this would be to see that the race gets the main share of the glory," wrote Barnes, "instead of, as usual, having it fall in the lap of go-getting whites."

Unless, admittedly, that go-getter was Albert Barnes himself.

CHAPTER 36

Albert and Laura Barnes in 1942, taking their ease with Fidèle at the newly purchased farm they named Ker-Feal.

KER-FEAL | THE ARBORETUM | BERTRAND RUSSELL

"A propagandist against both
religion and morality"

After all that manic shopping, Barnes had enough finds to fill a new home.

In the fall of 1940, his real estate agents had found one: a modest farmhouse of gracious proportion, built of stone and roofed in shingles at about the time of the Declaration of Independence. Once Barnes got his hands on it, it lost its chicken house and barn and grew to include two new wings, a cascade of stone terraces, and a garage for Barnes's latest Packards—a 12-cylinder sedan, a convertible coupe, and the automaker's brand-new Clipper, with its sleek "speed-stream" design.

For all of his continued love of technology, Barnes was adopting a countrified manner. The Savile Row suits that he'd worn for three decades were mostly replaced by Côte d'Azur casualwear. He favored the red pants of a French fisherman and liked to boast that he bought them by the half dozen. Laughton and Dewey were such frequent guests that bedrooms were given their names.

The former Cornman farm, about twenty miles west of the foundation, was rechristened Ker-Feal, Breton for "Fidèle's House," named after the beloved black-and-white spaniel that had adopted Barnes on one of his summer stays in Brittany. Barnes, a

serial dog lover, declared the faithful Fidèle a "charming colorful individual," while Fidèle seemed to bring out a charming, colorful side in his owner that has never gotten enough recognition. It was expressed in friendly notes to Laughton and others that were signed with the pet's name and paw print. (Although those were just as often affixed to rude notes to enemies made all the ruder for being signed by a dog; they were so hilariously scandalous they won Fidèle coverage in the papers.)

"My doghouse" was Barnes's nickname for his new country home, but it was bought with some other equally beloved new pets in mind: firedogs and copper pots, wooden hope chests and spoon racks, folk quilts and spatterware. Barnes's aesthetic and educational interests had never been fake, but they were always built on a foundation of sheer acquisitiveness, a pleasure in purchasing that he shared with every collector that's ever been, and that could be newly exercised at Ker-Feal.

But as a side effect at least, its 138 acres of grounds also gave Laura Barnes room to exercise her green thumb. "I am 'up to my ears' in work as Doctor surprised me, a week ago, by taking me up to the farm," she wrote to John Fogg, a Penn botanist who was helping her turn the foundation's arboretum into a force in horticultural education. "Outside is a desert and it is up to me to do the landscaping." Her long-standing efforts on the twelve acres of the foundation's arboretum were officially extended to the Barneses' new private realm.

For decades, while Albert Barnes had been busy making as much noise as he could with his great art collection, Laura Barnes had quietly made the most of the collection of plants that had come into her care. But it looks as if Barnes's expanding definitions of art, in the 1930s, had led to a new commitment to the foundation's plantings.

In 1935, a rare article about the arboretum talked about how its mandate had just expanded to include a new, one-semester

series of lectures on "the esthetic qualities and characteristics of plants." A few years later, de Mazia said that the foundation's goal of teaching students "how to learn to see" had now grown to include not only fine art but also "furniture, objects in wrought-iron, trees and flowers."

The new take on plants led to an investment in the arboretum's resources, now as a "collection pointed to esthetic rather than botanical or horticultural interest." In 1940, the official Arboretum School was launched, with two lectures on plants every week. Laura Barnes, long her husband's éminence grise, spent the next quarter century becoming ever more eminent for her greenery.

In the fall of 1940, when Barnes's real estate agents had come across the farm that would become Ker-Feal, they'd been on the hunt for a different country home with quite exacting specifications: It had to be at least fifty miles from Philadelphia, at some altitude above sea level, with six or seven bedrooms, a living room, a capacious study, and, if possible, a livable barn. What the agents found couldn't match all those specs, but it was a lovely stone house, a rental up on the side of a valley around the corner from Ker-Feal itself. Despite not matching all their desiderata, it did the trick for the new friends of Barnes's who had set him house hunting.

Patricia Russell (known always as Peter) told Barnes it was "a house which I love beyond reason, and which I hope and expect Bertie will love too." Bertie was her husband, Bertrand Arthur William, 3rd Earl Russell, the groundbreaking philosopher and logician whose work Barnes himself had loved—almost beyond reason, as his loves always began—for at least a quarter century. Back in the days before he had a foundation, Barnes had claimed to read Russell's "Free Man's Worship" at least twice a month,

declaring it "both philosophically and aesthetically the best thing I have ever read in the English language."

And here he now was, Albert Barnes of the Neck, in a position to save his intellectual hero—a British lord, no less—from homelessness and joblessness.

"Dear Dr. Barnes," Russell had written to his fan on June 18, 1940. "Thank you for sending me an account of the Barnes Foundation. I am deeply grateful to you for the suggestion that I should join it. . . . I cannot tell you what an immense boon your offer is to me."

Russell's troubles had begun as opportunities.

As one of the preeminent thinkers of his day, Russell had been invited to lecture at the University of California, Los Angeles, for the 1939 school year. That fall, after Britain entered World War II, Russell found that Hitler's submarines had left him stuck in the United States. UCLA turned out to be too conservative for him, so early in 1940 he accepted a position on the East Coast, as a visiting professor at the City College of New York.

CCNY had a nice little campus designed to recall the Gothic colleges of Oxford and Cambridge. Sociologically, however, it was nothing like those elite training grounds. Sited on the west side of Harlem, the college was publicly funded, with a mission to educate the children of the city's workers: a comedown for Russell from Trinity College, Cambridge, where the peer had begun his career. But if he had doubts about how he'd prosper at CCNY, he needn't have worried: he would never get to find out.

Although Russell was appointed to lecture on the intersections between logic, science, mathematics, and philosophy, his more social interests began to loom large. Already an avowed atheist and pacifist, he had caused a ruckus with a book called

Marriage and Morals that made claims like "the total amount of undesired sex endured by women is probably greater in marriage than in prostitution." Various divines and conservatives took umbrage at the hiring of a "propagandist against both religion and morality" and a Catholic judge eventually barred Russell from teaching at the public's expense because of his "immoral and salacious attitude toward sex."

The intelligentsia voiced their outrage, they planned a book in Russell's defense . . . and the great logician still had no prospects for earning his keep. Although Dewey was at odds with Russell, intellectually, he was a champion of the Englishman's academic freedoms, and one summer weekend in Merion he approached his old friend to find a solution; Barnes leaped in with the job offer and his help with house hunting.

Given Barnes's love of conflict, the scandal at CCNY was more likely to attract him than scare him off.

For Barnes, Russell's shocking *Marriage and Morals* was just part of the same "hope for a better social order" that was at the root of great art. "If you want to say what you damn please, even to giving your adversaries a dose of their own medicine, we'll back you up," said Barnes, when he asked Russell to join the foundation staff. "You may select any topic you wish and treat it as only you determine."

The two men settled on a five-year contract for once-a-week lectures on a modest little topic: "the ideas and cultural values that developed from the period of the early Greeks up to the present time." The salary would be a decent $8,000.

Barnes believed that Russell was the equal of Dewey and Einstein, "men who have excelled and dug down to the fundamental principles of life." If the foundation's mission was to contemplate

those principles through the prism of art, Russell would simply be extending that mission by looking at the ideas and culture that shaped life more directly.

The philosopher had already committed to talks at Harvard in the fall, so he didn't start his lectures in Merion until the day after New Year's in 1941—on Barnes's birthday, in fact, and there could not have been a more welcome present. It was "a dream come true," said Barnes.

Russell found teaching among the nudes in the main gallery "incongruous for academic philosophy," but once his talks were moved to a less fleshy space, he got on with his task: a four-year survey running through the entire history of Western philosophy and its cultural contexts and effects, for an audience of amateurs, some of whom might barely have a high school education.

The philosopher mostly delivered his foundation lectures off the cuff, based on an initial idea and then research by his thirty-something wife—his third—who had once been his student.

Barnes recalled Russell as having been "fluent, vivacious and witty," keeping the students attentive and interested. The collector would sit at the back of the room, quiet for once and absorbed, as the philosopher spoke at the front. The pair of sixty-nine-year-olds were almost too perfect in their divergence: Russell, weedy with a sunken chest and frantic white hair, played the Oxbridge professor to perfection; Barnes, broad-chested, beetle-browed, and scowling, was the self-made American from central casting.

"If I were a Frenchman I'd kiss you on both cheeks for the benefit you've brought to our efforts to do something worthwhile," Barnes wrote to Russell. "Don't you worry about your work here: take it in your stride of living a peaceful, carefree life." By the summer, the two men and their wives were sharing champagne-tinted evenings in the country.

From the moment of hiring him, Barnes had said he would back Russell heart and soul in his effort to do "the kind of work

which only you can do." That work, as begun at the foundation, went on to become one of the most widely read books in the very tradition Russell was trying to summarize. Published in 1945, *A History of Western Philosophy and Its Connection with Political and Social Circumstances from the Earliest Times to the Present Day* was, despite its long-winded title, a layman's guide to Europe's great ideas. Sprightly, opinionated, and sometimes off base, the book became an unlikely best seller, bringing Russell years of fine income and the Nobel Prize in Literature in 1950.

And as Russell had graciously said in his preface, "This book owes its existence to Dr. Albert C. Barnes."

CHAPTER 37

A poster advertising a Saturday Evening Post *profile of Barnes, published across four issues in the spring of 1942. For once, Barnes didn't enjoy his bad publicity.*

THE SATURDAY EVENING POST | FIRING RUSSELL

"Philadelphia's Millionaire Pepperpot"

t had never been seen and never would be again: a feature on a collector of modern art, stretching across four issues of a magazine bought by more than three million average Americans. What better validation could there be for the Barnes Foundation's two decades of aesthetic and educational labors?

And then, when Barnes finally got his hands on a copy of *The Saturday Evening Post* for March 21, 1942, the headline must have made his heart sink, knowing all those other Americans were seeing it too. "The Terrible-Tempered Dr. Barnes," read the front cover, riffing on an absurdly irate cartoon character readers knew as the Terrible Tempered Mr. Bang.

The article that followed continued to paint the same picture. It led with the tale of Barnes's response to an aristocrat's request for admission to his galleries, telling her they would be closed for a striptease contest for debutantes, "and to his distress, he could not invite Her Highness to the event because, out of consideration for the intrinsic modesty of the debs, it had been decided to limit the guests to the boy friends of the contestants."

As though setting out to prove the accuracy of the headline, and of the tales of ill temper that filled the remaining twenty-five thousand words of the profile, Barnes went out and with his own

two hands tore down every copy he could find of the two different posters advertising the issue, bearing photos of him and his beloved paintings and the words "Philadelphia's Millionaire Pepperpot."

His tantrum merely guaranteed that he'd receive still more *Post*-like coverage in the next day's newspapers.

Given his vast appetite for both attention and controversy, Barnes might have liked the profile as much as he despised it, at least on first taking it in.

As with so many of Barnes's misfires, the *Post* affair had begun on a promising note. In 1940, Barnes had taken up the profile's author, Carl McCardle, as a reporter "sympathetic to my side." Barnes had even invited him and his wife to Bertrand Russell's first foundation lecture, giving McCardle an exclusive on it for the newspaper he was then writing for.

Barnes then bought the reporter's pitch for the in-depth profile for the *Post*, even though the collector had recently dismissed the magazine as "tripe."

McCardle was given deep access to the foundation's files, and to the scandalous contents Barnes knew they held. "Naturally a weekly catering to the popular taste and eager to get sensational matter wanted to work up some of the incidents that have put me on the front page of the newspapers," Barnes told Dewey. The tabloid fodder would sugar the pill of what he called the article's "main central thesis": an elucidation and celebration of his foundation's twenty-year effort to make practical use of Dewey's theories on democracy and education.

For all his self-image as a hardheaded man of the world, Barnes could be terribly naive.

Of course McCardle did his best to give his readers some

kind of insight into the sometimes muddled ideas behind the foundation. McCardle talked about "some very practical theories" that aimed to "take the swoon out of art appreciation" and about *The Art in Painting* as a highly praised book. He acknowledged Barnes himself as "deadly serious about his work in art" and as a man who, despite his reputation as an ogre, was "inside his Shangri-La, unassuming, sensitive, even shy." But there was no way the article's sober evaluation, even praise, wouldn't be drowned out, in Barnes's mind and that of any reader, by the juicy stories McCardle had gathered.

There was the true story about the time the show-off drama critic Alexander Woollcott had telegraphed for admission to the foundation, only to hear back—in a letter sent by the dog Fidèle—that "Dr. Barnes was out on the lawn singing to the birds" and could not be asked to reply.

Also true was a story about the time Walter P. Chrysler Jr., a fellow collector and connoisseur of modern art, had suggested a visit, only to be told that Barnes could not be interrupted "during his present strenuous efforts to break the world's record for goldfish swallowing." Like many of Barnes's rude notes, that one was decently funny.

And then there was the story Barnes himself told about how, in Argyrol's early years, he used to compare the freight-car numbers on passing trains with the profits he was making. "I would see, for instance, 118,266, and I would say, 'Pooh, I got that much money.' Then one would come along with, for instance, 382,198, and I would say, 'Pooh, I got that much too.' Then one would go by with, for instance, 778,538, and I would say, 'I'll have that much before long.' Finally I had to give up the game because boxcar numbers didn't run high enough."

A few of the details in the profile were later proven false, but it's unlikely McCardle simply made them up. He was a twenty-year veteran of the news business, perfectly aware of libel law and

professional ethics; he went on to be an assistant secretary of state under Eisenhower. He might have got a few of his feature's less reliable tales from Barnes's enemies or prurient third parties; the era's memoirs, even when friendly to Barnes, are full of "recollections" of him that collapse when fact-checked. But McCardle must have got most of his information from the collector's own mouth and files. And anyway, Barnes and his lawyers had a chance to see the page proofs, with the *Post* accepting "ninety per cent" of their factual corrections. So Barnes must, at some level, have approved of any tall tales that remained.

He had a long history of happily spinning exaggerations and plain untruths about himself, and the *Post* piece was just the latest example. Aside from conveying misinformation that Barnes found useful, the act of "putting one over" on journalists, and then their publics, seemed to give Barnes the sense of power he always craved. That was doubly true when the stories established his contempt for settled hierarchies and values. But gathered between covers, even the soft covers of a magazine, the tales of intemperance that Barnes saw as signs of his independent and uncompromising nature actually made him look ridiculous.

It goes without saying that Barnes did not take well to the humiliation. He lost his terrible temper about it.

He planned on a lawsuit, first, but his lawyers told him there was nothing to sue about: while it was true that McCardle had agreed that Dewey would get to fact-check an early version of the feature, the agreement had never been with the *Post* and wouldn't bind it.

What was left to Barnes was, of course, vituperation. He wrote directly to McCardle, calling him "Judas Iscariot," "a Quisling," "Pearl Harbor Jap," "confidence man," "louse," and "rat." And then, going more public, Barnes issued a thousand copies of yet another one of his pamphlets, this one titled *How It Happened*.

Barnes didn't, or couldn't, specify any terrible inaccuracies in the profile. He merely said, in the most general terms, that he'd found it hard "to reconcile the author's romantic versions of people and events with the facts as we know them"—said romance almost certainly having been encouraged in interviews by Barnes himself.

As Barnes summarized the situation, "What McCardle asked of me, and what I willingly granted, was to take him on a journey through the beautiful valley of intelligent and enjoyable living. In return for that gratuity, he took me for a 'ride'—a long, four weeks' ride into the depths of the journalistic slums."

"The commoner Patricia Spence apparently ran into difficulty in swallowing the impressive title of Lady Russell: It evidently got stuck just below her larynx for she regurgitates it automatically to gentlefolk and telephone operators alike." McCardle quoted this description of Bertrand Russell's wife in the longest, and last, of all the colorful anecdotes in his profile of Barnes. Unfortunately, it was a verbatim quotation. The journalist had got it straight from Doctor himself.

Barnes was using McCardle's profile to make public a quarrel that was smoldering even before the Russells had moved to Pennsylvania.

"You are one of the most generous and noble-hearted people I have ever met; but you are also, to me, almost intolerably managing," Patricia "Peter" Russell had written to Barnes late in the fall of 1940, as the English couple were arranging their arrival at the foundation. Barnes was deploying all of his vast energy in "helping" them, which included giving unasked-for advice on the health, feeding, and education of their three-year-old son. "You must realise," Peter Russell went on, "that, like most people, we

wish, as far as our private lives are concerned, to be left alone." That "must" must have rankled Barnes, and the brush-off would have hurt. It included the Russells' deciding on their son's doctoring without help from Doctor and rejecting Barnes's "vehement opinions, amounting almost to instructions," on his schooling. "You have a wonderful capacity for not hearing what you do not want to hear, and seem to be convinced that you know better what people want than they do themselves," wrote Peter Russell, with perfect insight and accuracy but little diplomacy. She was a slim thirty-year-old with red hair and "a temper to match," as Barnes described her to McCardle, a temper since confirmed by several of her intimates.

In the glow of having snagged Bertrand Russell for his foundation, Barnes was surprisingly mild in his response to her letter. "I had a fight with Peter," Barnes wrote to the philosopher. "Kiss her for me and tell her I hope to make amends for all the crimes I've committed."

The mildness did not last.

Already by the spring of 1941, Barnes and Peter Russell had a more substantial fight after she objected, probably in rather haughty terms, to being denied access to her husband one day when he was being interviewed (by McCardle, in fact) at the foundation. As Barnes described the scene, she "catapulted into the hall and, bristling all over, said in a sharp, commanding tone, 'Where is Mr. Russell.'"

Barnes called her response a tantrum, and he explained to her husband that she had breached the rules of the foundation by even daring to seek admittance there without an invitation. To Dewey, Barnes complained about Bertrand Russell's "complete dominance by his wife and her attempts to extend her bossing to the Foundation's affairs and habitual practice of insulting members of the staff"—including, Barnes claimed, Laura Barnes. The question, Barnes said, was how to put Peter Russell in her place

"without bad effect upon the fine personal relations that have existed between Russell and the rest of us."

Barnes's solution verged on the absurd. He went after her knitting.

It seems that for some time Peter Russell had had the habit of knitting warm clothes for Allied soldiers on the front lines, and of doing so even when she attended her husband's lectures, many of which she would have helped prepare. At the foundation, however, all hell broke loose when her needles made themselves heard. An official and officious reprimand was issued by the Board of Directors of the Barnes Foundation. "Your constant movements in knitting during the course of the lecture were annoying and a distraction from attention to the speaker," said the board. Given her previous "disturbance of the peace"—that day when she'd pushed in to see her husband, almost a year earlier— and that she had never been formally enrolled in Russell's class, her presence was in violation of foundation bylaws and would have to cease.

Peter Russell's reply was a model of upper-class cool:

> If I am sometimes a little cold myself in future, when, having no errands, I wait for my husband outside the Barnes Foundation (outside the *grounds* of course) I will knit with more zest from a nearer realization of what it must mean to be cold and really without shelter; and I will marvel that in such a world anyone should be willing, deliberately, to make one fellow-human cold even for one hour. And I will marvel too, as I do now, that anyone should wish, in a world so full of mountains of hostility, to magnify so grandiloquently so petty a molehill.

Her husband told the board, accurately, that its letter was "astonishing by its incivility," but he apologized, with maybe some

nearly imperceptible sarcasm, for not having asked permission to have his wife at his own lectures.

Somehow Russell managed to continue with his class, a true miracle after he read the McCardle profile, with its quotations from Barnes about how Peter Russell had "high-hatted" the board and indulged in "grandstand stunts," and about her habit of forever "regurgitating" her title of Lady Russell—something her letters never show her doing, although her husband does give her the title in one wounded reply to Barnes's harassment.

Despite Bertrand Russell's forbearance, it looks as though Barnes couldn't resist his hatred of happy endings, confirming everything the *Post* had said about his terrible temper. By the end of 1942, the collector was fishing around for evidence that Russell was doing paid lectures beyond the foundation, and on the day after Christmas, Barnes used that as an excuse to fire the philosopher before his contract was up, knowing the dismissal would end up in the papers. "What is at stake is a conflict between John Dewey's democratic philosophy of life and the aristocratic, neo-fascist position of the European aristocracy and squirarchy," Barnes wrote to a Dewey protégé, although Russell himself told reporters the quarrel was over knitting. They might have been describing the same thing.

Russell sued Barnes for breach of contract, and won a judgment, and kept winning through various appeals. Not counting some big legal fees, Barnes's terrible temper had cost him $20,000.

CHAPTER 38

Renoir's Mussel-Fishers at Berneval, *from 1879, which earned headlines for Barnes when he paid $175,000 for it. It was one of the most significant purchases of his later years.*

FAILURES | WAR

*"The whole situation is so unspeakably
sad that I am overwhelmed with sorrow"*

Barnes has been as quiet as a mouse these last years," said a friend of Russell's from Bryn Mawr College, where the philosopher had found refuge after his debacle in Merion.

It was the beginning of 1945, and there were any number of reasons for Barnes's years of quietude. Troubles had been piling up.

On top of the Russell and McCardle disasters, his plans for Horace Pippin's monument to James Bland, the Black composer and performer, had petered out amid squabbles with local authorities.

Barnes's relationship with the Narberth firefighters had also become vexed, for similar reasons. After some three decades of comradeship, he broke with the fire department.

William Glackens, the beloved schoolmate who had launched Barnes into modern art, had suffered a fatal stroke in May of 1938, when he was only sixty-eight. Early in 1941, Pierre Matisse wrote to Barnes that his father, Henri, had undergone two emergency surgeries on his colon while also enduring "the terrible trial that besets all France," as Barnes put it. And then, in November of 1942, just when Barnes was girding his loins for battle with Russell, Dewey, his moral support in all things, went through a nasty,

two-part prostate operation, which eventually required a third surgery to clear up damage from the first and then a difficult recuperation. "His serenity throughout was amazing," Barnes wrote to a mutual friend, "went right along on reading, doing jig-saw puzzles and his talk never referred to pain or symptoms."

It was an illness parade, and Barnes, never exactly serene, can only have imagined himself next in line. For years, his precautions had included lunching only on salad and orange juice and spending hours in an "electric cabinet"—a kind of miniature steam bath—installed in his office bathroom. Barnes would boil in his cabinet while dictating invective, once emerging all red and cooked in front of a new stenographer. Barring storm or snow, the collector was out for a 6:00 a.m. hike every day that he slept at home. And all this prophylaxis must have seemed to work, since Barnes mostly stayed clear of doctors throughout the 1940s, except for months of treatment for a mauling by a country dog and then the back pains of any aging human.

Barnes's personal vexations of the 1940s played out against a background of global conflagration. Even before Hitler launched World War II, Barnes had welcomed a number of prominent exiles from the Nazi regime, including such stars as Albert Einstein ("who talks chiefly with twinkling eyes and a charming smile," Barnes said), Josef Albers ("doing most interesting and bizarre abstract painting"), the great art historian Erwin Panofsky, and the Nobel Prize novelist Thomas Mann. "If you are not too busy," Barnes wrote to a French friend in 1937, "you would do me a great favor if you would assassinate Hitler." Barnes's rhetoric against antisemitism, which had once been haphazard, became more pointed after Hitler's rise—especially since it provided extra ammunition in his battle with the Jew-baiting *Saturday Evening Post.*

When much of America was still in the grip of isolationism, foundation staff wrote to both Roosevelt and their senator demanding that arms and supplies be sent to the Allied forces, since "the preservation of the American tradition of democracy faces at this moment the threat of destruction through the forces of Nazism and Fascism." While Barnes was still a Russell fan, he invited the former pacifist to treat 160 notables and students to a lecture titled "Why I Support This War." The very day of Barnes's first attack on Russell's wife, he told the philosopher that the talk had "surpassed anything I ever heard, even from you, in clarity, cogency, logic, humanity, penetration, breadth of view, sincerity, compelling conviction."

Barnes helped arrange a flight from Vichy France for Marie Cuttoli, maker of his Picasso and Matisse tapestries, with plans for an American exhibition as the excuse for her departure. Jacques Lipchitz, the Jewish sculptor who had made cubist reliefs for the foundation two decades earlier, was also looking to flee, and Alfred Barr, of MoMA, asked Barnes to help fund the escape.

Barnes's dealer Georges Keller, who ran the New York branch of Bignou Gallery, kept him apprised of the grim news from France. "The whole situation is so unspeakably sad that I am overwhelmed with sorrow every time I think of it," said Barnes. On the other hand, that "situation" led to a stroke of luck: Renoir's vast *Mussel-Fishers at Berneval*, an 1879 painting that Barnes had wanted since first launching his collection, had found refuge from war in New York, and Barnes earned national headlines when he spent $175,000 to buy it. (See figure 21 in color insert.) With its family of ragged fisherfolk, the canvas touches on the social issues of nineteenth-century realism—there's an almost Ashcan edge, with maybe a hint of the Neck on view—but there are suggestions already of the stylizations that Barnes adored in Renoir's works

from three decades later. "Its color knocks you cold and then burns you up with excitement," said Barnes, days after hanging the painting on his wall. And then, remembering his foundation's purpose: "It is a tremendous contribution to art education in America."

Once the United States joined the conflict, Barnes could not give the support he had during World War I; he no longer had a drug company and its products to enlist in the cause. But he bought something like $750,000 in war bonds, and he planted acres of Ker-Feal land to grow the wartime produce Roosevelt was asking for. "Potatoes, asparagus, tomatoes, lima beans, peas, corn, string beans, lettuce, onions, melons, carrots, beets, cabbage, radishes, berries, cauliflower, etc.," was the list of crops Laura Barnes sent to the Office of Price Administration. "Dr. Barnes and myself have set aside part of each Saturday and each Sunday to do the necessary work of cultivation." They eventually hired men and tractors to help.

Foundation alumni sent Barnes harrowing reports from the European theater. He had a particularly long and powerful correspondence with a Jewish student named Abraham Chanin, drafted as a frontline medic and awarded a Silver Star for gallantry after dashing out to pull a wounded officer from a tank. With the Americans advancing into France and then into "Darkest Germany," as Chanin headed one letter, he spoke of "a succession of endless flaming villages and towns and running thru direct shellfire and foxholes and the almost forlorn hope of surviving until morning." He wrote to Barnes about the "Lublin murder camps" and gave news of the "shriveled, dull eyed" Jewish women and children he saw in Austria after the Nazis were defeated: "They tore to a hundred pieces two chocolate bars I had."

Leo Stein, writing from Tuscany, kept his upper lip comically stiff in the account he gave Barnes of his weight loss on short rations and of the attacks he lived through: "Nobody was shooting

at us on purpose but there were Germans on the hill above and English in the valley below and the Germans, either for fun or by accident would drop shells on us every now and then, just little three inch affairs, but according to all accounts if they hit you it wasn't very pleasant."

On the home front, Barnes complained that the foundation had "suffered severely" from losing several male teachers to conscription. Draft boards seemed immune to Barnes's claim that the loss had crippled the foundation's efforts to meet Roosevelt's mandates for education. Barnes also lamented a student body reduced to "mostly girls instead of the much more desirable, energetic young men that we had before."

Barnes was in constant tension and sometimes pitched battle with the same Office of Price Administration that had received Laura's news of their victory garden. Gasoline rationing cramped the once unstinting travel between Ker-Feal and the various foundation buildings, so Barnes went to some lengths to keep the gas flowing: he registered the private cars of his staffers in the foundation's name.

When the local ration board told him to switch to heating with coal, from the oil needed by the military, he replied with a public attack in doggerel:

I went to the Board to get some coupons,
You'd think I was on trial for my life,
They made me think I had committed murder,
They asked me if I ever beat my wife.

He claimed to have closed his foundation rather than risk subjecting its paintings to damage from coal smoke, when in fact all he seems to have shut was an off-campus office. The galleries themselves were heated with gas.

Other precious liquids were also in short supply at the foundation. Georges Keller procured gallons of olive oil for Barnes, as well as supplies of Perrier water.

Barnes asked Keller to deploy his London connections to procure something even more urgent: four pairs of made-to-measure underpants, sent over from the Jermyn Street tailor who had been supplying Barnes since 1910.

CHAPTER 39

Some five years before his death, Barnes contemplates a devotional work from the late Middle Ages as his devoted Fidèle contemplates him.

PENN REDUX | HAVERFORD | PENN AGAIN | SARAH LAWRENCE | LINCOLN UNIVERSITY

"I saw a possible relief to my prolonged, poignant anxiety about the future of the Foundation"

Everybody in America is, of course, elated that the war is over and there seems to be a universal feeling of a new life that will be free of the worries of wartime and contain hopes for a better future. It is in this spirit that we are going on with the Foundation.

With those words, Barnes expressed an optimism that carried over into some unlikely behavior: he tried, for the umpteenth time after so many failures, to forge bonds with the local academics.

He began with the University of Pennsylvania, whose "incubi" he'd broken with back in the fall of 1926. Bridge mending had begun in 1940 thanks to Laura Barnes and her relationship with John Fogg, the Penn botanist who'd helped her launch the foundation's Arboretum School. He went on to become Penn's vice-provost, which made him the perfect person to receive her husband's latest approaches.

It seems Barnes had got a kind of intellectual crush, like several he'd had before, on a young Harvard PhD named Roderick Chisholm who'd spent the war as an army psychologist and was about to come back into civilian life. Barnes told Fogg he wanted to fund Chisholm to become the Barnes Foundation Professor of Philosophy at Penn, rather as Thomas Munro had been two decades earlier—until he wasn't. As before, Barnes sweetened the pot by suggesting the university would be given control over the Barnes Foundation board once he and Laura were dead.

And then, as always seemed to happen, over the summer Barnes began to worry that his latest messiah might be yet another false one.

In early October of 1946, Chisholm gave his first lectures at the foundation, which were then minutely dissected by Barnes, his longtime teaching staff, and their most dedicated students. The brutal results were then passed on to Chisholm in a letter from Barnes that ended, "This is a pretty strong indictment, but it is not, as might be interpreted, a preliminary to your being fired. It is an honest, sincere, friendly effort to help you on the job with us." It was, in fact, just such a preliminary: within a month, Barnes had arranged another public humiliation for Chisholm, criticizing his performance in front of invited leaders from Penn, and then wrote him that a delegation of foundation students had asked him "to bring the pathetic situation to an end." Barnes himself took over the course, but in December, after Penn students had proven that "the time and energy devoted to them had been a dead loss," Barnes broke with the university once again.

"Thus ends a melancholy record of inertia, lethargy, disorder, blindness and futility on the part of Penn officials," Barnes wrote.

Amazingly—sadly—Barnes tried for yet another academic connection, the very next year. This time the idea was to join forces with Haverford, the Quaker men's college that was the foundation's neighbor on the Main Line. Gilbert White, an energetic

new president at Haverford, had asked Barnes to help him find a Barnesian to teach "aesthetic perception" at a college that had always scanted art and culture.

"Apparently no other academic institution in the neighborhood has been able to meet your standards of performance in a cooperative program," White wrote to Barnes. "Perhaps we won't, but I am anxious to see us try."

Barnes dug up a foundation alumnus to teach at Haverford, and as he had with Penn, he drafted a new version of the foundation's indenture with the college at the top of the post-Barnes power structure. But then Barnes discovered that Haverford was two-timing the foundation with its long-standing enemy, Bryn Mawr College, shockingly going so far as to allow a Bryn Mawr art historian to give a for-credit class on Haverford grounds, while the foundation class came with no credits. "Bryn Mawr sits in the parlor and the Foundation is concealed in an outhouse," Barnes said to Dewey. To White he wrote, "If I had known beforehand of this, the experiment would have never started." He ended it.

And then he allowed Penn to renew its courting.

A new university president had arrived, the forty-one-year-old wunderkind Harold Stassen, who had already been governor of Minnesota and in the running as a nominee for the presidency of the United States. Barnes had his doubts about Stassen's progressive credentials, calling him "a political stuffed-shirt." But he didn't balk in June 1949 when an old friend on the Penn board invited him to dine with Stassen, even though Barnes felt the new president was likely to "bamboozle the public with the same old dope, administered by the same old quacks." The usual dance ensued. Stassen worked hard to bring Barnes on board as a supporter of art education at Penn. Barnes declared the near impossibility of any rapprochement while making all kinds of suggestions for what he'd like to see change in Penn's art education. He then rebuffed Stassen's attempt at negotiation, saying any discussion would be

like "a Frenchman and a Chinese trying to convey to each other, each in his own language, the essentials of a problem in which both are interested." He taunted Stassen with Penn's imminent loss of a $10 million endowment and a picture collection worth twice that much.

"This is my last fight for democracy and education," Barnes wrote to Dewey in April of 1950. "If we lose, the Foundation ends its existence, the endowed fund of ten million dollars goes to the extension of a post graduate school of medicine for research and treatment, the paintings will be sold and the proceeds go to the same institution."

None of that happened when the rapprochement with Penn did, in fact, end. In June of 1950, after exactly one year of infinite patience on Stassen's part and infinite rudeness from Barnes, the collector simply broke off the engagement, using insults that were unworthy of his taste for fine invective.

"You are what psychologists term a 'mental delinquent,'" Barnes wrote to Stassen, "variously known to laymen as 'dumb bunny,' 'false alarm,' 'phony.'"

In the late 1940s, even as Barnes fought the bad fight with nearby academics, he had his share of private worries.

The summer of 1947, he was in "deep sorrow" after losing his old friend and sometime rival Leo Stein, who died in Italy from an operation for rectal cancer. ("My talks with him in the early days were the most important factor in determining my activities in the art world," Barnes wrote to Stein's wife just days after getting the bad news.) That fall Laurence Buermeyer, Barnes's old tutor, had an incapacitating stroke. Barnes visited often and secretly helped pay for his years of treatment.

His beloved Dewey, now ninety years old, was in and out of the hospital at the end of the decade, for a weak heart and a virus and hernia, with treatments funded by Barnes. The collector himself was laid up with "excruciating" lumbago and neuritis and a monthlong dose of the flu, had a cancer scare, and then had serious urological troubles and surgeries.

With mortality ever more present, he wrote to Violette de Mazia about his "prolonged, poignant anxiety about the future of the Foundation."

After that third break with Penn, Barnes flirted with Sarah Lawrence, the women's college in Bronxville, New York. Dewey dangled the foundation's treasures before his friend Harold Taylor, the college's young president ("there's gold in them hills," Dewey told Taylor), while Barnes gave Taylor the usual dose of abuse. After only four months, the long-suffering president threw up his hands. "There is nothing you have that I want," Taylor wrote to Barnes. "As far as I'm concerned you can stuff your money, your pictures, your iron work, your antiques, and the whole goddam thing right up the Schuylkill River, Pennsylvania."

And then Barnes wrote these words to Dewey in September of 1950: "News: Lincoln University, a 100-year-old Negro college located about 30 miles from here, took on a fresh lease on life under a new president, Horace Bond, about 40 years old, a Ph.D., Chicago." Lincoln had been the first Black college in the United States to grant a degree and had then given them out to both Langston Hughes—Barnes's tablemate at the long-ago Civic Club dinner—and Thurgood Marshall, who went on to be the first Black justice on the U.S. Supreme Court. Barnes had mooted a collaboration with Lincoln a quarter century earlier, when he was threatening to build his center for Black culture, and already from the late 1940s he had been in close touch with Bond—one of Black America's "most exciting men," according

to *Ebony* magazine—and in frequent and friendly debate with Lincoln's resident philosopher. It looks as though the only "news" was that Barnes was starting to see Lincoln as the latest heir to the foundation's future.

Barnes had a foundation alumnus installed to teach art to Lincoln students and faculty in the Merion galleries, echoing so many earlier arrangements that had failed. But unlike his relationships with the elites at Penn and Haverford, Barnes's support for Lincoln was in line with his long-standing principles as a progressive, a democrat, and an anti-racist, and with his lifetime identification with the downtrodden. Barnes funded some of Lincoln's poorest foreign students; he applauded Bond's efforts to integrate local schools; he tried to get treatment for a sick Lincoln scholar and was properly mortified and apologetic when his fine doctor friends refused to see a Black man lest it hurt their business with white patients.

After Barnes gave a lecture at Lincoln, one scholarship student from Sierra Leone spoke of the contribution the collector's funds had made to "the advancement of the millions in Africa" and of his pleasure in discovering "that there are in America men with open hearts toward the Negro."

It was just about possible to imagine a successful marriage between the Black university and the collector's foundation. Support for Lincoln let Barnes return to social issues that had mattered so much to him decades earlier, but that his art obsessions had overshadowed.

Barnes took the offer of posthumous control of his foundation that he'd used as bait with Penn and Haverford and this time turned it into legal fact: on October 20, 1950, members of the board of the Barnes Foundation, rubber-stamping a decision by its founder, changed the succession plan so that, after the death of Albert and Laura and the expiration of other board members' terms, Lincoln would get to choose almost all the board's

members, thereby getting ultimate control of the whole place. In thanks, Bond arranged to grant Barnes an honorary doctorate at the next Lincoln commencement, in June of 1951, with a citation that read, "You have faith in the capacities of the Negro people, and this faith you have demonstrated in many ways throughout your life and with particular reference to Lincoln University."

But Barnes didn't show up to hear that praise; a stand-in had to accept the degree. Disappointed with the performance of the new African American students, Barnes had begun to sour on what he called his "dreams for the future of Lincoln University." The partnership didn't come to an end right then, but it was showing cracks.

Bond must have worried that at some upcoming board meeting Barnes was likely to make Lincoln's role in shaping the foundation's future as evanescent as Penn's and Haverford's had been.

Fate and a truck intervened, and Lincoln fills seats on the foundation's board to this day.

CHAPTER 40

The remains of Barnes's Packard, after his fatal crash on July 24, 1951.

THE END

"Dr. Albert Barnes Dies in Crash: Art Collector Discovered Argyrol"

n 1942, Barnes made insurance claims for seven car accidents, even though wartime driving rules had cut traffic. Several collisions involved inanimate objects that had somehow got in his way.

Over the next nine years he made claims for another twelve crashes. None were terribly serious, and, funnily enough, the fault was never his: he was blinded by the sun, or it would have been dangerous to stop, or some obstacle had appeared out of nowhere. The toll might have been worse, except that Barnes eventually stopped driving at night.

The morning of July 24, 1951, dawned cool and cloudy in the Philadelphia suburbs. Leaving his home on the foundation's Merion campus, Barnes got into his 1938 Packard convertible coupe, a deluxe car with swooping front fenders now much repaired from previous crashes, and motored without incident to Ker-Feal. He had driven the same route hundreds of times before, although this was his first time taking it in the convertible since prostate surgery early in the year. Laura Barnes had arrived at the farm earlier that morning, to garden and pack up some chickens for the Merion freezer. She was surprised to see her husband pull up, but he said he had come out to the country to clear his head. The two had

lunch and Barnes sat on the porch thinking for a bit, then headed back to the foundation for a meeting with some new hires who would be taking over the Lincoln classes. He'd fired their predecessor, who, as usual, hadn't lived up to Barnes's expectations.

Loading Fidèle into the convertible, the seventy-nine-year-old collector sped off down country byways to make the trip home. After some five miles, his rural road crossed a small highway; it was a dangerous intersection where Barnes had had the good sense to make the state install a stop sign. Coming down the highway was Samuel E. Ash, a thirty-year-old employee of the Kulp & Gordon Motor Freight Company, driving a tractor trailer loaded with ten tons of paper. At 2:45 p.m., Barnes sped through the stop sign he'd lobbied for. Was he just enjoying the horsepower under his hood, or had he suffered a heart attack or stroke? We'll never know. There was no autopsy; the cause of death was obvious.

Ash hit him broadside. The semi turned over. The convertible somersaulted several times, throwing Barnes and Fidèle out onto the asphalt before flying into a nearby field, smashed to pieces with both doors and its top ripped off. Ash was largely unhurt. All of Barnes's ribs and his right leg were broken; he hemorrhaged from a crushed head and chest; he died almost instantly.

Private Gerald Robinson, arriving on the scene from the nearby barracks of the state police, drew his gun and put Fidèle out of his misery.

Barnes hadn't wanted a funeral, so Laura didn't give him one.

The collector was cremated, and his remains were buried beside Fidèle's in the foundation's woods.

The only public display of mourning came from Narberth's fire company, which draped its hall in black and lowered its flag to half-staff.

EPILOGUE

Violette de Mazia teaching a class at the Barnes Foundation some two decades after the death of its founder.

On a March day in 2024, ninety-nine years after the public opening of the Barnes Foundation, I took a final look at the place as I prepared to wrap up this biography. I wandered among the foundation's pictures, hinges, and hope chests, displayed just as they were on the day Albert Coombs Barnes met his end. So did clutches of visitors from France and Japan, from Texas and Montana, from North and South Philly.

In the two-story main hall, we marveled at its twenty-four Renoirs, seventeen Cézannes, and its landmark Seurat, works that had shocked their contemporaries but now seemed the safest of masterpieces. I was particularly taken with the gallery's west wall. By pairing the female models in the Seurat with the male card players in the great Cézanne below it, Barnes—or maybe his unconscious—had given us a little study of attitudes to gender in his day: women, naked and passive, are set out on offer to a male observer; men, clothed and engaged, go about their business without an onlooker in mind. This reading of mine wasn't, and needn't have been, available in the phone app that offered basic thoughts and data about almost any Barnes picture you could snap. And it certainly wouldn't be found in any of Barnes's own writings. But that's the way of his foundation in the twenty-first century: visitors are welcome to think their own thoughts about the works on view, or none at all if they prefer basking to ratiocination. The ghosts of Barnes and de Mazia barely hover.

That freedom of thought struck me again upstairs, where I spotted local college students taking notes on the African sculp-

tures and the Modiglianis still hanging near them. Seven decades after Barnes's death, those notes were less likely to reflect on his concept of plastic form than on racist colonialism and its effects on culture.

But I admit to having been most compelled by how that gallery, like all the others at the foundation, opened a window onto the history of taste from a century ago, and onto a past culture's ideas about art and the world. The Barnes doesn't stop you from analyzing a single picture, like an insect pinned down for inspection. But like all the other great house museums, in total it preserves a rare, unchanging record of what one obsessive art lover had in mind to do with his prizes.

Stepping out of the galleries, I and my fellow art lovers no longer took in the swelling lawns I'd found on a first visit, as a tweenager, decades ago when de Mazia still held sway. Instead, we emerged into a soaring, skylit atrium. In one corner, a café; in another, a white-cube space reserved for whatever non-Barnes art the foundation might want to show.

For a dozen years before my March visit, the foundation's original galleries had found themselves cocooned inside a grand modern building, in fossilized limestone and frosted glass. It came with all the conveniences of a twenty-first-century museum: that café and exhibition space; classrooms, auditorium, and a conservation lab; also, the vast and systematic archive that, with luck, allowed this biography to get a few things right.

The whole package now lived, and lives, in the center of Philadelphia, six miles from the foundation's former Main Line home and that much closer to the common people Barnes once embraced.

The foundation had come a long way since its founder left the stage.

For a little while after that fatal day in July of 1951, things had gone much as they had for the decades before. Barnes's very minimal will left Ker-Feal to his foundation and everything else he owned to his wife. There wasn't that much; mostly, a bit of real estate. The rest of Barnes's wealth had long ago passed to his foundation. Laura Barnes now became its president, at a salary of something like $30,000—a top surgeon's income—while the arboretum remained her focus. That's because, the year before, Barnes had decreed that after he died, Violette de Mazia would be director of education, and for the next four decades she remained fiercely in charge of the foundation's artistic and pedagogical life. Like many a disciple, she held more closely to the Master's teachings than even he might have done as the world changed around the foundation.

Inevitably, that world imposed changes.

In 1952, *The Philadelphia Inquirer* brought suit to make the foundation open its galleries to a larger public, citing the tax breaks the Barnes got as a public institution. A court ruled that only the state, not a newspaper, could fight for those changes—as the state later went on to do.

In 1957, change hit the foundation from inside: the board faced the death of the trustee Albert Nulty, the curator of paintings who had begun as Barnes's chauffeur; it also accepted the resignation of Mary Mullen after five decades of service to the Barnes cause.

The next year, Lois G. Forer, deputy attorney general of Pennsylvania, carried on the *Inquirer*'s quest to have the foundation open its doors a bit wider.

The lawsuit she brought before the Montgomery County Orphans' Court, which governed local nonprofits, was to say the least heated, and prolonged. Laura Barnes and de Mazia did their best to block the state's hunt for reliable information about their institution. Forer went on to describe de Mazia ("the high priestess

of the Foundation") as behaving like both "a gracious chatelaine receiving the homage of the visiting serfs" and a "detective keeping under constant surveillance any artists, critics or scholars she suspects to be unfriendly."

Forer rejected the foundation's first offer to open to twenty-five people twice a week for two hours, which she said would have allowed visitors "slightly more than seven seconds per picture, excluding artifacts and time to walk from room to room." In 1960, after seeing her case dismissed and then winning on appeal, she forced the collection to open on Fridays and Saturdays to two hundred visitors each day, with half admitted by advance reservation and the rest lining up at the door.

March 18, 1961, was the foundation's first day of unvetted admissions. People waited hours to see the Barnes treasure. Pinkerton guards were there to greet them—twenty-seven of them, guarding twenty-three rooms—and they searched bags to prevent photography. For want of fire escapes, said the foundation, only three guests at a time were allowed onto the second floor, which housed the African objects Barnes had been so specially proud of.

De Mazia's students picketed the opening as members of the Friends of the Barnes Foundation, an organization that spent the following decades resisting most attempts to make the Barnes go more public.

They were right to think that the changes went against Barnes's heartfelt belief that great art demanded—and deserved—only the most intense and deeply informed scrutiny, according to the axioms he had dreamed up. In the years since, however, many people have come to feel that art, with its roots in that freedom Barnes so admired, also deserves the freedom to have whatever effect it can, however it can, on whoever it can. Barnes's notion that there's a single, correct approach goes against most current ideas about the way art can and does play out in the world. Any single conception of art is likely to get things wrong as often as it gets

them right, or its methods will seem right only until a new conception proves them "wrong," at least for its new moment. Seven decades since Barnes's death, the institution he so fiercely guarded has come to offer a more open embrace.

The Barnes Method is still taught in its classes; it has an undeniable and fascinating place in the history of artistic ideas. But it no longer rules at the Barnes Foundation. Other classes discuss how "art can play a role in justice reform" or how public monuments "can animate democracy and foster generational change"— not typically Barnesian subjects.

⸺

On April 29, 1966, Laura Barnes passed away. Violette de Mazia was left more in charge than ever, as vice president to board president Nelle Mullen, last of the first-generation Barnesians. With the Barnes residence, a.k.a. the administration building, now empty and available to host de Mazia's classes, the foundation reluctantly agreed to open its galleries to the public for a third day. The classes could hardly have suffered.

But already by 1962, Barnes's dream of a working-class student body—the "carpenter, baker, chauffeur" he'd once talked about as his favored public—had essentially vanished: A count showed that most students were suburban homemakers from near the Main Line, plus a smattering of retirees and collegians. There were no workers at all enrolled in the classes.

Annual enrollment hovered at around 350 students throughout the 1970s, but by 1982 only 287 people had even applied to the foundation's courses, with fewer actually going on to attend. Applications remained low for the next half decade, as de Mazia kept teaching into her nineties. She died on September 20, 1988, at ninety-two. For the first time, that left room on the foundation's board for a majority of trustees nominated by Lincoln University.

They faced a parlous situation. From the start, Barnes had ruled that the foundation's endowment be invested only in the safest, least profitable vehicles. By the spring of 1991, forty years of such caution had left the endowment at only $10 million, much too little to cover expenses that had risen to $2 million a year. A desperate board applied for court permission to raise the admission fee (still set at the single dollar imposed in 1963), to invest more profitably, to rent out the facilities and use them for social events, and, most radically, to sell fifteen paintings to fund the endowment and vital renovations. An advisory committee objected to the sale, so luckily it did not happen. The court allowed the foundation to break with Barnes's investment plan, but denied the rentals and parties he had so clearly despised.

On July 22, 1992, the same court made a radical decision: faced with evidence of desperately needed renovations, and with a foundation too poor to fund them, a judge approved a moneymaking tour of major paintings from the foundation's collection.

In May of 1993, *From Cézanne to Matisse: Great French Paintings from the Barnes Foundation* began a two-year tour of important museums stretching from Toronto to Tokyo to Fort Worth. Millions of people rushed to see Albert Barnes's treasures—I caught them in Toronto—and the tour raised $17 million for renovations and conservation.

Aside from letting its paintings speak to more people than ever before (if artworks could have desires, that might be the main one), the tour set an important precedent: in the competition between current necessity and the wishes of a dead founder (wishes that have often seemed eccentric or outdated, or even wrongheaded), necessity might win out at the Barnes Foundation. But Barnes continued to have at least some sway from the grave.

After the renovations, when the foundation asked to open six days a week, the courts said that three and a half days would come closer to its founder's wishes.

Late in 1995, the foundation's neighbors, alarmed about parking and traffic in their deluxe suburb, got Merion's civic leaders to dial access back to only two and a half days a week and to two hundred visitors each day, close to how things had stood more than three decades before. That reduction was overturned by the courts, but the neighbors' efforts made clear how little change could ever come to the Merion site.

In 1998, an audit listed the foundation's annual income at $755,000 and expenses at $5.24 million, with an endowment of only $7 million—a decrease from where the endowment had stood right after Barnes's death. Four years later, on September 24, 2002, the Barnes Foundation revealed a plan to petition the courts to expand its board of trustees—an obvious way to find new donors—and to move its galleries to the center of Philadelphia. Controversy exploded.

Some observers saw—still see—the plan as a move to pass control of the foundation from Lincoln, a Black institution, to Philadelphia's white elites. Other opponents of the move felt and feel that the foundation's setting in Merion was conceived as an inseparable part of its identity and mission—which might be true, but may be irrelevant if that conception risked tanking the entire operation.

Early in 2004, the Orphans' Court declared the foundation's finances to be simply untenable, given its neighbors' resistance, "bordering on hysteria," to any increase in visitors. A year later, it approved both the expansion of the board, to fifteen members, and the move to Philadelphia. It imposed conditions that must have placated at least a few doubters: admissions would be limited, to preserve some of the contemplative peace the Barnes was known for (among those who could get in), while the galleries' interiors and "ensembles" had to be re-created precisely as they were on Barnes's death, with their artworks never to be moved or lent.

In September of 2007, the Barnes announced the full plan for its transformation: Tod Williams Billie Tsien Architects would be designing a grand new building on the Benjamin Franklin Parkway in Center City Philadelphia, near the Philadelphia Museum of Art, the Rodin Museum, the Free Library, and the Franklin Institute science museum. The groundbreaking began two years later—at almost the same time that the whole project was challenged in *The Art of the Steal*, a tendentious documentary that won worldwide attention. It presented the move to downtown Philadelphia as a conspiracy by local bigwigs long determined to grab the Barnes legacy. The movie cast plenty of shadow, but couldn't turn the clock back to 1951.

On May 19, 2012, the new Barnes Foundation campus opened to the public. In its first twelve months, it welcomed 300,000 visitors. In the dozen years after that, more than 2.5 million people came to see its permanent galleries and special exhibitions. Its outreach programs served more than 120,000 schoolchildren.

Some devout Barnesians still grumble that their master's unique vision is lost, and there's some truth to that. But he cherished his artworks for the insights they held, so could he protest when those now reach more people?

Knowing Barnes—yes.

A NOTE ON SOURCES

The best scholarly research on Barnes is in Mary Ann Meyers, *Art, Education, and African-American Culture: Albert Barnes and the Science of Philanthropy* (New Brunswick, NJ: Transaction Publishers, 2009). Meyers had limited access to Barnes's own archives, but her research in other sources was a vital help in preparing this biography. The writings of the late Richard Wattenmaker were also of great use, especially for Barnes's earlier years as a collector. The archivists' introductions to the finding aids for the Barnes Foundation Archives are another important source of reliable information on Barnes, and of course the vast archives themselves, on the way to being fully digitized as this book was nearing completion, are an inexhaustible supply of information and insight.

Full endnotes for this biography are available at http://hc.com/MavericksMuseum, with a copy also at the Barnes Foundation Archives.

ACKNOWLEDGMENTS

My first thanks must go to John Mcfadden, a Barnes Foundation trustee, and Andrew Wylie, my agent, who together set this project in motion. At the Barnes Foundation, executive director Thomas Collins and deputy director Sara Geelan removed all obstacles to its progress. The extraordinary Amanda McKnight, director of archives, oversaw my endless research in her department. Without help from Amanda and her team—Haley Richardson, Rob Jagiela, and Bertha Adams—this book, or any serious work on Barnes, could not exist. David Updike, director of the Barnes publications department, also gave gracious assistance, as did Deirdre Maher, director of communications, and Nina Diefenbach, deputy director for advancement. I'd also like to thank Mark Rooks and Dan Haig, of the InteLex Corporation, for giving me access to their electronic edition of the letters of John Dewey.

Elaina Ackatz Young gave wonderful research assistance in the early stages of this biography while David R. Kahn, archivist at Philadelphia's Central High School, gave wonderful assistance on the early stages of Barnes's life. Hugh Eakin, author of *Picasso's War*, was a big help on Barnes's relationship with John Quinn, and the staff at the New York Public Library—especially Deirdre Donohue, Maira Liriano, and Rhonda Evans—were as delightfully helpful as always. Thanks to a bookshelf in her apartment in

London, Claire MacDonald set me on the path to understanding Barnes's relationship to the Progressive movement.

Kerry Annos, of the Barnes Foundation, and Dan Trujillo and Janet Hicks, of the Artists Rights Society in New York, made it possible to stuff this book with images, while the map librarians at the Free Library in Philadelphia and the New York Public Library helped me understand the geography of South Philadelphia for this book's one map.

My father Irwin, my sister Alison, and my dear friend Alex Nagel all read drafts of this book and gave invaluable advice on it, some of which I even followed. Lucy Hogg, my wife, gave more of her time and energy to this biography, and especially to choosing and perfecting its images, than I or they deserved. And of course this book would never have existed at all without the help, and especially patience, of Gabriella Doob, my editor at Ecco, and Helen Atsma, my publisher there. Going well beyond the call of duty, copy editor Ingrid Sterner saved me from any number of hideous blunders. The production team at Ecco under Frieda Duggan, and especially the biography's designers, Alison Bloomer and Allison Saltzman, made the book come together as flawlessly and beautifully as any author could hope for. Any remaining flaws are all mine.

ILLUSTRATION CREDITS

Black-and-white images throughout

FRONTISPIECE

xi Albert C. Barnes on the Balcony of the Cret Gallery, Resting One Hand on the Baule Door, c. 1946. Photograph by Angelo Pinto, courtesy of the Pinto family. Gelatin silver print. Photograph Collection, Barnes Foundation Archives, Philadelphia.

PROLOGUE

1 *Town & Country*, Feb. 15, 1923, 30.

CHAPTER 1

8 "Bethany ME Church 11th and Mifflin Streets, Philadelphia PA," Mission Album Cities 5 page 77 H11020, courtesy The General Commission on Archives and History of The United Methodist Church, Madison, NJ.

CHAPTER 2

15 Illustration based on *New Map of the City of Philadelphia from the Latest City Surveys Prepared for Gopsill's Directories* (Philadelphia: J.L. Smith, 1893).

17 Joseph Pennell, *A Trucker's Farm-Yard*, in *Scribner's Monthly*, July 1881, 349.

17 Joseph Pennell, *Oil Refinery*, in *Scribner's Monthly*, July 1881, 346.

CHAPTER 3

23 Albert C. Barnes Seated at Desk, 1891. Unidentified photographer. Gelatin silver print. Photograph Collection, Barnes Foundation Archives, Philadelphia.

CHAPTER 4

30 Laura Leggett Barnes, c. 1901, from her Bride's Book. Unidentified photographer. Laura Leggett Barnes Papers, Barnes Foundation Archives.

32 Albert C. Barnes Seated in a Rocking Chair, c. 1900. Unidentified photographer. Gelatin silver print. Photograph Collection, Barnes Foundation Archives, Philadelphia.

384 ILLUSTRATION CREDITS

CHAPTER 5

41 Albert C. Barnes on Horseback, c. 1910. Unidentified photographer. Gelatin silver print. Photograph Collection, Barnes Foundation Archives, Philadelphia.

CHAPTER 6

50 Albert C. Barnes (left) and William James Glackens, c. 1920. Unidentified photographer. Gelatin silver print. Glackens Family Photographs, Barnes Foundation Archives, Philadelphia.

54 William Glackens. *Pony Ballet*, 1910–early 1911, Oil on canvas. The Barnes Foundation, BF340.

57 Vincent van Gogh. *The Postman (Joseph-Étienne Roulin)*, 1889, Oil on canvas. The Barnes Foundation, BF37.

58 Pablo Picasso. *Young Woman Holding a Cigarette (Jeune femme tenant une cigarette)*, 1901, Oil on canvas. The Barnes Foundation, BF318. © 2024 Estate of Pablo Picasso / Artists Rights Society (ARS), New York.

60 Pierre-Auguste Renoir. *Before the Bath (Avant le bain)*, c. 1875, Oil on canvas. The Barnes Foundation, BF9.

CHAPTER 7

62 John Sloan. *Nude, Green Scarf*, 1913, Oil on canvas. The Barnes Foundation, BF524.

66 Vincent van Gogh. *The Smoker (Le Fumeur)*, 1888, Oil on canvas. The Barnes Foundation, BF119.

CHAPTER 8

69 Vincent van Gogh. *Ravine*, 1889, Oil on canvas, 73 x 91.7 cm (28¾ x 36⅛ in.). Museum of Fine Arts, Boston, Bequest of Keith McLeod, 52.1524. Photograph © 2025 Museum of Fine Arts, Boston.

71 Paul Cézanne. *Five Bathers (Cinq baigneuses)*, 1877–1878, Oil on canvas. The Barnes Foundation, BF93.

73 Pablo Picasso. *Wineglass and Fruit*, 1908, Oil on panel. The Barnes Foundation, BF87. © 2024 Estate of Pablo Picasso / Artists Rights Society (ARS), New York.

CHAPTER 10

87 Maurice Prendergast. *Landscape with Figures*, c. 1910–1912, Oil on canvas. The Barnes Foundation, BF480.

CHAPTER 11

96 John Dewey photographed by Eva Watson-Schütze in 1902 at the University of Chicago.

CHAPTER 12

106 Albert C. Barnes, c. 1915. Unidentified photographer. Gelatin silver print. Photograph Collection, Barnes Foundation Archives, Philadelphia.

CHAPTER 13

113 Hotel Powelton (c. 1900), Warren-Ehret Company photograph albums (Accession 2002.251), Hagley Museum and Library, Wilmington, DE.

ILLUSTRATION CREDITS *385*

CHAPTER 14

125 Illustration to "How Much May a Husband Flirt," *Daily Home News* (New Brunswick, NJ), Feb. 25, 1922.

CHAPTER 15

134 *Anzia Yezierska*, Underwood & Underwood Studios, NY (1925), New York World-Telegram and the Sun Newspaper Photograph Collection, Library of Congress Prints and Photographs Division, Washington, DC.

CHAPTER 16

141 Auguste Renoir. *Les Baigneuses* (bet. 1918 and 1919), Oil on canvas (RF 2795), Paris, musée d'Orsay, accepté par l'Etat à titre de don des fils de l'artiste au musée du Luxembourg en 1923.

141 Paul Cézanne. *Mont Sainte-Victoire (La Montagne Sainte-Victoire)*, 1892–1895, Oil on canvas. The Barnes Foundation, BF13.

145 Marie Laurencin. *Woman with Muff (La Femme au manchon)*, c. 1914, Oil on canvas. The Barnes Foundation, BF384. © Fondation Foujita / Artists Rights Society (ARS), New York / ADAGP, Paris 2024.

CHAPTER 17

150 Charles Demuth. *The Masque of the Red Death*, c. 1918, Watercolor and graphite on wove paper. The Barnes Foundation, BF2009.

155 Pablo Picasso. *Musical Instruments on a Table (Instruments de musique sur un guéridon)*, 1915, Gouache, graphite, and charcoal on laid paper. The Barnes Foundation, BF203. © 2024 Estate of Pablo Picasso / Artists Rights Society (ARS), New York.

CHAPTER 18

156 "America's $6,000,000 Shrine for All the Craziest Art," *Philadelphia Inquirer*, April 29, 1923. Special Collections, Barnes Foundation Archives, Philadelphia.

CHAPTER 19

162 Hélène Perdriat. *Girl with Cat*, c. 1920, Oil on panel. The Barnes Foundation, BF400.

166 Henri Matisse. *Le Bonheur de vivre*, also called *The Joy of Life*, between October 1905 and March 1906, Oil on canvas. The Barnes Foundation, BF719. © 2024 Succession H. Matisse / Artists Rights Society (ARS), New York.

169 Jacques Lipchitz. *Harlequin with Clarinet*, 1919, Limestone. The Barnes Foundation, A234. © 2024 Estate of Jacques Lipchitz. All Rights Reserved—Estate of Jacques Lipchitz.

CHAPTER 20

171 Amedeo Modigliani. *Paul Guillaume, Novo Pilota*, 1915, Oil on cardboard. Musée de l'Orangerie, Paris. Photo by Sailko, Wikimedia Creative Commons Attribution 3.0 Unported license.

CHAPTER 21

180 Giorgio de Chirico. *Dr. Albert C. Barnes*, 1926, Oil on canvas. The Barnes Foundation, BF805. © 2024 Artists Rights Society (ARS), New York / SIAE, Rome.

182 Giorgio de Chirico. *The Arrival (La meditazione del pomeriggio)*, 1912–1913, Oil on canvas. The Barnes Foundation, BF377. © 2024 Artists Rights Society (ARS), New York / SIAE, Rome.

185 Amedeo Modigliani. *Reclining Nude from the Back (Nu couché de dos)*, 1917, Oil on canvas. The Barnes Foundation, BF576.

187 Chaim Soutine. *The Pastry Chef (Baker Boy) (Le Pâtissier)*, c. 1919, Oil on canvas. The Barnes Foundation, BF442.

CHAPTER 22

192 Reliquary Guardian Head (añgokh-nlô-byeri) from the Fang Betsi culture, 19th Century, Wood. The Barnes Foundation, A124.

192 Miniature Mask (Ma Go) from the Dan culture, Early 20th Century, Wood, unidentified metal, resin. The Barnes Foundation, A214.

CHAPTER 23

202 "Quelques-uns des Chanteurs de Bordentown," *Les Arts à Paris*, no. 12 (May 1926): 15. Special Collections, Barnes Foundation Archives, Philadelphia.

CHAPTER 24

213 Cret Gallery, Barnes Foundation, 1925. Photograph by Walter H. Evans. Gelatin silver print. Photograph Collection, Barnes Foundation Archives, Philadelphia.

217 Vincent van Gogh. *Reclining Nude (Femme nue étendue sur un lit)*, January–March 1887, Oil on canvas. The Barnes Foundation, BF720.

218 Gustave Courbet. *Woman with White Stockings (La Femme aux bas blancs)*, 1864, Oil on canvas. The Barnes Foundation, BF810.

219 Pierre-Auguste Renoir. *Reclining Nude (Femme nue couchée)*, c. 1910, Oil on canvas. The Barnes Foundation, BF97.

CHAPTER 25

223 Paul Cézanne. *Toward Mont Sainte-Victoire (Vers la Montagne Sainte-Victoire)*, 1878–1879, Oil on canvas. The Barnes Foundation, BF300.

CHAPTER 26

232 Pierre Matisse, *Albert Barnes Looking at Cézanne's* Bathers at Rest *at the Barnes Foundation*, 1932. © 2024 Estate of Pierre Matisse / Artists Rights Society (ARS), New York. Photograph Collection, Barnes Foundation Archives, Philadelphia.

CHAPTER 27

245 Albert C. Barnes and Laura Barnes on a Steamer, c. 1930. Photograph by Bain News Service. Gelatin silver print. Photograph Collection, Barnes Foundation Archives, Philadelphia.

251 Paul Cézanne. *The Card Players (Les Joueurs de cartes)*, 1890–1892, Oil on canvas. The Barnes Foundation, BF564.

252 Georges Seurat. *Models (Poseuses)*, 1886–1888, Oil on canvas. The Barnes Foundation, BF811.

CHAPTER 28

256 Albert C. Barnes Walking with Violette de Mazia (left) and Laura Geiger in Brides-les-Bains, France, c. 1930. Unidentified photographer. Photographic postcard. Photograph Collection, Barnes Foundation Archives, Philadelphia.

262 Moïse Kisling. *Buste de jeune fille*, 1922, Oil on canvas. The Barnes Foundation, BF2005.

CHAPTER 29

267 *Actor at Home with Art: Charles Laughton, Visiting His Old Friend, Dr. Albert C. Barnes in Merion, Admires Again the Barnes Collection*, Oct. 18, 1940, Photograph. George M. McDowell Philadelphia Evening Bulletin Collection, courtesy of the Special Collections Research Center, Temple University Libraries, Philadelphia, PA.

CHAPTER 30

274 Cret Gallery and Administration Building, c. 1927. Unidentified photographer. Gelatin silver print. Photograph Collection, Barnes Foundation Archives, Philadelphia.

CHAPTER 31

284 El Greco (Domenikos Theotokopoulos). *Apparition of the Virgin and Child to Saint Hyacinth*, c. 1605–1610, Oil on canvas. The Barnes Foundation, BF876.

284 Pablo Picasso. *Composition: The Peasants*, 1906, Oil on canvas. The Barnes Foundation, BF140. © 2024 Estate of Pablo Picasso / Artists Rights Society (ARS), New York.

CHAPTER 32

290 Henri Matisse using a bamboo stick to sketch *The Dance* in full size in his studio in Nice, 1931. Unidentified photographer. Gelatin silver print. Photograph Collection, Barnes Foundation Archives, Philadelphia. Matisse drawing is © 2024 Succession H. Matisse / Artists Rights Society (ARS), New York.

294 Ensemble view, Room 1, south wall, Philadelphia, 2012. Henri Matisse. *The Dance*, Summer 1932–April 1933, Oil on canvas; three panels. The Barnes Foundation, 2001.25.50a,b,c. © 2024 Succession H. Matisse / Artists Rights Society (ARS), New York. The work is shown installed at the Barnes Foundation in Center City, Philadelphia.

296 Henri Matisse. *Three Sisters with Grey Background (Les Trois soeurs sur fond gris)*, between May and mid-July 1917, Oil on canvas. The Barnes Foundation, BF888. © 2024 Succession H. Matisse / Artists Rights Society (ARS), New York.

388 ILLUSTRATION CREDITS

CHAPTER 33

304 Albert C. Barnes, holding Fidèle, and John Dewey with *Renoir's Leaving the Conservatory (La Sortie du conservatoire)* (BF862), 1941. Photograph by Angelo Pinto, courtesy of the Pinto family. Gelatin silver print. Photograph Collection, Barnes Foundation Archives, Philadelphia.

309 Pierre-Auguste Renoir. *Caryatids (Cariatides)*; also called *Deux baigneuses (panneau décoratif)*, c. 1910, Oil on canvas. The Barnes Foundation, BF918.

309 Pierre-Auguste Renoir. *Caryatids (Cariatides)*; also called *Deux baigneuses (panneau décoratif)*, c. 1910, Oil on canvas. The Barnes Foundation, BF919.

310 Pierre-Auguste Renoir. *Henriot Family (La Famille Henriot)*, c. 1875, Oil on canvas. The Barnes Foundation, BF949.

312 Pierre-Auguste Renoir. *Bathers in the Forest (Baigneuses dans la forêt)*, c. 1897, Oil on canvas. The Barnes Foundation, BF901.

CHAPTER 34

314 Albert C. Barnes (right) seated with Ambroise Vollard in the Cret Gallery, 1936. Unidentified photographer. Gelatin silver print. Photograph Collection, Barnes Foundation Archives, Philadelphia.

316 Pierre-Auguste Renoir. *Portrait of Jeanne Durand-Ruel (Portrait de Mlle. J.)*, 1876, Oil on canvas. The Barnes Foundation, BF950.

317 Paul Cézanne. *The Large Bathers (Les grandes baigneuses)*, c. 1894–1906, Oil on canvas. The Barnes Foundation, BF934.

CHAPTER 35

321 The frontispiece to Albert C. Barnes, *The Art in Painting*, 3rd ed. (New York: Harcourt, Brace and Co., 1937). Special Collections, Barnes Foundation Archives, Philadelphia.

323 Pablo Picasso with Atelier Delarbre. *Secrets (Confidences) or Inspiration*, 1934, Cotton warp and wool weft with silk highlights. The Barnes Foundation, 01.27.02. © 2024 Estate of Pablo Picasso / Artists Rights Society (ARS), New York.

329 Ensemble view, Room 1, north wall (detail), Philadelphia, 2012. Paul Cézanne, *Madame Cézanne with Green Hat (Madame Cézanne au chapeau vert)*, 1891–1892, oil on canvas, BF141, between Pierre-Auguste Renoir, *Bathing Group*, 1916, oil on canvas, BF709, and Paul Cézanne, *The Bellevue Plain / The Red Earth (La plaine de Bellevue / Les terres rouges)*, 1890–1892, oil on canvas, BF909.

330 Horace Pippin. *Supper Time*, c. 1940, Oil on burnt-wood panel. The Barnes Foundation, BF985.

330 John Kane. *Children Picking Daisies*, 1931, Oil on canvas (later mounted to hardboard). The Barnes Foundation, BF1151.

332 Henri Rousseau. *View of the Quai d'Asnières (Vue du quai d'Asnières)*; also called *The Canal and Landscape with Tree Trunks (Le Canal et paysage avec troncs d'arbre)*, between April and December 1900, Oil on canvas. The Barnes Foundation, BF583.

ILLUSTRATION CREDITS 389

CHAPTER 36

334 Albert C. Barnes, Laura L. Barnes and Fidèle at Ker-Feal, 1942. Photograph by Gottscho-Schleisner. Placed in the public domain by the heirs of the photographers. Gelatin silver print. Photograph Collection, Barnes Foundation Archives, Philadelphia.

CHAPTER 37

342 "The Terrible-Tempered Dr. Barnes," Poster, 1942. Ephemera Collection, Barnes Foundation Archives, Philadelphia.

CHAPTER 38

351 Pierre-Auguste Renoir. *Mussel-Fishers at Berneval (Pêcheuses de moules à Berneval, côte normand)*, 1879, Oil on canvas. The Barnes Foundation, BF989.

CHAPTER 39

358 Albert C. Barnes with Fidèle in Gallery 1 of the Cret Gallery, c. 1946. Photograph by Angelo Pinto, courtesy of the Pinto family. Copy print, 1995. Photograph Collection, Barnes Foundation Archives, Philadelphia.

CHAPTER 40

366 The remains of Barnes's Packard, after his fatal crash on July 24, 1951, photograph from *The Philadelphia Inquirer*. © 1951, Philadelphia Inquirer, LLC. All rights reserved. Used under license.

EPILOGUE

369 Violette de Mazia lecturing in Gallery 1 of the Cret Gallery as she stands in front of the west wall, 1970s. Photograph by Angelo Pinto, courtesy of the Pinto family. Film negative, nd. Photograph Collection, Barnes Foundation Archives, Philadelphia, courtesy the Pinto family.

Color insert

1 William Glackens. *Pony Ballet*, 1910–early 1911, Oil on canvas. The Barnes Foundation, BF340.

2 Vincent van Gogh. *The Postman (Joseph-Étienne Roulin)*, 1889, Oil on canvas. The Barnes Foundation, BF37.

3 Pablo Picasso. *Young Woman Holding a Cigarette (Jeune femme tenant une cigarette)*, 1901, Oil on canvas. The Barnes Foundation, BF318. © 2024 Estate of Pablo Picasso / Artists Rights Society (ARS), New York.

4 Pierre-Auguste Renoir. *Before the Bath (Avant le bain)*, c. 1875, Oil on canvas. The Barnes Foundation, BF9.

5 Marie Laurencin. *Woman with Muff (La Femme au manchon)*, c. 1914, Oil on canvas. The Barnes Foundation, BF384. © Fondation Foujita / Artists Rights Society (ARS), New York / ADAGP, Paris 2024.

6 Hélène Perdriat, *Girl with Cat*, c. 1920, Oil on panel. The Barnes Foundation, BF400.

7 Henri Matisse. *Le Bonheur de vivre*, also called *The Joy of Life*, between October 1905 and March 1906, Oil on canvas. The Barnes Foundation, BF719. © 2024 Succession H. Matisse / Artists Rights Society (ARS), New York.

390 ILLUSTRATION CREDITS

8 Giorgio de Chirico. *The Arrival (La meditazione del pomeriggio)*, 1912–1913, Oil on canvas. The Barnes Foundation, BF377. © 2024 Artists Rights Society (ARS), New York / SIAE, Rome.

8 Amedeo Modigliani. *Reclining Nude from the Back (Nu couché de dos)*, 1917, Oil on canvas. The Barnes Foundation, BF576.

9 Chaim Soutine. *The Pastry Chef (Baker Boy) (Le Pâtissier)*, c. 1919, Oil on canvas. The Barnes Foundation, BF442.

10 Paul Cézanne. *Toward Mont Sainte-Victoire (Vers la Montagne Sainte-Victoire)*, 1878–1879, Oil on canvas. The Barnes Foundation, BF300.

11 Georges Seurat. *Models (Poseuses)*, 1886–1888, Oil on canvas. The Barnes Foundation, BF811.

11 Paul Cézanne. *The Card Players (Les Joueurs de cartes)*, 1890–1892, Oil on canvas. The Barnes Foundation, BF564.

12 Ensemble view, Room 1, south wall, Philadelphia, 2012. Henri Matisse. *The Dance*, Summer 1932–April 1933, Oil on canvas; three panels. The Barnes Foundation, 2001.25.50a,b,c. © 2024 Succession H. Matisse / Artists Rights Society (ARS), New York. The work is shown installed at the Barnes Foundation in Center City, Philadelphia.

12 Ensemble view, Room 19, west wall (detail), Philadelphia, 2012. Henri Matisse. *Three Sisters with Grey Background (Les Trois soeurs sur fond gris)*, between May and mid-July 1917, Oil on canvas. The Barnes Foundation, BF888. © 2024 Succession H. Matisse / Artists Rights Society (ARS), New York. It sits installed at the Barnes Foundation, Philadelphia, between Matisse's *Three Sisters with an African Sculpture (Les Trois soeurs à la sculpture africaine)*, BF363, and his *Three Sisters and "The Rose Marble Table" (Les Trois soeurs à "La Table de marbre rose")*, BF25. Both © 2024 Succession H. Matisse / Artists Rights Society (ARS), New York.

13 Pierre-Auguste Renoir. *Bathers in the Forest (Baigneuses dans la forêt)*, c. 1897, Oil on canvas. The Barnes Foundation, BF901.

13 Paul Cézanne. *The Large Bathers (Les grandes baigneuses)*, c. 1894–1906, Oil on canvas. The Barnes Foundation, BF934.

14 Pablo Picasso with Atelier Delarbre. *Secrets (Confidences) or Inspiration*, 1934, Cotton warp and wool weft with silk highlights. The Barnes Foundation, 01.27.02. © 2024 Estate of Pablo Picasso / Artists Rights Society (ARS), New York.

15 Horace Pippin. *Supper Time*, c. 1940, Oil on burnt-wood panel. The Barnes Foundation, BF985.

15 John Kane. *Children Picking Daisies*, 1931, Oil on canvas (later mounted to hardboard). The Barnes Foundation, BF1151.

16 Pierre-Auguste Renoir. *Mussel-Fishers at Berneval (Pêcheuses de moules à Berneval, côte normand)*, 1879, Oil on canvas. The Barnes Foundation, BF989.

All images of works in the collection of the Barnes Foundation are courtesy of the Barnes Foundation.

INDEX

Abbey, 276
Addams, Jane, 110
Adler, Alfred, 128, 132, 160
African Americans. *See also individual people*
 Barnes's factory and, 36–39
 camp meetings and, 13–14
 Civic Club dinner and, 2–4, 198, 199, 200, 203, 205–206, 208
 education campaign for, 209–210
 spirituals of, 197, 202*fig*, 236, 241
African art, 192*fig*, 193–195, 200, 205, 281, 326, 370–371
Agnew Clinic (Eakins), 91
Albers, Josef, 353
Alexander, Frederick Matthias, 132–133
Alexander Technique, 121, 132–133
Alte Pinakothek, 157
Altman, 94
American Ambulance Hospital of Paris, 135
American Civil Liberties Union, 19
American Scene, The (James), 48
American Therapeutic Society, 36
Anderson, Sherwood, 121
antisemitism, 175–177, 353
antiseptics, 34–36
Apollinaire, Guillaume, 173, 196
Apparition of the Virgin and Child to Saint Hyacinth (El Greco), 284*fig*, 287

Approach to Art, An, 227
arboretum at Ker-Feal, 336–337
Arboretum School, 337, 359
Archer-Shaw, Petrine, 197
Archipenko, 196
Argyrol, 3, 35–40, 42, 45, 52, 84, 135, 136
Argyrol factory
 art in, 150*fig*, 152–153, 155*fig*
 Barnes's control of, 48
 expansion of, 142
 race relations and, 206
 sale of, 286
 worker education and, 117–118, 153–155, 200–201, 227–228
 workforce at, 36–37, 39, 114–115
Armory Show, 79*fig*, 80–81, 82–83
Arrival, The (de Chirico), 182*fig*
Art (Bell), 95
Art as Experience (Dewey), 104–105, 304*fig*, 306–308, 323, 326
Art in Painting, The (Barnes), 220, 228–231, 240, 241, 244, 259, 269, 303, 321*fig*, 325, 345
Art Institute of Chicago, 252
Art News, The, 268
Art of Renoir, The (Barnes), 308, 310–313
Art of the Steal, The (documentary), 377
Artist's Family, The (Renoir), 322
Arts à Paris, Les, 173, 174–175, 178

Arts and Decoration, 94, 95
Ash, Samuel E., 368
Ashcan school, 22, 52, 54–55, 56, 58, 64, 82
Association for the Study of Negro Life and History, 206
Atelier Delarbre, 323*fig*
"Attitude of Soul, The" (Hille), 44

Baldwin, Roger, 19
Barbizon school, 51, 65
Barnes, Albert Coombs
 access to Barnes Foundation and, 265–266, 268–272
 African art and, 4–6, 184–185, 192*fig*, 193–197, 200, 205, 281
 Alexander Technique and, 132–133
 American painters and, 151–153
 Argyrol factory and, 114–115, 117–118
 Armory Show and, 80–81, 82–83
 art collection of, 51–54, 57–60, 65–66, 70, 75, 90, 107, 108, 112, 142–144, 145–148, 157–158
 art purchased by, 60–61, 63–64, 71–74, 181
 birth of, 11
 Black community/culture and, 13–14, 36–39, 197–201, 203–205, 206–212, 279–281, 307, 331–333
 Black culture center plans and, 276–277, 278–279
 Black rights and, 6–7
 Buermeyer and, 126–127, 128–129, 130
 camp meetings and, 12–14
 car accidents and, 367
 cars and, 48–49
 on Cézanne, 148–149
 character of, 25–26, 43–44, 83–86, 88, 170, 266, 281–283
 childhood of, 16, 18, 19–22
 Chisholm and, 360
 death of, 366*fig*, 367–368

 defense of modern art from, 156*fig*, 159–160
 Demuth and, 91–92
 description of, 2–3
 Dewey and, 97–100, 103–105, 107–111, 129, 304*fig*, 306
 faith and, 12–13
 father and, 18–19
 Fidèle and, 335–336
 in Germany, 27–29
 Glackens and, 52–54
 Great Depression and, 315
 Guillaume and, 172–175, 177–179, 181, 182–184, 285–286
 Haverford and, 360–361
 health of, 363
 Hille and, 43–45
 honeymoon of, 33–34
 lectures by, 263
 lifestyle of, 272–273
 Lincoln University and, 363–365
 literature and, 88–89, 198–199
 on the Main Line, 45–48
 management principles of, 114–118, 121–122
 marriage of, 31–33
 Matisse and, 291–292, 293, 294–300, 301–303
 in medical school, 23*fig*, 24–26
 memory of, 129–130
 museum plans of, 3–5
 music and, 89
 Neck and, 16, 18
 opening of Barnes Foundation and, 224–225, 233
 PAFA exhibition and, 159–160
 in Paris, 71–74, 75–77, 145–146, 167, 188
 pharmaceutical trade and, 34–36, 39–40, 42–43
 photographs of, xi*fig*, 1*fig*, 23*fig*, 32*fig*, 41*fig*, 50*fig*, 106*fig*, 232*fig*, 245*fig*, 256*fig*, 304*fig*, 314*fig*, 334*fig*, 358*fig*

portrait of, 180*fig*
Prendergast and, 92–93
profile of, 342*fig,* 343–347
Progressive movement and, 110–111
psychological studies and, 127–128,
130–132
Quinn and, 81–83, 93
recession and, 142
Renoir and, 308, 310–313
Rosier and, 125*fig,* 131–132
Russells and, 337–338, 339–341,
347–349, 355
Soutine and, 186–188
Steins and, 76–78, 80, 89–90, 132, 148
support for artists from, 67–68
University of Pennsylvania and,
359–360, 361–362
Vollard and, 315–317
women in roles of authority and,
117–121
in Woodstock, 151
worker education and, 117–118,
121–124
World War I and, 135–136
World War II and, 354–357
writings on art by, 93–95, 233–234,
254
Yezierska and, 138, 139
zoning change and, 275–278
Barnes, Albert Coombs, works by
The Art in Painting, 220, 228–231,
240, 241, 244, 259, 269, 303,
321*fig,* 325, 345
The Art of Renoir, 308, 310–313
"Cézanne: A Unique Figure Among
the Painters of His Time,"
148–149
"Cubism: Requiescat in Pace," 83,
128
A Disgrace to Philadelphia, 319
How It Happened, 346–347
"How to Judge a Painting," 94–95, 128
Barnes, Charles, 11

Barnes, John Jesse (father), 10, 18–19,
24, 286
Barnes, Laura Leggett (wife)
Argyrol and, 36
background of, 31–32
Buermeyer and, 127
car accident and, 175
de Mazia and, 260
death of, 374
Guillaume and, 178
honeymoon of, 33–34
horticulture and, 161, 336, 337, 355
husband's death and, 367–368, 372
influence of, 120
lawsuits against foundation and,
372–373
marriage of, 31, 33
photographs of, 30*fig,* 245*fig,* 334*fig*
Russells and, 348
University of Pennsylvania and, 359
in Woodstock, 151
Barnes, Lydia A. (née Schaffer; mother),
10, 11–12, 14, 19, 24, 63, 121
Barnes & Hille Company, 36, 39, 43, 45
Barnes Company, A. C., 45, 114,
118–119, 120, 121–122, 286
Barnes Foundation
access to, 265–266, 268–272
African art and, 4, 195–196
after Barnes's death, 371–377
articles on, 199
L. Barnes and, 33
Buermeyer and, 127
building plans for, 168–170, 214–216
collection of, 220
"demonstrations" at, 261–265
Dewey and, 306
educational goals of, 225–227, 235,
237–238, 246–247, 258–259,
369*fig*
"ensembles" in, 321*fig,* 328–329,
329*fig,* 376
founding of, 160–161, 163–165

394 INDEX

Barnes Foundation (*cont.*)
 galleries of, 213*fig*, 214–217
 Guillaume and, 189
 lawsuits against, 372
 Lincoln University and, 364–365
 Lipchitz and, 168
 naming of, 19
 opening of, 195, 224–225
 photographs of, 274*fig*
 reactions to, 220–222
 relocation of, 376–377
 women working at, 119
 during World War II, 356
Barr, Alfred H., 228–229, 230, 355
baseball, 22, 25, 307
Bathers (Renoir), 141*fig*, 146–147
Bathers in the Forest (Renoir), 312, 312*fig*
Bazille, Jean Frédéric, 65
Beaux, Cecilia, 56
Before the Bath (Renoir), 60–61, 60*fig*
Bell, Clive, 75, 95, 242
Bellevue Plain, The (Cézanne), 328
Benin bronzes, 287
Bennett, Gwendolyn, 2, 279–280, 281
Benton, Thomas Hart, 152–153, 154
Berenson, Bernard, 157, 254
Bergson, Henri, 128
Bethany Methodist Episcopal Church,
 8*fig*, 12, 15*fig*
Bignou Gallery, 355
Bit and Spur, 47
Bland, James, 333, 352
Bond, Horace, 363–365
Bonnard, Pierre, 63, 294
Bordentown School, 208
Bordentown Singers, 202*fig*, 208, 236
Bosanquet, Robert, 128
Boyd, Alison, 198, 205, 237, 332
Braddock, Jeremy, 130
Bryn Mawr College, 247, 352, 361
Buermeyer, Laurence
 Barnes Foundation and, 227, 238,
 254

 falling out with, 257
 financial issues with, 170
 health of, 362
 mental health of, 248
 Rosier and, 131
 as tutor, 126–127, 128–129, 130
Burlington Magazine, 71
Bushong, Albert "Doc," 22
Buste de jeune fille (Kisling), 262*fig*

Card Players (Cézanne), 250–252,
 251*fig*, 291, 328
Carles, Arthur, 189
Carnegie International exhibition,
 291
Caro, Robert, 211
cars, 48–49
Caryatids (Renoir), 308, 309*fig*
Cassatt, Mary, 55–56, 276, 308
Cendrars, Blaise, 196
Central High School, 20–22, 24–25, 27
Cézanne, Paul
 Barnes on, 143, 148–149, 230, 240,
 319–320
 in Barnes's collection, 59, 63, 68,
 70–72, 76, 80, 90, 146, 147–148,
 232*fig*, 287, 291, 317–320, 322,
 325, 328, 329*fig*, 370
 Glackens and, 56–57
 Pippin compared to, 332
 Titian compared to, 229
 Vollard and, 67
 works of, 71*fig*, 141*fig*, 223*fig*,
 250–252, 251*fig*, 317*fig*
"Cézanne: A Unique Figure Among the
 Painters of His Time" (Cézanne),
 148–149
Chanin, Abraham, 355
Chardin, 322
Chester Valley Hunt Club, 47–48
Children Picking Daisies (Kane), 330*fig*
Chisholm, Roderick, 360
Chrysler, Walter P., Jr., 345

City College of New York (CCNY),
338–339
Civic Club, 2–4, 198, 199, 200, 203,
205–206, 208
Civil War, 9–10, 19, 31–32, 100
Clark, Kenneth, 272, 273, 325–327
cognitive behavioral therapy, 26–27
Cold Harbor, 9–10, 100
Columbia, 247–248, 253, 258, 277
Composition: The Peasants (Picasso),
284*fig*, 287
Cone sisters, 94
constructivism, 242
Coolidge, Calvin, 2
Corot, Jean-Baptiste-Camille, 322
Courbet, Gustave, 217, 218*fig*, 328–329
crafts, 322–328
Cret, Paul, 214–217, 219
Croly, Herbert, 111, 200
cubism, 74, 81, 83, 128, 220, 228, 242,
320
"Cubism: Requiescat in Pace" (Barnes),
83, 128
Cullen, Countee, 198, 281
Cuttoli, Marie, 323, 324, 355

Dan culture, 192*fig*, 195
Dance, The (Matisse), 221, 290*fig*, 291–
295, 293*fig*, 298–299, 301–303
Daumier, Honoré-Victorin, 65
de Chirico, Giorgio, 180*fig*, 181–183,
182*fig*, 185
de Mazia, Violette
background of, 259–260
Barnes contrasted with, 261
Barnes's death and, 372
Cézanne and, 319
death of, 374
on decorating, 325
educational goals and, 337
future of Barnes Foundation and, 363
ironwork and, 328
L. Barnes's death and, 374

lawsuits against foundation and,
372–373
Matisse and, 299
photographs of, 256*fig*, 369*fig*
Renoir and, 308
role of, 119
teaching of, 261
Degas, Edgar, 57, 68
Delacroix, Eugène, 63
Democracy and Education (Dewey), 107,
109–110, 122, 204–205, 270
Demuth, Charles, 91–92, 150*fig*, 153,
154, 159
Dent, Louis, 38
Derain, André, 167, 193
Dercum, Francis Xavier, 159
design, concept of, 242
Detroit Institute of Arts, 214
Dewey, Alice, 119, 143
Dewey, Archibald, 100
Dewey, John
Alexander Technique and, 121, 132
background of, 100–101
L. Barnes and, 120
Barnes Foundation and, 33, 163, 164,
199, 201, 214, 225, 254, 259
Barnes on, 152
on Barnes's intellect, 129
Barnes's relationship with, 97–100,
104–105
Barnes's writings and, 149
Buermeyer and, 127
de Mazia and, 260
educational theory and, 122,
235–236, 265
Haverford and, 361
health of, 352–353, 363
Journal of the Barnes Foundation and,
254
at Ker-Feal, 335
Lincoln University and, 363
management principles and, 114, 115,
116

396 **INDEX**

Dewey, John (*cont.*)
 photographs of, 96*fig,* 304*fig*
 Poland/Polish project and, 138–140
 pragmatism and, 144
 race relations and, 199–200, 203–204
 Russells and, 339, 348
 Saturday Evening Post profile and,
 344
 University of Pennsylvania and, 362
 on upper-class culture, 270
 women's suffrage and, 119
 work of, 101–104, 107–111
 worker education and, 117, 123,
 153–154
 World War I and, 135–136, 137
 writings on art by, 306–308, 323, 326
 Yezierska and, 134*fig,* 137–138
Dewey, Lucina, 101
Disgrace to Philadelphia, A (Barnes), 319
door knockers, 322
Douglas, Aaron, 280, 281, 332
Douglass, Frederick, 199
Du Bois, W. E. B., 2, 3, 4, 37–38, 199
Duchamp, Marcel, 83, 220–221, 320
Dunbar, Paul Laurence, 199
Durand-Ruel (gallery), 67, 89, 146
Durand-Ruel, Georges, 146

Eakins, Thomas, 56, 91, 161, 243
Ebony, 278
Edman, Irwin, 136–137
education/educational theory, 102–103,
 107, 122, 225–227, 235. *See also*
 under Barnes Foundation; Dewey,
 John
Eglington, Guy, 268–269
Egyptian statuary, 183
Eighty-Second Regiment of
 Pennsylvania Volunteers, 9–10, 100
Einstein, Albert, 176, 339, 353
El Greco, 183–184, 284*fig,* 287
Eliot, T. S., 271
Ellis, Havelock, 152, 239–240

eugenics, 6
Ex Libris, 5, 198–199, 205–206

Fang Betsi culture, 192*fig,* 195
Fauset, Jessie, 2, 4
fauves, 166, 167, 193, 294
feminism, 119–120
Fidèle, 304*fig,* 334*fig,* 335–336, 345,
 358*fig,* 368
First Vermont Cavalry, 100
Fisk University, 207
Five Bathers (Cézanne), 71–72, 71*fig*
Fleur de Lis Club, 209
Fogg, John, 336, 359
Folies Bergère, 179
Ford, Henry, 176
Forer, Lois G., 372–373
formalism, 55, 92, 167, 185–186,
 228–229, 234, 236–237, 312–313,
 328
"Free Man's Worship" (Russell),
 337–338
French Legion of Honor, 178
Freud, Sigmund, and Freudianism,
 127–128, 130–132, 159–160, 176
Frick, Henry Clay, 72, 94
Friends of the Barnes Foundation,
 373
From Cézanne to Matisse: Great
 French Paintings from the Barnes
 Foundation, 375
Fry, Roger, 75, 154, 177
Funk, Charles, 116, 142

Gad, 27
Galerie Paul Guillaume, 173
Gauguin, Paul, 57, 63
Geiger, Laura, 118, 119, 120, 231,
 256*fig,* 259, 325
George, Waldemar, 174, 177
Giorgione, 166
Girl with Cat (Perdriat), 162*fig*
Glackens, Edith, 33, 90, 119

INDEX 397

Glackens, William "Butts"
art advice from, 51–54, 90
Barnes on, 152
Barnes's acquisitions and, 56–59,
183–184
credit to, 235
death of, 352
Duchamp and, 221
friendship with, 22
National Academy of Design show
and, 64
in Paris, 56–57
photograph of, 50*fig*
Prendergast and, 93
Renoir and, 311
wife of, 33
work of, 53–54, 54*fig*, 67, 153, 243,
276
Glen Grant scotch, 273
gonorrhea, 35, 36
Gottlieb, Rudolf, 27
Goya, Francisco, 65
Grafly, Dorothy, 190, 191
Grafton Galleries, 74–75
Grande Jatte, La (Seurat), 252
Grant, Ulysses S., 9–10
Gray, Jim, 38
Gray's Glycerine Tonic, 28
Great Depression, 38, 206, 305, 315
Great School of Natural Science, 44–45
Greenberg, Clement, 229–230
Grimke, Angelina Weld, 198
Guillaume, Paul
African art and, 193, 196, 254
on Barnes, 188–189
Barnes Foundation and, 235
Barnes's acquisitions and, 172–175,
177–179, 181, 182–184
on Barnes's teaching style, 263
Bordentown Singers and, 208
de Mazia and, 261
falling out with, 285–286
gallery of, 308

Modigliani and, 184–186
portrait of, 171*fig*, 184
Soutine and, 186–187

Harlem Renaissance, 3, 6, 194
Harlequin with Clarinet (Lipchitz),
169*fig*
Harper's Weekly, 81
Hart, Henry, 280–283, 305
Hartley, Marsden, 152, 153, 157, 159,
299
Haverford, 360–361
Henner, Jean-Jacques, 51, 59
Henri, Robert, 52
Henriot Family (Renoir), 310, 310*fig*,
316
Hill, Theodore, 38
Hille, Hermann, 29, 34, 35–36, 42,
43–45, 114
Hinkson, DeHaven, 207
History of Western Philosophy (Russell),
341
Hitler, Adolf, 353
Hodgkinson, Chas. A., 46
Hogans, Paul, 209
Honegger, Arthur, 196
Hotel Powelton, 113*fig*
House & Garden, 328
How It Happened (Barnes), 346–347
"How to Judge a Painting" (Barnes),
94–95, 128
Hughes, Langston, 2, 363
Hughes, Mike, 4

Idyl (Perdriat), 168, 190
Impressionism, 56
In Fact, 305
Ingersoll, Sturgis, 298
Ingres, 65
insanity defense, 131–132
International Exhibition of Modern Art,
80
ironwork, 321*fig*, 322, 324–328

398 INDEX

Jacob, Max, 173, 174
James, Henry, 48, 158
James, William, 82, 101, 107, 117, 123, 128, 132, 152
Johnson, Charles Spurgeon, 3, 4, 199, 207, 209–210, 278, 279–280
Johnson, James Weldon, 236
Johnson, John Graver, 64–65
Johnson, Lyndon, 210–211
Journal of the Barnes Foundation, 254
Joy of Life (Matisse), 165–167, 166*fig*, 174, 190, 295
Joyce, James, 92
Jung, Carl, 128, 160

Kahnweiler, Daniel-Henry, 73–74, 146
Kane, John, 330*fig*, 331
Keller, Georges, 355, 357
Ker-Feal, 334*fig*, 335, 336–337, 372
keyhole plates, 322
Kimball, Fiske, 265, 297
Kisling, Moïse, 262*fig*, 263
Klemperer, 27
Ku Klux Klan, 6
Kulp & Gordon Motor Freight Company, 368

Laboratory School, 103, 109
Lagut, Irène, 119, 145, 181
Landscape with Figures (Prendergast), 87*fig*
Lange, Dorothea, 331
Large Bathers (Cézanne), 317–320, 317*fig*, 322, 325
Laughton, Charles, 267*fig*, 271, 331, 335, 336
Lauraston, 45–46, 142
Laurencin, Marie, 119, 145, 145*fig*
Lawrence, D. H., 92
Le Corbusier, 235
League for International Democracy and Education, 137

Leggett, Clara, 36
Leggett, Laura. *See* Barnes, Laura Leggett (wife)
Leggett, Richard Lee, 31–32
Leonardo da Vinci, 74
Lincoln University, 277, 363–365, 374–375, 376
Linge, Le (Manet), 316
Lipchitz, Jacques, 168–169, 169*fig*, 170, 176, 196, 221, 355
Liveright, Horace, 2
Lloyd, Harold, 126
Locke, Alain, 2, 3, 4, 199, 210, 234
Louvre, 157
Lucy, Martha, 311
Lusitania, 91
lynchings, 6

Mack, Connie, 22
Maeterlinck, Maurice, 88
Majestic, 178
Manet, Édouard, 65, 179, 316
Mann, Thomas, 353
Man's Supreme Inheritance (Alexander), 132
Manual Training and Industrial School for Colored Youth, 208
Marriage and Morals (Russell), 339
Marshall, Thurgood, 363
mask, miniature, 192*fig*
Masque of the Red Death (Demuth), 150*fig*, 154
Matisse, Henri
 Barnes on, 94, 190, 299–300
 in Barnes's collection, 76, 80, 145, 220, 221, 294–298
 commission for *The Dance*, 291–295, 298–299, 301–303
 Glackens and, 56, 57
 at Grafton Galleries, 74, 75
 health of, 352
 photographs of, 290*fig*

purchases of, 181
Renoir and, 311
Schapiro article on, 270
Stein and, 78
tapestries based on, 323
work of, 165–167, 166*fig*, 174, 293*fig*, 296*fig*
Matisse, Pierre, 352
Maurer, Alfred, 55, 56, 65–68, 70, 75
McCardle, Carl, 344–347, 348, 350
McCarter, Henry, 158
McFadden, John, 64
Mencken, H. L., 2, 121
Mercy Hospital, 27
Methodist Episcopal Church, 12–13, 14
Metropolitan Museum of Art, 276, 355
Michelangelo, 294
Michener, James, 84
Milhaud, Darius, 196
Military Intelligence Bureau, 139–140
Mill, John Stuart, 98
Millet, Jean-François, 51, 65
minimalism, 215
Miró, 323
Models (Seurat), 252–253, 252*fig*, 291
Modigliani, Amedeo, 181, 184–186, 185*fig*, 196, 371
Monet, Claude, 56, 57, 65, 312
Mont Sainte-Victoire (Cézanne), 141*fig*, 147–148
Morgan, J. P., 72
Mulford, H. K., 139
Mulford and Company, H. K., 28–29, 33, 34, 36
Mullen, Mary
Barnes Foundation and, 254, 259, 262–263, 264–265, 268, 372
collection of, 153
decorating and, 325
factory management and, 119–120
worker education and, 118, 122
writings on art by, 227

Mullen, Nelle E., 44, 118–119, 120, 153, 259, 325, 374
Munro, Thomas, 248–249, 253, 257–258, 360
mural paintings, 294. See also *Dance, The* (Matisse)
Musée d'Art Moderne de Paris, 301
Musée d'Orsay, 141*fig*
Museum of Fine Arts (Boston), 69*fig*
Museum of Modern Art (MoMA), 219, 228
Mussel-Fishers at Berneval (Renoir), 351*fig*, 355–356
Myers, John Andrew, 189–190

Narberth Fire Company, 11, 178, 352, 368
National Academy of Design, 64
National Association for the Advancement of Colored People (NAACP), 204, 209, 280–281
National Cash Register Company, 116–117, 122
National Gallery (London), 272, 325–327
Neck, the, 14, 15*fig*, 16, 17*fig*, 18
Negro Achievement Hour, 281
Neurotic Constitution (Adler), 132
New Negro movement, 2, 205
New Republic, 111, 200
New School for Social Research, 111, 122
New York Herald Tribune, 299
New York Philharmonic, 157
New York Times, The, 191, 293, 318, 319
New Yorker, The, 35, 238, 271
North American, 190, 191
Nude Descending a Staircase (Duchamp), 83
Nudes in Landscape (Cézanne), 319–320
Nulty, Albert, 216, 372

Office of Price Administration, 355, 356
Oil Refinery (Pennell), 17*fig*

400 INDEX

O'Keeffe, Georgia, 287–288, 289, 331

Ophthalmoscope, The, 42

Opportunity magazine, 3, 198, 200, 278, 279–280

originality, concept of, 239

"Outlawry of War, The," 130

Outline of History (Wells), 122, 200

Overbrook Farms, 34, 46

Ovoferrin, 40

Paderewski, Ignacy Jan, 139–140

Paintings and Drawings by American Artists Showing the Later Tendencies in Art (exhibition), 159–160

Panofsky, Erwin, 353

Pastry Chef (Soutine), 186, 187*fig*

Paul Guillaume, Novo Pilota (Modigliani), 171*fig*, 184

Peale, Rembrandt, 21–22

Peale family, 191

Peerless Motor Car Company, 49

Pennell, Joseph, 17*fig*

Pennsylvania Academy of the Fine Arts (PAFA), 158–160, 163, 189–191, 247–248

pensions, veterans', 10–11, 24

Perdriat, Hélène, 119, 145, 162*fig*, 167–168, 181, 190–191

pharmaceutical trade, 34–36

Philadelphia Art Alliance, 159–160

Philadelphia Athletics, 22, 307

Philadelphia Inquirer, The, 56, 191, 275, 276, 277, 372

Philadelphia Museum of Art, 65

Philadelphia Negro, The, 37

Phillips, Duncan, 161

Phillips Collection, 219–220

Picasso, Pablo

 African art and, 5, 195, 196

 Barnes on, 81, 94, 301–302

 in Barnes's collection, 59, 73–74, 80,

90, 145–146, 220, 221, 284*fig*, 287, 323*fig*

 Barnes's support for, 83

 Barr on, 228

 Cézanne and, 320

 El Greco and, 287

 in factory collection, 153, 154

 at Grafton Galleries, 74, 75

 Philadelphia Inquirer article and, 56

 Renoir and, 311

 Soutine contrasted with, 188

 Stein and, 76–78

 tapestries based on, 323

 timing of first purchase of, 235

 work of, 58*fig*, 73*fig*, 155*fig*

Pippin, Horace, 329, 330*fig*, 331–333, 352

Playboy of the Western World (Synge), 88

Poe, Edgar Allan, 154

pointillism, 252, 252*fig*

Poiret, Paul, 281

Poland/Polish project, 137–140

Polyclinic Hospital, 27

Pony Ballet (Glackens), 53–54, 54*fig*

Portenar, Jeanette, 261

Portrait of Jeanne Durand-Ruel (Renoir), 316–317, 316*fig*

Postman (van Gogh), 57–58, 57*fig*

Poulenc, Francis, 196

Pound, Ezra, 266

Poussin, Nicolas, 166

Powelton Hotel, 36

pragmatism, 101–104, 107, 115, 144, 204

Prendergast, Charles, 92

Prendergast, Maurice, 87*fig*, 92–93, 146, 152, 153

Principles of Psychology (James), 123

Progressive movement, 110, 111, 116–117, 122, 188, 200, 243

Protocols of the Elders of Zion, The, 176

psychology, 26–27, 122–123, 127–128, 129, 130–132, 241, 264–265

Public Ledger, 190, 191
Pullman Strike, 110

quadratura effects, 294
Quinn, John, 81–83, 93, 152

racism, 204, 210–211, 276
radical empiricism, 123
Raphael, 72
Ravine (van Gogh), 69*fig,* 70
readymades, 220–221
Reconstruction in Philosophy (Dewey), 123
Red Madras Headdress (Matisse), 295
Red Studio (Matisse), 75
Redon, Odilon, 181
Reeve, W. Foster, III, 47
reliquary guardian head, 192*fig*
Rembrandt, 72
Renoir, Pierre-Auguste
 at Barnes Foundation, 355–356
 Barnes on, 143–144, 240
 Barnes's book on, 308, 310–313, 323–324
 in Barnes's collection, 59, 60–61, 90, 146–147, 221, 287, 308, 309*fig,* 310, 310*fig,* 312*fig,* 315, 316–317, 316*fig,* 322, 328, 329*fig,* 351*fig,* 370
 death of, 143–144
 Steins and, 56, 76
 Titian compared to, 264–265
 work of, 60*fig,* 141*fig,* 217, 219*fig*
Richardson, Dorothy, 121
Richardson, John Emmett ("TK"), 44–45
Rimbaud, Arthur, 196
Roberts, Owen, 269
Robeson, Paul, 208
Robinson, Gerald, 368
Rochambeau, 55
Rodgers, Daniel, 110
Rodin, Pierre-Auguste, 72

Rohland, Caroline, 151
Rohland, Paul, 151
Roosevelt, Franklin D., 305, 354, 355
Rose Tree Hunt, 64
Roseanne (Stephens), 206
Rosenberg, Paul, 172
Rosier, Catherine, 125*fig,* 131–132
Rouault, Georges, 287
Rousseau, Henri, 331, 332*fig*
Rudenstine, Neil, 308, 310
Ruskin, John, 243
Russell, Bertrand
 background of, 338–339
 on Barnes, 26, 211
 on L. Barnes, 33
 Barnes and, 128, 129, 337
 at Barnes Foundation, 339–341, 344, 348, 349–350, 355
 influence of, 107
 Thomas Hart Benton and, 152
 worker education and, 117, 122, 153
Russell, Patricia (Peter), 337, 347–350

Salon des Indépendants, 166
Santayana, George, 82, 107, 128, 132, 152, 154
Sarah Lawrence, 363
Satie, Erik, 177, 196
Saturday Evening Post, The, 176, 342*fig,* 343–347, 350, 353
Schaffer, Lydia A. (later Barnes; mother), 10, 11–12, 14, 19, 24, 121
Schapiro, Meyer, 270
Schoenberg, Arnold, 89, 176
Schuyler, George S., 211
Scientific American, 49
Scientific Method in Aesthetics (Munro), 258
Scott, Walter, 88
Scribner's Monthly, 16

Second Post-impressionist Exhibition, 74–75

Secrets (Confidences) or Inspiration (Picasso), 323*fig*

Seldes, George, 305

Sense of Beauty (Santayana), 154

Seurat, Georges, 252–253, 252*fig*, 291, 328, 370

sexism, 120

significant form, theory of, 242

silver antiseptic, 34–36

Sisley, Alfred, 65

Sistine Chapel, 294

Skemp, Olive, 261

Sloan, John, 22, 49, 62*fig*, 67, 95, 157, 159, 243, 276

Smoker, The (van Gogh), 66

"social question," 110–111

Soutine, Chaim, 155, 186–188, 187*fig*, 189, 196, 235

Spanish flu, 136

Spence, Patricia. *See* Russell, Patricia (Peter)

St. James Protestant Episcopal Church, 31

Starry Night (van Gogh), 179

Stassen, Harold, 361–362

Stein, Gertrude, 56, 76, 77, 88, 311, 362

Stein, Leo
 Barnes Foundation and, 91
 Barnes's friendship with, 77–78
 correspondence with, 80, 89–90, 132, 142, 148
 death of, 362
 Glackens and, 56
 on Matisse, 166
 Renoir and, 311
 salon hosted by, 76
 World War II and, 355–356

Stein, Michael, 76–77

Stephens, Nan Bagby, 206

Stephenson, Sydney, 42

Stieglitz, Alfred, 152, 158, 287

Stillwagon, Howard S., Jr., 277

Stock-Taking and Fact-Finding Conference on the American Negro, 279–280

Stokowski, Leopold, 84, 89, 176, 196, 224, 276

Stravinsky, Igor, 177

Supper Time (Pippin), 330*fig*

Synge, John Millington, 88

tapestries, 323–324, 323*fig*

Taylor, Harold, 363

Tempesta (Giorgione), 249

textiles, 323–324, 323*fig*

Theosophical Society, 44

Thibaud, Jacques, 89

Three Sisters with Gray Background (Matisse), 295–298, 296*fig*, 300, 318

Titian, 229, 264–265

Tod Williams Billie Tsien Architects, 377

Toulouse-Lautrec, Henri de, 70

Toward Mont Sainte-Victoire (Cézanne), 223*fig*, 230

trolley system (Philadelphia), 20

Trucker's Farm-Yard, A (Pennell), 17*fig*

Truth, Sojourner, 198–199

Tutankhamen's tomb, 194

Ulysses (Joyce), 92

University of California, Los Angeles (UCLA), 338

University of Pennsylvania, 22, 121, 163, 248, 253, 255, 258, 359–360, 361–362

Urban League, 3

Van Doren, Carl, 2

Van Gogh, Vincent
 in Barnes's collection, 57–58, 59, 66, 68, 70, 80
 passing on, 179

purchases of, 181
work of, 57*fig*, 69*fig*, 217, 218*fig*
Van Vechten, Carl, 271
Vare, Edwin H., 18
Vare brothers, 18
Varieties of Religious Experience (James), 123
Victoria, Queen, 333
View of the Quai d'Asnières (Rousseau), 332*fig*
Vision and Design (Fry), 154
Vollard, Ambroise, 67, 72–73, 172, 250, 314*fig*, 315–317
vorticism, 242
Vuillard, Édouard, 294

Wall Street Journal, The, 301
Wallace Collection, 160
Walrond, Eric, 198
Warren State Hospital for the Insane, 26
Washington, Booker T., 199
Washington Post, The, 307
Watson-Schütze, Eva, 96*fig*
Waverley novels (Scott), 88
Wells, H. G., 122, 200
White, Gilbert, 360–361
White, John, 38, 124, 228
White, Walter F., 2, 204
"Why I Support This War" (Russell), 355

Why Men Fight (Russell), 122
Widener, Joseph, 318–319
Widener, Peter, 10, 64, 94
William Welsh School, 15*fig*
Williams, William Carlos, 144, 221, 244
Wilson, Joseph Lapsley, 161, 163
Wilson, Woodrow, 111, 137, 138, 139–140, 200
Wineglass and Fruit (Picasso), 73*fig*, 74
Woman with Muff (Laurencin), 145*fig*
Woman with White Stockings (Courbet), 218*fig*
Women in Love (Lawrence), 92
women's suffrage, 119
Woollcott, Alexander, 345
workplace reforms, Progressive movement and, 116–117
World War I, 91, 122, 128, 135–137, 138–139
World War II, 338, 354–357, 359
wrought-iron hinges, 322

Yezierska, Anzia, 134*fig*, 137–138, 139
Young Woman Holding a Cigarette (Picasso), 58*fig*

Zonite Products Corporation, 286, 305